THE
MEDUSA
READER

CultureWork
A book series from the Humanities Center at Harvard
Marjorie Garber, editor, and Rebecca L. Walkowitz, associate editor

Psychoanalysis, Historicism, and Early Modern Culture
Carla Mazzio and Douglas Trevor, editors

The Turn to Ethics
Marjorie Garber, Beatrice Hanssen, and Rebecca L. Walkowitz, editors

One Nation Under God?
Religion and American Culture
Marjorie Garber and Rebecca L. Walkowitz, editors

Field Work
Sites in Literary and Cultural Studies
Marjorie Garber, Paul Franklin, and Rebecca L. Walkowitz, editors

The Seductions of Biography
Mary Rhiel and David Suchoff, editors

Secret Agents
The Rosenberg Case, McCarthyism, and Fifties America
Marjorie Garber and Rebecca L. Walkowitz, editors

Media Spectacles
Marjorie Garber, Jann Matlock, and Rebecca L. Walkowitz, editors

THE
MEDUSA
READER

EDITED BY *Marjorie Garber* AND *Nancy J. Vickers*

ROUTLEDGE
New York and London

Published in 2003 by
Routledge
29 West 35th Street
New York, NY 10001
www.routledge-ny.com

Published in Great Britain by
Routledge
11 New Fetter Lane
London EC4P 4EE
www.routledge.co.uk

Routledge is an imprint of the Taylor & Francis Group.

The text of this book was composed in Perpetua and Univers 47 with Rotis Semi Serif display
face. Book design by Scott McCarney. Printed and bound in the United States of America by
Sheridan Books, Inc.

Library of Congress Cataloging-in-Publication Data

The Medusa reader / edited by Marjorie Garber and Nancy J. Vickers
 p. cm.
 Includes bibliographical references and index.
 ISBN 0-415-90098-0 (alk. paper) — ISBN 0-415-90099-9 (pbk.: alk. paper)
 1. Medusa (Greek Mythology). I. Garber, Marjorie B. II. Vickers, Nancy J.
BL820.M38M43 2002
292.2'13—dc21 2001041823

Contents

Illustrations

Figure 1. *The Head of Medusa*, oil on canvas mounted on a wooden shield, by Caravaggio, 1590–1600.

Figure 2. Perseus slaying the Medusa as Centaur, relief amphora vase, Boeotia, c. 660 B.C.E.

Figure 3. Running Gorgon on side B of a panathenaic amphora, attic red vase, attributed to the Berlin Painter, c. 490 B.C.E., Etruria.

Figure 4. Gorgoneion and Tondo, detail of a kylix, attic black vase interior, attributed to Group of Walters, c. 510–500 B.C.E., Vulci.

Figure 5. Silver ten scruples coin with winged Gorgon, early to mid-third century B.C.E.

Figure 6. *Medusa Rondanini* (Roman copy), original by Phidias, c. fifth century B.C.E.

Figure 7. Drawing of Perseus with the head of Medusa, from a manuscript of Hyginus's *Fabularum Liber*, c. tenth century.

Figure 8. Venetian illumination of Dante's *Inferno*, Canto 9, c. 1425–1450.

Figure 9. *Perseus*, bronze sculpture, by Benvenuto Cellini, 1545–1554.

Figure 10. *Perseus Holding the Head of Medusa*, marble sculpture, by Antonio Canova, 1804–1806.

Figure 11. *Head of Medusa*, engraving, by Cornelius Cort, mid-sixteenth century.

Figure 12. *Matière à réflection pour les jongleurs couronnées*, 1793.

Figure 13. *The Head of Medusa*, oil on canvas, by Peter Paul Rubens, c. 1618.

Figure 14. *Medusa*, Flemish School Painting, c. 1620–1630.

Figure 15. *Medusa (Laura Dreyfus Barney)*, pastel on canvas, by Alice Pike Barney, 1892.

Figure 16. *Medusa*, by Lucien Lévy-Dhurmer, 1897.

Figure 17. *Medusa*, marble sculpture, by Harriet Hosmer, 1854.

Acknowledgments

The Medusa Reader began in the summer of 1986 when the two of us discovered a common strain in our research. Each of us had written an essay on Shakespeare, the one on *Macbeth* and the other on *Lucrece*, that had almost inadvertently drawn us to Medusa; both had been attracted by the wealth and range of provocative interpretation inspired by Medusa's deeply enigmatic story. Striking too was the regularity with which a figure more than "a millennium in the making" (to cite an advertisement for 1999's hottest "scream machine"—a roller coaster named "Medusa" [Figure 32]) returned within the high and low cultural production of our contemporaries. The net of our collaboration expanded to include generous colleagues as well as a team of enthusiastic undergraduate and graduate research assistants. Toby Kasper unearthed texts and produced an invaluable bibliography. Paul Franklin found countless images, both canonical and noncanonical. Lois Leveen in Los Angeles and Karen Paik and Mindy Smart in Cambridge drafted headnotes, pursued permissions, located further images, added bibliographical references, and kept track of myriad crucial details. This anthology would have been unimaginable without them. Lesley Lundeen, Valerie Jaffe, Nish Saran, and Brina Milikowsky contributed additional headnotes and assistance at key moments. Marcie Bianco, Nell Booth, and Nina Vergari helped us achieve closure. Our institutions—Bryn Mawr College, Harvard University, and the University of Southern California—provided critical financial support. William Germano, our editor at Routledge, has been alternately persistent and patient. Both qualities are deeply appreciated. Our hope is that the volume serves scholars who will find these texts usefully assembled and profit from a wealth of bibliography, students who will learn here how myth generates meaning over time, and general readers who will find short and compelling selections and images in these pages to seduce and astonish the imagination.

Marjorie Garber and Nancy J. Vickers

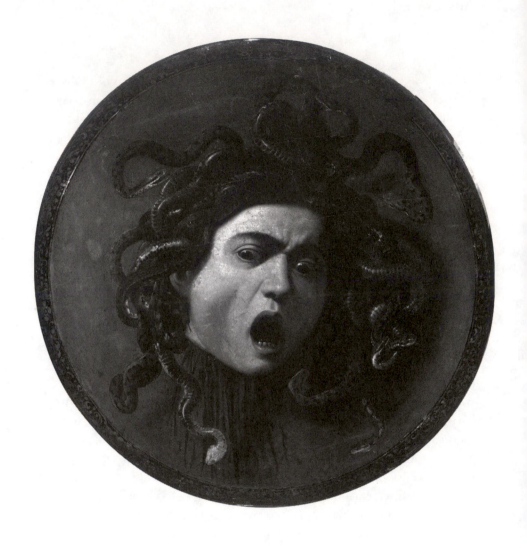

FIGURE 1. *The Head of Medusa*, oil on canvas mounted on a wooden shield, by Caravaggio, 1590–1600, Galleria degli Uffizi, Florence.

Introduction

Marjorie Garber and Nancy J. Vickers

Poets have called her a Muse. Feminists have adopted her as a sign of powerful womanhood. Anthropologists read her image as embedded in the paradoxical logic of amulets, talismans, and relics. Psychoanalysts have understood the serpents wreathing her head as a symbol of the fear of castration. Political theorists have cast her as a figure for revolt. Artists have painted her in moods from sublime to horrific. The most canonical writers (Homer, Dante, Shakespeare, Goethe, Shelley) have invoked her story and sung both her praise and her blame. The most adventurous of postmodern designers and performers see her as a model, a logo, and a figure for the present age.

Petrifying. Astonishing. Monumental. All these words, which have at their core the idea of being turned into stone, are central to the figure of Medusa.

From its distant beginnings, the story of Medusa has fascinated listeners and readers—and terrified them. For what is most compelling in the long history of the myth and its retellings is Medusa's intrinsic doubleness: at once monster and beauty, disease and cure, threat and protection, poison and remedy, the woman with snaky locks who could turn the unwary onlooker to stone has come to stand for all that is obdurate and irresistible.

Although the original Medusa was said to be a beauty, "Medusa" in common parlance came to mean monster. The tension between the beautiful Medusa and the monstrous one is intrinsic to the story, to the figure of Medusa herself, and to the twin strands of feminism and misogyny that have attached themselves to retellings of the Medusa myth throughout the ages.

Who is Medusa, and how can we account for her persistent fascination?

Ancient sources differ on some details (as will be clear from the selections included in this volume), but the gist of the story is this:

The exquisitely beautiful Medusa, one of the three Gorgons of Greek myth and the only mortal one, was said to have dallied with—or, in other versions, to have been raped by—the sea god Poseidon in the Temple of Athena. As punishment for this transgression, Athena transformed Medusa from woman to monster, changing her luxuriant long hair into a tangle of hissing snakes. A spectator gazing at Medusa would henceforth be turned to stone.

One of the tasks of the hero Perseus, son of Zeus and the mortal Danae, was to slay Medusa—a task he was able to perform with the help and advice of the gods. Warned not to look directly at her, he gazed instead at her reflection in his shield and, guided by her mirrored image, cut off her head. The two children of the union of Medusa and Poseidon sprang to life at the instant of their mother's decapitation. One of these was Chrysaor, later the father of the monster Geryon, and the other was Pegasus, later the winged horse of the Muses (hence the persistent association of Medusa with poetry and the arts). Perseus next appropriated Medusa's head as a device for his own protection, holding it up to petrify his enemies. On one occasion he punished the inhospitality of the giant Atlas by showing him the Medusa head: Atlas was transformed into a mountain, whose rocky bulk held up the heavens. On another occasion, that of his own wedding to Andromeda, Perseus produced the head of Medusa to vanquish a rival suitor and his partisans. The rival was turned to stone. Ultimately, Perseus gave Medusa's head to his patroness Athena, the very goddess who had caused Medusa's monstrosity. Athena wore it thereafter in the center of her aegis and used it to subdue her foes. Thus the head of Medusa, initially figuring rebellion, competition, and sexual desirability, becomes, under Athena's sign, transformed into a beneficial emblem and a source of civic and martial strength. Indeed, Athena, by some accounts, invented the art of weaponry: she was regarded as the goddess of heralds. The first and most ancient of armorial signs is the head of the Medusa, often emblazoned on a proud warrior's breastplate as well as on his shield. Medusa's head thus becomes apotropaic, literally warding off or turning away the evils it embodies. Terror is used to drive out terror, so that the formerly stupifying image is turned back upon one's enemies. Both trope (a turn of phrase, a figure of speech) and apotrope (a warning), the head of Medusa partakes of linguistic as well as material culture, and has over time been seen as the epitome of the apotropaic object. As we shall see, by the later twentieth

century the double potential of the apotrope will inform representations of Medusa in popular culture as well as in high art. The same combination of danger, power, and beauty that led Athena to adopt the Medusa head as her emblem has rendered the head an evocative sign—and a literal logo—for advertising, music video, and visual culture today.

The story of Medusa is told by such classical authors as Hesiod, Apollodorus, Ovid, and Lucan. Later imitated and appropriated by the Middle Ages and the Renaissance, Medusa becomes a figure for a remarkable series of public virtues and private terrors: eloquence, fame, and admiration; stupor, erotic temptation, and the confusion of genders. This allegorized Medusa appears in authors ranging from Dante, Boccaccio, and Christine de Pizan to Shakespeare and Francis Bacon.

The myth, moreover, is interpreted not only in literature and political theory but also in painting and sculpture. The celebrated Caravaggio *Medusa*, painted on a round shield and reproduced on the cover of this volume, inspired Louis Marin's 1977 meditation on the nature of representation; a portrait by Leonardo da Vinci provides a provocative occasion for Freud to speculate on Oedipal conflict; Cellini's monumental statue of Perseus displaying Medusa's head—victor and vanquished uncannily twinned in expression—offers ground for political (Neil Hertz) and anthropological (Tobin Siebers) reflection.

Some etymologies of the word "Medusa" derive it from the Greek for ruler or queen, and Medusa has long been associated by commentators with female rulers and also with the Amazons. But Medusa has many political roles: Hertz, for example, analyzes the ways in which the French Revolution was also depicted in the figure of Medusa, seen in words and images of the period "not as a petrifier but as a beheader, her own head recognizably snaky yet still firmly attached to her shoulders." It may be that political theorists conflated the snake-haired Medusa with the many-headed Hydra (glossed by mythographers as political chaos) which grew two new heads for every one that was cut off. But Medusa's volatile femininity added another dangerous element. What Hertz calls the "representation of what would seem to be a political threat as if it were a sexual threat" locates in the Medusa figure something not only powerful but also elusive, elliptical, unable to be subdued. Feminists have long seen Medusa as an emblem of emancipation, and protestors against matriarchy and "Momism" find Medusa the all-too-perfect emblem of what is wrong with powerful women.

Since Freud's famous essay on "Medusa's Head" (and even before it) the decapitation of Medusa has been read in some quarters as a sign of castration, and the presence of multiple snakes in her hair as a "compensation" for fears of losing the penis. It is the sight of the mother's genitalia, said Freud, that produces in the male child the fear that he himself will become castrated and provokes in him the defensive fantasy of the phallic mother or phallic woman. But this is not merely a fantasy, some critics have replied: Medusa is both the sign of the possibility of phallic womanhood and an emblem of the punishment that power, wielded by women, always attracts.

What happens when a male figure takes on, or is imbued with, some of the attributes of Medusa? In Renaissance portraits of male rulers (Francis I of France or Cosimo I of Tuscany, for example) the wearing of the aegis of Athena is not a sign of feminization, but rather marks them as warriors. But in the case of Shakespeare's Macbeth, the slaying of the good King Duncan produces a "new Gorgon" that "destroy(s) the sight" of the terrified Scottish onlookers, and Macbeth himself becomes an apotropaic figure warding off future tyranny when he is beheaded at the play's close. Freudian readings have established Medusa as the very type of the "phallic woman"—but what happens when the phallic woman is a man? Late twentieth-century male Medusas tend to be entertainment figures knowledgeably playing with gender.

Goethe, Shelley, Pater, Rossetti and Swinburne are among the many Romantic artists obsessed with Medusa, who appears in their writings as a figure for art as well as for woman. The Romantic Medusa is an object of beauty and terror—"the tempestuous loveliness of terror," as Shelley writes in his poem on the Medusa of Leonardo da Vinci. Indeed, Shelley's Medusa head seems a relative of the "shattered visage" of Ozymandias he describes in a famous sonnet, the head of the immense statue of the king that now lies, a "colossal wreck," upon the sands. ("It lieth," his Medusa poem begins, "gazing on the midnight sky / Upon the cloudy mountain-peak supine.") But unlike Ozymandias's stone image with its frown and wrinkled lip, its empty sneer of command, the decapitated head of Medusa is sublime rather than ironic: "It is less the horror than the grace / Which turns the gazer's spirit into stone." Dante Gabriel Rossetti saw the Platonic power of shadows in the Medusa story, cautioning "Let not thine eyes know / Any forbidden thing itself" but only "safely seen" in its reflection. Here too the danger of gazing is the danger of the sublime as

well as the terrible—or the terrible as well as the sublime. Thus Medusa could be made to reflect, and refract, the doubled power and danger of poetic as well as visual representation. The ambivalence shown toward this dark double and muse becomes a recurrent motif emblematizing aestheticism and sexuality.

It is perhaps not surprising that Medusa exercised a particular fascination for male writers and painters of the Romantic period; it would remain for twentieth-century feminism and psychoanalysis to regender and reframe the questions posed by this most problematic and elusive of figures. Theorists have shown a remarkable interest in the figure of Medusa; from Freud's suggestive brief essays to the works of contemporary critics like Roger Callois, Hélène Cixous, Teresa de Lauretis, Stephen Heath, and Diana Fuss. The modern discourses of feminism, psychoanalysis, politics, and cultural history have been marked by a will to confront this singular figure: to look her, so to speak, in the face. While acknowledging that gazing at Medusa is always an activity performed and enacted obliquely and at risk, these most recent interpreters—psychoanalysts, anthropologists, film theorists, and poets as well as literary critics—have taken a new look at Medusa and her story.

In the twentieth century, poet after poet comments on Medusa's eyes: "the stiff bald eyes" of Louise Bogan, the "brilliantly blind" Medusa of James Merrill, whose eyes "Upon pure intellection glare." Daryl Hine's "slumbering Medusa" dreams of "the mate that she will never meet / Who will look into her eyes and live." May Sarton boasts, "I looked you straight in the cold eye, cold. / I was not punished, was not turned to stone." By the poem's end she recognizes Medusa's face as her own.

Countee Cullen's "Medusa," whom he initially fears for her basilisk eyes, is at the last a "lovely face" he " brave(s)" despite dire forebodings. His poem takes the form of a sonnet, the specter of Medusa giving way to an emotion more like (merely) human love. But not all Medusas, close-up, are so benign, or so "reason-bred," to use Cullen's own term. In one of the most powerful and disturbing of all modern Gorgon poems, Sylvia Plath's "Medusa," "old barnacled umbilicus," is both mother and jellyfish. Her mother's name, Aurelia, was close to that of the species of jellyfish, *aurela*; the French word for jellyfish is *méduse*. She stages another encounter with Medusa through the figure of Perseus, armed with "a mirror to keep the snaky head / In safe perspective,"—"a fun-house mirror that turns the tragic muse / To the bedraggled head of a sullen doll."

Of overwhelming importance to those concerned with the Medusa story has been the question of the status of the mirroring moment that immediately precedes Medusa's decapitation. What is it about the shield as mirror that permits the successful completion of Perseus's task? Is it that his deflected gaze permits him to look upon her with impunity? Or does a mirror image shown to Medusa serve in fact to stupify her with her *own* appearance? In other words, is it his gaze or hers that costs her her life? This is a question that has been of special interest to theorists of representation, to psychoanalysts, and to psychoanalytic critics. Influenced by Jacques Lacan, many recent readers have interpreted Medusa's horror at seeing herself as a kind of mirror stage, in which gazer and gazed-upon are locked in a dialectic of mutual reflection. "What, then, of the look for the woman?" asks film theorist Stephen Heath. Freud had posited the looker in the Medusa story as male. Heath continues: "If the woman looks, the spectacle provokes, castration is in the air, the Medusa's head is not far off; thus, she must not look, is absorbed herself on the side of the seen, seeing herself seeing herself, Lacan's femininity." Tobin Siebers calls this the "like cures like" logic of the amulet. Art critic Craig Owens calls the staging of an identification between the seer and the seen "the Medusa effect." Owens notes that the most powerful position here becomes, paradoxically, that of the already-frozen: the painting, the photograph, the posed and posing performer. "A pose, then, is an apotrope. And to strike a pose is to pose a threat."

The implications of this perception for theater and advertising, for fashion, for the runway, for Madonna's restaging of the 1980s dance moves known as voguing are, as will be seen, remarkable and far-reaching. (The connection between Madonna's voguing and "the Medusa effect" was, in fact, brilliantly enacted by performer Julie Brown's video parody *Medusa: Dare to Be Truthful*, a send-up of Madonna's 1991 film *Truth or Dare*). What film theorists like Heath and Teresa de Lauretis saw in "the gaze," fashion gurus could find in the pose. The pose was the Medusa effect as deployed in, and for, popular (as well as high) culture.

What is especially striking is the way in which ancient and modern ways of looking at the Medusa have tended to coincide. Consider, for example, the ways in which Medusa has become a figure in the language of fashion. We might think of this as a phenomenon of the Romantic and Victorian periods with their decorative Medusas and their reminiscences of heraldry and the armorial tradition, or especially, perhaps, of the

commercial culture of late-twentieth-century advertising and beauty products. But in fact the Medusan aegis of Athena and the Medusa shield of Agamemnon are "fashion statements" on Homer's battlefield. Lucan's *Pharsalia* comments at some length on Medusa's fashion-forward hairstyle: "Medusa loved to feel the serpents which served for hair curled close to her neck, and dangling down her back, but with their heads raised to form an impressive bang over her forehead—in what has since become the fashionable female style at Rome." (In the same spirit critic Roland Barthes, in his *Mythologies*, noted that bangs were the very "label of Roman-ness" in film.) In the 1990s, Italian designer Gianni Versace adopted the Medusa as his personal signature, embossing perfume bottles, key chains, silk scarves, and other elegant apparel with her unmistakable countenance, and repeatedly arranging his models in Medusan—and Persean—attitudes (Figures 28 and 29). The fact that he himself later met his death at the hands of a crazed fan only adds to the aura of that representation. In 1995 pop diva Annie Lennox, a singer-songwriter whose career has depended both on her appreciable talent as a musician and her savvy manipulation of her own arresting image, reached the top ten with an album titled simply, *Medusa* (Figure 31).

Rather than "evolving" over time from one set of interpretations to another, the Medusa myth thus includes, from its very beginnings, all the conflicting elements that have fascinated audiences and readers. For that reason the selections in this volume have been placed chronologically rather than thematically. Our organization resists headings like "beauty," or "philosophy," or "politics," or "war," or "gender," since most entries will defy any single label. For the use of interested readers, however, many such topics will be found in our extensive bibliography. Turning the pages of this book (*caveat lector*), the reader will encounter poems, pictorial images, cultural caricatures, diatribes, and political appropriations that offer a compelling composite glimpse of what "Medusa" might have meant throughout the ages.

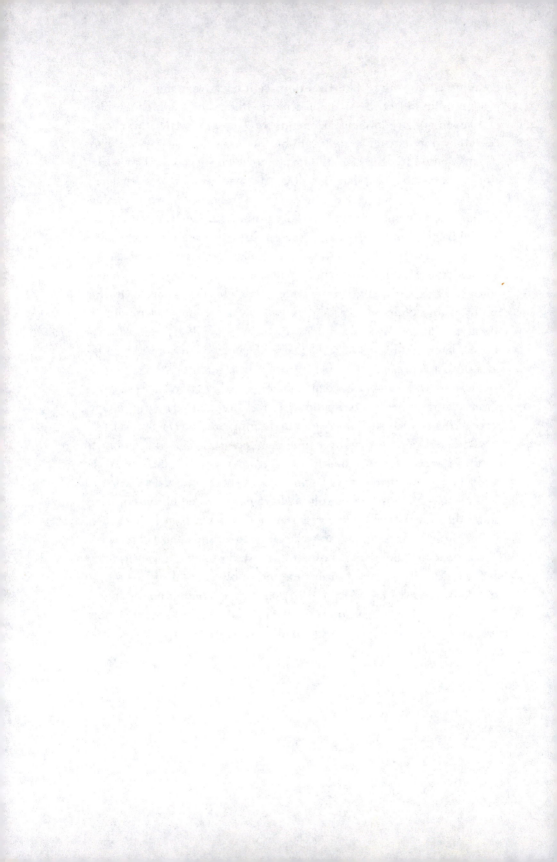

1 HOMER

from *The Iliad* (c. 750–725 B.C.E.)
translated by Richmond Lattimore

Medusa as Shield and Sign

The most famous of Greek poets, Homer might best be considered a construction, because little is certain about this individual: no definite dates, no birthplace, no proof that he was the single author of the *Iliad* and the *Odyssey*, particularly since both incorporate earlier legends and descriptions. Yet, the consistency of plot and character suggest that each work is a unified whole. Regardless of these ambiguities, Homer's importance and influence are evident throughout subsequent classical and modern European literature. The *Iliad*, which tells the tale of the final year of the siege of Troy, was probably written c. 750–725 B.C.E. In the excerpt from Book 5, Athena claims Medusa's power as she dresses herself for battle. This image is echoed in Book 11, when Agamemnon dons the image of Medusa as he dresses to the sound of Athena's thunderbolt. Both pieces offer excellent early examples of the use of Medusa's face in martial attire.

Now in turn Athene, daughter of Zeus of the aegis,
beside the threshold of her father slipped off her elaborate
dress which she herself had wrought with her hands' patience,
and now assuming the war tunic of Zeus who gathers
the clouds, she armed in her gear for the dismal fighting.
And across her shoulders she threw the betasselled, terrible
aegis, all about which Terror hangs like a garland,
and Hatred is there, and Battle Strength, and heart-freezing Onslaught
and thereon is set the head of the grim gigantic Gorgon,
a thing of fear and horror, portent of Zeus of the aegis.

<div align="right">Book 5.733–742</div>

He took up the man-enclosing elaborate stark shield,
a thing of splendour. There were ten circles of bronze upon it,
and set about it were twenty knobs of tin, pale-shining,

and in the very centre another knob of dark cobalt.
And circled in the midst of all was the blank-eyed face of the Gorgon
with her stare of horror, and Fear was inscribed upon it, and Terror.
The strap of the shield had silver upon it, and there also on it
was coiled a cobalt snake, and there were three heads upon him
twisted to look backward and grown from a single neck, all three.

<div align="right">Book 11.32–40</div>

2 HESIOD

from *The Shield of Herakles* and *Theogony* (C. 700 B.C.E.)
translated by Richmond Lattimore

Medusa and Perseus

Hesiod was an early Greek poet, a self-described shepherd visited by Muses who
gave him the gift of song, a persona later invoked metaphorically by numerous po-
ets. His *Theogony*, a geneaology of the pantheon of Greek gods, provides the earli-
est surviving systematic mythology and has served as a source for most subsequent
theogonic literature. The traditional attribution of *The Shield of Herakles* to Hesiod
has been challenged in recent years. This excerpt from *The Shield* gives little ac-
count of the fate of Medusa herself but describes in greater detail the fates and fu-
tures of her offspring. It also provides a vivid account of the rage of Medusa's sister
Gorgons subsequent to her beheading.

On Perseus' feet
 were the flying sandals,
and across his shoulders was slung
 the black-bound sword, suspended
on a sword-belt of bronze, and he hovered
 like a thought in the mind,
and all his back was covered
 with the head of the monster, the dreaded
Gorgon, and the bag floated about it,
 a wonder to look at,
done in silver, but the shining tassels
 fluttered, and they
were gold, and the temples
 of the lord Perseus were hooded over
by the war-cap of Hades, which confers
 terrible darkness.
The son of Danaë, Perseus himself,
 sped onward, like one who

goes in haste and terror, as meanwhile
 the rest of the Gorgons
tumbled along behind him, unapproachable,
 indescribable,
straining to catch and grab him,
 and on the green of the steel
surface gibbered the sound of their feet
 on the shield running
with a sharp high noise,
 and on the belts of the Gorgons a pair
of snakes were suspended,
 but they reared and bent their heads forward
and flickered with their tongues.
 The teeth for their rage were made jagged
and their staring fierce,
 and over the dreaded heads of the Gorgons
was great Panic shivering.

The Shield of Herakles. 220–237.

 And to Phorkys Keto bore the Graiai,
 with fair faces
and gray from birth, and these the gods
 who are immortal
and men who walk on the earth call Graiai,
 the gray sisters,
Pemphredo robed in beauty and Enyo
 robed in saffron,
and the Gorgons who, beyond the famous stream
 of the Ocean,
live in the utmost place toward night,
 by the singing Hesperides:
they are Sthenno, Euryale, and Medusa,
 whose fate was a sad one,
for she was mortal, but the other two
 immortal and ageless
both alike. Poseidon, he of the dark hair,
 lay with

one of these, in a soft meadow
 and among spring flowers.
But when Perseus had cut off
 the head of Medusa
there sprang from her blood great Chrysaör
 and the horse Pegasos
so named from the *pegai*, the springs
 of the Ocean, where she was born,
while Chrysaör is named from the golden aör,
 the sword he handles.

Theogony. 270–283.

3 PINDAR
"Pythian 12" (c. 490 B.C.E.)
translated by Geoffrey S. Conway

Medusa and Music

Our knowledge of this famed Greek lyric poet is based largely on his own poems,
leading biographers to differ on what is fact and what is poetic license. Still, we
know that he was trained in Athens, traveled extensively throughout the ancient
Greek world, and enjoyed prestige during both his lifetime and later into the Roman
Empire. He is the best preserved of the Greek lyric poets, although all we possess
today of his vast corpus is a selection of victory odes written in commemoration of
various games, particularly those held at Olympia and Delphi. "Pythian 12," with its
sudden segue into the story of Medusa, is a prime example of Pindar's frequent
mythological insertions and his characteristic nonlinear retellings of myth. Of partic-
ular note is the poet's identification of Medusa and her Gorgon sisters as the origin
of a popular music entitled the "many-headed tune." This link establishes a connec-
tion between Medusa and the arts.

For Midas of Acragas
Winner of the Flute-Playing Contest

I pray you, lover of splendour,
Seat of Persephone, fairest of all
Cities of men, high-built upon your hill above
The stream of Acragas, and her rich banks of pasture
O queen, grant of your gentle heart to accept
This crown of Pytho, Midas' glory, and give him
Goodwill of the immortals and of men;
Welcome him too that he surpassed
All Hellas in the art
That long ago Pallas Athene invented,
Weaving in music's rich refrain
The ghoulish dirge of the fierce-hearted Gorgons

This in their anguished struggle
From those dread maidens' lips was heard streaming,
And from those writhing serpent heads untouchable,
When Perseus o'er the third of those fell sisters launched
His cry of triumph, and brought fatal doom
To Seriphoe by the sea—doom for that isle
And for her people. Yes, for he had made blind
The grim offspring of Phorcus, and bitter
The wedding-gift he brought
To Polydectes, thus to end his mother's
Long slavery and enforced wedlock—
That son of Danäe who raped the head

Of the fair-cheeked Medusa;
He who, men tell, was from a flowing stream
Of gold begotten. But when the goddess maid delivered
From these labours this man she loved, then she contrived
The manifold melodies of the flute, to make
In music's notes an image of the shrill
Lamenting cries, strung from Euryale's
Ravening jaws. A goddess found,
But finding, gave the strain
To mortal men to hold, naming it the tune
Of many heads, a glorious grace
For the great contests where the peoples gather.

Often its clear call rings
From the light bronze, and from the reeds which grow
Beside the Graces' city, home of lovely dances,
Where the nymph, daughter of Kephissus, has her precinct;
Faithful their witness to the dancers' feet.
Now if a mortal man wins happy fortune
Not without toil shall this be seen: a god may
Bring it to pass—today, maybe—
Yes, but the will of fate
None can escape. Soon shall there come an hour
To strike beyond all expectation,
And give one boon past hope, withhold another.

4 EURIPIDES

from *Ion* (c. 413 B.C.E.)
translated by Ronald Frederick Willetts

The Power of Gorgon's Blood

A tragic dramatist and poet, the Athenian Euripides crafted numerous works focusing on the female psyche. *Ion* is as much the story of Creusa as of her son Ion. Raped by Apollo, Creusa abandons her baby, whom the gods take to Delphi to be raised as Apollo's servant. Years later, Apollo's priests give Ion to a childless Creusa, saying he is her husband Xuthus's natural child. However, the truth is later revealed to mother and son, who are joyfully reunited. The play emphasizes Creusa's bitter pain and anger, questioning the god's behavior and pitying her position first as a rape victim and then as a barren woman. In the scene presented here, Creusa, believing that Ion is Xuthus's illegitimate son, plots to kill him with the Gorgon's blood. The dialogue stresses the Gorgon's origins, while the "two drops of Gorgon's blood" are an early manifestation of Medusa's simultaneous destructive and restorative powers.

Old Man (*despairingly*)
> You play the coward; come, give me your plan now.
> > (*A pause, as she prepares to explain her scheme; she goes near to him,*
> > *speaking softly and urgently, as if to emphasize her own resolution.*)

Creusa
> Yes, I have something which is sure and subtle.

Old Man
> And I can help in both these ways.

Creusa
> Then listen. You know the war fought by Earth's sons?

Old Man
> When giants fought against the gods at Phlegra.

Creusa
> Earth there produced an awful monster, Gorgon.

Old Man
> To harass all the gods and help her children?

Creusa

Yes, but destroyed by Zeus's daughter Pallas.

Old Man

Is this the tale which I have heard before?

Creusa

Yes, that she wears its skin upon her breast.

Old Man

Athene's armor which they call her aegis?

Creusa

So called from how she rushed into the battle.

Old Man

What was the form of this barbaric thing?

Creusa

A breastplate armed with serpent coils.

(*An impatient pause.*)

Old Man

But my child, what harm can this do to your foes?

Creusa

You know Erichthonius?—Of course you must.

Old Man

The founder of your house, the son of Earth.

Creusa

A newborn child, Athene gave to him—

(*She pauses.*)

Old Man

Yes, what is this you hesitate to say?

Creusa (slowly)

Two drops of Gorgon's blood.

Old Man

And these have some effect on men?

Creusa

One is poisonous, the other cures disease.

Old Man

But how did she attach them to the child?

Creusa

A golden chain which he gave to my father.

Old Man

 And when he died it came to you?

Creusa

 Yes, I always wear it on my wrist.

Old Man

 How is the twofold gift compounded then?

Creusa

 The drop extracted from the hollow vein—

Old Man

 How is it to be used? What power has it?

Creusa

 It fosters life and keeps away disease.

Old Man

 What action does the other of them have?

Creusa

 It kills—a poison from the Gorgon's snakes.

Old Man

 You carry them apart or mixed together?

Creusa

 Apart. For good and evil do not mingle.

Old Man

 O my dear child, you have all that you want!

Creusa

 By this the boy shall die, and you shall kill him.

Old Man

 But when and how? Tell me, it shall be done.

Creusa

 In Athens when he comes into my house.

 (A pause, as the slave considers.)

Old Man

 No, I distrust this plan as you did mine.

Creusa

 Why?—Can we both have seen the same weak point?

Old Man

 They will accuse you, innocent or guilty.

Creusa

 Since foster mothers must be jealous.

Old Man

But kill him now and so deny the crime.

Creusa

And in that way I taste my joy the sooner.

Ion. 984—1027

5 PALAEPHATUS

"The Daughters of Phorcys" (fourth century B.C.E.)
from *On Unbelievable Tales*
translated by Jacob Stern

A Rationalist View

Little information exists on this obscure Greek writer, but scholars believe that he spent most of his life in Athens, where he became a close friend of Aristotle. His only known work is titled *Peri Apiston* (*On Unbelievable Tales*), a collection of myths retold from a rationalizing perspective. Thus, in the Medusa myth, Palaephatus explains that "the Gorgon" was really a golden statue of Athena, Medusa a strong-willed queen, and Perseus an unscrupulous pirate. Jacob Stern observes that the Graeae and the Gorgons are conflated here—a single group of sisters are given the "property held in common" attribute of the former and the names of the latter. Stern also notes that another rationalizing interpretation of the "eye" of the Graeae as a human being can be found in Heraclitus 13, where the Eye is a guide used by the sisters when traveling. Palaephatus's version of the Medusa story is one of the few in which Medusa is not, and does not become, a horrifying monster. However, she is still presented as a powerful female figure.

About the daughters of Phorcys a much more ridiculous story is told: that Phorcys had three daughters who had only one eye which they used in succession. The one who was using it put it into her head and thus was able to see; she would then hand it off to the next, and so in their turn all could see. Now Perseus came up behind them stealthily and grabbed their eye. He said that he would not give it back unless they told him where the Gorgon was. And so they told him. Whereupon Perseus cut off the Gorgon's head and came with it to the island of Seriphos. There he showed it to Polydectes and turned him to stone. This last is particularly ridiculous: for a living man to be petrified by looking on the head of a corpse. For what could be the power of a dead body?

What happened was the following: Phorcys was a Cernaean—by race these are Ethiopians who live on the island of Cerne outside the pil-

lars of Heracles. The fields they till are Libyan by the River Annon, straight across from Carthage; and a gold-rich people they are. Now Phorcys was the king of the islands—there are three of them—beyond the pillars of Heracles, and he made a golden statue of Athene which was six feet tall. The Cernaeans, it should be noted, call Athene "Gorgon," just as Artemis is called "Bendis" by the Thracians, "Dictyna" by the Cretans, and "Oupis" by the Lacedaemonians. Phorcys, however, died before dedicating the statue in the temple, and was survived by his three daughters: Stheno, Euryale, and Medusa. These had no desire to marry, but instead distributed their father's property among themselves so that each ruled over one of the three islands. As for the Gorgon, they decided not to dedicate it nor to divide it up. Rather by turns they each kept it as their own treasure. Before his death, Phorcys had had a noble companion and the three daughters continued to avail themselves of him in all matters—he was, as it were, their Eye.

Now Perseus, an exile from Argos, was making piratical raids with ships and troops along the sea coast. When he found out that there was a kingdom there in the hands of women—which was also rich in gold and had only a few men—he approached. He first lay in ambush in the narrows between Cerne and Sarpedonia; then, as the Eye was sailing across from one to the other, Perseus seized him. The Eye told Perseus that there was nothing worth taking from the sisters but the Gorgon, and he also revealed how much gold was in it. As for the sisters themselves, when the Eye on his rounds failed to arrive according to their agreement, they came together and began to accuse each other. But each of them denied that she was holding the Eye, and they all began to wonder what might have happened. At that very moment, while they were all together, Perseus sailed against them. He announced that he was holding the Eye and that he would not return him, unless they told him where the Gorgon was. He threatened in addition to kill them, if they did not tell him. Now Medusa refused to tell, but Stheno and Euryale did; Perseus therefore slew Medusa and returned the Eye to the other two sisters.

When he got his hands on the Gorgon, Perseus cut it in pieces; then, by way of fitting out his trireme, he put the head of the Gorgon on it and thereafter called the ship by the name "Gorgon." Sailing around in this ship he exacted money from the islanders and slew those who refused to give. In this way he sailed eventually against the people of Seriphos and

demanded money from them. They in turn asked for a few days time in which to collect the money. But instead they brought together and set up man-sized stones in the marketplace and then abandoned the island of Seriphos. Perseus sailed back to demand his money, but when he came into the marketplace he found no men but rather the man-sized stones. Thereafter, whenever any of the other island people would not pay their tribute, Perseus would say: "Be careful that you too do not suffer what the people of Seriphos did, who saw the Gorgon's head and were turned to stone."

6 APOLLODORUS

from *The Library* (second century B.C.E.)
translated by James George Frazer

The Beauty of Medusa

The Athenian scholar Apollodorus is now thought to have authored none of the works traditionally attributed to him, though for convenience his name is still used. The *Bibliotheca* is a study of Greek heroic myth, which may have been composed as late as the second century C.E., some time after Apollodorus's actual lifetime. This excerpt emphasizes Athena's strong-willed complicity in the beheading of Medusa. In this account Perseus receives assistance from a variety of female figures who serve as involuntary accomplices in the attack on the Gorgon.

When Acrisius inquired of the oracle how he should get male children, the god said that his daughter would give birth to a son who would kill him. Fearing that, Acrisius built a brazen chamber under ground and there guarded Danaë. However, she was seduced, as some say, by Proetus, whence arose the quarrel between them; but some say that Zeus had intercourse with her in the shape of a stream of gold which poured through the roof into Danaë's lap. When Acrisius afterwards learned that she had got a child Perseus, he would not believe that she had been seduced by Zeus, and putting his daughter with the child in a chest, he cast it into the sea. The chest was washed ashore on Seriphus, and Dictys took up the boy and reared him. Polydectes, brother of Dictys, was then king of Seriphus and fell in love with Danaë, but could not get access to her, because Perseus was grown to man's estate. So he called together his friends, including Perseus, under the pretext of collecting contributions toward a wedding gift for Hippodamia, daughter of Oenomaus. Now Perseus having declared that he would not stick even at the Gorgon's head, Polydectes required the others to furnish horses, and not getting horses from Perseus ordered him to bring the Gorgon's head. So under the guidance of Hermes and Athena he made his way to the daughters of Phorcus, to wit, Enyo, Pephredo, and Dino; for Phorcus had them by

Ceto, and they were sisters of the Gorgons, and old women from their birth. The three had but one eye and one tooth, and these they passed to each other in turn. Perseus got possession of the eye and the tooth, and when they asked them back, he said he would give them up if they would show him the way to the nymphs. Now these nymphs had winged sandals and the *kibisis*, which they say was a wallet. But Pindar and Hesiod in *The Shield* say of Perseus:—

> "But all his back had on the head of a dread monster,
> The Gorgon, and round him ran the *kibisis*."

The *kibisis* is so called because dress and food are deposited in it. They had also the cap of Hades. When the Phorcides had shown him the way, he gave them back the tooth and the eye, and coming to the nymphs got what he wanted. So he slung the wallet (*kibisis*) about him, fitted the sandals to his ankles, and put the cap on his head. Wearing it, he saw whom he pleased, but was not seen by others. And having received also from Hermes an adamantine sickle he flew to the ocean and caught the Gorgons asleep. They were Stheno, Euryale, and Medusa. Now Medusa alone was mortal; for that reason Perseus was sent to fetch her head. But the Gorgons had heads twined about with the scales of dragons, and great tusks like swines, and brazen hands, and golden wings, by which they flew; and they turned to stone such as beheld them. So Perseus stood over them as they slept, and while Athena guided his hand and he looked with averted gaze on a brazen shield, in which he beheld the image of the Gorgon, he beheaded her. When her head was cut off, there sprang from the Gorgon the winged horse Pegasus and Chrysaor, the father of Geryon; these she had by Poseidon. So Perseus put the head of Medusa in the wallet (*kibisis*) and went back again; but the Gorgons started up from their slumber and pursued Perseus: but they could not see him on account of the cap, for he was hidden by it.

Being come to Ethiopia, of which Cepheus was king, he found the king's daughter Andromeda set out to be the prey of a sea monster. For Cassiepea, the wife of Cepheus, vied with the Nereids in beauty and boasted to be better than them all; hence the Nereids were angry, and Poseidon, sharing their wrath, sent a flood and a monster to invade the land. But Ammon having predicted deliverance from the calamity if Cassiepea's daughter Andromeda were exposed as a prey to the monster,

Cepheus was compelled by the Ethiopians to do it, and he bound his daughter to a rock. When Perseus beheld her, he loved her and promised Cepheus that he would kill the monster, if he would give him the rescued damsel to wife. These terms having been sworn to, Perseus withstood and slew the monster and released Andromeda. However, Phineus, who was a brother of Cepheus, and to whom Andromeda had been first betrothed, plotted against him; but Perseus discovered the plot, and by showing the Gorgon turned him and his fellow conspirators at once into stone. And having come to Seriphus he found that his mother and Dictys had taken refuge at the altars on account of the violence of Polydectes; so he entered the palace, where Polydectes had gathered his friends, and with averted face he showed the Gorgon's head; and all who beheld it were turned to stone, each in the attitude which he happened to have struck. Having appointed Dictys king of Seriphus, he gave back the sandals and the wallet (*kibisis*) and the cap to Hermes, but the Gorgon's head he gave to Athena. Hermes restored the aforesaid things to the nymphs and Athena inserted the Gorgon's head in the middle of her shield. But it is alleged by some that Medusa was beheaded for Athena's sake; and they say that the Gorgon was fain to match herself with the goddess even in beauty.

7 DIODORUS SICULUS

from *The Historical Library* (C. 60–30 B.C.E.)
translated by G. Booth

The Gorgons and the Amazons in Africa

The history of Diodorus the Sicilian, or Diodorus Siculus, covers earliest times
through Caesar's Gallic War and attempts to include all known civilizations. The
work is a library in the sense of a collection of other historians' writings, a fact that
marks both its value and its limitations for modern readers. The excerpted discus-
sion of North Africa in Book 3 provides an early connection of Medusa with Africa.
The comparison of the Gorgons with the Amazons is particularly interesting: both
Gorgons and Amazons are races of women whose courage and power bring them tri-
umph, but they also are enemies to each other and are eventually destroyed by Her-
cules as a symbol of his opposition to female rulers.

In Africa there was not one race only of women who were famous for
valour and warlike exploits: for we are informed that the Gorgons
(against whom Perseus made war) for courage and valour were eminent:
how famous and potent they were, may be gathered hence, inasmuch as
that son of Jupiter (the most eminent hero among the Grecians in his
time) made choice of this expedition as the greatest and most noble en-
terprise. And as for the Amazons, of whom we are now about to write,
their valour was most eminently remarkable, if we compare them with
the greatest spirited women of our own times.

In the western parts of Africa, upon the borders of those tracts that
are inhabitable, there were antiently a nation under the government of
women, whose manners and course of living were altogether different
from ours. It was the custom for those women to manage all matters of
war; and, for a certain time keeping themselves virgins, they went out as
soldiers into the field, and, after so many years spent in their warfare,
they accompanied with men, for the preservation of posterity; but the
magistracy, and all public offices, they kept wholly in their own hands,
and the men (as the women do with us) looked to the household affairs,

submitting to whatever was thought fit to be done by the wives, and were not upon any terms admitted to intermeddle in martial affairs, or to command, or be in any public authority, which might any ways encourage them to cast off the yoke of their wives.

As soon as any child was born, they delivered it to the father to nurse it up with milk and other meat agreeable to its age. If it were a girl, they seared off its paps, lest they should be burthensome when they grew up, for they looked upon them to be great hindrances in fighting; and from the searing of their paps, the Grecians called them Amazons.

It is reported they inhabit an island called Hisperia, because it lies to the west, near to the morass called Tritonis: this fen, they say, is near to the ocean, which surrounds it, and is called Titronis, from a river that runs into it, called Titron. This morass borders upon Ethiopia, under the greatest mountain in those parts, called by the Grecians Atlas, extending itself to the ocean.

This island, they say, is very large, abounding with all sorts of fruit-trees, which supply the inhabitants with food: that they have many herds of cattle, and flocks of sheep and goats, which feed their possessors both with their milk and flesh: but that they had no sort of corn, for that in those times they knew not what it was.

These Amazons, therefore, for valour eminent above all others, and heated with an ambitious desire of war, first subdued all the cities of this island (except one called Mena, accounted sacred) inhabited now by the Ethiopians, called Ichthophages: it is often scorched with many eruptions of fire, which break out of the earth, and its bowels are enriched with precious stones, which the Grecians call anthraces, sardes, and smaragdos.

Afterwards, having subdued many of the neighbouring Africans and Numidians, they built a great city in the morass Tritonis, which for the shape of it was called Chersonesus.

Then being further instigated by their innate valour and courage, they attempted greater matters, and invaded many other countries. And first they attacked them upon Mount Atlas, a soft sort of people, who enjoyed a rich country full of great cities; among whom (in those parts bordering upon the ocean) the gods first had their origin, as the Grecians fabulously report, of whom a particular account shall be given hereafter.

To this end, when Merina was queen of the Amazons, she raised an army of thirty thousand foot, and two thousand horse, for they were

very exact and diligent in training up horses for the war. The armour they wore for coats of mail, were the skins of vast serpents, with which sort of creatures Africa abounds. But for offensive arms, they carried swords, darts, and bows, in which they were so expert, that with these they not only broke their enemies' battalions, but when they pursued them upon their flight, they were sure to hit their mark.

Entering, therefore, the country of the Atlantides, in a battle they routed them that inhabited Cercene, and pursued them so close, that they entered pell-mell with them that got within the walls, and took the city: and to strike a greater terror into their neighbours, they executed horrid cruelties upon the conquered: for they put all the men to the sword, and having razed the city to the ground, carried away captive all the women and children. The noise of this destruction being spread all over the country, the rest of the Atlantides (being struck with a panic fear) submitted, and delivered up all their cities: whereupon Merina received them all into her favour, and made a league with them, and in the room of that which was destroyed, built another city, calling it after her own name, and peopled it with the captives, and with such as were willing to come there to inhabit.

In the mean time being presented by the Atlantides with many rich gifts, and decreeing to her (with a general consent) many high honours, she not only graciously accepted those marks of their kindness, but promised she would for the future endeavour to merit the good opinion of the whole nation.

Being, therefore, often infested by their envious neighbours the Gorgons, Merina, to gratify the Atlantides (who addressed themselves to her for that purpose) with an army invaded the country of the Gorgons, where, joining battle with them, the engagement was smart, in which the Amazons got the day, and killed great numbers of their enemies, and took three thousand prisoners; the rest flying into woods, Merina (designing utterly to root up the nation) endeavoured to set the woods on fire; but not being able to effect it, she returned with her army into the confines of her own country, where, by reason of her late victory, being secure and careless in setting her watch, the prisoners killed many of her Amazons with their own swords as they were asleep; but at length, being surrounded by the whole army (fighting it out to the last) they were every man killed upon the spot. Then Merina erected three funeral piles, and burnt up all those of her army that were slain,

and raised up as many mounts of earth over them, which are at this day called the Amazon's sepulchres.

The Gorgons, notwithstanding, were afterwards of great power, till the reign of Medusa, at which time they were conquered by Perseus. At length both they and the Amazons were utterly extirpated by Hercules, at the time when he travelled into the western parts, and erected the pillar in Africa. For it was a thing intolerable to him, who made it his business to be renowned all the world over, to suffer any nation to be governed any longer by women.

8 OVID

from *Metamorphoses* (C. 43 B.C.E.–17 C.E.)
translated by Rolfe Humphries

The Story of Perseus

Ovid, a poet and well-known figure in Rome, is best known today as the author of *Metamorphoses*, an encyclopedic narrative of more than two hundred legends involving physical transformations. The work has influenced centuries of European writers and authors as a major source for Roman legends. In "The Story of Perseus" and "The Fighting of Perseus," excerpted here, the slain Medusa is a source of power for Perseus, a means to avenge affronts, win a wife, and defend himself against rivals. By the time he battles to save Andromeda, Perseus recognizes that Medusa's head must be cared for and preserved as a vital source of his own power. Although Medusa is treated only indirectly, through Perseus's tale, the position of the beautiful woman as both threat and threatened links her to Andromeda. Medusa provides the subject of Perseus's wedding story and the means for the glorious victories that make up Perseus's own tale.

The Story of Perseus

India, conquered, worshipped Bacchus; Greece
Thronged to his temples. King Acrisius only,
Of the same stock, still kept him out of Argos,
Took arms against the god, would not admit him
The son of Jove. Nor would he grant that Perseus
Was also son of Jove, the child begotten
On Danaë in the golden rain. But truth
Is powerful: Acrisius learned repentance
For his attack on the god, and his denial
Of his own grandson. Bacchus was in Heaven,
But Perseus, bringing back the wondrous trophy
Of the snake-haired monster, through thin air was cleaving
His way on whirring wings. As he flew over

The Libyan sands, drops from the Gorgon's head
Fell bloody on the ground, and earth received them
Turning them into vipers. For this reason
Libya, today, is full of deadly serpents.

From there he drove through space, the warring winds
Bearing him every way, as a squall is driven.
From his great height he looked on lands outspread
Far, far below; he flew the whole world over,
Saw the cold Bears, three times, and saw the Crab
With curving claws, three times, whirled often eastward,
Whirled often to the west. As the day ended,
Fearful of night, he came down for a landing
On the West's edge, the realm of Atlas, seeking
A little rest, till the Morning-star should waken
The fires of dawn, and Dawn lead out the chariot
Of the new day. Atlas, Iapetus' offspring,
Loomed over all men in his great bulk of body.
He ruled this land and the sea whose waters take
The Sun's tired horses and the weary wheels
At the long day's end. He had a thousand herds,
No neighbors, and he had a tree, all shining
With gold, whose golden leaves hid golden branches,
Whose golden branches hung with golden apples.
Perseus greeted Atlas: "If the glory
Of lofty birth has any meaning for you,
I am the son of Jove; if you prefer
To wonder at great deeds, you will find that mine
Are very wonderful. I ask for rest,
For friendly shelter." But Atlas, doubtful,
Thought of an ancient oracle of Themis:
Atlas, the time will come when your tree loses
Its gold, and the marauder is Jove's son.
Fearful of this, Atlas had walled his orchard,
Given its keeping to a monstrous dragon,
And kept all strangers off. He answered Perseus:
"Get out of here, you liar! Neither Jove
Nor glory gets you entrance here." He added

A lusty shove, though Perseus resisted,
Argued, and tried appeasement. But at last,
Inferior in strength (for who could equal
The strength of Atlas?), he told the giant:
"Well, anyway, since you will give me nothing,
I have something here for you!" He turned his back,
Held up, with his left hand behind his body,
Medusa's terrible head, and, big as he was,
Atlas was all at once a mountain: beard
And hair were forests, and his arms and shoulders
Were mountain-ridges; what had been his head
Was the peak of the mountain, and his bones were boulders.
But still he grew, for so the gods had willed it,
And his great bulk upheld the starry Heaven.

And Aeolus by now had closed the winds
In their eternal prison; the bright star
That wakes men to their toil, had risen brightly
In the clear morning air, and Perseus fastened
His winged sandals to his feet, took up
The scimitar, and soared aloft. Below him
Lay many lands, and finally he saw
The Ethiopians, King Cepheus' people.
There the god Ammon, not without injustice,
Ordered a daughter, who had not deserved it,
To pay the penalty for her mother's talking,
And Perseus saw her there, Andromeda,
Bound by the arms to the rough rocks; her hair,
Stirred in a gentle breeze, and her warm tears flowing
Proved her not marble, as he thought, but woman.
She was beautiful, so much so that he almost
Forgot to move his wings. He came down to her
Saying: "My dear, the chains that ought to bind you
Are love-knots rather than shackles. May I ask you
Your name, your country, the reason for this bondage?"
At first she made no answer, too much the virgin
To speak to any man; she would have hidden
Her modest features with her hands, but could not

Since they were bound. Her eyes were free, and filling
With rising tears. And Perseus urged her, gently,
Not to seem too unwilling, but to tell him
What wrong she had done, if any; so, at last,
She gave her name, her country, adding further
How her mother had bragged too much about her beauty.
She had not told it all, when the sea roared
And over the sea a monster loomed and towered
Above the wave. She cried aloud. Her parents
Were near at hand, both grieving, but the mother
More justly so, and they brought no help with them,
Only the kind of tears and vain embraces
Proper on such occasions. This struck Perseus
As pretty futile. "There is time, and plenty,
For weeping, later," he told them, "but the moment
For help is very short. If I were here as suitor,
I, Perseus, son of Jove and Danaë,
Conqueror of the snaky-headed Gorgon,
The daring flier through the winds of Heaven,
You would accept me, I think, before all others.
But to such great endowments I am trying
To add, with the gods' blessing, a greater service.
If I save her by my valor, do I have her?"
What could they say but Yes? They promised also
A kingdom as her dowry.

 As a galley
Bears down, with all the sturdy sweating rowers
Driving it hard, so came the monster, thrusting
The water on both sides in a long billow.
A slinger from the cliff could almost hit him
When Perseus rose cloudward, and his shadow
Fell on the surface, and the monster, seeing
That shadow, raged against it. As an eagle
Sees, in open field, a serpent sunning
Its mottled back, comes swooping down upon it,
Grasps it behind its head, to miss the poison
Sent through the deadly fangs, and buries talons
In scaly neck, so Perseus came plunging

In his steep dive down air, attacked the monster
That roared as the right shoulder took the sword-blade
Up to the hilt. The wound hurt deep, the sea-beast
Reared, lashed, and dived, and thrashed, as a wild-boar does
When the hounds bay around him. Perseus rose
When the fangs struck, he poised, he sought for openings
Along the barnacled back, along the sides,
At tapering fishy tail; the monster's vomit
Was blood and salty water. The winged sandals
Grew heavy from that spew, and Perseus dared not
Depend upon them further. He found a rock
Projecting out of the sea when the waves were still,
Hidden in storm. There he hung on, from there
He struck, again, again, and the sword went deep
Into the vitals, and the shores re-echoed
To Heaven with applause. Father and mother,
Rejoicing, hail their son-in-law, the savior
Of all the house. The chains are loosened
From the girl's arms, and she comes slowly forward,
The cause, and the reward, of all that labor.
Water is brought so that the victor may
Wash his hands clean of blood; before he washes,
Lest the hard sand injure the Gorgon's head,
He makes it soft with leaves, and over them
Strews sea-weed for a cover, and puts down
Medusa's head. And the twigs, all fresh and pliant,
Absorb another force, harden and stiffen
In branch and leaves. The sea-nymphs test the wonder
With other boughs, and the same wonder happens
To their delight, and they use the twigs as seedlings,
Strewing them over the water, and even now
Such is the nature of coral, that it hardens,
Exposed to air, a vine below the surface.

Now Perseus built three altars to three gods,
The left for Mercury, the right for Pallas,
The central one for Jove, and sacrificed
Heifer and bull and yearling steer. He wanted

No dowry save Andromeda in payment
Of his reward. And Love and Hymen shook
The marriage-torches, fires fed fat on incense,
Glowing and fragrant, and the garlands hung
Down from the timbers, and the lyre and flute
And song made music, proof of happy spirits.
Great doors swung open, and the golden halls
Were set for splendid banqueting, and courtiers
Came thronging to the tables.

 So they feasted
And took their fill of wine, and all were happy,
And Perseus asked them questions about the region,
People and customs and the native spirit.
They told him, and they asked in turn: "Now tell us,
Heroic Perseus, how you slew the Gorgon."
He told them how there lay, beneath cold Atlas,
A place protected by the bulk of the mountain
Where dwelt twin sisters, daughters, both, of Phorcys.
They had one eye between them, and they shared it,
Passing it from one sister to the other,
And he contrived to steal it, being so handed,
And slipped away, going by trackless country,
Rough woods and jagged rocks, to the Gorgons' home.
On all sides, through the fields, along the highways,
He saw the forms of men and beasts, made stone
By one look at Medusa's face. He also
Had seen that face, but only in reflection
From the bronze shield his left hand bore; he struck
While snakes and Gorgon both lay sunk in slumber,
Severed the head, and from that mother's bleeding
Were born the swift-winged Pegasus and his brother.

And he went on to tell them of his journeys,
His perils over land and sea, the stars
He had brushed on flying pinions. And they wanted
Still more, and someone asked him why Medusa,
Alone of all the sisters, was snaky-haired.
Their guest replied: "That, too, is a tale worth telling.

She was very lovely once, the hope of many
An envious suitor, and of all her beauties
Her hair most beautiful—at least I heard so
From one who claimed he had seen her. One day Neptune
Found her and raped her, in Minerva's temple,
And the goddess turned away, and hid her eyes
Behind her shield, and, punishing the outrage
As it deserved, she changed her hair to serpents,
And even now, to frighten evil doers,
She carries on her breastplate metal vipers
To serve as awful warning of her vengeance."

Book 4. 606–893

The Fighting of Perseus

So Perseus told his story, and the halls
Buzzed loud, not with the cheery noise that rings
From floor to rafter at a wedding party.
No; this meant trouble. It was like the riot
When sudden squalls lash peaceful waves to surges.
Phineus was the reckless one to start it,
That warfare, brandishing his spear of ash
With sharp bronze point. "Look at me! Here I am,"
He cried, "Avenger of my stolen bride!
No wings will save you from me, and no god
Turned into lying gold." He poised the spear,
As Cepheus shouted: "Are you crazy, brother?
What are you doing? Is this our gratitude,
This our repayment for a maiden saved?
If truth is what you want, it was not Perseus
Who took her from you, but the Nereids
Whose power is terrible, it was hornèd Ammon,
It was that horrible monster from the ocean
Who had to feed on my own flesh and blood,
And that was when you really lost her, brother;
She would have died—can your heart be so cruel
To wish it so, to heal its grief by causing

Grief in my heart? It was not enough, I take it,
For you to see her bound and never help her,
Never so much as lift a little finger,
And you her uncle and her promised husband!
So now you grieve that someone else did save her,
You covet his reward, a prize so precious,
It seems, you could not force yourself to take it
From the rocks where it was bound. Let him alone!
He took her from the rocks—I am not childless,
Now, nor in my old age. He has earned his prize,
I keep my word. You have this much of comfort,
The choice was not between two men, but rather
Between one man and death."

 There was no answer,
As Phineus looked in doubt from one to the other
Wondering which to let alone, and waited,
And then, with all the strength that anger gave him,
Let fly the spear at Perseus, but the weapon
Missed, piercing through the bench's coverings,
And Perseus, all warrior, leaped down
And flung it back again, and would have killed him,
But Phineus cringed and hid behind the altar
And so found safety, but the spear-point found
Another victim; it drove through Rhoetus' forehead,
Somebody pulled it loose, and Rhoetus groveled,
Spattering blood across the ground and tables.
Nothing could stop them now . . .

 [Here ensues an extended battle between those loyal to Perseus
 and those loyal to Phineus.]

. . . Perseus knew his strength at last would fail
Before those endless numbers. "Since you ask it,"
He cried, "I call my enemy to help me.
If any friend is here"—he raised it high,
The Gorgon's head—"If any friends are here,
Then turn away your faces!" Thescelus answered:
"Seek someone else to frighten with your magic!"

And raised his javelin, and became a statue
Poised for a javelin-throw. The next was Ampyx,
Who thrust a sword, and felt the right hand stiffen,
The wrist grow rigid. Nileus, a liar,
Who said his father was the famous river
Whose seven mouths, part silver and part gold,
He wore as shield's device, called: "See, O Perseus,
The fountain of my blood, and take this comfort
Down to the silent shades—a hero killed you!"
The last words broke, half spoken; if you saw him
So, open-mouthed, you might perhaps have wondered
Why the lips made no sound, for all they tried to.
They were cowards both, thought Eryx, and he said so,
Said there was nothing in this Gorgon-magic,
Urged them to join his charge, and he was charging,
Or would have charged, but the floor seemed to hold him,
And there he stood, a flinty man, unmoving,
A monument in armor.
 They deserved it,
All three, but there was one, a soldier fighting
On Perseus' side, Aconteus, whose bad luck
It was to see the Gorgon, and what happened
Afflicted friend, for once, and not a foeman.
Astyages, mistaking rock for flesh,
For living flesh, struck at him, and the sword
Rang with a sound not made on flesh or armor,
And as it rang, Astyages, in wonder,
Was wondering marble. It would take too long
To tell the names of all of those who perished;
Two hundred men survived; at least as many
Looked at the Gorgon and were turned to stone.

And Phineus, now, repents this evil warfare,
But what is there to do? He sees them all,
All images, posing, and he knows each one
By name, and calls each one by name, imploring
Each one for help: seeing is not believing,
He touches the nearest bodies, and he finds them

All marble, all. He turns his face away,
Holds out his hands, cautiously, sidewise, pleading:
"You win, O Perseus! Take away that monster
That face that makes men stone, whoever she is,
Medusa, or—no matter: take her away!
No hate for you, no lust for power drove me
Into this fight; it was my bride I fought for.
Your claim was better in merit, mine in time.
I yield, and gladly, and now I ask for nothing
Except my life: let all the rest be yours!"
And all the time he spoke, he dared not look
At the man he spoke to. Perseus made answer:
"Dismiss your fear, great coward: I can give you
A great memorial; not by the sword
Are you to die; you shall endure for ages,
Be seen for ages, in your brother's household,
A comfort for my wife, her promised husband,
His very image." And he swung the head
So Phineus had to see it; as he struggled
To turn his eyes, his neck grew hard, his tears
Were changed to marble, and in marble still
The suppliant look, the pleading hands, the pose,
The cringe—all these were caught and fixed forever.

Book 5. 1–236

LUCAN
from *Pharsalia* (c. 61–65)
translated by Robert Graves

Medusa and the Snakes of Libya

A member of an important Spanish family, Lucan was favored by Nero but upon falling from favor and joining a conspiracy against the emperor, he was compelled to commit suicide. Of all his writings, only the *Pharsalia* survives. Still unfinished at the time of Lucan's death, the *Pharsalia* relates the story of the civil war between Pompey and Julius Caesar, with strong sympathy for Pompey and the cause of the Republic. This excerpt from Book 9 serves as a digression from the text's description of Cato leading the troops through North Africa after Pompey's death. In this passage, the story of Medusa is associated closely with the scalding North African desert and the venomous power of that region's snakes.

Having been unable to ascertain why the soil of Libya is mysteriously plagued with such myriads of venomous reptiles, I can do no better than record the delusive but widespread legend of Medusa, daughter of Phorcys. Medusa is said to have lived in the far west of Africa, at the point where the Ocean laps against the hot earth, in a wide, untilled, treeless region which she had turned entirely to stone merely by gazing around her. The story is that, when her head was cut off, serpents were bred from the fallen blood and came hissing out to display their forked tongues.

Medusa loved to feel the serpents which served for hair curled close to her neck and dangling down her back, but with their heads raised to form an impressive bang over her forehead—in what has since become the fashionable female style at Rome. And when she used a comb, their poison would flow freely.

Those serpents were the only part of the luckless Medusa which one could study without being turned to stone. Nobody ever felt fear as he gazed at that monster's grinning face, because he had no time to feel any emotion whatsoever. One could not even describe what happened to

him as death, for being prevented from gasping out his spirit, this became petrified with his body. A sight of the Furies' serpent locks causes simple madness, and when Orpheus played his lyre in the Underworld he glanced unharmed at the serpents of Cerberus's mane, which presently ceased hissing; Hercules, too, was able to decapitate, without danger, the serpent heads which sprouted from the Hydra's neck. But Medusa was dreaded by her own father Phorcys, Neptune's second-in-command, by her mother Ceto, and even by her sister-Gorgons; she had the extraordinary power of paralysing everything in sea, in sky, or on earth by turning it to stone. Birds suddenly grew heavy and crashed to the ground; beasts stood frozen on their rocks; entire tribes of neighbouring Ethiopians were transformed to statues. No living creature, in fact, could bear to look at that face, not even the serpents on her head; which explains why they curled back from her forehead. Moreover, Medusa's head made Titan, the giant who supports the western pillars, turn to stone; and eventually saved the day for the Olympian Gods, when Pallas Athene wore it in the centre of her aegis at the terrible Battle of Phlegra, and converted the snake-legged Giants into mountains. It was to Medusa's lair that Perseus, son of that Danaë whom Jupiter had wooed in a shower of gold, went flying with the winged sandals given him by the Arcadian god Hermes. When Pallas Athene saw him heading west, and recognized the sandals and the falchion in his hand as belonging to her half-brother (inventor of the lyre and the oil which wrestlers use), she decided to help him. The falchion, by the way, was already stained with the blood of Hundred-eyed Argus, the giant ordered by Jupiter to guard Io, daughter of Inachus, whom Juno had metamorphosed into a heifer. Athene offered Perseus a bargain: if he promised her Medusa's head she would show him how to cut it off. Then she placed a polished bronze shield in his left hand, and told him that when he reached the Libyan frontier he must fly backwards through Gorgon territory and employ the shield as a mirror, thus avoiding petrifaction.

Perseus found Medusa asleep—it was to be her last sleep—but some of the serpents on her head kept watch and darted out to protect her, while the rest lay draped like a curtain over her face and closed eyes. He felt somewhat nervous and the falchion trembled in his hand; but Athene guided the blow, which he struck while looking at the shield, and it fell clean at the junction of head and body. Medusa's features must have worn a ghastly grimace in the moment of her decapitation—I have no

doubt that the mouth belched poison and the eyes flashed instant death. Athene herself could not look at those eyes, and though Perseus had averted his face he would nevertheless have been petrified, had she not ruffled Medusa's hair and made the dead serpents serve as a veil. Then he seized the head and soared safely away.

Perseus had planned to take the quickest route across Europe, but Athene forbade this; asking him to consider the damage he would do if he passed over cities and cultivated lands. On seeing such a large object flying aloft, everyone would look up, and be turned to stone; the corn would also be ruined. So he wheeled about and with the West Wind behind him sailed across Libya, because that was an untilled region, viewed only by the Sun and the stars. In Libya, as I have already explained, the Sun travels straight overhead, burning up the soil; another effect being that, when the Sun passes exactly underneath, the conical shadow of the Earth rises higher here than anywhere else—so that if the Moon were to forget her usual slanting orbit and run along the Zodiac, without troubling to pass either north or south of the Earth's shadow, she would find herself eclipsed.

Thus, though the Libyan soil was sterile and the fields unproductive, they drank the poisonous blood, dripping from Medusa's head, which became more poisonous still by contact with the loose burning earth. The first snake to spring from the ground after this rain of Gorgon's blood was the deadly asp with its puffed neck; and since the blood happened to be particularly abundant at this point, and mixed with clotted venom, it proved to be the most deadly of all the Libyan varieties. The asp loves heat and therefore never visits cold regions, always keeping to the desert west of the Nile; so we should be ashamed to have let our mercantile instincts get the better of us by importing this African poison into Italy.

10 LUCIAN

from *The Hall* (c. 120–180)
translated by A. M. Harmon

The Sirens and the Gorgons

A Greek writer known for his wit, Lucian used the dialogue form to satirize his con-
temporaries. In the first of two excerpts from his work *The Hall*, Lucian explains that
it is the beauty of the Gorgons that transfixes beholders, and there is no reference to
Medusa's transformation into an horrific sight. The second excerpt describes a wall
hanging that depicts Perseus using Medusa's head in his battle to free Andromeda.

That the power of the tongue is no match for the eyes, one can learn by
comparing the story of the Sirens with the one about the Gorgons. The
Sirens charmed passing voyagers by making music and working on them
with songs, and held them long when they put in. In short, their perfor-
mance only exacted a delay, and no doubt one or another voyager went
by them, neglecting their music. On the contrary, the beauty of the Gor-
gons, being extremely powerful and affecting the very vitals of the soul,
stunned its beholders and made them speechless, so that, as the story has
it and everyone says, they turned to stone in wonder. . . .

Then comes Perseus again, in the adventure which preceded the sea
monster. He is cutting off the head of Medusa, and Athena is shielding
him. He has done the daring deed, but has not looked, except at the re-
flection of the Gorgon in the shield, for he knows the cost of looking at
the reality. . . .

11 PAUSANIAS

from *Description of Greece* (c. 143–176)
translated by W. H. S. Jones

Another Rationalist View

Pausanias, also called "the Guide," was a late-second-century writer from Lydia who traveled extensively throughout Egypt, Palestine, Italy, Rome, and Greece. His only known work, excerpted here, is a *Description of Greece*, based on his journeys. Divided into ten books, the *Description* strives both to entertain and to educate the reader about the country and its heritage. With attention to folklore, local stories, and guides, Pausanias attempts to distinguish between legend and reality. Medusa appears in his section on Corinth, where a mound near the Argos marketplace was said to be her buried head. True to the work's pedantic purpose, Pausanias dismisses what he sees as the more "miraculous" aspects of the story in favor of a version describing Medusa as a Libyan warrior queen. Perseus remains a Greek prince, but one at war with Medusa's tribe. After she is assassinated, he decapitates her in order to show off her indescribable beauty to his fellow Greeks.

Not far from the building in the market-place of Argos is a mound of earth, in which they say lies the head of the Gorgon Medusa. I omit the miraculous, but give the rational parts of the story about her. After the death of her father, Phorcus, she reigned over those living around Lake Tritonis, going out hunting and leading the Libyans to battle. On one such occasion, when she was encamped with an army over against the forces of Perseus, who was followed by picked troops from the Peloponnesus, she was assassinated by night. Perseus, admiring her beauty even in death, cut off her head and carried it to show the Greeks.

12 ACHILLES TATIUS

from *The Adventures of Leucippe and Clitophon* (second century)
translated by John Winkler

Medusa and the Power of Ekphrasis

Achilles Tatius is the author of the ancient Greek novel *The Adventures of Leucippe and Clitophon*. In the passage we quote, the two lovers of the novel's title come upon a diptych in a temple in Egypt. In it they see a depiction of Andromeda bound to a rock and menaced by a sea monster. Perseus, flying by, uses the Gorgon's head as a weapon against the monster. Achilles' account is a brilliant rhetorical ekphrasis— a literary work that describes a specific work of painting or sculpture. Andromeda, chained to a rock, resembles a statue, and Medusa's head seems "a graphic delineation of intimidation."

[Andromeda's] arms were spread against the rock, bound above her head by a manacle bolted in the stone. Her hands hung loose at the wrist like clusters of grapes. The color of her arms shaded from pure white to livid, and her fingers looked dead. She was chained up waiting for death, wearing a wedding garment, adorned as a bride for Hades. Her robe reached the ground—the whitest of robes, delicately woven, like spider-web more than sheep's wool, or the airy threads that Indian women draw from the trees and weave into silk.

The sea monster rose from below the sea, parting its surface directly in front of the girl. Most of him was hidden in the water; only his head emerged, but the dim outline of his body was drawn below the surface, as were the scaly laminations and sinuous laps of his neck, the spiny crest, and loops of tail. His jaws were long and large, opening wide from a point of intersection at the shoulders, and all the rest was gullet.

Between the monster and the girl, Perseus was drawn descending from the air, in the direction of the beast. He was entirely naked but for a cloak thrown over his shoulders and winged sandals on his feet. A felt cap covered his head, representing Hades' helmet of invisibility. In his left hand he held the Gorgon's head, wielding it like a shield. Even as a paint-

ing it was a frightening object, with eyes starting out of their sockets, and serpentine hair about the temples all writhing and erect: a graphic delineation of intimidation. This was his left hand's weapon of war; his right was armed with a twin-bladed implement, a scythe and sword in one. The single hilt contains a blade that divides halfway along its extent—one part narrows to a straight tip, the other is curved; the one element begins and ends as a sword, the other is bent into a sinister sickle, so a single maneuver can produce both a deadly lunge and a lethal slash. This was Andromeda's drama.

13 FULGENTIUS
from *Mythologies* (late fifth–early sixth centuries)
translated by Leslie G. Whitbread

Terror and Manliness

Although often identified with St. Fulgentius, Bishop of Ruspa, the author of the *Mythologies* is probably a different writer. A Christian from North Africa, his writing, particularly his commentary on Virgil, was widely influential during the Middle Ages and the Renaissance. Medusa appears in his *Mythologies* as a rich queen whose cunning gave her the reputation of having a snakelike head. Fulgentius also presents Medusa's tale as an allegory in which manliness (Perseus) and wisdom (Minerva) destroy the three types of terror embodied by the Gorgon sisters, Medusa being the terror imprinted upon both the mind and the face.

The Fable of Perseus and the Gorgons

They say that Perseus was the slayer of the Gorgon Medusa. They intended there to be three Gorgons—the first of them Sthenno; the second, Euryale; the third, Medusa—and since their story has been written by Lucan and Ovid, poets perfectly well known in the first teaching stages taken with schoolmasters, I have considered it unnecessary to repeat the tale at length. Theocnidus, the historian of antiquities, relates that there was a King Phorcys, who left his three daughters wealthy. Of these Medusa, who was the more forceful, increased her wealth by her rule and by cultivation and husbandry; whence she is called Gorgo, for *georgigo,* for in Greek *georgi* is the name for husbandmen. She is also described as having a snakelike head because she was the more cunning. Perseus, coveting her rich domain, slew her (he is called winged because he came with ships); and carrying off her head, that is, her substance, he grew all the richer by securing her wide territories. Then, invading the kingdom of Atlas, he forced him to flee into a mountain, whence he is said to have been changed into a mountain, as it were, by the head of the Gorgo, that is, by her substance. But let me explain what the Greeks, inclined as they are to

embroider, would signify by this finely spun fabrication. They intended three Gorgons, that is, the three kinds of terror: the first terror is indeed that which weakens the mind; the second, that which fills the mind with terror; the third, that which not only enforces its purpose upon the mind but also its gloom upon the face. From this notion the three Gorgons took their names: first, Sthenno, for *stenno* is the Greek for weakening, whence we call *astenian* sickness; second, Euryale, that is, broad extent, whence Homer said: "Troy with its broad streets"; then Medusa, for *meidusam*, because one cannot look upon her. Thus Perseus with the help of Minerva, that is, manliness aided by wisdom, destroyed these terrors. He flew away with face averted because manliness never considers terror. He is also said to carry a mirror, because all terror is reflected not only in the heart but also in the outward appearance. From her blood Pegasus is said to have been born, shaped in the form of renown; whereby Pegasus is said to have wings, because fame is winged. Therefore also Tiberianus says: "Pegasus neighing thus across the upper air." Then he is also described as having struck out a fountain for the Muses with his heel, because the Muses either follow their own method of describing the renown of heroes or indicate that of the ancients.

The Fable of Bellerophon

. . . Then, too, Bellerophon, that is, good counsel, rides a horse which is none other than Pegasus, for *pegaseon,* that is, an everlasting fountain. The wisdom of good counsel is an everlasting fountain. So, too, is Pegasus winged, because he looks down on the whole nature of the world with a swift perception of its designs. Then, too, he is said to have opened up the fountain of the Muses with his heel, for wisdom supplies the Muses with a fountain. He is born of the blood of the Gorgon because the Gorgon is explained as fear: she is attached to the heart of Minerva, as Homer says in his book thirteen: "Whereon is embossed the Gorgon fell of aspect, glaring terribly." Thus the interpretation can be one of two kinds: either wisdom is born when fear is ended, as Pegasus from death in the blood of the Gorgon, because folly is always fearful, or "fear is the beginning of wisdom," because wisdom grows from fear of its master, and when anyone fears fame he grows wise.

14 JOHN MALALAS

from *The Chronicle* (sixth century)
translated by Elizabeth Jeffreys, Michael Jeffreys, and Roger Scott

The Sorcery of Perseus

A Byzantine chronicler of Syrian origin, Malalas belongs to a tradition of popular historians influential in the codification of early Christian and, indeed, Western history. His *Chronographia* in eighteen books is a compilation of history from the Creation to about 565 C.E. and was written in the popular Greek of unlearned Christian circles. In this excerpt from Book 2, Medusa appears as a virginal country girl whose head Perseus cuts off rather mercilessly and transforms through "loathsome sorcery" into a weapon against his enemies.

So Perseus was persuaded by his father Picus Zeus. Later, after the death of his father Picus and when he had become full-grown, he coveted the Assyrians' empire. He was jealous of the children of Minos his uncle, his father's brother. So, having consulted the oracle he went off to the land of Libya. Along the road a country girl, a virgin, with wild hair and eyes met Perseus. He stopped and questioned her, saying, "What is your name?" She answered freely, "Medusa." Perseus grasped her by her hair and cut off her head with the sickle-shaped sword which he was carrying. Perseus took her head and immediately performed mysteries over it, as he had been instructed by his father Picus, in the deception of loathsome sorcery. He carried the head to help him against all his opponents and enemies, to subjugate and destroy them. He called the head "Gorgon" (quick), because of the swift way it helped and because of its effectiveness against enemies.

Crossing over from there he came to the land of Ethiopia, over which Kepheus reigned. Finding there a temple of Poseidon, he entered and saw a girl, a virgin known as Andromeda, living in the temple; she had been dedicated in accordance with a vow of her father Kepheus. Perseus dragged her away from the temple, ravished her because of her beauty and made her his wife. . . .

As Perseus came to Isauria and Cilicia and met resistance from the enemy, he was given this oracle, "When you dismount from your horse and place the sole of your foot (*tarsos*) on the ground, may you gain victory." So, getting down from his horse in the village known as Andrasos, Perseus placed the sole of his foot there. Winning a victory by means of the Gorgon, he made the village into a city and called it Tarsos, from the oracle about his foot. He sacrificed an innocent girl named Parthenope to purify the city.

After he had made his thanksgiving, he set out from there by way of Mount Argaios against the Assyrians. He defeated them and slew Sardanapolos, their emperor, who was descended from his own family. He subjugated the Assyrians and reigned over them for fifty-three years. He called them Persians after himself, depriving the Assyrians of both their empire and their name. He planted trees and called them *perseai;* he planted *perseai* not only there but also in the Egyptian lands in memory of himself. He taught the Persians too the rite of the loathsome and unholy *skyphos* of Medusa, and because of this teaching he called their land the land of the Medes. . . .

After a time the emperor Kepheus, the father of Andromeda, attacked him from Ethiopia and made war on him. Because of his old age Kephaus was unable to see. When Perseus heard that Kepheus was making war on him, he was extremely angry. He marched out against him holding the Gorgon's head and showed it to him. Since Kepheus could not see, he charged at him on horseback. Then Perseus, unaware that Kepheus could not see, thought that the Gorgon's head which he was holding had lost its powers. So he turned the head towards himself and looked at it. He was blinded, stood motionless as if dead, and was killed. The son of Perseus and Andromeda reigned over the Persians, appointed by his grandfather, Kepheus, the emperor of Ethiopia. Kepheus gave the order and the loathsome head of the Gorgon was burned, and he departed for his own land. The descendants of Perseus remained there after that, reigning over the land of Babylonia.

15 DANTE ALIGHIERI

from *Inferno* (c. 1310–1314)
translated by Allen Mandelbaum

Virgil, Dante, and Medusa

A fourteenth-century Florentine poet, Dante's finest achievement is the great epic poem of Christian conversion, *The Divine Comedy*. In Canto 9 of the *Inferno*, Dante and Virgil approach the walls of the city of Dis, where their path is blocked. The Furies appear on the parapets, taunting them and claiming that Medusa is about to appear before them. John Freccero's essay, included later in this volume, discusses the implications of this moment. See also Figure 8.

And [Virgil] said more, but I cannot remember
because my eyes had wholly taken me
to that high tower with the glowing summit

where, at one single point, there suddenly
stood three infernal Furies flecked with blood,
who had the limbs of women and their ways

but wore, as girdles, snakes of deepest green;
small serpents and horned vipers formed their hairs,
and these were used to bind their bestial temples.

And he, who knew these handmaids well—they served
the Queen of never-ending lamentation—
said: "Look at the ferocious Erinyes!

That is Megaera on the left, and she
who weeps upon the right, that is Allecto;
Tisiphone's between them." He was done.

Each Fury tore her breast with taloned nails;
each, with her palms, beat on herself and wailed
so loud that I, in fear, drew near the poet.

"Just let Medusa come; then we shall turn
him into stone," they all cried, looking down;
"we should have punished Theseus' assault."

"Turn round and keep your eyes shut fast, for should
the Gorgon show herself and you behold her,
never again would you return above,"

my master said; and he himself turned me
around and, not content with just my hands,
used his as well to cover up my eyes.

O you possessed of sturdy intellects,
observe the teaching that is hidden here
beneath the veil of verses so obscure.

<div align="right">Canto 9.34–63</div>

16 PETRARCH

Rime Sparse, #197 (c. 1327–1374)
translated by Robert M. Durling

Francesco Petrarca, or Petrarch, was an Italian poet and humanist, best known for his sequence of love poems devoted to a single beloved, Laura. In Sonnet 197, a poem in which he memorializes his first sight of Laura, he compares the instant of falling in love to being enraptured by Medusa, thereby likening the beauty of his beloved to the stunning powers of Medusa. Here, Petrarch also invokes the story of how Perseus turned Atlas into a stony mountain by showing him Medusa's head. In his use of Medusa as a figure for the power of Laura's beauty, Petrarch puns consistently on his own name; the Latin *petra* means stone or rock.

The heavenly breeze that breathes in that green laurel, where Love smote Apollo in the side and on my neck placed a sweet yoke so that I restore my liberty only late,

has the power over me that Medusa had over the old Moorish giant, when she turned him to flint; nor can I shake loose that lovely knot by which the sun is surpassed, not to say amber or gold:

I mean the blond locks and the curling snare that so softly bind tight my soul, which I arm with humility and nothing else.

Her very shadow turns my heart to ice and tinges my face with white fear, but her eyes have the power to turn it to marble.

17 COLUCCIO SALUTATI

from *On the Labors of Hercules* (c. 1381–1391)
translated by Lesley Lundeen

Medusa as Artful Eloquence

The Chancellor of Florence from 1375 to 1406 and one of the most famous of the Florentine humanists, Coluccio Salutati allegorized the meaning of Medusa in this passage from the third book of his *De Laboribus Herculis*. Here, he offers an argument for the association of Medusa with artful eloquence. This association comes from a false etymology; the author reads the name of Medusa's father, Phorcys, as a pun on the infinitive of the Latin "to speak." Part of the Medusa effect is dazzlingly artful speech, striking the listener dumb. (The relationship between Medusa and eloquence is discussed in Nancy Vickers's essay, excerpted later in this book.)

Moreover, Jupiter had Medusa's head on this shield, or, to be more accurate, he was believed to have it. This also, in my judgment, can signify rhetorical skill, and because of this I shall undertake a more in-depth explanation. A King Phorcys had three daughters of exceptional beauty, whose names were Euryale, Stheno, and Medusa. They say these girls possessed a single eye, which they each used in turn. However, Medusa alone had snakes for hair, the result of a tryst with Neptune in the temple of Minerva. Perseus, well protected by either a crystal or a bronze shield, killed her with a sickle-shaped sword and cut off her head, a head which used to instantly turn its viewers into stones. From her blood soon sprang Pegasus, the winged horse, who, by pawing up the ground with his foot, brought forth an underground spring, which is particularly sacred to poets. And indeed, if one would fully understand this, one must go back to the end of the fourth book of Ovid's *Metamorphoses*, where the old tale is examined in detail. But as I was saying, "Phorcys" stands for rhetorical skill, since the name derives from *for, faris*, the Latin "to speak," or the Greek *foros*, in Latin *ferre*. Certainly, one's speech reveals one's aim. Yet the Greek *orchon* is the Latin *iuramentum*, which is spoken as a religious affirmation, for there is always something of this skill to

speak powerfully in either a plain narrative or in a logical argument or when relying on a persuasive charm. In any case, his three daughters were as follows: Stheno, who, according to Fulgentius, represents weak prose, and which can be understood through grammar, because it can be learned at a tender age and because this capability still is in itself quite feeble, inasmuch as it may neither move nor prove nor persuade nor simply narrate; Euryale, to be sure, just as the same author, Fulgentius, proposes, represents "extensive depth," which, in my opinion, is clearly logical; but he asserts that Medusa signifies oblivion, which is doubtless the art of oratory, an art which, by changing men's desires, erases their former thoughts. In this way, this last "daughter" is finer than the others, particularly with regards to the decoration of the hair, since it is in the rhetorical ornaments (which are represented by hair, and which is, as Apuleius shows, the special glory of women. And this is due to the fact that, if her hair should be removed, no woman would be so beautiful that she would not, in actual fact, appear most unsightly) and in the details of the argument, that rhetoric flourishes and that oratory itself is finer than the rest, seeing that, beyond grammatical agreement and proper signification and logical proof and the aim of persuasion, it adds ornament to one's words and sentences. Nevertheless, Neptune once lay with this Medusa in Minerva's temple. A wondrous secret lies hidden in this union. Note how just as when I previously argued about the unpraised Busiris, I once asserted that Neptune represents moisture. Natural eloquence derives its model from this, since eloquence resides in the voice, and no voice can become natural without moisture. Accordingly, Medusa is artful eloquence, Neptune the natural origin of that same eloquence, and Minerva the goddess of wisdom. Thus, every time the art and instruction of speaking are joined with natural eloquence in Minerva's temple, namely within that innermost place, the shrine of wisdom, then Medusa's locks are transformed into snakes. That is, the rhetorical ornaments become the "heads" and in fact the instruments of wisdom. And indeed, snakes can possess the figure of wisdom since this species of animals is reported to be the most cunning. However, before this particular union, Medusa could be seen without adverse consequences. From this fact comes the quote: "I discovered those who say they saw her" (Ovid, *Metamorphoses*, 4.797). Yet, after nature had been joined together with art and wisdom, then, on account of a certain numbing admiration, the result transforms those observing it into stones, since those listening, just

as if they had been terrified into paralysis, appear as stones. Or else they are so convinced of what they have been persuaded that they may be said to have acquired a stony quality.

18 CHRISTINE DE PIZAN

from *The Book of the City of Ladies* (1405)
translated by Earl Jeffrey Richards

Medusa's Beauty

Christine de Pizan, a French woman of letters born in Venice, was a writer of consider-
able skill. Both a poet and an historian, she authored a treatise on war and the
only poem about Joan of Arc written during the latter's lifetime. De Pizan partici-
pated in the famous late medieval debate about women, the "querelle des
femmes," as a staunch defender of women. Her *Book of the City of Ladies* cata-
logues illustrious women and is considered an important early feminist tract.

Similarly, Medusa (or Gorgon) was celebrated for her outstanding
beauty. She was the daughter of the very wealthy king Phorcys whose
large kingdom was surrounded by the sea. This Medusa, according to the
ancient stories, was of such striking beauty that not only did she surpass
all other women—which was an amazing and supernatural thing—but
she also attracted to herself, because of her pleasing appearance—her
long and curly blond hair spun like gold, along with her beautiful face
and body—every mortal creature upon whom she looked, so that she
seemed to make people immovable. For this reason the fable claimed
that they had turned to stone.

19 LEONE EBREO

from *The Philosophy of Love* (1535)
translated by F. Friedeberg-Seeley and Jean H. Barnes

Allegorical Meanings

Generally known to the Christian world and to historical scholarship as Leone Ebreo, Judah ben Isaac Abravanel was a Spanish Jew who fled Lisbon for Italy in 1492 with his father, the famous Jewish statesman and philosopher, Don Isaac Abravanel. Judah Abravanel exercised considerable influence on both Spanish mysticism and Italian Renaissance philosophy. He is most famous for his *Dialoghi d'Amore* (Dialogues of Love/Philosophy of Love), composed in the late 1490s and published posthumously in 1535. The participants of the *Dialoghi* are two abstract entities, Philone and Sophia, who discuss the nature of love in great detail. In the following excerpt, Philone interprets the victory of Perseus over Medusa as a theological allegory for the ascent from earthliness and vice to spirituality and perfection.

Perseus, son of Jupiter (according to a poetic tale), killed the Gorgon and, after his victory, flew away through the ether, which is the highest heaven. The historic meaning of this is that Perseus, [called] a son of Jupiter because of the share he had of jovial virtues, or else because he was descended from one of the kings of Crete, Athens, or Arcady, named Jupiter—Perseus killed Gorgo, an earthly tyrant—(for "Gorgo" means "earth" in Greek)—and was by men exalted to the skies for his virtues. Or again morally Perseus signifies the prudent man, son of Jupiter, [i.e.,] endowed with Jupiter's virtues, who, destroying the base and earthly vice symbolised by the Gorgon, ascended to the heaven of virtue. Then as for its allegoric meanings: first, it tells how the human mind, Jupiter's offspring, slaying and overcoming the earthiness of the gorgonic nature, raised itself to understanding of the noble and eternal truths of Heaven, in which speculation human perfection consists. This allegory is the natural one, because Man is a natural being. But the [tale] also stands for another, heavenly allegory, to wit: that the celestial nature, child of Jupiter, having by its continual movement caused death and destruction among

lower terrestrial bodies—this celestial nature, triumphant over corrupt-ible things, detaching itself from their mortality, flew on high and re-mained immortal. Furthermore [the tale] stands for a third, theological allegory, namely: that the angelic nature, which is the child of Jupiter, supreme god and creator of all things, destroying and putting from itself all corporeity and earthy materialness, symbolised by the Gorgon, rose to Heaven, forasmuch as it is the intelligences separated from body and matter which forever move the heavenly spheres.

20 GIORGIO VASARI

from the "Life of Leonardo da Vinci,
Florentine Painter and Sculptor" (1550)
translated by George Bull

Leonardo Paints the Head of Medusa

Giorgio Vasari was a painter and architect of the Italian Renaissance, now best
known for his design of the Uffizi museum and for his book *The Lives of the Most
Excellent Architects, Painters and Sculptors* (1550 and, in a significantly enlarged
and revised edition, 1568). This text was the first grand history of the visual arts in
the Renaissance and defined the field for centuries afterwards. It remains important
for the biographical detail Vasari offered as well as for his articulation of certain
notions about art, the figure of the artist, and the period's defining "rebirth" of clas-
sical culture.

The story goes that once when Piero da Vinci was at his house in the
country one of the peasants on his farm, who had made himself a buckler
out of a fig tree that he had cut down, asked him as a favour to have it
painted for him in Florence. Piero was very happy to do this, since the
man was very adept at snaring birds and fishing and Piero himself very
often made use of him in these pursuits. He took the buckler to Flo-
rence, and without saying a word about whom it belonged to he asked
Leonardo to paint something on it. Some days later Leonardo examined
the buckler, and, finding that it was warped, badly made, and clumsy, he
straightened it in the fire and then gave it to a turner who, from the
rough and clumsy thing that it was, made it smooth and even. Then hav-
ing given it a coat of gesso and prepared it in his own way Leonardo
started to think what he could paint on it so as to terrify anyone who saw
it and produce the same effect as the head of Medusa. To do what he
wanted Leonardo carried into a room of his own, which no one ever en-
tered except himself, a number of green and other kinds of lizards,
crickets, serpents, butterflies, locusts, bats, and various strange creatures
of this nature; from all these he took and assembled different parts to

create a fearsome and horrible monster which emitted a poisonous breath and turned the air to fire. He depicted the creature emerging from the dark cleft of a rock, belching forth venom from its open throat, fire from its eyes and smoke from its nostrils in so macabre a fashion that the effect was altogether monstrous and horrible. Leonardo took so long over the work that the stench of the dead animals in his room became unbearable, although he himself failed to notice because of his great love of painting. By the time he had finished the painting both the peasant and his father had stopped inquiring after it; but all the same he told his father that he could send for the buckler when convenient, since his work on it was completed. So one morning Piero went along to the room in order to get the buckler, knocked at the door, and was told by Leonardo to wait for a moment. Leonardo went back into the room, put the buckler on an easel in the light, and shaded the window; then he asked Piero to come in and see it. When his eyes fell on it Piero was completely taken by surprise and gave a sudden start, not realizing that he was looking at the buckler and that the form he saw was, in fact, painted on it. As he backed away, Leonardo checked him and said:

"This work certainly serves its purpose. It has produced the right reaction, so now you can take it away."

Piero thought the painting was indescribably marvelous and he was loud in praise of Leonardo's ingenuity. And then on the quiet he bought from a pedlar another buckler, decorated with a heart pierced by a dart, and he gave this to the peasant, who remained grateful to him for the rest of his days. Later on Piero secretly sold Leonardo's buckler to some merchants in Florence for a hundred ducats; and not long afterwards it came into the hands of the duke of Milan, who paid those merchants three hundred ducats for it. . . .

Leonardo then took it in mind to do a painting in oils showing the head of Medusa attired with a coil of serpents, the strangest and most extravagant invention imaginable. But this was a work that needed time, and so as with most of the things he did it was never finished.

21 NATALE CONTI
from *Mythologies* (1551)
translated by Anthony DiMatteo

Beauty and Pleasure

In the tenth book of his *Mythologies*, the Renaissance mythographer Natale Conti glosses the figure of Medusa, allegorizing her to mean pleasures that entice and destroy man. Thus, she is made to stand as a moral lesson on the need for restraint. The image that emerges—that of the triumph of the rational over the uncontrollable—is later reinvoked in Sylvia Plath's poem "Perseus," also included in this volume.

Medusa

To demonstrate how constant we must remain in our confrontation with pleasures, the sages depicted Medusa as the most beautiful of women, on account of her appearance and charm that allured others, but all who saw her the ancients said were changed into stone by her, Minerva having given her this damnable power to make her odious to everyone after she had polluted Minerva's temple with Neptune, because all dedicated to pleasure belittle all reverence paid the Gods and are accustomed to trampling under their feet all the rights of humanity and requisites of duty and become useless in all honorable things. Others thought that pride and arrogance were put down through this fable because Medusa had contended with the Goddess over the beauty of her hair. Those who worry about such vain things belittle both men and Gods. So did the ancients warn that lust, boldness, and arrogance must be restrained because God is the most exacting avenger of these flaws. For not only did Medusa lose her hair, Perseus through the counsel and support of the Gods having been sent to destroy her utterly.

The Gorgons

Because these are said to be two faculties or parts of our soul, one partaking of reason, the other without reason, that which is made up of reason were called the Graeae, the elder born of the sisters, that is, wisdom which is a necessity especially in difficult things and public affairs, but their younger sisters were the Gorgons, that is, the pleasures that entice and destroy men, from which Perseus could not have freed himself were it not for the help of the Graeae. Because reason and lust are born from out of the same mind, lust must yield to reason, the cause why Perseus, or prudence, is said to have conquered the Gorgons with an eye taken from the Graeae and with the counsel and support of Pallas.

Physically understood, the Gorgons are said to be the daughters of the waters of the sea, getting their name from the groaning and gargling sound the waves make. Perseus or the sun as an agent of the divine mind strives to find them and does so with the help of Minerva because all the acts of nature come about through divine wisdom since God and nature do nothing in vain. Due to the swiftness of the sun's movement, the ancients said Perseus wore the winged shoes of the nymphs because the sun penetrates all. Because the sun so extenuates the vapors that they cannot be seen, Perseus is said to have the helmet of Pluto and the sword of Mercury. Perseus slew Medusa, the only mortal among the Gorgons, since the sun draws up only the more refined or thinner part of the water which is created on the surface and which is susceptible to change. Since the wisdom of God is a marvel, and he has given the sun its strength, he who proves worthy by thought and mind to penetrate into the secret works of nature is thunderstruck when it comes to the rest of human affairs, nothing else concerning him a bit.

22 VINCENZO CARTARI

from *Images of the Gods* (1556)
translated by Walter Hryshko

Imaging Medusa

Vincenzo Cartari, an Italian mythographer, describes the clothing appropriate to Minerva (Athena) in this excerpted section from his *Images of the Gods*. He argues that her mode of dress is taken from Africa and that the fringe of her aegis looks like little snakes and thus resembles Medusa's head.

Regarding [Minerva's] tunic with the armor over it, Herodotus writes that the Greeks copied that mode of dress from African women who live around the Triton swamp, differing only in that the tunic which the African women wore underneath is made of animal hides and the hems or fringes of the vest worn over are not made of tiny serpents but of leather cut in small strips. The African women likewise also made the vest of leather from she-goat hide; for this reason, the Greeks called it "Egida," since "Ega" in their language means "she-goat." It is this "Egida" that we have called armor that had a fringe all around made of tiny serpents, as it appears that Herodotus meant when he wrote about the difference in dress between the African women and the attire of Minerva. The Ancients often placed on Minerva's breastplate the image of the Gorgon, which was the head of Medusa crowned with a mane of serpents and sticking out her tongue. They also placed this image at times on her shield, which was called "Egida" as well, because Diodorus writes that Jove covered it with the skin of the she-goat named Amalthea, and then gave it to Minerva. But more frequently, with the term "Egida" one means the breastplate, which, as Hyginus writes, was not thus named due to "Ega" or goatskin but from a daughter of the Sun with this very same name that was, as is told in fables, of a marvelous whiteness with a stupendous splendor, but was nevertheless not pretty (in fact she was horrible to look at) and as soon as she showed herself to the Titans (enemies of Jove) they were all scared and stunned. Whereby the earth,

beseeched by the Titans to take her away from their sight, hid her in Crete in a certain cave where she stayed until Jove removed her, when he wanted to have also the head of Medusa, because the Oracle had said that without this he could not win against the Titans, as he subsequently did, and after the victory he gave the "Egida," made from the skin of Ega with the head of Medusa to Minerva, who from then on always wore it. Virgil, when he writes that Vulcan puts the Cyclops to work to make Aeneas' arms (as he had prayed Venus) and when he recounts what they were charged to produce (the thunderbolts of Jove, the chariot of Mars, and the armor of Minerva who is similarly called "Pallas") says of this last one: "And with golden serpent scales they industriously made the tremendous Egida, with which irate Pallas often arms herself; and to the breast of the goddess they affixed the truncated Gorgon's head who rolls her eyes with a menacing and wild glare."

With the term "Gorgon," however, one always means the head of Medusa, the sight alone of which could kill another, although Atheneus writes that among the Nomads of Libya there was a certain beast with this very same name that was similar to a ewe, or, according to others, similar to a calf. This creature possessed such awful breath that it could kill just with this alone all other beasts that came near to it. It could also kill with its gaze when sometimes by shaking its head it would displace some hairs that would normally come down its forehead and cover its eyes. Some soldiers of Marius experienced this when he went against Jugurtha; while chasing that beast they fell down dead as soon as it looked at them. The inhabitants of the area told the nature of this beast to Marius and they also killed it since they knew how, lying in wait, one could kill it from afar.

The skin was of such a variety of colors that when it was sent to Rome, there was no one there who knew from which animal it came and it was therefore placed in Hercules' temple to be marveled at. Proclus of Carthage writes, as Pausanias relates, that from the many and diverse animals that were in the African deserts there were also wild and beastlike men and women, and that he saw one of them brought to Rome, and he wanted to believe that Medusa was one of those women, who had gone to the Triton swamp and there had done evil to the inhabitants of that country until she was killed by Perseus with the help of Minerva (as she was a deity of that place). Diodorus writes that the Gorgons were bellicose women in Africa who were conquered by Perseus, who also killed

Medusa, their queen, and this could have been part of history. But the fables relate, as one can read in Apollodorus' work, that the Gorgons were three sisters, of whom only Medusa could die. The other two, who were named Euryale and Stheno, were immortal, and all of them had their heads covered with scaly serpents, and had teeth as large as a pig's, hands of copper, and wings of gold, with which they flew as they liked, and changed into stone whomever was seen by them. Perseus, having found them while they were sleeping cut off Medusa's head and carried it away and gave it then to Minerva, who then helped him with this deed, since he had her shield, and from Mercury he had the scimitar and talarics, the helmet of Orcus, that made one invisible, and a certain type of sack in which he carried the horrible head he received from some nymphs, who were shown to him by three other sisters of the Gorgons to get back the eye and the tooth which he had stolen from them. One reads that these sisters were born old and only had one eye and one tooth among them and they took turns using them now one, now the other. For this reason, as Pausanias writes, in the temple of Minerva in a certain part of Greece there was a statue of Perseus to whom (as if he were going then to Africa to fight against Medusa) some nymphs were giving a helmet and were attaching talarics to his feet. They also say, and this is the most common tale, that of the three beautiful sisters, called the Gorgons after certain islands of the same name, Medusa was the most becoming and had golden hair. Whereby Neptune became enamored of her and lay with her in the temple of Minerva, who in turn was offended and greatly angered and therefore turned Medusa from beautiful and pleasant to look at (as she was at first) to something completely terrible and fearsome by changing her golden locks into ugly serpents. She wanted anyone who looked at Medusa turned into stone, but since the world could not tolerate such a strange monster, Perseus killed her with the help that I mentioned and gave the head to Minerva who always carried it on her shield, or on the breastplate of her armor.

23 JOHN HARINGTON
from his preface to the *Orlando Furioso* (1591)

Allegories of Man and Earth

John Harington's 1591 translation of Ludovico Ariosto's chivalric epic *Orlando Furioso* into English heroical verse was the version best known to Elizabethan England. Ariosto (1474–1533), an Italian poet, presented a Renaissance recasting of the adventures of Roland in this work. The account of Medusa found in Harington's preface to his translation is typical of Renaissance allegorizations.

Perseus, sonne of *Jupiter*, is fained by the Poets to have slaine *Gorgon*, and after that conquest atchieved to have flowen up to heaven. The Historicall sence is this: *Perseus*, the sonne of *Jupiter*, by the participation of *Jupiters* vertues that were in him, or rather comming of the stock of one of the kings of Creet or Athens so called, slew *Gorgon*, a tyrant in that country (*Gorgon* in greeke signifieth earth), and was for his vertuous parts exalted by men up into heaven. Morally it signifieth thus much: *Perseus*, a wise man, sonne of *Jupiter*, endewed with vertue from above, slayeth sinne and vice, a thing base and earthly signified by *Gorgon*, and so mounteth up to the skie of vertue. It signifies in one kinde of Allegorie thus much: the mind of man being gotten by God and so the childe of God, killing and vanquishing the earthlinesse of this Gorgonicall nature, ascendeth up to the understanding of heavenly things, of high things, of eternal things, in which contemplacion consisteth the perfection of man; this is the natural allegory, because man, one of the chiefe works of nature. It hath also a more high and heavenly Allegorie, that the heavenly nature, daughter of *Jupiter*, procuring with her continuall motion corruption and mortalitie in the inferior bodies, severed it selfe at last from these earthly bodies and flew up on high and there remaineth for ever. It hath also another Theological Allegorie, that the angelicall nature, daughter of the most high God the creator of all things, killing and overcomming all bodily substance, signified by *Gorgon*, ascended into heaven; the like infinite Allegories I could pike out of other Poeticall fictions, save that I would

avoid tediousnes. It sufficeth me therefore to note this, that the men of greatest learning and highest wit in the auncient times did of purpose conceale these deepe mysteries of learning and, as it were, cover them with the vaile of fables and verse for sundrie causes; one cause was that they might not be rashly abused by prophane wits in whom science is corrupted like good wine in a bad vessell; another cause why they wrote in verse was conservation of the memorie of their precepts as we see yet the generall rules almost of everie art, not so much as husbandrie, but they are oftner recited and better remembred in verse then in prose; another and a principall cause of all is to be able with one kinde of meate and one dish (as I may so call it) to feed divers tastes.

24 FRANCIS BACON

"Perseus, or War," from *The Wisdom of the Ancients* (1609)
translated by James Spedding

Tyranny and the Art of War

A major figure in the intellectual and political world of Jacobean England, Francis
Bacon is celebrated for his works as a writer, scientist, philosopher, and statesman.
This excerpt comes from *De Sapientia Veterum*, which he wrote in 1609, and which
was first translated as *The Wisdom of the Ancients* in 1619. In his book, Bacon of-
fers thirty-one political parables through readings of mythology. Thus, the encounter
between Perseus and Medusa becomes an opportunity for Bacon to give advice on
armed conflict with an enemy.

Perseus was sent, it is said, by Pallas to cut off the head of Medusa, from
whom many nations in the westernmost parts of Spain suffered grievous
calamities:—a monster so dreadful and horrible that the mere sight of
her turned men into stone. She was one of the Gorgons; and the only
one of them that was mortal, the others not being subject to change. By
way of equipment for this so noble exploit, Perseus received arms and
gifts from three several gods. Mercury gave him wings for his feet; Pluto
gave him a helmet; Pallas a shield and a mirror. And yet though so well
provided and equipped, he did not proceed against Medusa directly, but
went out of his way to visit the Graeae. These were half-sisters to the
Gorgons; and had been born old women with white hair. They had but
one eye and one tooth among them, and these they used to wear by
turns; each putting them on as she went abroad, and putting them off
again when she came back. This eye and tooth they now lent to Perseus.
Whereupon, judging himself sufficiently equipped for the performance
of his undertaking, he went against Medusa with all haste, flying. He
found her asleep; but not daring to face her (in case she should wake) he
looked back into Pallas's mirror, and taking aim by the reflection, cut off
her head. From the blood which flowed out of the wound, there sud-
denly leaped forth a winged Pegasus. The severed head was fixed by

Perseus in Pallas's shield; where it still retained its power of striking stiff, as if thunder or planet stricken, all who looked on it.

The fable seems to have been composed with reference to the art and judicious conduct of war. And first, for the kind of war to be chosen, it sets forth (as from the advice of Pallas) three sound and weighty precepts to guide the deliberation.

The first is, not to take any great trouble for the subjugation of the neighbouring nations. For the rule to be followed in the enlarging of a patrimony does not apply to the extension of an empire. In a private property, the vicinity of the estates to each other is of importance; but in extending an empire, occasion, and facility of carrying the war through, and value of conquest, should be regarded instead of vicinity. We see that the Romans, while they had hardly penetrated westward beyond Liguria, had conquered and included in their empire eastern provinces as far off as Mount Taurus. And therefore Perseus, though he belonged to the east, did not decline a distant expedition to the uttermost parts of the west.

The second is that there be a just and honorable cause of war: for this begets alacrity as well in the soldiers themselves, as in the people, from whom the supplies are to come: also it opens the ways to alliances, and conciliates friends; and has a great many advantages. Now there is no cause of war more pious than the overthrow of a tyranny under which the people lies prostrate without spirit or vigour, as if turned to stone by the aspect of Medusa.

Thirdly, it is wisely added that whereas there are three Gorgons (by whom are represented wars), Perseus chose the one that was mortal, that is, he chose such a war as might be finished and carried through, and did not engage in the pursuit of vast or infinite projects.

The equipment of Perseus is of that kind which is everything in war, and almost ensures success; for he received swiftness from Mercury, secrecy of counsel from Pluto, and providence from Pallas. Nor is the circumstance that those wings of swiftness were for the heels and not for the shoulders without an allegorical meaning, and a very wise one. For it is not in the first attack, so much as in those that follow up and support the first, that swiftness is required; and there is no error more common in war than that of not pressing on the secondary and subsidiary actions with an activity answerable to the vigour of the beginnings. There is also an ingenious distinction implied in the images of the shield and the mirror (for the parable of Pluto's helmet which made men invisible needs no

explanation) between the two kinds of foresight. For we must have not only that kind of foresight which acts as a shield, but that other kind likewise which enables us (like Pallas's mirror) to spy into the forces and movements and counsels of the enemy.

But Perseus, however provided with forces and courage, stands yet in need of one thing more before the war be commenced, which is of the highest possible importance,—he must go round to the Graeae. These Graeae are treasons; which are indeed war's sisters, yet not sisters german, but as it were of less noble birth. For wars are generous; treasons degenerate and base. They are prettily described, in allusion to the perpetual cares and trepidations of traitors; as old and white from their birth. Their power (before they break out into open revolt) lies either in the eye or the tooth; for all factions when alienated from the state, both play the spy and bite. And the eye and tooth are as it were common to them all: the eye because all their information is handed from one to another, and circulates through the whole party; the tooth, because they all bite with one mouth and all tell one tale,—so that when you hear one you hear all. Therefore Perseus must make friends of those Graeae, that they may lend him their eye and tooth,—the eye for discovery of information, the tooth to sow rumours, raise envy, and stir the minds of the people.

These matters being thus arranged and prepared, we come next to the carriage of the war itself. And here we see that Perseus finds Medusa asleep; for the undertaker of a war almost always, if he is wise, takes his enemy unprepared and in security. And now it is that Pallas's mirror is wanted. For there are many who before the hour of danger can look into the enemy's affairs sharply and attentively; but the chief use of the mirror is in the very instant of peril, that you may examine the manner of it without being confused by the fear of it; which is meant by the looking at it with eyes averted.

The conclusion of the war is followed by two effects: first the birth and springing up of Pegasus, which obviously enough denotes fame, flying abroad and celebrating the victory. Secondly the carrying of Medusa's head upon the shield; for this is incomparably the best kind of safeguard. A single brilliant and memorable exploit, happily conducted and accomplished, paralyses all the enemies' movements, and mates malevolence itself.

25 WILLIAM DRUMMOND
"The Statue of Medusa" (1616)

Lord of Hawthornden (near Edinburgh) where he was born and died, William Drummond was the first notable poet in Scotland to write deliberately in English. He was also the first to use the canzone, a medieval Italian or Provençal metrical form, in English verse. "The Statue of Medusa" was written, however, in the form of an epigram, interesting in this context since many epigrams were originally composed to be carved on monuments. Here, Drummond meshes the two myths of Medusa and Narcissus to produce, in eight lines, a poem of extraordinary power about self and image, masculine and feminine, art and life.

Of that *Medusa* strange,
Who those that did her see in Rockes did change,
None Image carv'd is this;
Medusas selfe it is,
For whilst at Heat of Day,
To quench her Thirst Shee by this Spring did stay,
Her curling Snakes beholding in this Glasse,
Life did Her leave, and thus transform'd Shee was.

26 JOHANN WOLFGANG VON GOETHE
from *Faust* (1808)
translated by Stuart Atkins

Gretchen and Medusa

Goethe's centrality to German Romanticism is evidenced by the frequent reference to that period as "The Age of Goethe." Poet, novelist, dramatist, critic, and scientist, Johann Wolfgang von Goethe was the early leader of the Sturm und Drang movement in German literature, culture, and politics, only to break with the movement and enjoy many years as a favorite of the court. Perhaps Goethe's best-known work, *Faust*, published in Germany in 1808 and 1832, reveals the futility of striving for absolute transcendence. In this scene, at a witches' mountaintop den, Faust imagines he sees Gretchen, the innocent young girl he plans to seduce. Mephistopheles's warning that the seeming beauty is only an apparition put forth by Medusa might serve as a larger caution to Faust as well; what he imagines he controls and enjoys will actually be the force that destroys him. This scene stresses the image of Medusa as a beautiful and seductive force against which men are weak.

 Mephisto, do you see
off there, alone, dead-pale, a lovely girl?
Now she is slowly moving away,
dragging her feet as if they were in fetters.
I have to say I can't help thinking
that she looks like my own dear Gretchen.
MEPHISTOPHELES. Leave that alone—it only can do harm!
 It is a magic image, a phantom without life.
 It's dangerous to meet up with;
 its stare congeals a person's blood
 and almost turns him into stone—
 you've surely heard about Medusa!
FAUST. I know those are the eyes of someone dead,
 eyes that no loving hand has closed.

That is the breast which Gretchen let me press,
 that the sweet body which gave me joy.
MEPHISTOPHELES. Don't be so gullible, you fool! It's sorcery:
 to every man she looks like her he loves.
FAUST. What ecstasy, and yet what pain!
 I cannot bear to let this vision go.
 How strange that on that lovely neck
 there is as ornament a single scarlet thread
 no thicker than a knife!
MEPHISTOPHELES. You're right, I see it too.
 She also can transport her head beneath her arm,
 thanks to the fact that Perseus lopped it off.
 I see you never lose your craving for illusions!

<div align="right">Part 1.4183–4209</div>

27 PERCY BYSSHE SHELLEY
"On the Medusa of Leonardo da Vinci
in the Florentine Gallery" (1819)

A poet and prose writer, Percy Bysshe Shelley was a central figure in British Roman-
ticism; joyous ecstasy and brooding despair are themes throughout his works. The
narrator of "On the Medusa of Leonardo da Vinci . . ." emphasizes the humanity ly-
ing beneath the amalgam of suffering and beauty that he sees on the face of
Leonardo's *Medusa*. The poem was published posthumously by Mrs. Shelley in
1824. Words are missing in stanzas 3 and 5. For this image, see Figure 14 (no longer
attributed to Leonardo da Vinci).

1

It lieth, gazing on the midnight sky,
 Upon the cloudy mountain-peak supine;
Below, far lands are seen tremblingly;
 Its horror and its beauty are divine.
Upon its lips and eyelids seems to lie
 Loveliness like a shadow, from which shine,
Fiery and lurid, struggling underneath,
The agonies of anguish and of death.

2

Yet it is less the horror than the grace
 Which turns the gazer's spirit into stone,
Whereon the lineaments of that dead face
 Are graven, till the characters be grown
Into itself, and thought no more can trace;
 'Tis the melodious hue of beauty thrown
Athwart the darkness and the glare of pain,
Which humanize and harmonize the strain.

3

And from its head as from one body grow,
 As grass out of a watery rock,
Hairs which are vipers, and they curl and flow
 And their long tangles in each other lock,
And with unending involutions show
 Their mailèd radiance, as it were to mock
The torture and the death within, and saw
The solid air with many a raggèd jaw.

4

And, from a stone beside, a poisonous eft
 Peeps idly into those Gorgonian eyes;
Whilst in the air a ghastly bat, bereft
 Of sense, has flitted with a mad surprise
Out of the cave this hideous light had cleft,
 And he comes hastening like a moth that hies
After a taper; and the midnight sky
Flares, a light more dread than obscurity.

5

'Tis the tempestuous loveliness of terror;
 For from the serpents gleams a brazen glare
Kindled by that inextricable error,
 Which makes a thrilling vapour of the air
Become a and ever-shifting mirror
 Of all the beauty and the terror there—
A woman's countenance, with serpent-locks,
Gazing in death on Heaven from those wet rocks.

28 KARL MARX

from *Capital* (1867)

translated by Samuel Moore and Edward Aveling

The Medusa of Capitalist Production

Perhaps best known as the primary author of the "Manifesto of the Communist Party" (1848), Karl Marx has arguably had a more profound impact on modern ideology and political society than has any other thinker. Conceiving history as a series of class conflicts, Marx critiqued the capitalist system of production, which, he argued, exploited workers who become alienated from the products of their own labor. Through his analyses of ideology and commodity fetishism, Marx showed how capitalism effectively obscures for worker and capitalist alike the true nature of social relations. Here, in his preface to the first edition of Volume 1 of *Capital* (1867), his seminal work on political economy, Medusa's head embodies the social "evils" that hide behind the "veil" of normalized capitalist production. Just as Perseus's "magic cap" shielded him from "the monsters" he hunted, Marx maintains that individuals now hide under their magic caps and pretend that the monsters of capitalism do not exist.

The physicist either observes physical phenomena where they occur in their most typical form and most free from disturbing influence, or, wherever possible, he makes experiments under conditions that assure the occurrence of the phenomenon in its normality. In this work I have to examine the capitalist mode of production and the conditions of production and exchange corresponding to that mode. Up to the present time, their classic ground is England. That is the reason why England is used as the chief illustration in the development of my theoretical ideas. If, however, the German reader shrugs his shoulders at the condition of the English industrial and agricultural labourers, or in optimist fashion comforts himself with the thought that in Germany things are not nearly so bad; I must plainly tell him, "*De te fabula narratur!*" ["This story is about you!"]

Intrinsically, it is not a question of the higher or lower degree of development of the social antagonisms that result from the natural laws of

capitalist production. It is a question of these laws themselves, of these tendencies working with iron necessity towards inevitable results. The country that is more developed industrially only shows, to the less developed, the image of its own future.

But apart from this. Where capitalist production is fully naturalised among the Germans (for instance, in the factories proper) the condition of things is much worse than in England, because the counterpoise of the Factory Acts is wanting. In all other spheres, we, like all the rest of Continental Western Europe, suffer not only from the development of capitalist production, but also from the incompleteness of that development. Alongside of modern evils, a whole series of inherited evils oppress us, arising from the passive survival of antiquated modes of production, with their inevitable train of social and political anachronisms. We suffer not only from the living, but from the dead. *Le mort saisit le vif!* ["The dead man seizes the living one!"]

The social statistics of Germany and the rest of Continental Western Europe are, in comparison with those of England, wretchedly compiled. But they raise the veil just enough to let us catch a glimpse of the Medusa head behind it. We should be appalled at the state of things at home, if, as in England, our governments and parliaments appointed periodically commissions of inquiry into economic conditions; if these commissions were armed with the same plenary powers to get at the truth; if it was possible to find for this purpose men as competent, as free from partisanship and respect of persons as are the English factory-inspectors, her medical reporters on public health, her commissioners of inquiry into the exploitation of women and children, into housing and food. Perseus wore a magic cap that the monsters he hunted down might not see him. We draw the magic cap down over eyes and ears as a make-believe that there are no monsters.

29 DANTE GABRIEL ROSSETTI
"Aspecta Medusa" (1870)

Born in Britain to a family of Italian exiles, Dante Gabriel Rossetti was highly edu-
cated and became known as a visual artist as well as a writer and translator. In 1848
he helped to found the "Pre-Raphaelite Brotherhood," a group of artists seeking to
revitalize theme and technique in British art. This selection evidences what Rossetti
advocated as the interrelation of painting and poetry; the poem offers his commen-
tary on his proposed painting of the same name. Both works focus on Andromeda's
desire to see Medusa and Perseus's crafty fulfillment of that desire. Medusa here
represents the forbidden thing that must be resisted, and the lesson to be learned is
the importance of forgoing what we crave.

(For a Drawing.)

Andromeda, by Perseus saved and wed,
Hankered each day to see the Gorgon's head:
Till o'er a fount he held it, bade her lean,
And mirrored in the wave was safely seen
That death she lived by.

Let not thine eyes know
Any forbidden thing itself, although
It once should save as well as kill: but be
Its shadow upon life enough for thee.

30 FRIEDRICH NIETZSCHE
from *The Birth of Tragedy* (1872)
translated by Walter Kaufmann

Medusa, Apollo, and Dionysus

A nineteenth-century German philosopher and writer, Friedrich Nietzsche is one of the most influential thinkers of the modern day. More a literary and social critic than a strict philosopher, Nietzsche contributed greatly to theories of art and aesthetics, affirming a dichotomy between what he called Apollonian and Dionysian art. *The Birth of Tragedy*, published in 1872, was Nietzsche's first book. In it he speaks of the tension between the Apollonian and Dionysian spirits. Early in his argument, Nietzsche invokes the Gorgon's head as a symbol of the Apollonian denial of the Dionysian spirit, the Gorgon's head interestingly guarding against the influences of Dionysian music and its orgiastic feeling, rather than being a force of seduction itself.

From all quarters of the ancient world—to say nothing here of the modern—from Rome to Babylon, we can point to the existence of Dionysian festivals, types which bear, at best, the same relation to the Greek festivals which the bearded satyr, who borrowed his name and attributes from the goat, bears to Dionysus himself. In nearly every case these festivals centered in extravagant sexual licentiousness, whose waves overwhelmed all family life and its venerable traditions; the most savage natural instincts were unleashed, including even that horrible mixture of sensuality and cruelty which has always seemed to me to be the real "witches' brew." For some time, however, the Greeks were apparently perfectly insulated and guarded against the feverish excitements of these festivals, though knowledge of them must have come to Greece on all the routes of land and sea; for the figure of Apollo, rising full of pride, held out the Gorgon's head to this grotesquely uncouth Dionysian power—and really could not have countered any more dangerous force. It is in Doric art that this majestically rejecting attitude of Apollo is immortalized.

31 DAVID STARR JORDAN
"The Head and the Snakes" (1899)

A Story for Children

The leading ichthyologist of his day, David Starr Jordan is perhaps best known as the first president of Leland Stanford Junior University, later known simply as Stanford. Prior to that, he had also served as president of Indiana University in Bloomington. "The Head and the Snakes" comes from a collection of stories—"some original, some imitative, some travesties of the work of real story-tellers," as he puts it—told to and later illustrated by children.

Once there was a lady and she lived in a house all alone by herself, because her neighbors did not like her and she could not keep any servants. The trouble with her was that instead of hair she wore snakes, and her eyes turned everybody they looked on into stone, and whenever a tramp came along and knocked on the door and called for the lady of the house, she had only to look on him a moment and he turned into stone. She had in her back yard a whole pile of people leaned up against the fence, and every one of them had been turned into stone, because whenever she looked at anybody it turned him into stone.

The neighbors got very tired of her, and so they told Perseus about it, and Perseus went off and borrowed a pair of wings that belonged to Quicksilver, and he fastened them on his feet. Then he went around to Venus and borrowed a nice new looking-glass she had, and he took that in his left hand. Then he went out and got his big broadsword and took that in his right hand. Then he flew away with the wings to the house where Medusa lived, but he did not dare look at Medusa for fear she would turn him into stone, and he felt how ridiculous he would look turned into stone, with wings on his feet and a looking-glass in his hand! So he walked on his toes backward up to the house and knocked with his hind foot on the door. Nobody came to the door, so he turned the knob and went in backward. Now it happened that Medusa was taking a nap on the lounge, and there wasn't a single serpent, by good chance, that

was awake. So Perseus backed up to the lounge, holding the mirror before him, so that he could see where he was going, until he was opposite her; then looking into the mirror he swung his sword over backward and cut Medusa's head right off, and then he grabbed it in his hand by the frizzes of snakes and went right out through the door without saying good-by or anything, and flew away with the head in his hand.

Then he did not know what to do with the head, and the blood dripped out of it and fell into the sand, and every drop that fell made a new snake, and the track over the desert of Libya where he went has been filled with snakes ever since, made out of that blood. Finally he carried the head around to where he saw a great big whale swimming after a girl that somebody had tied to a rock out by the sea, and the girl was crying and calling for her mother. So he just turned the face of Medusa on the whale and changed the whale into stone, and the whale lies there and has been stone ever since. But the girl he untied, and he showed her the way to go home. Still Perseus did not know how to get rid of the head. He never dared to look at it at all for fear it would turn him into stone. Finally as he flew about on the wings of Quicksilver, he saw old Jove taking a morning stroll through the skies, and he told Jove that he might have the head if he wanted it for his museum. And Jove was much pleased, for he liked all sorts of odd things, and he took it from Perseus and hung it up on one of the stars, and there it hangs yet, and if you go out any night and look up into the sky you will see that head way off in among the stars. There are three stars of them making a triangle away on the other side of the North Pole from the Big Dipper, and the star the head is fastened to is the one in the angle at the middle. And when the head was hung up its face was turned toward the earth and it changed the earth into stone, and that is why there is so much rock and stone on the earth now. And some say that the moon was changed to stone too. But I don't know about that; the moon looks too white to be stone. Anyhow, up in the sky the old head of Medusa is hanging yet, and if you go out at night you want to look at it over your right shoulder.

32 LOUISE BOGAN
"Medusa" (1921)

The *New Yorker*'s poetry critic from 1931–1969, Louise Bogan held the chair of poetry at the Library of Congress and was awarded the Bollingen Prize in 1954. "Medusa," first published in *The New Republic* in 1921, appears in an early volume of poems titled *Body of this Death* (1923).

I had come to the house, in a cave of trees,
Facing a sheer sky.
Everything moved,—a bell hung ready to strike,
Sun and reflection wheeled by.

When the bare eyes were before me
And the hissing hair,
Held up at a window, seen through a door.
The stiff bald eyes, the serpents on the forehead
Formed in the air.

This is a dead scene forever now.
Nothing will ever stir.
The end will never brighten it more than this,
Nor the rain blur.

The water will always fall, and will not fall,
And the tipped bell make no sound.
The grass will always be growing for hay
Deep on the ground.

And I shall stand here like a shadow
Under the great balanced day,
My eyes on the yellow dust, that was lifting in the wind,
And does not drift away.

33 SIGMUND FREUD

"Medusa's Head" and from "The Infantile Genital Organization"
(1922 and 1923)
translated by James Strachey

The Classic Psychoanalytic Reading

Sigmund Freud was a Vienese psychiatrist and the originator of psychoanalysis.
Freud's prolific writings addressed the idea of the unconscious, the psychic region
governing drives, emotion, and memory as well as a wide variety of topics in literary,
cultural, social, and sexual life. His writings on Medusa epitomize his ability to con-
nect mythology and individual behavior to common psychic causes and functions.
"Medusa's Head," written in 1922 and published posthumously in 1940, ushered in a
new wave of Meduseana. Both followers and critics responded, directly or indi-
rectly, to Freud's suggestive reading of the myth. In this essay, the fear of castration-
as-decapitation is explicitly linked to the fear of a horrific sight—the sight of the
adult female genitals—mitigated in the myth of Medusa by the presence of the
phallic snakes and by the equation of petrification with male erection.

Medusa's Head

We have not often attempted to interpret individual mythological
themes, but an interpretation suggests itself easily in the case of the hor-
rifying decapitated head of Medusa.

To decapitate = to castrate. The terror of Medusa is thus a terror of
castration that is linked to the sight of something. Numerous analyses
have made us familiar with the occasion for this: it occurs when a boy,
who has hitherto been unwilling to believe the threat of castration,
catches sight of the female genitals, probably those of an adult, sur-
rounded by hair, and essentially those of his mother.

The hair upon Medusa's head is frequently represented in works of
art in the form of snakes, and these once again are derived from the cas-
tration complex. It is a remarkable fact that, however frightening they

may be in themselves, they nevertheless serve actually as a mitigation of the horror, for they replace the penis, the absence of which is the cause of the horror. This is a confirmation of the technical rule according to which a multiplication of penis symbols signifies castration.[1]

The sight of Medusa's head makes the spectator stiff with terror, turns him to stone. Observe that we have here once again the same origin from the castration complex and the same transformation of affect! For becoming stiff means an erection. Thus in the original situation it offers consolation to the spectator: he is still in possession of a penis, and the stiffening reassures him of the fact.

This symbol of horror is worn upon her dress by the virgin goddess Athene. And rightly so, for thus she becomes a woman who is unapproachable and repels all sexual desires—since she displays the terrifying genitals of the Mother. Since the Greeks were in the main strongly homosexual, it was inevitable that we should find among them a representation of woman as a being who frightens and repels because she is castrated.

If Medusa's head takes the place of a representation of the female genitals, or rather if it isolates their horrifying effects from their pleasure-giving ones, it may be recalled that displaying the genitals is familiar in other connections as an apotropaic act. What arouses horror in oneself will produce the same effect upon the enemy against whom one is seeking to defend oneself. We read in Rabelais of how the Devil took to flight when the woman showed him her vulva.

The erect male organ also has an apotropaic effect, but thanks to another mechanism. To display the penis (or any of its surrogates) is to say: "I am not afraid of you. I defy you. I have a penis." Here, then, is another way of intimidating the Evil Spirit.[2]

In order seriously to substantiate this interpretation it would be necessary to investigate the origin of this isolated symbol of horror in Greek mythology as well as parallels to it in other mythologies.[3]

The Infantile Genital Organization

We know, too, to what a degree depreciation of women, horror of women, and a disposition to homosexuality are derived from the final

conviction that women have no penis. Ferenczi (1923) has recently, with complete justice, traced back the mythological symbol of horror—Medusa's head—to the impression of the female genitals devoid of a penis.[4]

Notes

1. [This is referred to in Freud's paper on "The 'Uncanny'" (1919h), middle of Section II.]

2. [It may be worth quoting a footnote added by Freud to a paper of Stekel's, "Zur Psychologie des Exhibitionismus," in *Zentralbl. Psychoanal., 1* (1911b), 495: "Dr. Stekel here proposes to derive exhibitionism from unconscious narcissistic motive forces. It seems to me probable that the same explanation can be applied to the apotropaic exhibiting found among the peoples of antiquity."]

3. [The same topic was dealt with by Ferenczi (1923) in a very short paper which was itself briefly commented upon by Freud in his 'Infantile Genital Organization of the Libido' (1923e).]

4. I should like to add that what is indicated in the myth is the *mother's* genitals. Athene, who carries Medusa's head on her armour, becomes in consequence the unapproachable woman, the sight of whom extinguishes all thought of a sexual approach.—[Freud had himself drafted a short paper on this subject a year earlier, which was published posthumously (1940c [1922]).]

34 SÁNDOR FERENCZI

from "On the Symbolism of the Head of Medusa" (1923)
translated by Olive Edmonds

Medusa and Castration

Trained as a neurologist and heavily influenced by Breuer and Freud's *Studies on Hysteria*, Sándor Ferenczi joined weekly meetings of the Vienna Psychoanalytic Society in 1908 and remained one of Freud's closest friends and most frequent correspondents for many years. Ferenczi helped found and was president of the International Psychoanalytic Society and contributed significantly to innovations in analytic technique. This excerpt, from his *Further Contributions to the Theory and Technique of Psycho-Analysis*, was written after Freud wrote "Medusa's Head" but before that piece was published. It offers a concurring view that Medusa symbolizes the terrifying sight of the female genitalia.

In the analysis of dreams and fancies, I have come repeatedly upon the circumstance that the head of Medusa is the terrible symbol of the female genital region, the details of which are displaced "from below upwards." The many serpents which surround the head ought—in representation by the opposite—to signify the absence of a penis, and the phantom itself is the frightful impression made on the child by the penis-less (castrated) genital. The fearful and alarming starting eyes of the Medusa head have also the secondary meaning of erection.

35 COUNTEE CULLEN
"Medusa" (1935)

Countee Cullen is most widely remembered as a poet of the Harlem Renaissance.
Much of his literary contribution to that movement occurred while he was still quite
young. Published in Cullen's 1935 volume *The Medea and Some Poems*, "Medusa"
may be read as a meditation on ambivalence. Cullen's poems often use traditional
verse forms: *Medusa* is a sonnet.

I MIND me how when first I looked at her
A warning shudder in the blood cried, "Ware!
Those eyes are basilisk's she gazes through,
And those are snakes you take for strands of hair!"
But I was never one to be subdued
By any fear of aught not reason-bred,
And so I mocked the ruddy word, and stood
To meet the gold-envenomed dart instead.

O vengeful warning, spiteful stream, a truce!
What boots this constant crying in the wind,
This ultimate indignity: abuse
Heaped on a tree of all its foliage thinned?
Though blind, yet on these arid balls engraved
I know it was a lovely face I braved.

36 WALTER BENJAMIN
from "Paris, Capital of the Nineteenth Century" (1939)
translated by Howard Eiland and Kevin McLaughlin

Medusa and Modernity

A German literary critic of the early twentieth century, Walter Benjamin wrote some
of the most influential philosophical and social discourses of modern times. This ex-
cerpted passage, in which Benjamin imagines Medusa's gaze as a definition of
modernity, is from his essay "Paris, Capital of the Nineteenth Century," written in
1939 for his monumental *Arcades Project*. An earlier version of the essay, written in
1935, does not include the Medusa passage.

The linchpin of [Baudelaire's] entire theory of art is "modern beauty,"
and for him the proof of modernity seems to be this: it is marked with
the fatality of being one day antiquity, and it reveals this to whoever wit-
nesses its birth. Here we meet the quintessence of the unforeseen, which
for Baudelaire is an inalienable quality of the beautiful. The face of
modernity itself blasts us with its immemorial gaze. Such was the gaze of
Medusa for the Greeks.

37 PHILIP WYLIE

from *Generation of Vipers* (1942)

Momism

Philip Wylie, a science fiction writer and screenwriter who produced both serious and popular works, defined "momism" for the American public in what he himself described as "one of the most renowned (or notorious) passages in Modern English Letters." In 1942, spurred by what he saw as Americans' selfishness and moral impurities, Wylie expressed his views in *Generation of Vipers*, a book that, among other things, attacks American women as greedy, materialistic, and power hungry—faults embodied in the caricature of "mom." In this excerpt from the essay "Common Women," the desexualized, haglike mom is first contrasted to, but then conflated with, the younger, sexually appealing woman, described by Wylie as both "Cinderella" and "Medusa."

Most decriers of matriarchy, however, are men of middle age, like me.

Young men whose natures are attuned to a female image with more feelings than mom possesses and different purposes from those of our synthetic archetype of Cinderella-the-go-getter bounce anxiously away from their first few brutal contacts with modern young women, frightened to find their shining hair is vulcanized, their agate eyes are embedded in cement, and their ruby lips case-hardened into pliers for bending males like wire. These young men, fresh-startled by learning that She is a chrome-plated afreet, but not able to discern that the condition is mom's unconscious preparation of somebody's sister for a place in the gynecocracy—are, again, presented with a soft and shimmering resting place, the bosom of mom.

Perseus was carefully *not* told that the Gorgons had blonde back hair and faces on the other side, like Janus, which, instead of turning him to stone, would have produced orgasms in him. Thus informed he would have failed to slay Medusa and bring back her head. He might have been congealed—but he might not. Our young men are screened from a knowledge of this duality also, but they are told only about the blonde

side. When they glimpse the other, and find their blood running cold and their limbs becoming like concrete, they carom off, instanter, to mom. Consequently, no Gorgons are ever clearly seen, let alone slain, in our society. Mom dishes out her sweetness to all fugitives, and it turns them not to stone, but to slime. . . .

I give you mom. I give you the destroying mother. I give you her justice—from which we have never removed the eye bandage. I give you the angel—and point to the sword in her hand. I give you death—the hundred million deaths that are muttered under Yggdrasill's ash. I give you Medusa and Stheno and Euryale. I give you the harpies and the witches, and the Fates. I give you the woman in pants, and the new religion: she-popery. I give you Pandora. I give you Proserpine, the Queen of Hell. The five-and-ten-cent-store Lilith, the mother of Cain, the black widow who is poisonous and eats her mate, and I designate at the bottom of your program the grand finale of all the soap operas: the mother of America's Cinderella.

We must face the dynasty of the dames at once, deprive them of our pocketbooks when they waste the substance in them, and take back our dreams which, without the perfidious materialism of mom, were shaping up a new and braver world. We must drive roads to Rio and to Moscow and stop spending all our strength in the manufacture of girdles: it is time that mom's sag became known to the desperate public; we must plunge into our psyches and find out there, each for each, scientifically, about immortality and miracles. To do such deeds, we will first have to make the conquest of momism, which grew up from male default.

38 JEAN-PAUL SARTRE
from *Being and Nothingness:*
A Phenomenological Essay on Ontology (1943)
translated by Hazel E. Barnes

The Other's Look

A French novelist, playwright, philosopher, and cultural icon, Jean-Paul Sartre figures among the most renowned of modern intellectuals. He declined the Nobel Prize for literature (for his autobiography, *The Words*) in 1964. This much discussed excerpt from his major work on existentialism, *Being and Nothingness*, figures the look of Medusa as that which situates the otherwise transcendent "for-itself" in a world of other things. For an analysis of this passage, see the text by Hazel E. Barnes excerpted in this volume, pp. 124–27.

It is only when the oppressed class by revolution or by a sudden increase of its power posits itself as "they-who-look-at" in the face of members of the oppressing class, it is only then that the oppressors experience themselves as "Us." But this will be in fear and shame and as an Us-object. . . .

As for the Us-object, this is directly dependent on the Third—i.e., on my being-for-others—and it is constituted on the foundation of my being-outside-for-others. And as for the We-subject, this is a psychological experience which supposes one way or another that the Other's existence as such has been already revealed to us. It is therefore useless for human-reality to seek to get out of this dilemma: one must either transcend the Other or allow oneself to be transcended by him. The essence of the relations between consciousnesses is not the *Mitsein*; it is conflict.

At the end of this long description of the relations of the for-itself with others we have then achieved this certainty: the for-itself is not only a being which arises as the nihilation of the in-itself which it is and the internal negation of the in-itself which it is not. This nihilating flight is entirely re-apprehended by the in-itself and fixed in in-itself as soon as the Other appears. The for-itself when alone transcends the world; it is the

nothing by which *there are* things. The Other by rising up confers on the for-itself a being-in-itself-in-the-midst-of-the-world as a thing among things. This petrifaction in in-itself by the Other's look is the profound meaning of the myth of Medusa.

39 JAMES MERRILL
"Medusa" (1946)

James Merrill, a much honored American poet (National Book Award, Pulitzer Prize, National Book Critics Circle Award, Bollingen Prize), is known both for his elegant, urbane lyric poems and for his epic trilogy, *The Changing Light at Sandover* (1982). "Medusa," published in his early volume *The Black Swan* (1946), invokes images of both the Gorgon and Perseus through contemplation of a garden statue.

The head, of course, had fallen to disrepair
If not to disrepute. The bounteous days
When the blank marble gaze
Was blind in its own right, did not need moss
To mar its sightlessness,
Brilliantly blind, the fabulous days are rare
Spiralings in the ear
Of time. The fountain-mouth
Whitens with bird-droppings. The birds are south
That whistled on the basin's rim, or circled
Delightfully where the white water sparkled.

Snake-laurelled head with overturned eyeballs,
The genius of our summer has become
Its monument, its tomb.
We idle here under its massive spell
Where ferns, toothed yellow, tell
How summerlong the makeshift waterfalls,
Birds and their songs were false
For being perishable.
That face, now but a dry-lipped mask, ababble
No more of feet that fly and glass that looks—
In whose dream are rewound its peerless clocks?

Birds foul a blind eye, that is how we dream.
The face like godhead in this world of sense
Had been a powerful lens
Of crystal once, perfection in its scope.
But now leaves rasp and skip
Throughout the peeling empire, it would seem
That nothing is the same;
We might be studying
The litter in our lives, in everything;
And presently the word Oblivion
Turns us to one another, as to stone.

Our lives, yes, but emptied of our living!
The blinding days have left no light in hand
Or hand's shade on the ground
Where, hand in hand, we harden, whiten, grown
Silent and parched within,
Bewildered that there is no rainbow diving,
No liveliness, no loving,
Not even the glad splatter
Making the face shine, if such trifles matter
Once all is stone—that is, all but the snakes'
Loud, lazy crown, the mouth that opens, speaks,

The eyes whose suns of no return upon
Pure intellection glare, until *it* dims . . .
O maddened by such dreams,
Such features rolling in his head like eyes,
Tonight may one of us
Stride out into the coldest, roundest moon
And strip his dreaming down
To a cheap serpent horror
Too long reflected in a noble mirror
Of lust and birdsong, waterplay and guile,
And raise his quivering sword, and think to kill.

40 ERICH NEUMANN

from *The Origins and History of Consciousness* (1949)
translated by R. F. C. Hull

A Jungian View of the Terrible Mother

A German-born analytic psychologist, Erich Neumann was heavily influenced by the
archetypal theories of consciousness proposed by Carl Jung. In this passage from
On the Origins and History of Consciousness, Neumann associates the archetypal
Gorgon figure with the "castrating" womb and with the "lower," maternal aspects of
the feminine persona.

Among the symbols of the devouring chasm we must count the womb in
its frightening aspect, the numinous heads of the Gorgon and the
Medusa, the woman with beard and phallus, and the male-eating spider.
The open womb is the devouring symbol of the uroboric mother, espe-
cially when connected with phallic symbols. The gnashing mouth of the
Medusa with its boar's tusks betrays these features most plainly, while
the protruding tongue is obviously connected with the phallus. The snap-
ping—i.e., castrating—womb appears as the jaws of hell, and the ser-
pents writhing round the Medusa's head are not personalistic—pubic
hairs—but aggressive phallic elements characterizing the fearful aspect
of the uroboric womb. The spider can be classified among this group of
symbols, not only because it devours the male after coitus, but because it
symbolizes the female in general, who spreads nets for the unwary
male. . . .

Now the Gorgons are the daughters of Phorcys, the "Gray One,"
who, like his two sisters Keto ("the monstrous") and Eurybia ("the great
in strength"), and his brother Thaumas ("the wonder-maker"), is a child
of the deep, Pontos. All of them give birth to a terrifying and fabulous
brood of monsters. The Gorgons, metallic-winged, serpent-haired and
serpent-engirdled, tusked like boars, bearded and barbed, and with pro-
truding tongues, are uroboric symbols of what we might justly call "the
Infernal Feminine." Their sisters and guardians are the Graeae, whose

name means fear and dread. They too, with their one eye and one tooth between them, are uroboric creatures who dwell on the uttermost confines of night and death, far to the westward, by the shores of the primeval ocean.

Perseus has Hermes and Athene on his side, the tutelary deities of wisdom and consciousness, with whose help he outwits the Graeae, contriving to learn from them the way to the nymphs. These beneficent sea-goddesses give him the helmet of invisibility that belongs to Hades, a pair of winged sandals, and a wallet. Hermes presents him with a sword, and Athene lends him her brazen shield for a mirror, in which he can see the Medusa's head reflected and so is able to kill her, for to look directly upon the Gorgon's features is to risk certain death by being instantly turned to stone.

We cannot enter more closely into this exceedingly interesting symbolism, except to say that intellect and spiritualization symbols play a most significant part. Flying, invisibility, and reflected sight form a homogeneous group, and to this we would add the wallet in which Perseus hides the Gorgon's head, thus making it invisible and harmless, as a symbol of repression.

Now, what is so very odd is the manner in which Perseus is represented in early Greek art. The main feature is not, as one might think, the killing of the Gorgon, but the hero's headlong flight from the pursuing sisters. To our way of thinking it is strange indeed to see the valiant Perseus depicted over and over again as a tearing fugitive.

Evidently the winged sandals, the helmet of invisibility, and the hiding-wallet are much more important to him than the death-dealing sword, and his fear greatly enhances the horrific aspect of the slain but ever-pursuing Gorgon. Once more we encounter the mythological prototype of Orestes pursued by the Furies, for, like him, Perseus becomes a hero because he has killed the Terrible Mother.

The uroboric character of the Gorgon can be adduced not only from the symbols but also from the history of religion. In connection with the Gorgonesque sculpture on the temple of Artemis in Corfu, dating from the sixth century, Woodward [In *Perseus: A Study in Greek Art and Legend*] writes:

It may seem odd that this uncouth, grimacing figure should be given the place of honor on the temple pediment, but the idea

behind it takes us back to a time long before these Gorgon-figures were identified with the creatures of the Perseus legend. With her attendant lions, she embodies the great Nature Spirit of primitive belief, who appears in early Asiatic and Ionian works of art as a goddess, with birds, lions, or snakes heraldically set on either side of her, the prototype of the Cybele of Phrygian worship and the Artemis of the Greeks. Here, through one aspect of her nature, she has become partly identified with Medusa.

Without pausing to comment on this passage, we can take it that the identity of the Gorgon dispatched by Perseus, and the figure of the Great Mother who rules over wild animals, is proven, even for investigators not familiar with the real background of the myth.

The hero's flight and escape, then, testify very clearly to the over-powering character of the Great Mother. Despite the assistance of Hermes and Athene, despite the miraculous gifts bestowed on him by the nymphs, and despite the fact that he averts his face for the death stroke, he is barely man enough to kill her. (Note that the paralyzing and petrifying effect of the hideous death mask reappears as the "stickfast motif" in the story of Theseus. Attempting to abduct Persephone from the underworld, he sticks fast to the rocks and is tormented by the Erinyes until Herakles comes to his rescue.) The power of the Great Mother is too overwhelming for any consciousness to tackle direct. Only by indirect means, when reflected in Athene's mirror, can the Gorgon be destroyed—in other words, only with the help of the patron goddess of consciousness, who, as the daughter of Zeus, stands for "heaven."

On his way back from killing the mother, Perseus frees Andromeda from a horrible sea monster that ravages the land and is about to devour the girl. This monster has been sent by Poseidon, who is referred to as "the Medusa's lover" and is, as ruler of the ocean, himself the monster. He is the Terrible Father, and since he is the Medusa's lover, he is clearly related to the Great Mother as her invincible phallic consort. Again and again in his wrath he sends monsters to devastate the land and destroy the inhabitants; he is the dragon or bull who represents the destructive masculine side of the uroboros which has split off and became autonomous. The defeat of this monster is the task of the hero, whether he be called Bellerophon or Perseus, Theseus or Herakles.

Thus the sequence so typical of the hero myth is recapitulated in the story of Perseus: the killing of the transpersonal mother and father (the Medusa and the sea monster) precedes the rescue of the captive, Andromeda. His father a god and his mother the bride of a god, a personal father who hates him, then the killing of the transpersonal First Parents, and finally the liberation of the captive—these are the stages that mark the progress of the hero. But this path can only be trodden to its triumphal conclusion with the help of the divine father, whose agent here is Hermes, and with the help of Athene, whose spiritual character and hostility to the Great Mother we have already emphasized.

The fact that Perseus then gives the Gorgon's head to Athene, and that she emblazons it upon her shield, crowns this whole development as the victory of Athene over the Great Mother, of the warrior aspect which is favorable to man and consciousness, and which we also met in the *Oresteia*. The most striking feature in the figure of Athene is the defeat of the old mother goddess by the new, feminine, spiritual principle. Athene still has all the characteristics of the great Cretan goddess. On numerous vase paintings she is surrounded by snakes; indeed the great snake is her constant companion right to the end. Likewise her emblem, the tree, and her appearance in the form of a bird betray her Cretan origins. But the primordial power of the female has been subdued by her; she now wears the Gorgon's head as a trophy upon her shield. From quite early times she had been the patron goddess of the ruler and was worshiped in his palace, so that she came to symbolize the revolution which, in the patriarchal age, broke the power of the mother deity. Sprung from the head of Zeus, she is father-born and motherless in contrast to the mother-born, fatherless figures of ancient times; and in contrast, again, to the Terrible Mother's animosity toward all things masculine, she is the companion and helper of the masculine hero.

"Perseus" and "Medusa" (1958 and 1962)

Sylvia Plath, poet, story-writer, and author of the novel *The Bell Jar*, wrote "Perseus: The Triumph of Wit Over Suffering" in 1958. Prompted by a drawing by Paul Klee, it was one of several poems inspired by works of art. In 1962, less than a year before her suicide, she wrote the angry "Medusa," which plays on the similarity between the Latin name for the jellyfish medusa (*aurela*) and Plath's mother's name (Aurelia). The "eely tentacle" of Medusa's hair becomes, in this poem, the Atlantic cable over which Plath and her mother had begun to speak on the telephone.

Perseus: The Triumph of Wit Over Suffering

Head alone shows you in the prodigious act
Of digesting what centuries alone digest:
The mammoth, lumbering statuary of sorrow,
Indissoluble enough to riddle the guts
Of a whale with holes and holes, and bleed him white
Into salt seas. Hercules had a simple time,
Rinsing those stables: a baby's tears would do it.
But who'd volunteer to gulp the Laocoön,
The Dying Gaul and those innumerable pietàs
Festering on the dim walls of Europe's chapels,
Museums and sepulchers? You.

 You
Who borrowed feathers for your feet, not lead,
Not nails, and a mirror to keep the snaky head
In safe perspective, could outface the gorgon-grimace
Of human agony: a look to numb
Limbs: not a basilisk-blink, nor a double whammy,
But all the accumulated last grunts, groans,
Cries and heroic couplets concluding the million
Enacted tragedies on these blood-soaked boards,

And every private twinge a hissing asp
To petrify your eyes, and every village
Catastrophe a writhing length of cobra,
And the decline of empires the thick coil of a vast
Anaconda.
 Imagine: the world
Fisted to a foetus head, ravined, seamed
With suffering from conception upwards, and there
You have it in hand. Grit in the eye or a sore
Thumb can make anyone wince, but the whole globe
Expressive of grief turns gods, like kings, to rocks.
Those rocks, cleft and worn, themselves then grow
Ponderous and extend despair on earth's
Dark face.
 So might rigor mortis come to stiffen
All creation, were it not for a bigger belly
Still than swallows joy.
 You enter now,
Armed with feathers to tickle as well as fly,
And a fun-house mirror that turns the tragic muse
To the beheaded head of a sullen doll, one braid,
A bedraggled snake, hanging limp as the absurd mouth
Hangs in its lugubrious pout. Where are
The classic limbs of stubborn Antigone?
The red, royal robes of Phèdre? The tear-dazzled
Sorrows of Malfi's gentle duchess?
 Gone
In the deep convulsion gripping your face, muscles
And sinews bunched, victorious, as the cosmic
Laugh does away with the unstitching, plaguey wounds
Of an eternal sufferer.
 To you
Perseus, the palm, and may you poise
And repoise until time stop, the celestial balance
Which weighs our madness with our sanity.

Medusa

Off that landspit of stony mouth-plugs,
Eyes rolled by white sticks,
Ears cupping the sea's incoherences,
You house your unnerving head—God-ball,
Lens of mercies,

Your stooges
Plying their wild cells in my keel's shadow,
Pushing by like hearts,
Red stigmata at the very center,
Riding the rip tide to the nearest point of departure,

Dragging their Jesus hair.
Did I escape, I wonder?
My mind winds to you
Old barnacled umbilicus, Atlantic cable,
Keeping itself, it seems, in a state of miraculous repair.

In any case, you are always there,
Tremulous breath at the end of my line,
Curve of water upleaping
To my water rod, dazzling and grateful,
Touching and sucking.

I didn't call you.
I didn't call you at all.
Nevertheless, nevertheless
You steamed to me over the sea,
Fat and red, a placenta

Paralysing the kicking lovers.
Cobra light
Squeezing the breath from the blood bells
Of the fuchsia. I could draw no breath,
Dead and moneyless,

Overexposed, like an X-ray.
Who do you think you are?
A Communion wafer? Blubbery Mary?
I shall take no bite of your body,
Bottle in which I live,

Ghastly Vatican.
I am sick to death of hot salt.
Green as eunuchs, your wishes
Hiss at my sins.
Off, off, eely tentacle!

There is nothing between us.

42 ROGER CAILLOIS

from *The Mask of Medusa* (1960)
translated by George Ordish

The Gorgon Mask

A writer, editor, critic, cultural advocate, and sociologist, Roger Caillois made significant and varied contributions to French thought. His *Méduse et Compagnie* was first published in French in 1960 and translated into English as *The Mask of Medusa* in 1964. As part of his systematic effort to describe human mythologies of disguise and mimicry in aesthetic terms that parallel the terms of the natural world, Caillois compares the penetrating power of the Medusa's gaze to that of a sacred mask and links this power to that used by insects.

The story [of Perseus and Medusa] is quite transparent. It is merely an account of an initiation ceremony. The youth, given advice by his teachers and fitted out with all the necessary accoutrements, travels to the Other World, that is, he goes into the bush, or to the surroundings where the sorcerer is to carry out the ceremony. He has to submit to the test and win through in order to become a man and have the right to wear the mask which will make him a member of the class of male adults or of a secret society. Not till then can he carry the disguise and paralyse his enemies with fright.

The Gorgon's head is nothing more than a mask. It is not irrelevant to see in its intervention the belief in the evil eye, the hyponotising power of ocelli, clearly related to the wearing of masks in primitive communities, where often even the chance sight of a ceremonial mask by a non-initiate is a sacrilege bringing death, or at least the partial paralysis or the consumption of the bold or unfortunate person. And those in power will see to it that these expected results do indeed happen. At times they need do nothing, the thought alone will be sufficient.

According to some, Perseus buried Medusa's head beneath the agora of Argos, but others have it that he offered it to Athene, who asked Hephaestos to place it on her shield. It is also said that Athene got the head as

a prize of battle, or that Zeus, the only legitimate owner, lent it to Athene, and to other gods of sufficient rank, so that they might petrify their enemies. This fatal trophy is, like the eye, frequently found on shields.

In classical times Athene carried it in the shape of a pectoral on the aegis. In fact the aegis is the double of the *Gorgoneion*. It is the skin of the goat Aegis, so fearsome that the sight of it made the bravest tremble: even the Titans asked Gaia, its mother, to hide it. Consequently she shut it up in the grotto where Amalthea came to get its milk for the young Zeus. Later on Zeus used the skin to cover his shield.

Another fable represents Aegis as an enormous monster who created the earth by his own means. His mouth spouted fire. He burnt up Phrygia entirely and the Caucasian forests as far as India. Athene killed him and used his skin as a breastplate.

The aegis was not always a close-fitting breastplate made of scales on which shone the terrible head of Medusa. It could also be a large animal skin covering the torso at least as far as the loins. Put over the head, it hides the face and replaces it with the hideous mask of the Gorgon, with huge eyes, the tongue hanging between savage teeth and the hair a mass of writhing snakes. A painting from a piece of an Amasis vase leaves no doubt on this point and makes one think that originally the aegis was the complete disguise and the *Gorgoneion* the mask. From the beginning (for instance in Homer's *Iliad*, v. 737) this disguise and its accessory are at one and the same time offensive and defensive, spellbinding, paralysing, like the evil eye, like the ocelli of caterpillars, butterflies and moths. . . .

Almost everywhere we see in man this tenacious, almost ineradicable, fear of the eye whose gaze paralyses, roots him to the spot, suddenly deprives him of thought, movement, and will. He is afraid of finding himself in front of this circular device, which can bring unconsciousness or death, which can kill or turn to stone. He is terrified by it, but at the same time tries to use this instrument of terror so as to be master of it in his turn. He invents fabulous creatures with the sole object of wringing from them this paralysing power, against which he feels defenceless, but which he hopes to take and use for his own ends.

43 DARYL HINE
"Tableau Vivant" (1968)

Canadian-born Daryl Hine, a poet and translator, was editor of *Poetry* magazine from 1968 to 1978. Author of numerous volumes of poetry, he has translated the verse of Ovid, Homer, and Hesiod. In a 1972 essay on Medusa and Romantic literary iconology, critic Jerome McGann describes "Tableau Vivant" as "a brief allegory about what has happened to western art between the sixteenth century and our own day. . . . Hine's poem says to us: pictured here is the moment just before the hero Perseus will strike dead the monstrous offspring of Phorcys and Ceto. The artist knew only one way to tell the ancient story, but we now can see how equivocal it all might be, how much he is able to suggest of which he could not have been aware and would never have approved."

Perseus on an ornamental charger,
German work, sixteenth century,
Hovering above the slumbering Medusa
Like a buzzing fly or a mosquito
On beaten, golden wings. His head averted
From her agate gaze. In his right hand
A sword, in his left a mirror.

Helmeted by night, slipshod by darkness.
Wondering where to strike. She looks asleep
As if dreaming of petrified forests,
Monumental dryads, stone leaves, stone limbs,
Or of the mate that she will never meet
Who will look into her eyes and live.

"The Muse as Medusa" (1971)

Although critical recognition arrived late for May Sarton, she acquired a large fol-
lowing over a career that stretched from her first book of poetry published in 1937 to
her last collection in 1992. Her 1965 book *Mrs. Stevens Hears the Mermaids
Singing*, in which Sarton came out as a lesbian, made her a feminist cult figure. In
"The Muse as Medusa," the speaker claims Medusa's "frozen rage" as her own,
identifying it as a source of creativity and inspiration.

I saw you once, Medusa; we were alone.
I looked you straight in the cold eye, cold.
I was not punished, was not turned to stone—
How to believe the legends I am told?

I came as naked as any little fish,
Prepared to be hooked, gutted, caught;
But I saw you, Medusa, made my wish,
And when I left you I was clothed in thought . . .

Being allowed, perhaps, to swim my way
Through the great deep and on the rising tide,
Flashing wild streams, as free and rich as they,
Though you had power marshaled on your side.

The fish escaped to many a magic reef;
The fish explored many a dangerous sea—
The fish, Medusa, did not come to grief,
But swims still in a fluid mystery.

Forget the image: your silence is my ocean,
And even now it teems with life. You chose
To abdicate by total lack of motion,
But did it work, for nothing really froze?

It is all fluid still, that world of feeling
Where thoughts, those fishes, silent, feed and rove;
And, fluid, it is also full of healing,
For love is healing, even rootless love.

I turn your face around! It is my face.
That frozen rage is what I must explore—
Oh secret, self-enclosed, and ravaged place!
This is the gift I thank Medusa for.

45 JOHN FRECCERO
from "Medusa: The Letter and the Spirit" (1972)

On Dante's Medusa

John Freccero, author of *Dante: The Poetics of Conversion*, and numerous essays on topics in Italian literature, is one of America's foremost Dante scholars. "Medusa: The Letter and the Spirit" is an analysis of the figure of Medusa as it appears in both Dante's *Rime Petrose* and *The Divine Comedy*. Here, Freccero argues that the threat posed by Medusa is first and foremost the threat of the beautiful Medusa, the threat of petrification based on erotic attraction. For Dante's text, see pp. 51–52. See also Figure 8.

Several times in the course of his poem, Dante insists that his verses be read allegorically, but nowhere is his insistence more peremptory or more baffling than in Canto IX of the *Inferno*, after Virgil covers the pilgrim's eyes to protect him from the sight of the Medusa:

> O voi ch'avete li 'ntelletti sani
> Mirate la dottrina che s'asconde
> Sotto 'l velame de li versi strani.
> > (*Inferno*, IX, 61–63)

> [O you who have sound understanding,
> see the doctrine that is hidden
> under the veil of the strange verses.]

These lines have always represented something of a scandal in the interpretation of Dante's allegory, primarily because they seem to fail in their didactic intent: in fact, the *dottrina* referred to here remains as veiled to us as it was to the poet's contemporaries. More than that, however, the *dottrina*, whatever it is, seems scarcely worth the effort. The verses suggest a personification allegory—Medusa as moral abstraction—very different from the theological allegory that, since the work of Charles Singleton,[1]

we have taken to be uniquely dantesque. The allegory of the episode would seem to be no different from the "allegory of poets," described in the *Convivio* as a *menzogna* [lie] hiding a moral truth, so that we are tempted to conclude either that Dante's allegory, though obscure, is no different from that of other poets, or that this first explicit reference to it in the poem is somehow atypical of the rest of the allegory.

My purpose in this paper will be to suggest that neither of these alternatives is correct and that this passage, when properly understood, can provide us with a model for understanding Dante's allegory throughout the poem. I hope to show that the allegory is essentially theological and, far from being of purely antiquarian interest, a bizarre exegetical theory irrelevant to poetic practice, is actually indistinguishable from the poem's narrative structure. Christian allegory, I will argue, is identical with the phenomenology of confession, for both involve a comprehension of the self in history within a retrospective literary structure.

Perhaps the principal difficulty with the address to the reader in the episode of the Medusa has arisen from our tendency to read it as though it were dramatically unrelated to its context, a generic recall to a moral code exterior to the text. In fact, however, this passage, like all of the addresses to the reader, is exterior to the fiction, but central to the text. The authorial voice is at once the creation of the journey and its creator, an *alter Dantes* [other Dante] who knows, but does not as yet exist, dialectically related to the pilgrim, who exists but does not as yet know. The addresses to the reader create the author as much as they create his audience; they are as the paradigm of the entire narrative, ensuring the presence of the goal at each step along the way. It is Dante's fiction that the author's existence precedes that of the poem, as though the experience had been concluded before the poem were begun. In reality, however, the experience of the pilgrim and the creation of the authorial voice take place at the same time, in the writing of the poem. The progress of the pilgrim and the addresses to the reader are dramatic representations of the dialectic that is the process of the poem. Journey's end, the vision of the incarnation, is at the same time the incarnation of the story, when pilgrim and author, being and knowing, become one.

In precisely the same way that the pilgrim and the authorial voice are dialectically related to each other, the dramatic action involving the Medusa is related to the address to the reader immediately following it.

This is suggested by a certain inverse symmetry: the *covering* of the pilgrim's eyes calls forth a command to *uncover* and see (*mirate*) the doctrine hidden beneath the verses, as if the command were consequent to the action rather than simply the interruption that it is usually taken to be. As readers of the poem, we ordinarily assume that the dramatic action is stopped from time to time for an authorial gloss, as if the poet were arbitrarily intruding upon a rerun of his own past in order to guide us in our interpretation. Here, however, the symmetry between the action and the gloss suggests a more intimate, even *necessary*, relationship. The antithetical actions (covering/uncovering) suggest that we look for antithetical objects (Medusa/*dottrina*) in two analogous or parallel realms: the progress of the pilgrim and the progress of the poem. The threat of the Medusa lends a certain moral force to the command to *see* beneath the strange verses, just as the address to the reader lends to the Medusa a certain hermeneutic resonance. It is *because* the pilgrim averted his eyes from the Medusa that there is a truth to be seen beneath the veil; because seeing it is a way of understanding a text, however, the implication seems to be that the Medusa is an interpretive as well as a moral threat. In other words, the aversion from the Medusa and the *conversion* to the text are related temporally, as the *before* and *after* of the same poetic event. Between those two moments, there extends the experience of the pilgrim, who has himself seen the *dottrina* and has returned as poet to reveal it to us.

A passage in the *Purgatorio* lends considerable weight to our suggestion that petrification is an interpretive as well as a moral threat and that the act of interpretation depends on a moral condition. At the end of the second *cantica*, on the occasion of Dante's own revelation, Beatrice chides him for his *vani pensieri* [vain thoughts] and for the delight he has taken in them:

> . . . io veggio te ne lo 'ntelletto
> fatto di pietra ed, impietrato, tinto
> sì che t'abbaglia il lume del mio detto.
> <div align="right">(Purg. XXXIII, 73–75)</div>

> [. . . I see you turned to stone in your mind,
> and stonelike, such in hue that
> the light of my word dazes you.]

If we apply this imagery to the episode of Canto IX, then it is clear that petrification can mean the inability to see the light of truth in an interpretive glance. Thus, the threat of the Medusa may in a sense be a danger to be averted by the reader as well as the pilgrim: an "intelletto sano," as Dante tells us in the *Convivio*, is a mind that is not obscured by ignorance or *malizia* [malice], a mind that is not petrified.[2]

The dialectic of blindness and vision, aversion and conversion in the interpretation of the text, is central to biblical hermeneutics and is discussed by St. Paul with the figure of the veil. The use of the word *velame* in Dante's verses would seem to be an allusion to the Pauline tradition. To speak of a truth hidden beneath a veil was of course a banality in Dante's day, as it is in ours, but its familiarity derived from its biblical origin, where the veil was literally a covering for the radiant face of Moses and figuratively the relationship of the Old Testament to the New. Paul, in II Corinthians, extends his discussion of the "letter that kills" and of the "Spirit that gives life" by blending the words of Jeremiah about God writing his law in the hearts of his people with those of Ezekiel about the people of God having hearts of flesh instead of hearts of stone.[3] In St. Paul's New Testament perspective, the hearts of stone become the inscribed tablets of the Law of Moses, contrasted with the inscribed hearts of the faithful. He then discusses the meaning of the veil:

> Having therefore such hope, we show great boldness. We do not act as Moses did, who used to put a veil over his face that the Israelites might not observe the glory of his countenance, which was to pass away. But their minds were darkened (*obtusi sunt sensus eorum*); for to this day, when the Old Testament is read to them, the selfsame veil remains, not being lifted (*non revelatum*) to disclose the Christ in whom it is made void. Yes, down to this very day, when Moses is read, the veil covers their hearts; but when they turn in repentance to God, the veil shall be taken away (*Cum autem conversus fuerit ad Dominum, auferetur velamen*). (II Cor. iii. 12–16)

Paul here contrasts the Letter of the Old Testament, written on tablets of stone, with the Spirit of the New, Who is Christ, the "unveiling," or *revelation*. The significance of the letter is in its final term, Christ, Who was present all along, but revealed as the Spirit only at the end, the conver-

sion of the Old Testament to the New. Understanding the truth is not then a question of critical intelligence applied here and there, but rather of a retrospective illumination by faith from the standpoint of the ending, a conversion. In the original Greek, the term used to describe the darkening of the minds of the Jews, πώρωσις, petrification,[4] is rendered in the Vulgate as *obtusio* [dullness], but the sense of hardness remains alive in the exegetical tradition, where the condition is glossed as *duritia cordis* [hardness of the heart].[5]

After the Revelation, the inability to see beneath the veil is attributable to the "God of this world," who strikes the unbeliever senseless. It is this God, which later tradition was to identify with the devil, that provides a generic biblical meaning for the Medusa:

> But if our gospel also is veiled, it is veiled only to those who are perishing. In their case, the God of this world has blinded their unbelieving minds, that they should not see the light . . . while we look not at the things that are seen, but at the things that are not seen. For the things that are seen are temporal, but the things that are not seen are eternal. (II Cor. iv. 3 ff.)

The familiar dialectic of blindness and vision, as old as Sophocles, assumes a special poignancy in the life of Paul, who was at successive moments blind: first to the truth of Christ and then, on the road to Damascus, to the things of this world. Conversion is for him, much as it was for Plato, a turning away from the false light of temporal things, seen with the eyes of the body, to the light of eternity, seen with the eyes of the soul. Above all, blindness and vision are in the Pauline text metaphors for interpretation, the obtuse reading of faithless literalists transformed, by unveiling, into a reading of the same text in a new light.

I should like to propose that the episode of the Medusa is an application of this dialectic to both the pilgrim and the reader. The "before" and the "after" of the conversion experience are rendered sequentially and dramatically by the threat to the pilgrim, on one hand, and the authorial voice, on the other. Between the aversion from a temporal threat and the conversion to the Christian truth, the *dottrina*, there is the Christ event in the experience of the pilgrim, the moment that marks the coming together of pilgrim and poet. From that ideal moment, Dante fulfills the role of a Virgil to the reader, sufficient to the task of averting his pupil's

glance from the "God of this World," the temptation of *temporalia,* yet not sufficient for the task of *re-velation.* The threat to the pilgrim, petrification, seems to correspond to the various conditions of unbelief suggested by the Pauline text: blindness, hardness of heart, darkening of the mind, senselessness; while vision (presumably accomplished by the pilgrim/author and now proffered to the reader) corresponds to the eternity of "things that are not seen." Literalists are blind to spiritual truth precisely because they see temporal things, while the things of this world are invisible to those who see the Spirit within. The Christ event in history, as described by St. Paul, is applied to the *now* of the pilgrim's journey in his meeting with Beatrice and is left as testament to the reader, who is exhorted to follow in his own way. En route, however, both must avert their glance from the God of this world.

Whatever the merit of this dramatic outline, it still leaves us in the realm of poetic fiction. Several difficulties immediately present themselves which can be resolved only by exploring more deeply the relationship between the Pauline text and the verses of Canto IX. In the first place, the Pauline dialectic is built upon the fundamental opposition of two terms which are a unity in the Bible: the Letter and the Spirit, figuratively translated into visual terms by the opposition "veil" / "face of Moses" (Christ). Dante's use of the word *velame* also suggests a translation into visual terms of the interpretive act required of the reader at this point; what is not as yet clear is the sense in which the threat of the Medusa is in Dante's text, as petrification is in Paul's, the corresponding threat of the "Letter that kills." In other words, how is the face of Medusa the opposite of the face of Moses? Secondly, once the opposition between the threat of the Medusa and the *dottrina* is established, there remains the problem of their relationship, for Letter and Spirit, though opposed, are still one, as the Old Testament, written on tablets of stone or engraved on the stony hearts of unbelievers, is still one with its New Testament interpretation, written upon the "fleshly tablets of the heart" (II Cor. iii. 3). The same is true of the figure of the veil: it is under the same veil, perceived by believers and unbelievers alike, that the Truth is hidden. Paul attributes interpretive blindness to the "God of this world," but in Dante's text it is the diabolic threat itself that must somehow lead beyond itself. In what sense might it be said that the threat of the Medusa masks a *dottrina* that is nowhere to be found on the printed page? The resolution of both of these difficulties

will become clear when we decide which, precisely, are the *versi strani* referred to in the text.

Our response must begin with some interpretive and historical remarks about the Medusa herself. To begin with, her story in antiquity seems a perfect counterpart to the story of the veiling of Moses' face. Dante was doubtless aware of the false etymology of her name concocted by the mythographers: μὴ ἰδῶσαυ, *quod videre non possit* [because one cannot look upon her].[6] To see her was death; in order to protect himself from this threat, Perseus required the shield of Minerva, just as we, according to the allegorization of Albertus Magnus, require the shield of wisdom to protect us against *delectationes concupiscentiae* [the pleasures of desire].[7] On the other hand, the face of Moses is a figure for the glory of Christ, *illuminatio Evangelii gloriae Christi* (II Cor. iv. 4), requiring nothing less than a conversion in order to be unveiled (*revelatio*). It remained for Dante to associate the two stories, recasting the Pauline dialectic of blindness and vision into the figure of the Medusa (corresponding to St. Paul's "God of this world") and contrasting it with the admonition, immediately following, to gaze at the truth beneath the veil. The two stories serve as excellent dramatizations of the two moments of conversion: aversion from the self and the things of this world, conversion to God. Separating those two moments there extends the whole of the journey.

A closer look at the tradition surrounding the Medusa suggests a more than dramatic aptness in the choice of this figure for the representation of a diabolic threat. The most startling thing about traditional efforts to discuss this episode is that they have missed what to a modern reader is most obvious: whatever the horror the Medusa represents to the male imagination, it is in some sense a female horror. In mythology, the Medusa was said to be powerless against women, for it was her feminine *beauty* that constituted the mortal threat to her admirers. From the ancient *Physiologus* through the mythographers to Boccaccio, the Medusa represented a sensual fascination, a *pulchritudo* so excessive that it turned men to stone.[8] In Dante's text, there seems to be a survival of the theme of fascination, for it would be difficult to imagine why Virgil does not trust the pilgrim's ability to shield his own eyes if the image were not an entrapment.

Fascination, in this context, suggests above all the sensual fascination celebrated in the literature of love. Whatever the significance of the

Medusa motif to Freud and Ferenczi, we are dealing here with a highly self-conscious poetry and a kind of love poetry at that. It happens that there is an explicit reference in the text that helps to identify the subject matter as specifically erotic and literary, rather than abstractly moral. When the Furies scream out for the Medusa, they recall the assault of Theseus: "Mal non vengiammo in Teseo l'assalto" ["Poorly did we avenge the assault of Theseus"] (IX. 54). This would seem to be an allusion to Theseus' descent into the Underworld with his friend Pirithoüs, a disastrous enterprise from which he, unlike his hapless companion, was rescued by Hercules, but the point is that the descent had for its objective the abduction of Persephone; it was therefore an erotic, not to say sexual, assault.

The presence of the theme here is not merely anecdotal; Dante is himself in a sense searching for a prelapsarian Persephone, an erotic innocence which he recaptures, at one remove, in his encounter with Matelda at the top of the Mountain of Purgatory:

> Tu mi fai rimembrar dove e qual era
> Proserpina nel tempo che perdette
> La madre lei ed ella primavera.
>
> (*Purg.*, XXVIII. 49–51)

> [You make me remember where and who Proserpina was when her mother lost her and she the spring.]

These two references to Persephone in the poem, the first implied and the second clearly stated, suggest that the figure of the Medusa is somehow coordinate to that of Matelda. Whatever else she may represent, the pastoral landscape and the erotic feelings of the pilgrim would seem to indicate the recapture, or near recapture, of a pastoral (and therefore *poetic*) innocence, a return to Eden after a long askesis. For the moment, it might be argued that the Medusa represents precisely the impediment to such a recapture; her association with Persephone goes back to the *Odyssey*, where Odysseus in the Underworld fears that Persephone will send the gorgon to prevent him from leaving (*Odyssey* XI. 634ff). Whatever Dante's sources for making the same association, the point seems to be that short of Eden, there is no erotic—or *poetic*—innocence. . . .

The *Rime Petrose* [*Stony Rhymes*], the dazzling virtuoso pieces of Dante's youth, celebrate a violent passion for the "Stony Lady" whose hardness turns the poet, her lover, into a man of stone. In the survey of the progress of Dante's love and of his poetry from the *Vita Nuova* [*New Life*] to the *Commedia,* the *Rime Petrose* constitute a surd element, radically fragmentary, Contini has called them,[9] finding no place clearly identifiable in the poet's development. At one point in the *Purgatorio* when Beatrice castigates the pilgrim for his infidelity, she accuses him of a love for "vanità," a "pargoletta," or little girl, using precisely the same word that the poet had used somewhat disparagingly of his *Donna Pietra* [Stony Lady] in one of the *rime.* The recall in the *Purgatorio* of this word has given rise to endless speculation about the identity of the woman whom Dante denoted with the code name of *Donna Pietra.* Critics have been right, I think, to wish to see biography in the poem, but they have been incorrect to imagine that the words of the poem were simply vehicles for communicating true confessions. We have learned from Contini that the biography of a poet, as poet, is his poetry,[10] and it is in a quite literal sense that the *Rime Petrose* are present and relevant here. In the same poem that has given rise to speculation about the "pargoletta," there appear some verses of potentially greater significance. They describe a wintry scene in which the despairing lover seems to have lost his beloved forever. . . .

The description of a world without love [*Rime* 43 (c), 53ff.], matching the poet's winter of the soul, contains exactly the rhyme words (*alto, smalto, assalto*) from Dante's description of the Medusa [*Inferno* 9. 49ff.], sibilants that might qualify as *versi strani* in the address to the reader. Thus, in a passage which threatens petrification, is recalled, in a reified, concrete way, precisely the poem that described such a reification at the hands of a kind of Medusa. The words themselves reflect each other in such a way that they constitute a short circuit across the temporal distance that separates the two moments of poetic history, a block that threatens to make further progress impossible. For the reader, the parallel threat is to refuse to see the allegory through the letter, to ignore the double focus of the *versi strani.* The appearance of a recall to the *Rime Petrose* is an invitation to the reader to measure the distance that separates the *now* of the poet from the *then* of his *persona*; in the fiction of the poem, the Medusa is, like the lady of stone, no historic character at all, but the poet's own creation. Its threat is the threat of idolatry. In terms of

mythological *exempla*, petrification by the Medusa is the real conse-
quence of Pygmalion's folly. . . .

There is some evidence that our suggested reading of the Medusa
episode may have been anticipated by a near contemporary of the poet,
or at least that the problematic was recognized and radically transformed
by him. I refer of course to Petrarch, whose very name was for him an
occasion for stony puns. In the course of his *Canzoniere* [*Song Book*], he
provides us with a definitive gloss on Dante's Medusa. Like Pygmalion,
Petrarch falls in love with his own creation and is in turn created by her:
the pun *Lauro/Laura* [*laurel/Laura*] points to this self-contained process
which is the essence of his creation. He creates with his poetry the Lady
Laura who in turn creates his reputation as poet laureate. She is there-
fore not a mediatrix, pointing beyond herself, but is rather enclosed
within the confines of his own being as poet, which is to say, the poem.
This is precisely what Petrarch acknowledges when he confesses in his fi-
nal prayer to the sin of idolatry, adoration of the work of his own hands.
Speaking of Laura no longer as the infinitely beloved, he calls her a
Medusa: "Medusa e l'error mio m'han fatto un sasso" ["Medusa and my
error have made me a stone"]. For all of his tears of repentance, however,
there seems to be a consolation for a more secular age. Petrarch's endur-
ing fame as the weeping lover seems to suggest that, if he was turned to
stone because of idolatry, at least a stone lasts forever. If it is devoid of
the spirit linking it to reality and to the life of the poet, it is nevertheless
immune to the ravages of time, a monumental portrait of the artist. In
the same poem, he sees the problem of reification and idolatry as inher-
ent in all poetry, including that of his illustrious predecessor. This, I take
it, is the point of his address to the Virgin as the only true mediatrix and
"bringer-of-blessings": *vera beatrice*, where the absence of capitalization
drives the point home more forcefully. For Petrarch, precursor of Ro-
manticism, there can be no middle ground, not even that occupied by
Dante.

We are now in a position to answer some of the fundamental ques-
tions concerning Dante's allegory raised by the episode of the Medusa.
Doubtless, the Pauline "God of this world" provides us with an appropri-
ate and abstract moral meaning in the dramatization that might lead us to
classify it as an example of the allegory of poets. At the same time, how-
ever, we have seen that the passage is charged with the temporality of the
poet's own career, the Dante who *is*, looking back at the Dante who was,

through the medium of words. This retrospective illumination is the very essence of Biblical allegory, what Dante called the "allegory of theologians." The Christ event was the end term of an historical process, the "fullness of time," from the perspective of which the history of the world might be read and judged according to a meaning which perhaps even the participants in that history could not perceive. The "then" and "now," the Old Testament and the New, were at once the continuity and discontinuity of universal history, the Letter and the Spirit respectively of God's revelation. Christian autobiography is the application of this diachronism to one's own life for the purpose of witness, "confession," of the continual unfolding of the Word.

Both confession and Christian allegory have their roots in the mystery of language. As language is unfolded along a syntagmatic axis, governed at each moment of its articulation by a paradigm present in the mind of the speaker and made manifest at the ending of the sentence, so the authorial voice in the text is as the paradigm of the entire narrative, of which the evolution of the pilgrim is, as it were, the syntax. When this dialectic is translated into dramatic terms that purport to be autobiographical, we are presented with a narrative which seems to demand both continuity and discontinuity: an organic continuity, so that it may make a claim to authenticity, yet with the definitive detachment of the author who makes a claim to finality. For the pilgrim and the author to be one and the same requires nothing short of death and resurrection: death, so that the story may be definitive and final; resurrection, so that it may be told. This narrative translation of the dialectic of language may in turn be translated into theological terms: Conversion, the burial of the Old Man and the birth of the New, the essence of Pauline allegory. Christ, the ending of the story, is simply the manifestation of its subject, paradoxically present as the paradigm, the Logos, from the beginning. The final manifestation of the paradigm is the presence of the Logos made flesh. Just as history required an Archimedean point from which Christians could judge it to have been concluded, so the literature of confession would seem to require an Archimedean point outside of itself from which its truth can be measured, a point that is at once a beginning and an end, an Alpha and an Omega. "Conversion" was the name that Christians applied to such a moment in history and in the soul. In this sense, Biblical allegory, conversion, and narrative all share the same linguistic nature.

When St. Paul refers to the relationship of the Old Testament to the New, he is in fact applying this linguistic metaphor to the Christ event, the Spirit inseparable from the letter of the Bible whereby It is made manifest. Without the Letter, the Spirit is the eternal Logos, with no point of tangency to history, God's intentionality without relation to man. Without the Spirit, the Letter is utterly devoid of significance, as dead as the mute stones upon which it was written. God's utterance to man is the Word incarnate.

Paul goes on to suggest that the Word of God interprets the hearts of men, the stony tablets turning to stone the hearts of unbelievers, while the Spirit writes upon the fleshly tablets of the faithful. So too, in Dante's text, it is the power of the Letter to enthrall the beholder that makes of it a Medusa, an expression of desire that turns back to entrap its subject in an immobility which is the very opposite of the dynamism of language and of desire.[11] To see beyond it, however, is to see in the spiritual sense, to transform the Eros of the Medusa into the transcendent Eros of Caritas. This is Dante's whole achievement as a love poet: a refusal of the poetics of reification, sensual and verbal, for the poetics of "translation," as scribe of the Spirit which is written on "the fleshly tablets of the heart": "I'mi son un che, quando / Amor mi *spira*, noto, e a quel modo / Ch' e' *ditta dentro*, vo significando" ["I am one who, when love inspires me, takes note, and goes setting it forth after the fashion which he dictates within me"] (*Purg.* XXIV, 52). The Book of Memory has as its Author God Himself. In this sense, Dante's poem is neither a copy nor an imitation of the Bible. It *is* the allegory of theologians in his own life.

Nonetheless, the passage from the events of Dante's life to the words and images he uses to signify them is one that we cannot make. This is why it is impossible to guess at the identity of the *Donna Pietra*, just as it is impossible to see in the Medusa some event of the poet's life. We must be content with words on words, the double focus on a poetic expression, beyond which it would take an act of faith equal to Dante's to go, beyond which indeed, there is no Dante we can ever know.

The address to the reader is thus not a stage direction, but an exhortation to conversion, a command to await the celestial messenger so that we, like the pilgrim, may "trapassare dentro" ["pass within"].[12] Beneath the veil of Moses, we behold the light of the Gospel; beneath the veil of Dante's verses, the *dottrina* is derived from that, or it is nothing at all.

Notes

1. Charles S. Singleton, *Dante Studies I: Commedia, Elements of Structure* (Cambridge, Mass.: Harvard University Press, 1954); "Allegory." For general bibliography on Dante's allegory, see Robert Hollander, *Allegory in Dante's "Commedia"* (Princeton: Princeton University Press, 1969).

2. *Convivio* IV. xv. 11, Cf. II. i. 4.

3. See R. P. G. Hanson, *II Corinthians* (London, 1954), p. 39, commenting on II Cor. iii and iv.

4. On the word and its history, see J. A. Robinson, *St. Paul's Epistle to the Ephesians* (London, 1914), pp. 264–74.

5. *Glossa Ordinaria; Patrologia Latina,* 114, 55.

6. Fulgentius, *Mythologicon* I, 26, in A. Van Staveren, *Mythographi Latini* (Amsterdam, 1742), p. 657.

7. Quoted by Hermann Gmelin, *Kommentar: Die Göttliche Komödie* (Stuttgart, 1954), *ad. loc.*

8. Among the encyclopedias, I have found Röscher (*Lexikon der G. und R. Mythologie*) to be most helpful on the subject of M.'s beauty. Arnolf d'Orléans says of her: "illa autem mutabat homines in saxum quia pre amore illius obstu pebant." Berthe M. Marti (ed.), Arnulfi Aurelianensis, *Glosule super Lucanum*, Papers and Monographs, Amer. Acad. Rome (1958), Vol. XVIII, p. 470. Boccaccio, *Geneologie* X, 9, ed. V. Romano (Bari, 1951), p. 496. See expecially on the subject, A.A. Barb, "The Mermaid and the Devil's Grandmother," *Journal of the Warburg and Courtauld Inst.* XXIX (1966) and "Diva Matrix," in the same journal, XVI (1953).

9. "Introduction to Dante's *Rime*," in *Dante: Twentieth Century Views*, ed. J. Freccero (Englewood Cliffs, 1965), p. 36.

10. "Dante come Personaggio-poeta della *Commedia*," *Approdo* I (1958), 19.

11. See Jacques Lacan, *Ecrits* (Paris, 1966), p. 40, for a neo-Freudian restatement of the tyranny of the letter, or "signifier."

12. *Purg.* VIII, 21. In a future study, I intend to examine the startling similarities between Cantos IX *Inferno* and VIII *Purgatorio*. If, as I have suggested, the arrival of the messenger is an *interpretive* descent, then the identification of that messenger with Mercury (from Statius, *Thebaid* II. 2; cf. Pietro di Dante) is peculiarly apt: the *Hermes* of a new Christian *hermeneutics*. The angel fulfills this role, as well as the others, of the classical messenger of the gods.

46 JO SPRINGER
"Medusa Head Picture" from *Pleasures of Crewel* (1972)

Embroidering Your Own Medusa

Jo Springer is the author of a book on *Creative Needlework*. Medusa's appearance in the 1972 *Betty Crocker Home Library* volume *Pleasures of Crewel* marks a significant recasting of her fierce features, with the demure figures of flowers, birds, and butterflies replacing the mythical snakes. For this image, see Figure 26.

Although the use of the human face and form is rare in the field of embroidery, it is not entirely unheard of, particularly in antique pieces. This modern version of the mythical Medusa head uses flowers, a bird, and a butterfly in place of the traditional snakes. An improvement, don't you agree? The design would also make an attractive pillow.

Size:
Circle 16" in diameter

Materials:
22" square of white linen
Crewel wool, two 30-yard cards of bronze
Silk or rayon embroidery floss, one skein each: pink, rose, green, lavender, purple, yellow, beige, taupe, brown, and black
Circle of heavy cardboard 16" in diameter
Circle of 1/4"-thick foam rubber 16" in diameter
Masking tape
White glue
Round picture frame with opening 16" in diameter

Pattern:
Enlarge diagram (each small square=1/2" square). Transfer to background fabric.

Working Method:

Embroider entire head, face, and hair (everything but shaded areas) in two strands of crewel wool, using Outline Stitch throughout. Work shaded areas in three strands of silk.

Embroider bird in stripes of brown and beige Outline Stitch. Then work head and breast shading from rose to pink to beige Long and Short Stitch. Make yellow beak, rose crest, black chin area all in Satin Stitch. Make eye in black French Knot and foot in black Outline Stitch.

Embroider upper flower on left in pink shaded with a little rose Long and Short Stitch. Make leaf in green Satin Stitch.

Finishing:

Block, then trim embroidered piece to circle 19" in diameter. Finish following directions for Framing a Picture.

HAZEL BARNES
from "The Look of the Gorgon" (1974)

Sartre and the Existentialist Medusa

Hazel Barnes, a professor of philosophy, is a noted Sartre scholar. In this excerpt from *The Meddling Gods*, she explores Sartre's reference to Medusa and postulates an existentialist interpretation of the myth. The text she discusses is included in this volume, pp. 92–93.

Near the end of his discussion of human relations, in *Being and Nothingness*, Jean-Paul Sartre declares that "the profound meaning of the myth of Medusa" is the petrification of Being-for-itself in Being-in-itself by the Other's Look.[1] At first reading we may fairly conclude that the fear of this kind of petrification is less pressing for at least half of the world's population than the dread of castration. If we strip away the technical language and consider Sartre's intended meaning, then I think we may find that in this one-sentence interpretation of a myth, there is a valid appeal to universal human experience and an appropriate recognition of what must have been the psychological factor behind the origin of the Gorgon. Instead of "Being-for-itself," read "a human consciousness"; for "Being-in-itself," read "nonconscious being." Sartre is saying that when another person looks at me, his look may make me feel that I am an object, a thing in the midst of a world of things. If I feel that my free subjectivity has been paralyzed, this is as if I had been turned to stone, made like one of the lifeless statues in King Polydectes' court.

Sartre's interpretation is as closely attached to his fundamental philosophical system, as inevitable for one closely acquainted with his work as Freud's association of Medusa and the idea of castration. In neither case should this fact be taken as rendering the interpretation suspect. Both men selected the image as expressing what seemed to them a self-evident truth about emotional experience. Sartre's view, if valid, has the advantage of applying to all of the human race, not solely to its favored half. It has, of course, its own difficulties.

For Sartre, Medusa is *the Look,* or at least one manifestation of it. The Look is the revelation of the existence of the Other. The illustration which Sartre uses, the famous "keyhole" passage, has by now become one of the great philosophical myths. Sartre asks us to imagine that we are looking through a keyhole watching intently what is going on inside. At this moment the persons before me are only objects of my consciousness, as completely so as the furniture or as the walls of the room which surround them. Everything refers back to me; the scene is an organized whole with me as center of awareness. I am a sovereign consciousness, pure subjectivity. I do not need to reflect upon myself, for all there is of me is engaged in the activity of spying. I am nothing but this activity. I am the subject to whom all objects appear. This is not a privileged moment of experience. This is my condition, my being, insofar as I am not forced by the Other to reflect upon another dimension of myself. But now as I stand there absorbed in my spying, suddenly there are footsteps in the corridor. I straighten up to encounter the eyes which have already been looking at me as I was looking through the keyhole. There is a dramatic, a cataclysmic reversal. In acute shame and embarrassment I realize that I have been object to another subject. I am not solely a pure subjectivity. I am not only my self-for-me. I have a self-for-others.[2]

Sartre's claim that it is the Look which reveals to me the existence of the Other has inspired a hostile critic to paraphrase his position in the statement: "I am stared at; therefore you exist." If we were to insert the words *I realize* before "you exist," the parody would become a true summation. For Sartre, my realization of the Other's existence as an independent subjectivity beyond my reach occurs simultaneously with my discovery that I, who am always and solely a free subject so long as I live nonreflectively, can be turned into an object for another and viewed from the outside. I may be seen as a hostile object, as disgusting, shameful, attractive, or admirable. The important point is that this judgment comes to me from without. I cannot control it. Nor can I know exactly what it is. The self which I am for-the-other is not the same as the self which I am for-me. It is the only self which the Other knows, and it is a self which I myself can never quite grasp. The Other's Look reveals to me that I am not alone in the world. This in itself might be reassuring. What turns it into a threat is my sudden perception that if I am not alone in the world, then *the* world is no longer *my* world. Worse yet, insofar as I have been in the habit of assigning to other people their place in the world of

my mind and emotions, so I find that I am made part of the furnishings of the Other's world. The Look of the Other, which reveals to me my object side, judges me, categorizes me; it identifies me with my external acts and appearances, with my self-for-others. It threatens, by ignoring my free subjectivity, to reduce me to the status of a thing in the world. In short, it reveals my physical and my psychic vulnerability, my fragility.

The Medusa complex represents my extreme fear that by denying my own freely organized world with all of its connections and internal colorations, the Other's look might reduce me permanently to a hard stonelike object. My most obvious recourse against this threat is precisely that of the Greeks. I don a menacing mask. I seek to stare the other down, to neutralize the hostile countenance with my own, to reduce him to an object before he can objectify me. In *Being and Nothingness* Sartre's entire discussion of human relations is developed within the context of this subject-object conflict which the Look initiates. We can observe how precisely the Look is commensurate with the Medusa encounter. Neither my looking at an object nor my being looked at by a subject is sufficient by itself. The full experience of the Look requires that I am aware of myself as being looked-at. My eyes must encounter those of the Gorgon who looks at me.

The question will be raised as to whether it is reasonable to assume that so sophisticated and contemporary an analysis could possibly be appropriate for the primitive period in which fear of the Gorgon Stare and, even earlier, the less differentiated concept of the Evil Eye originated. Or to put it more strongly, is not Sartre's interpretation based on an exaggerated sense of isolated and alienated individuality which perhaps fits twentieth-century experience but has nothing in common with the complex of ideas which gave rise to the story of Perseus and Medusa? To this objection I should reply that at least by the time of the Homeric Greeks, the sense of individualism is already very strong. For them the feeling of what one *is* depends primarily on the recognition which is bestowed by others, so much so that scholars have used the term *shame culture* to describe the prevailing pattern of interpersonal reactions. If I feel that I am as others view me, we have the requisite soil for nourishing a belief in the power of the eye of the Other to do me harm. But I do not believe that the Gorgoneion is exclusively linked with Homeric society any more than I think the experience described by Sartre is restricted to the twentieth century.

Notes

1. Jean-Paul Sartre, *Being and Nothingness*, trans. Hazel E. Barnes (New York: Washington Square Press, 1966), p. 555.

2. Ibid., pp. 347–48.

48 JACQUES DERRIDA
from *Glas* (1974)
translated by John P. Leavey, Jr., and Richard Rand

The Gorgon and the Jew

Jacques Derrida is an influential French philosopher and critical theorist who first
articulated the style of reading called deconstruction. *Glas*, the monumental 1974
work from which the following piece is excerpted, has been variously called "Der-
rida's chef-d'oeuvre," "philosophy's *Fleurs du Mal*," and "a hyper-text avant la let-
tre." It has also often been compared to *Finnegans Wake* for its "unreadability." In
this passage, Derrida is reading Hegel's account of two founding Judaic moments—
circumcision and the sacrifice of Isaac—in *The Spirit of Christianity*, when he no-
tices a passing analogy that Hegel makes between the Jew and the Gorgon. Taking
this analogy—placed between dashes in Hegel's text—as a key interpretive locus,
Derrida deploys the figure of Medusa to describe, among other things, the writing of
a particular structure of power in a founding moment of Judaism.

In the jealous God of Abraham and his posterity there lay the horrible
demand that he alone and this nation be the only ones to have a God.
[Hegel writes:]

"But when it was granted to his descendants to reduce the gap sepa-
rating their actuality from their ideal, when they themselves were pow-
erful enough to realize their idea of unity, then they exercised their
mastery (*herrschten*) mercilessly with the most revolting and harshest
tyranny, that utterly extirpated all life; for it is only over death that unity
hovers. Thus the sons of Jacob avenged with satanic atrocity the outrag-
ing of their sister even though the Shechemites had tried to make amends
with unexampled generosity. Something alien had been mingled (*gemis-
cht*) with their family, had willed to fasten a bond (*Verbindung*) with them
and so to disturb their segregation. Outside the infinite unity in which
nothing but they, the favorites (*Lieblingen*), can share, everything is mat-
ter—the Gorgon's head transformed everything to stone—a stuff, love-

less, with no rights, something accursed which, as soon as they have power enough, they treat as accursed and then assign to its proper place if it attempts to raise anything [a finger, voice, protestation]."

". . . ist alles Materie—das Haupt der Gorgo verwandelte alles in Stein—, ein lieb- und rechtloser Stoff, ein Verfluchtes, das denn, so-bald die Kraft dazu da ist, auch so behandelt, ihm, das sich regen wollte, seine Stelle an-gewiesen wird."

The head of Medusa, one of the three Gorgons, is between dashes. Like the Gorgon, the Jew materializes, petrifies everything he sees and everything that regards him, that raises, for example the eyes, toward him. An analogous accusation had been hurled against Socrates, and the analogy affords many readings.

Hegel does not exploit further this small phrase between dashes. This phrase seems to effect, on the surface, a sort of conventional, illustrative, and pedagogical mythological recourse. Just that and nothing more. A Greek mytheme nevertheless seems to him pertinent for describing a figure of Judaism. One could ask oneself, in Hegel's terms or otherwise, about the general and pre-philosophical power of a mytheme born of a strongly determinate culture, which is opposed even, should the case arise, to that of Judaism.

So Hegel makes the Gorgon upsurge and maintains her between dashes, as between parentheses or brackets. In the same way he had, in passing, situated circumcision and Isaac's sacrifice.

An effect of the wide open mouth. Convergence: the Jew effects (on) himself a simulacrum of castration in order to mark his ownness, his properness, his property, his name; to found the law he will suffer in order to impose it on others and to constitute himself as the favorite slave of the infinite power. By first incising (*entamant*) his glans, he defends himself in advance against the infinite threat, castrates in his turn the enemy, elaborates a kind of apotropaic without measure. He exhibits his castration as an erection that defies the other.

The logical paradox of the apotropaic: castrating oneself *already*, always already, in order to be able to castrate and repress the threat of castration, renouncing life and mastery in order to secure them; putting into play by ruse, simulacrum, and violence just what one wants to pre-

serve; losing in advance what one wants to erect; suspending what one raises: *aufheben*. The relief is indeed the apotropaic essence of life, life as apotrope. Now being is life; being is *Aufhebung*. The Medusa provides for no off-scene (*hors-scène*). She sees, shows only stony columns.

49 ROLAND BARTHES

from *Roland Barthes* (1975)
translated by Richard Howard

The Jellyfish "Medusa" and the Power to Stun

Roland Barthes, most widely known as a semiotic and structuralist theorist, wrote his anti-autobiography, *Roland Barthes*, in 1975. His book represents a synthesis of form with content: the fragmentary style was intended to show the inconsistency of the literary subject, a subject that cannot be fixed with either the writer's or the reader's stare. In this excerpt, Barthes weaves together the images of the mythical Gorgon and of the Medusa jellyfish to formulate a metaphorical representation of "Doxa," accepted beliefs or "public opinion." Our ready acceptance of Doxa, he argues, obfuscates the difficulty of viewing Truth through language.

The *Doxa* is current opinion, meaning repeated *as if nothing had happened.* It is Medusa: who petrifies those who look at her. Which means that it is *evident.* Is it seen? Not even that: a gelatinous mass which sticks onto the retina. The remedy? As an adolescent I went swimming one day at Malo-les-Bains, in a cold sea infested with the kind of jellyfish we call medusas (what aberration led me to agree to swim there? I was one of a group, which justifies any cowardice); it was so ordinary to come out of the water covered with stings and blisters that the locker-room attendant phlegmatically handed you a bottle of potassium chloride as soon as you left the beach. In the same way, one might conceive of taking a (perverse) pleasure in the endoxal products of mass culture, provided that when you left the immersion of that culture, someone handed you on each occasion, as if nothing had happened, a little detergent discourse.

Queen and sister of the hideous Gorgons, Medusa was of a rare beauty with regard to the luster of her hair. Neptune having ravished and wed her in the temple of Minerva, the latter rendered her repulsive and transformed her hair into snakes.

(It is true that in the *Doxa*'s discourse there are former beauties sleeping, the memory of a once-sumptuous and fresh wisdom; and it is indeed Athena, the wise deity, who takes her revenge by making the *Doxa* into a caricature of wisdom.)

Medusa, or the Spider: castration. Which *stuns* me, an effect produced by a scene I hear but do not see: my hearing is frustrated of its vision: I remain *behind the door.*

The *Doxa* speaks, I hear it, but I am not within its space. A man of paradox, like any writer, I am indeed *behind the door;* certainly I should like to pass through, certainly I should like to see what is being said, I too participate in the communal scene; I am constantly *listening to what I am excluded from;* I am in a stunned state, dazed, cut off from the popularity of language.

The *Doxa* is, as we know, oppressive. But can it be repressive? Let us read this terrible phrase from a revolutionary sheet (*La Bouche de Fer*, 1790): ". . . above the three powers must be placed a censorial power of surveillance and public opinion which will belong to all, and which all will be able to exercise without representation."

50 HÉLÈNE CIXOUS
from "The Laugh of the Medusa" (1975)
translated by Keith Cohen and Paula Cohen

A Classic of Feminist Theory

Hélène Cixous is known internationally as a literary theorist as well as a writer of
fiction and drama. Her groundbreaking essay "Le Rire de la Méduse," which first ap-
peared in French in 1975, remains one of the cornerstones of French feminist criti-
cism. Revising Freud's essay on Medusa to hypothesize the power of *écriture
feminine*, the writing specific to women advocated by French feminists, Cixous
transforms the image of Medusa from that of a terrifying and ugly threat to a beauti-
ful and subversive figure, one whose ability to disrupt "phallologocentrism" is em-
bodied in her laughter. Both an attack on the repression of the past and an
imperative to write, "The Laugh of the Medusa" provides a crucial revision of the
Medusa myth.

The Dark Continent is neither dark nor unexplorable.—It is still unexplored
only because we've been made to believe that it was too dark to be ex-
plorable. And because they want to make us believe that what interests
us is the white continent, with its monuments to Lack. And we believed.
They riveted us between two horrifying myths: between the Medusa and
the abyss. That would be enough to set half the world laughing, except
that it's still going on. For the phallologocentric sublation[1] is with us, and
it's militant, regenerating the old patterns, anchored in the dogma of
castration. They haven't changed a thing: they've theorized their desire
for reality! Let the priests tremble, we're going to show them our sexts!

Too bad for them if they fall apart upon discovering that women
aren't men, or that the mother doesn't have one. But isn't this fear con-
venient for them? Wouldn't the worst be, isn't the worst, in truth, that
women aren't castrated, that they have only to stop listening to the
Sirens (for the Sirens were men) for history to change its meaning? You
only have to look at the Medusa straight on to see her. And she's not
deadly. She's beautiful and she's laughing.

Men say that there are two unrepresentable things: death and the feminine sex. That's because they need femininity to be associated with death; it's the jitters that gives them a hard-on! for themselves! They need to be afraid of us. Look at the trembling Perseuses moving backward toward us, clad in apotropes. What lovely backs! Not another minute to lose. Let's get out of here.

Let's hurry: the continent is not impenetrably dark. I've been there often. I was overjoyed one day to run into Jean Genêt. It was in *Pompes funèbres*.[2] He had come there led by his Jean. There are some men (all too few) who aren't afraid of femininity.

Almost everything is yet to be written by women about femininity: about their sexuality, that is, its infinite and mobile complexity, about their eroticization, sudden turn-ons of a certain miniscule-immense area of their bodies; not about destiny, but about the adventure of such and such a drive, about trips, crossings, trudges, abrupt and gradual awakenings, discoveries of a zone at one time timorous and soon to be forthright. A woman's body, with its thousand and one thresholds of ardor—once, by smashing yokes and censors, she lets it articulate the profusion of meanings that run through it in every direction—will make the old single-grooved mother tongue reverberate with more than one language.

We've been turned away from our bodies, shamefully taught to ignore them, to strike them with that stupid sexual modesty; we've been made victims of the old fool's game: each one will love the other sex. I'll give you your body and you'll give me mine. But who are the men who give women the body that women blindly yield to them? Why so few texts? Because so few women have as yet won back their body. Women must write through their bodies, they must invent the impregnable language that will wreck partitions, classes, and rhetorics, regulations and codes, they must submerge, cut through, get beyond the ultimate reserve-discourse, including the one that laughs at the very idea of pronouncing the word "silence," the one that, aiming for the impossible, stops short before the word "impossible" and writes it "as the end."

Notes

1. Standard English term for the Hegelian *Aufhebung,* the French *la relève.*
2. Jean Genêt, *Pompes funèbres* (Paris, 1948), p. 185.

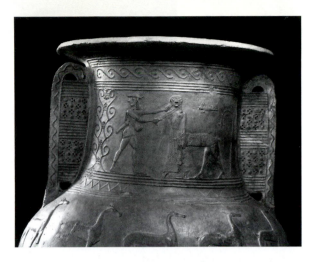

FIGURE 2. Perseus slaying the Medusa as Centaur, relief amphora vase, Boeotia,
c. 660 B.C.E., Musée du Louvre, Paris. Photo copyright © RMN.

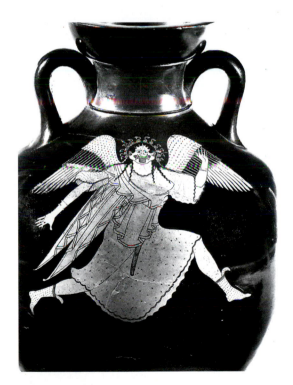

FIGURE 3. Running Gorgon on side B of a panathenaic amphora, attic red vase, attrib-
uted to the Berlin Painter, c. 490 B.C.E., Etruria, Staatliche Antikensammlungen und
Glyptotek, Munich.

FIGURE 9. *Perseus*, bronze sculpture, by Benvenuto Cellini, 1545–1554, Loggia dei Lanzi, Florence. Photo: Alinari/Art Resource, New York.

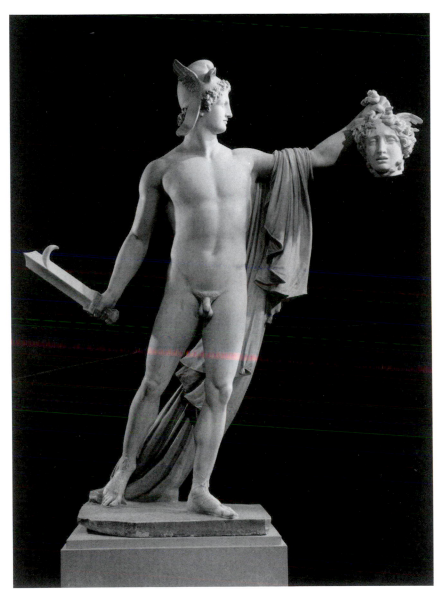

FIGURE 10. *Perseus Holding the Head of Medusa*, marble sculpture, by Antonio Canova, 1804–1806, Metropolitan Museum of Art, New York.

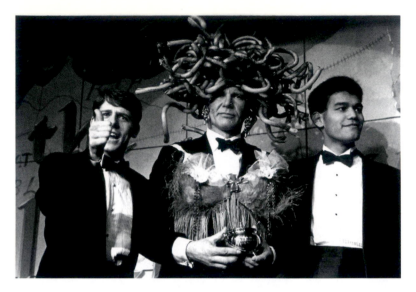

FIGURE 30. Harrison Ford as Medusa at the Hasty Pudding "Man of the Year" award ceremony, Harvard University, 1996.

FIGURE 31. *Medusa*, Annie Lennox.
Cover design: Bettina Rheims, 1995.

FIGURE 32. Advertisement for Medusa, the world's first floorless roller coaster, Six Flags Great Adventure, Jackson, New Jersey, 1999.

51 COLLEEN J. McELROY
"A Navy Blue Afro" (1976)

Colleen J. McElroy is a poet and short-story writer as well as a professor of English and creative writing. "A Navy Blue Afro" first appeared in *Epoch* in 1975 and subsequently in her 1976 book *Music from Home*. It exemplifies the exploration of identity—personal, sexual, and racial—that dominates the second half of that volume. McElroy juxtaposes the girl with the navy blue Afro against the "fake Furies" who tame "their Medusa hair," equating Medusa with the natural, with a pride in blackness that challenges the pretensions and evasions of the women among whom she walks.

I see her crossing the square
her hair
 glinting like the midnight
 of a blue Jamaican sky
she walks through the crowds
of ragged students
 her hair oddly blue
 her chin arched and poised
walking like some illustrated page
of today's woman
 you have seen them
 in their Rhine wine sunglasses
vying for visibility
 for cover stories
you have seen them
all those fake Furies
 coiffured
 powdered
 and costumed
their Medusa hair tamed
and dressed in new money
 they are so rich

 they piss in droplets
or fake it commenting
in cultured voice on the latest trivia
 smiling always smiling
 into the camera
you have seen them poised
and ready for a call to charity
 microsex
 unisex
 jetsex
sometimes I can almost see
the girl with the navy blue hair
 among them
 until she turns
and her blackness sings to me
like a Jacob Lawrence painting.

52 LOUIS MARIN

from *To Destroy Painting* (1977)
translated by Mette Hjort

Caravaggio's "Head of Medusa": A Theoretical Perspective

The work of Louis Marin included linguistics, semiotics, theology, philosophy, anthro-
pology, rhetoric, and art history; he specialized in studies of the seventeenth century
and issues of representation (both in portraiture and in politics). In this excerpt from
To Destroy Painting, he uses the representation of the decapitated Medusa head as
a crucial figure for his theories about the art of visual representation.

The parodic process of displacement repeats the very operation in which
painting destroys itself: the parody mimicks itself, as it designates its own
operation of collapse and thereby avoids any claim to embody the truth.

*It will thus be a matter of the painted head of Medusa the Gorgon, "sopra
una rotella rapportata."* [For this image, see the cover and Figure 1 of this
volume.]

Catalogue

Baglione, 136: "Among the works for the Cardinal del Monte, Car-
avaggio painted on a round shield ("sopra una rotella rappor-
tata"), a frightful head of a Medusa with snakes for hair, which the
Cardinal sent as a gift to Ferdinand, Grand Duke of Tuscany."

Bellori, 205: "The head of the Medusa, given by Cardinal del Monte to
the Grand Duke of Tuscany, was especially praised by Cavaliere
Marino, first in glory among men of letters, whose portrait Car-
avaggio had painted."

Marino, Galeria 1620, p. 28: "*La Testa di Medusa* in una rotella di
Michelangelo da Caravaggio nella Galeria del Gran Duca di
Toscana." . . .

Head of Medusa. Florence, Uffizi, tondo on wood, diam. 55.5 cm.,
 Cat. 1926, p. 94, Mostra No. 5.

The head of the *Medusa* is painted upon an old tournament shield of
the sixteenth century with a border of gold ornaments on a dark
background; pieces of leather and velvet are still visible.

The wedding of Cosimo, to which Cardinal del Monte was invited,
took place in 1608, and the *Medusa* was undoubtedly given in celebra-
tion of this event. . . . The painting is connected with the juvenile pe-
riod, but certainly comes at the end of it.[1]

Why start here? One might ask whether the choice is arbitrary, but I
insist that it is not. I insist that it is logically necessary given the issues
that confront us here, beginning with the question of truth in painting,
the problem of the relation between painting and the truth that the criti-
cal texts call "nature," or "natural," a relation that is termed "representa-
tion." Félibien essentially said as much: "One must imitate nature, but
only up to a certain point," for one must *know* how to be selective and
how to regulate the process of imitation by means of knowledge or the
idea of beauty. The goal, then, is to imitate nature, but according to a
certain idea or *design*.

The key issue, then, may be stated as follows. It is necessary to start
with a singular painting, one that may be singular only to the extent that
it is organized around the point of truth in the place of the center. What
is at stake, then, in the truth of a painting when the work itself destroys
painting, because, as we are told, it is not merely true, but *too* true?

Why the *Head of Medusa*? Because it is a painting of *decapitation,* not
first and foremost the iconic depiction or story of a decapitation, but de-
capitation itself, since the painting is in itself a decapitated head. There
are many decapitations in the work of Caravaggio, but I know of only this
one painting that is itself a severed head.

Imagine, then, that nature, truth, idea, and design regulate pictorial
mimesis, providing the law of beautiful representation, or, in short, the
"head" of the artistic process in the eyes of Félibien, Bellori, and all acad-
emic critics. Imagine as well that Caravaggio came into the world in or-
der to destroy painting. If this was his destiny, then I, too, am fated, at the
head of my discussion, to encounter the one painting that is a Medusa
head—or, more precisely, a severed head of Medusa.

History

It seems that the first of Caravaggio's paintings, after his years of apprenticeship in Lombardy and Milan, depicted half-figures and were sold in the streets of Rome.[2] The *Head of Medusa* was painted for Caravaggio's first patron in Rome, the Cardinal del Monte. He bought the *rotella* and gave it to Cosimo, the future Grand Duke of Tuscany as a wedding present in 1608. This was in no way surprising or exceptional, as such "parade shields" were fashionable and "often painted or repainted by fairly reputable artists."[3] Now, on many of these round or oblong shields prevalent in the sixteenth and seventeenth centuries, a Medusa head was represented, sometimes in relief, often painted. In all the examples known to us today, the head played the classic, prophylactic role of the apotropaion. In other words, its symbolic function was to petrify the enemy of the Prince, which helps explain the allegorical and philosophical meaning that Cesare Ripa, for example, attributes to it in his *Iconologia* (1603).[4] The enemies of man are construed as internal enemies, the evil and disruptive passions. Ripa "therefore defines the head of the Medusa as a symbol of the victory of reason over the senses, the natural foes of 'virtue,' which like [the political and] physical enemies [in the myth of the 'origin,'] are petrified when faced with the Medusa."[5] The head of Medusa, then, is the defensive and offensive weapon wielded by wisdom in its war against the passions.

> Cavaliere Marino, in his small book *Galeria Distinta*, dedicated a short poem to Caravaggio's "Head of the Medusa in the Palace Gallery of the Grand Duke of Tuscany," in which the shield is praised solely as an apotropaion having the power to change the Duke's enemies into "cold marble." [But he concluded that] the true protector of the Duke, is his own valor (*la vera Medusa è il valor vostro*).[6]

Iconography

There were three Gorgons: Sthenno, Euryale, and Medusa, all three daughters of the sea gods, Phorcys and Ceto. Only the last, Medusa, was

mortal, the other two being immortal. We commonly call Medusa "the Gorgon" because we think of her as the Gorgon par excellence. These three monsters lived in the Far East, not far from the kingdom of the dead, the land of the Hesperides. Their heads were covered with serpents. They had large tusks like boars, bronze hands, and golden wings that allowed them to fly through the air. Their eyes shone with looks so penetrating that whoever faced them was turned into stone. Mortals and immortals alike were terrified of them. As Hesiod says, Medusa "was mortal, but the other two immortal and ageless; and with her the god of the Sable Locks [Poseidon] lay in a soft meadow among the spring flowers."[7] Once Medusa's head had been cut off by Perseus, Athena placed it on her shield. Henceforth her enemies would be petrified at the very sight of the goddess.

The legend of Medusa undergoes various changes as we trace it from its beginnings to the Hellenic period. The Gorgon starts out as a monster but is later presented as the victim of a metamorphosis:

> Her beauty was far-famed, the jealous hope
> Of many a suitor, and of all her charms
> Her hair was loveliest; so I was told
> By one who claimed to have seen her. She, it's said,
> Was violated in Minerva's shrine
> By Ocean's lord. Jove's daughter turned away
> And covered with her shield her virgin's eyes,
> And then for fitting punishment transformed
> The Gorgon's lovely hair to loathsome snakes.
> Minerva still, to strike her foes with dread,
> Upon her breastplate wears the snakes she made.[8]

We have, then, two Medusas in one: a horrible monster as well as a striking beauty: the fascination of contraries mixed together.

Vasari tells us that the young Leonardo painted a Medusa head with serpents in the place of hair, one of his most extravagant and bizarre inventions. But Leonardo also took a circular piece of wood and painted on it something so horrible that one could barely look at it: there were lizards, serpents, and frogs, all of them so dreadful that they recalled the head of Medusa. Leonardo kept this object in his private collection, and it is rumored that his father sold this "animalaccio" to the Duke of Milan.

One more comment should be made here. Contemporary art historians debate the resemblance between the Uffizi's *Head of Medusa, Bacchus,* and other portraits of young boys (*Boy Bitten by a Lizard, The Lute Player,* and *The Musicians*). Are these the painter's self-portraits, studies of his own features and emotional expressions created by looking at himself in a mirror? Could they be studies in physiognomy? But if so, what emotion was the *Head of Medusa* meant to depict? Could they also be so many disguises, a kind of travesty of the subject's identity?

An Analytic Strategy and a Mythical Ruse

How should we go about looking at the Uffizi's *Head of Medusa*? How, like a new Perseus clad in Hermes's sandals, can we attack this painting?

My strategic, analytic calculation was initially to apply to Caravaggio's painting the operative model that I used in studying both Poussin and Le Brun. It was a matter of first constructing a model of the dynamic network of the representational process itself in order subsequently to analyze the transformations brought about in and by the particular object or scene represented in the individual work. Yet applying this method to the *Head of Medusa* does not work, a fact that gives us a first indication about how we must proceed if we are to articulate this painting's discourse. When we attempt to apply the method in question, we soon realize that the discourse cannot remain stably situated on either the level of representation or on that of what is represented: a discursive slippage takes place between the two levels. Something similar was at work in *The Arcadian Shepherds*, which represents the very process of representation itself. In the *Head of Medusa*, however, the turbulence that affects the discourse of representation is much more immediate. In *The Arcadian Shepherds*, the folding back of representation upon itself is "mediated" in a symbolic manner by the tomb, the epitaph, the name "Arcadia," the word "Ego" and the dialogue of gestures and gazes. No such symbolic mediation is at work in the *Head of Medusa*, for Caravaggio's painting not only makes representation visible in what is represented but also uses mimesis to *destroy* the mimetic process.

How exactly did Perseus kill Medusa? How did he "encounter" the Gorgon in the military sense of the term? There would seem to be an insurmountable and irresolvable aporia at work here insofar as the enemy

in question wields the absolute weapon, the look that kills at any distance, a deadly invisible ray. Perseus can only hope to triumph over such an enemy by using a *ruse*, the trick of the mirror and its reflecting power. And this ruse is preceded by another trick that is of great symbolic interest in the present context. Both ruses concern the three poles of the perspectival apparatus, the Poussinian "prospect," that "function of reason [that] depends on three things, that is, on the eye, on the visual ray, and on the distance between the eye and the object."[1] We must reread Poussin's phrase in light of Ovid's narration of Perseus's adventure:

> And Perseus told him of the place that lies,
> A stronghold safe below the mountain mass
> Of icy Atlas; how at its approach
> Twin sisters, Phorcys' daughters, lived who shared
> A single eye, and how that eye by stealth
> And cunning, as it passed from twin to twin,
> His sly hand caught, . . .[2]

The first trick involves using a hidden act of substitution to obtain the Gorgons' single eye. In this manner Perseus enters an unknown space and occupies what is essentially the "point of view." In a sense, then, he adopts the position of the viewer, taking the place of the painter. This is similar to my looking at the Church of St. John depicted in the painting while covering one eye with my hand, just as if I were Filippo himself with his easel set up on a tripod immediately inside the central portico of Saint Mary of the Flowers. The first of reason's three terms—prospect (or the eye)—is indeed the first element in a rational model. However, it is also the first move—an act of substitution—within an apparatus of entrapment, a machination or trick, the beginnings of a snare: . . . "and then through solitudes, / Remote and trackless, over rough hillsides / Of ruined woods [here the aporia resumes: Perseus may have dealt with the first aporia now that he has the eye, but he still must cover the distance between the eye and the object, which means he must trace the trajectory of the visual ray] he reached the Gorgon's land."[3] What does Perseus find in this aporetic space? Dispersed here and there in the domain of the Gorgons he finds a variety of stony figures—those of men and savage beasts, which have been grasped and transfixed by the Gaze, "all changed / To stone by glancing at Medusa's face."[4] How can Perseus

conquer this gaze now that he has the eye? How can he, in turn, begin to produce figures? The answer is: by means of a second ruse involving a mirror, the ruse of representation. "But he, he said, looked at her ghastly head / Reflected in the bright bronze of the shield / In his left hand."[5]

The aporia that Perseus must resolve resides in the impossibility of contacting and killing an enemy who keeps her distance by immobilizing the opponent wherever he is, using her petrifying gaze to hold him at the point of view. Thus Medusa remains at the vanishing point, at the very limit of the depth of field, poised at the aporetic position of infinity. And, at the moment of his *death*, she occupies the enemy's point of view, re-connoiters him. The ruse Perseus employs in order to encounter and kill Medusa, while also keeping his distance, is a kind of retaliation in which the Gorgon's own power is turned against her. Perseus substitutes Medusa's gaze for his own, replacing his weakness with her strength, positioning Medusa's deadly gaze in the round bronze eye of his shield.

The representation of Medusa's gaze in the reflecting and reflexive mirror is a ruse and a machination. An element of reason—prospect—reversed or overturned, results in the reflection and retaliation of reason. The gaze is trapped by the eye in the confrontation between weakness and strength, life and death. The painting is, first of all, Medusa petrifying herself with her own gaze in the present and immediate moment of polemical violence, before assuming a place of power on the breast of Jupiter's daughter as an attribute of the latter's divine institution.

Humorous Features

Let us return to Ovid's narrative as we read Caravaggio's painting over the shoulder of the poet of metamorphosis: "and while deep sleep held fast / Medusa and her snakes, he severed it / Clean from her neck."[6] It would seem that the beautiful and elaborate ruse described above falls short, since Medusa is asleep when Perseus decapitates her. The ruse is useless, then, unless we take pleasure in its sheer beauty, or in its elegance, as mathematicians would say. If Medusa and her serpents are asleep, none of them can look at the adversary, and thus there is no need to employ the shield's bronze mirror. The lesson is simple: the strong, the powerful, and the absolutely powerful cannot ever afford to sleep. Power depends on distance and absolute vigilance, and no one with

power can afford to rest or sleep on the job. This point is amply illustrated by the many examples of wakeful attention and failures to remain vigilant described in Marcel Détienne and Jean-Pierre Vernant's *Cunning Intelligence in Greek Culture and Society.*[7]

In my reading of the legend, I carry Perseus's trick to its extreme: I imagine a Medusa who petrifies herself by looking at her image in the shield's mirroring eye. In keeping with this myth, the French verb *méduser* means to petrify, to turn someone into a frozen, marble statue. But if we read the legend this way, one question remains unanswered. If Medusa was transformed into marble the very moment she saw herself in the bronze mirror, then how could Perseus possibly have decapitated her with his golden sword? Would he not have broken his sword against the hard stone? Perhaps he cut her head off the very instant her self-transformation took place, or, rather, the very instant it was about to occur or was *in the process of occurring.* Perhaps the decapitation happens when the tender flesh of the beautiful Medusa, who had been ravished by Neptune, is no longer quite so tender but is not yet as hard as marble. Neither flesh nor stone; still flesh, already stone; Medusa hovers in the instant of the now, that is, the neuter, the complex moment of the transformational process.

How can we look at the *Head of Medusa?* We must be tricky, attentive, and vigilant. At every moment we must avoid the trap of this painting, which represents the trap laid by Perseus. We must in turn set our own traps, since strength can be weakness, and weakness strength. Such was Medusa's gaze and Perseus's eye or glance.

My first move, then, is to "begin" with the gaze and with the orientation of the represented head. This seems an appropriate starting point since we are dealing with Medusa and the "subject" of the painting is the gaze—mine, hers, the painting's, Perseus's, and the painter's. Medusa's head is turned to the left at a forty-five-degree angle. Properly speaking, Medusa does not look *at me;* she looks down and to the left. I try to position myself within her gaze, but this proves impossible: what we have here is yet another aporia. As far as Medusa is concerned, I am transparent. Indeed, she looks at me as though I were nothing, as though I did not exist. Why does her head tilt forward and to the left? Why is there this imperceptible movement, a movement that is oblique in relation to the plane of the painting? This is essentially the same movement, but in reverse, generated by the tomb in Arcadia, which opened up a space in which the scene

and its figures could take on meaning. The answer, in part, is this: the painting is not a plane but a gently curved convex surface, which makes the left part of the face stand forward and the right part withdraw. Thus we can say that in the very "subject" of the painting, which is the *gaze*, we find an effect created by the representation's material support: *the represented object is affected and troubled at its surface by the support.*

By the same stroke, we see that what at first glance could appear to be one of the dimensions of the representational apparatus—namely, the "I-thou" correlative subjectivity—is displaced from its function of reciprocity by the partial effect of an element that is foreign to that apparatus. As a result, the *Head of Medusa* is a full-face portrait, but not entirely.

In a full-face portrait, the represented model looks at me; the model looks me in the eye, focusing on my gaze at the very point of view. In a kind of silent dialogue, she returns my gaze. She is "I," and I am the "thou" who corresponds to her, but also the "thou" that *I* look at. She is "I" because she is internal to the representational utterance and external to the "thou" that I am (for her). But she is "thou" for me, as viewer, since "I" am always transcendent in relation to "thou." When I go outside of myself in order to enter into a living relation with someone else, Benveniste writes, I necessarily posit a "thou" who is, besides myself, the only imaginable person. A full-face portrait doubles and *animates* this correlative subjectivity, because it is a (frontal) *representation*. Although it is discreetly hidden, we can discern a conflict of forces here, an opposition having no equivalent, for the polarity does not signify either equality or symmetry. "Ego" always has a position of transcendence with regard to "thou," although neither term can be conceived in the absence of the other. The terms are complementary, even reversible, although their relation is one of interiority and exteriority. "Ego" has a position of dominance. Represented full face on the canvas, "ego" seizes my viewing and receptive eye by means of her gaze. But as viewer I do the same to her. I seize your gaze with my viewing and emitting eye. There is a struggle in this linguistic structure, but it is not Hegel's mortal combat in language because the opposition between us is a matter of the complementary and reversible relations of conversation. What is strange about the iconic dialogue—and here we find the very enigma of visibility more generally— is that the mortal combat coincides with its pacification, as conflict is replaced by an alternation of dialogic positions. It is not a matter of there first being an "I" who speaks to a "thou," for "thou" becomes the "I" who

speaks to an "I" who has become a "thou." Indeed, an immediate oscillation occurs, an instantaneous shifting of the terms "I"/"thou." Essentially, we here have the story of Perseus and Medusa. Yet, in the iconic dialogue, the mortal combat has no final winner or loser. Both parties are at once master and slave in a warlike entrapment of warfare.

The *Head of Medusa* is a full-face portrait, but not entirely. I *almost* look at Medusa as though I were looking at an "it." And in the viewer/reader's second step, which is the second moment of "theory," she looks at me, *but not really*. Medusa and I are doubly located somewhere between "I" and "thou," between "I/thou" and "it." In other words, what I reflexively look at is a rift or a gap—a nothing-in-between—within what is represented. What Medusa reflexively gazes at is a gap in the representation itself. Here we find a positioning of a double gap, one within the space of what is represented, the other within the space of what can be represented. Rather than witnessing the resolution of the conflict in an appeasement of the reversible positions of enunciation and representation, we encounter *two violent forces that miss each other* in a *parodic* mortal combat. It is critical not to miss this point, for otherwise I would lose my head, would fall headfirst into nothingness, lack, castration, the primal scene. *For the painting is all this as well.* It turns out that I ran the risk of being decapitated by this painting of a severed head. For every trick there is a countertrick. The painting wanted to make me say "nothing" when in fact what one should say is "almost." It wanted me to say "lack" when in fact "rhythm" is the right word, to say "always already" when I should say "every time until now."

Everything I have described takes place, at least partially, because the canvas is slightly curved. But of course it's curved. After all, it's a shield. What remains unclear, however, is the identity of the shield's owner. Is the shield Perseus's instrument of war or is it simply an ornamental object presented as a gift to the Grand Duke of Tuscany? In response to this question I find myself once more saying "either-or," "both-and."

What I see is the shield, the bronze mirror wielded by the clever mythical hero. But what I see on the "wood" is also the reflected image of the head of Medusa, floating in a deep space, standing forth in the virtual and illusory space of the mirror. Look, for example, at the shadows cast by the head and serpents on the right.

The head, however, has already been severed and the blood on the Gorgon's neck has already coagulated. The sword has already struck. It

follows that the head I see here is not the image of the head reflected in the bronze mirror, so the shield must be the shield of the Grand Duke of Tuscany. Or, more precisely, the ornamental shield is a representation of Perseus's shield after the struggle, when it was decorated with the fearful head. And that is why the head stands forth, in relief, from the surface of the *rotella*.

However, because it stands out, the head is at once decorative and apotropaic. What is more, the head's relief serves to invert the convexity of the representation's material support into an illusory concavity. This inversion produces a certain depth, which is, once again, where the reflected image of Medusa's head floats. And this brings me to the hero's bronze mirror. The spurts of blood are not curved by the convexity of the painting's surface, which they would have been had the head "really" been lying on the *rotella*.

Yes, of course, one may respond, but the fact remains that the head has already been severed and is thus merely represented on the surface, in relief. And it is not only the head that is distorted by this surface (the left cheek in particular), but also, and perhaps most of all, the spots of light on the serpentine hair all around Medusa's head.

In other words, the head of Medusa is simultaneously inside the represented space and outside the space of representation. It is inside and outside, but also neither inside nor outside. The shield is both the shield of Perseus *and* the shield of the Grand Duke. It is the specular tool of the violent heroic ruse *and* a spectacular ornament symbolizing the Duke's virtue and power. The head is a reflected image, and thus the product of a representation, but it is also a simulacrum and a double; as such, it is representation itself. The head is a reflection made at the very moment before death. It is a double of the dead Gorgon, her petrified figure, forever frozen immediately after her death. This head exists in the here and now, yet it is also part of the past, frozen in representation. It plays the topological game of standing at that boundary which is the very surface of representation. As an effect of the support and of the surface, it disturbs all of the spaces enclosed by the painting within its representational system. The space of representation is the curve of the support; the represented space is the undecidable hesitation between convexity and concavity. And the space of representability—the viewer's space—is the double positioning and rift between correlative subjectivities and personalities.

The Medusa Head as Historical Painting

To stumble "headlong" into my topic, let me offer these scattered re-
marks as a recapitulation of the preceding analyses.

Two different moments in the story of Perseus and Medusa are re-
flected in and on the mirror/shield, in a kind of condensation or over-
lapping of the story onto itself. This effect can be described by adopting
an image Claude Lévi-Strauss uses in discussing music: the fabric of the
narrative has been folded back over itself to produce what we, the view-
ers, perceive as a painting.

The first of the two moments is found at the level of what is essen-
tially the story's represented "content": Medusa is stupefied and turned
into a statue by her own reflection. The singular potency of her own gaze
is applied intransitively to itself, reflecting itself and thereby producing
its own petrifaction. The first moment represented in the painting, then,
is the moment of this singular metamorphosis, the moment when the
Gorgon's violence is immobilized in its very *expression, imprinting* itself on
itself. In this regard, it is instructive to compare Caravaggio's work with
other representations of the Gorgon (Friedlaender's study is a valuable
source). Caravaggio captures the moment of petrifaction just an instant
before it happens. The interval in question here is the most furtive, infin-
itesimal instant of time, but in its very evanescence it is also the most
permanent moment of all. I would like to name it the *sculptural moment.*
The metamorphosis is unusual because, properly speaking, it does not
involve a change of form or external appearance. The Gorgon who has
just petrified herself is exactly the same being that all of her victims have
glimpsed at the moment of death. She bears the same terrifying gaze that
these victims did not have time to perceive; she voices the same savage
cry that they did not have time to hear. Instead of a metamorphosis, one
might speak of an automorphosis in which Medusa immobilizes herself
at the acme of her violence, which differs considerably from a metamor-
phic transformation of one form into another, a process during which a
prior identity is lost. The automorphosis is also a *displacement* from one
temporality to another, a passage from the moving, linear time of life and
history to the time of representation with its immobility and perma-
nence. The glancing blow struck by the gaze has become, in a fleeting
moment, in an embryonic time, the wink of an eye blinded in its very
gaze. The voice, the cry, has been lost in silence.

A Humorous Objection

Why is it that the Gorgon does not look straight ahead, thereby staring into the eyes of the Duke's enemies, serving as an apotropaic ornament? Why doesn't she stare into the eyes of anyone who looks at the decorative shield, or into her own eyes, since she petrified herself by looking at her reflection in the shield? Were that the case, the viewer would be located in the external space of representability, would occupy the Gorgon's own position.

The Answer

To respond to the objection, we may imagine the following arrangement. When Medusa saw herself in the shield, it was positioned lower and to the left in relation to the surface of the representational space. As a result, the viewer who occupies an external position is not in fact located in the position of the real Gorgon. Instead, the viewer is where Perseus was (a moment before), just after he cut off her head, when his sword was no longer reflected in the shield.

A Counterobjection

Yes, but in keeping with this arrangement, the shield itself would have to be reflected as an ellipse inscribed in the circle of the shield / painting that is presented frontally to the viewer. This is not the case. What is more, according to the imagined arrangement, the convex mirror would no longer coincide with the convex support of the painting, for the painting would have to be an iconic story, or at least a fragment of one, a properly narrative representation.

An example is provided by Annibale Carracci's fresco, *Perseus and Medusa*, in the Farnese Palace in Rome. Athena (?) is shown holding up Perseus's shield like a mirror, while Perseus, positioned on one side, looks at the image—but not directly. Holding Medusa's head by the serpents, he aims his blow by keeping track of the head in the mirror. The viewer of this fresco sees the "round" shield as an ellipse inside the scene of the narrative. In other words, Carracci causes us to move from the representation-enunciation to what is represented and enunciated following the kinds of transformations I have formulated and formalized above. Car-

avaggio himself makes use of these transformations when depicting a number of mythical figures, for example, in his *Sacrifice of Isaac, Judith Beheading Holofernes, The Decapitation of Saint John the Baptist,* and *David with the Head of Goliath.* But he does not generate the transformations in painting Medusa, perhaps because of the extreme violence of her gaze.

These remarks do not settle the issue, however, for both the objections and responses to them stand. The debate must be continued.

The "represented utterance" of the painting comes first, then the representation itself, or, in other words, the total product that Caravaggio presents to the viewer. The latter includes everything that comes "after" the decapitation. We can call this the ornamental or decorative moment, when the mirror, Perseus's defensive weapon, becomes a shield bearing an image of a Medusa who is ready to go on repeating her deadly act. Medusa is capable, at this point, of renewing her violence because her gaze and cry were captured in that furtive instant located infinitesimally prior to the moment of self-stupefaction. The moment of decapitation left its traces, its writing, on the painting. These straight lines of streaked blood dried instantly on contact and serve to record the event as past. But the moment of decapitation is only a trace because Caravaggio's painting is not a representation of the moment when Perseus, with his back turned to the Gorgon, strikes his retroactive blow. Instead, the painting depicts Medusa's head as an ornament on the shield, an ornament, that is ready to go on working its powerful magic. Medusa's head is represented at the moment when it is made the object of a representation on the shield. From that moment on, the painting/mirror once again becomes the hero's shield. Yet the ornament remains dangerous and alive. What the Cardinal del Monte presents to the Grand Duke of Tuscany is indeed an ornamental shield, the persistent powers of which are allegorically praised by Cavaliere Marino. The shield still has the power to stupefy and petrify enemies and onlookers. The moment of self-representation and automorphosis is captured in the instant of representation, the moment when the object is exposed to sight. The Gorgon's face-off with her own reflection, seized and frozen at the moment of the original glancing blow, has become a face-off between the Gorgon and the viewer in a painting/shield that indefinitely repeats the unique, unlocalizable, signless moment of the initial scene.

Caravaggio's painting is a historical painting because it condenses two historical moments, causing each of them to envelop the other. The

painting presents without presenting a model of the temporality of representation in its most powerful form. The rift or fold in historical time that I have just delineated is also indicated, pointed out, in and by the painting itself as a rift. The fact that the moment of the blow itself cannot be presented is designated by the folding together of the moments just before and after the blow. For what is absent from the painting is indeed Perseus's gesture of severing Medusa's head. The hero's stroke is absent, as is the stroke of the painter's brush in making his painting. In a sense, this painting recapitulates all of the historical and contemporary discussions of Caravaggio's work. It has often been said that in Caravaggio representation becomes nature's equal. This is indeed the artist's drama, for the very moment of art is to proceed, as Félibien puts it, from one inequality to another: an art that is perpetually inferior to nature is replaced by one that exceeds nature. Art is this very discontinuity or leap. With a single blow or bound, art crosses the gap between too little and too much. Such is the moment of the *Head of Medusa*, which in its very presence represents the moment of the leap and blow. Or rather, this painting mobilizes the story of the Gorgon to represent the rift in this leap. The moment after the blow envelops the moment before it, just as the painting designates itself as the blow's effect. At the level of contemplation and theory, this painting represents the moment in which art and Nature become equal, a moment when Nature is produced as an art, a moment that is unbearable and literally stupefying. I would add that it was precisely such a moment that Caravaggio sought to capture as nearly as possible.

Digression: A Comparison of the Decisive "Moment" in a Romanesque Fresco and in Caravaggio's Two Paintings

The fresco I wish to discuss is in the chapel of the small priory of Berzé-la-ville and depicts the martyrdom of Saint Blaise. Having been decapitated, the saint's head rolls on the ground while his kneeling body collapses forward. Standing in front of the saint is the hangman who, leaning on the sheath of his sword, raises the sword above his head *in order to strike* the deadly blow with all his force. In the space of the narrative scene, the Romanesque painter cleaves apart the moments prior to and just after the decapitation; the unity of time's succession of instants has

been broken in order to show "two aspects" at once. On the right is the inceptive moment in which the hangman raises his sword; on the left is the terminative moment when the saint's head rolls on the ground like a ball, surrounded by its circular halo. What is more, the whole scene is framed by two inscriptions reading from left to right, running in a direction contrary to that of the figures, who move from right to left. As a result, we are incited to read the narrative retrospectively, so that its surface-level, syntagmatic order runs as follows: he was put to death; the hangman raised his sword and the head rolled on the ground. When we read the text in this order, the first utterance describes the entire scene—Saint Blaise martyred through decapitation—and constitutes its end. In this totality, the causal concatenation is inscribed: the hangman's preparatory gesture—the raised sword—is the cause; the saint's head on the ground is the effect; and the fall of the headless body is a second effect. In other words, by *separating* the two limiting terms of the narrative, the Romanesque painter *shows what is not representable* in this moment, namely, its central instant, the instantaneous and decisive movement of the sword's blade slicing through the thickness of the neck, the acme of violence. But at the same time, by inverting the syntagmatic order of the represented narrative sequence through the presence of a legible text, the artist provides the viewer with a *typical figure* of representation, namely, the martyrdom of a saint, which is situated within the didactic and apologetic dimension of the narrative. Here is the painting's lesson, which coincides, we may note, with the end of the story it narrates. What comes *after the narrative* is the *figural ending* that gave the narrative its meaning *at the outset*. Between these two terms lies the unrepresentable moment when the head is severed by the sword.

Let us now consider Caravaggio's *Judith Beheading Holofernes,* a painting in which the inevitable servant appears to the right of Judith as she performs the act of decapitation. In this work Caravaggio shows us the "central" moment when the blow of the sword is being delivered, for the blade is pictured at the midpoint of its trajectory, halfway through the victim's neck. Judith's left hand holds Holofernes's head by its hair and three spurts of blood gush out onto the pillow and sheets. Here there is no before and after, only the unique, decisive, and deadly moment of an infinitesimal duration. But there is change, which is perhaps not as surprising as one might think. The moment of the action is immobilized by the very representation of its instantaneity. The sword blow freezes

halfway to its completion. Judith will never stop cutting off Holofernes's head with her arrested sword. The story of her deed freezes there as well, having neither a past nor a future, as if it were truly atemporal. This permanence is not a matter of an obsessional or compulsive repetition, but rather the immobile "now" of a phantasm.

Finally, let us consider Caravaggio's *The Sacrifice of Isaac*. Here the story opens at the moment when Abraham stands leaning over Isaac, brutally pressing his head against the sacrificial stone, about to cut his throat with a knife. Entering from the left, the angel, God's messenger, stays the murderous arm of Abraham with his right hand. Abraham turns his head to follow the angel's left index finger, which *points out* to him what the Lord's angel sees: the ram on the right that will be *sacrificed* in place of the son. In this arrangement, where the retrospection moves from the center to the left, simultaneity functions as an inchoative and prospective immobilization. The gesture and gaze move from left to right where the future is being prepared. A story finds its starting point in the interval between the halting of the knife and the offering of the neck, the instant that serves as the matrix of a successive temporality. But something very strange happens in this space "between" two moments, this interdiction of a sacrificial murder that *will not* take place. The viewer's eye is tricked into producing this moment. It is trapped by the *single eye* of Isaac lying on the stone, who, his mouth open as he cries in terror, looks at me with a gaze that is something like the look of Medusa. This gaze has no equal, unless it is the much more complex gaze of the head of Goliath/Caravaggio held by the young David, as depicted in the painting in the Borghese Gallery.

Medusa Revisited

I spoke above of the absent gesture of Perseus the hero and of the absent gesture of the painter's act of painting. Yet suddenly the painter makes his entrance into the mirror/shield, not as a hand or a gesture but as a gaze and a head, as the subject of the painting and as its *means of execution.* In other words, we still have some ground to cover. Or perhaps I should say that I have another move to make in the game of my encounter with Medusa.

The first part of my move involves studying the story told by Car-

avaggio in order to discover the gesture in which the head (the center, the chief, the top) is cut off. I should point out, however, that Caravaggio does not really narrate a story because the viewer cannot, on the basis of representation of a single moment, silently tell himself the story. Yet, at the same time, the viewer is suddenly thrust into the middle of the *theory* of a story that has been painted. The onlooker is plunged into the center of a pictural story in order to discover *the absence of this very center*. What the viewer has to discover, even if this has been contested and is at once hidden and revealed, is that the Medusa head is a portrait of the painter. This is a new and the most radical kind of self-reflexivity of painterly representation, since the painter, who is the subject of the representation, simultaneously occupies the position of the absent hero, Perseus the carrier of the shield, and that of the Grand Duke, the recipient of the shield. The painter has severed the head and carries it as an ornament on the shield he has painted, but he is also the one who is represented on the shield in the form of this very head. The blinding and blinded gaze and the silent scream belong to him. Thus the painter inscribes himself in the painting in a dual manner, for he figures there as the petrifying and petri-fied gaze of Medusa, but also as the caesura of what allows him to be a gaze, namely, the head, but a head cut off at the point of its greatest power and most extreme violence. The painter presents the very vio-lence of the caesura itself. When we construct the series of gestures of decapitation that have constituted this painting, and when Caravaggio at-tempts to seize as nearly as possible the instantaneity of the cut in his painting, we can imagine that we are witnessing—in a single stroke—the very realization of the cut, a kind of maximal decapitation in which the painter himself has his head cut off. Isaac, Holofernes, Goliath, and John the Baptist are all merely representatives of this decapitated painter. By means of the same transformation, the shield, a defensive weapon, be-comes the blade of the sword that does the cutting. Thus we are shown how all representation is a kind of power based on violence, for represen-tation is founded and becomes an *institution* at the very place of the cut.

In the second part of my move, I note that the discourse that I have just written only gives voice to the pathos of the painting and could very well be a trap. The painter, after all, not only disguises himself as Medusa; he also cross-dresses as a Gorgon, a woman, or at least as the head of a woman. This is a woman of striking beauty, Ovid tells us, or at

least she would be were it not for her hair of serpents, which she wears as a punishment for having been raped by Neptune. She is a headstrong woman, but also, like a freak in a carnival, a kind of detached, bodiless head. Here the most serious and essential question—and along with it, the metaphysics of representation—is disguised in a game of substitutions involving the headstrong woman, the woman without a head, and the head without the woman. And this game leads to the frivolous and superficial surprise of finding a woman who is only a head. This game is a humorous parody of the denegation of enunciation. And this motif leads me back to the story and to the enunciative modality that characterizes it, for within the story we discover that the subject who utters it is both effaced and disguised. The events *seem* to tell themselves (and we must underscore Benveniste's use of the term *seems* in this context). I have called this a denegation of the enunciation, by which I mean to identify a process of positing and suppressing, asserting and negating, in which the assertion is there only to lead to its negation and is posited only to be excluded. The concept of denegation is appropriate here because what is shown in the painting is the cutting off of the story's head, or rather, of its generative source, the subject of the enunciation himself. This subject's gaze and cry are cut off at the very moment when he looks and screams. What the painting shows us and allows us to see is representation as a cut, a cutting blade severing the story from the subject who tells it while also severing the scene from those who look at it and produce it as a scene. But how does this work? The operation is performed by showing the severed head on the plane of the painting-mirror-shield-sword. And this head, which is the painter's, is also the head of a transvestite.

Now that I have made this move, I am sure that you are waiting for me to speak of castration. You may in fact have been waiting for this from the outset. Given the nature of our modern "situation," a book is always more or less a kind of gratification, or at least it tries to provide some kind of gratification, and I can hardly disappoint my readers in this regard. After all, Freud himself wrote on Medusa.

Having played my game, I must follow the rules of the game that I have been playing backwards. In short, I must go along with the game. So I will cite and then comment on "Das Medusenhaupt" as a kind of interlude, an interlude being some kind of entertainment or amusement—such as a ballet, a dance, or chorus—included between the acts of a play.

Psychoanalytic Interlude

Freud's essay "Medusa's Head" was written on May 14, 1922, but was published posthumously in 1940. I think it important to begin with an idea that has not been taken seriously enough in the literature on Freud. The psychoanalytic interpretation of the terrifying severed head of Medusa is *too easy* because it is readily suggested by the mythological theme itself. It seems as if the interpretation is already included in the theme of the story, so what need could there possibly be for any further interpretation?

> Fear of Medusa is thus a fear of castration linked to the action of looking for something and finding it missing. It is, in a sense, linked to the sight of a "lack." But how can one see a lack? We see only what is there. If I see what is not there, I must have been expecting to see something.

I shall try to delineate the scene in which the mother's sex is seen, and shall do so with a staging of the *Head of Medusa*.

1. The head of Medusa is, *first of all,* a head, a raised head. Here I follow Freud. It is a penis, and when the Viennese master decodes the serpents as a multiplication of penises, it is this reference that he is noting. This is what I expected to see and indeed what I do see.
2. But the head of Medusa is *secondarily* a head that is a gaze, the sole function of which is to look. It is a head/glance of the eye, my own eye, and my own glance.

 In other words, on the one hand, we have the object we expected to see, which is there, but, on the other hand, we have the gaze of this very expectation, the eye. On the one hand, we have the object constituted by our expectations, by our foresight and knowledge; on the other, we have this foresight, knowledge, and gaze in the object itself.

 In short, we have the "prospect" which according to Poussin depends on three things: the eye, the visual ray, and the distance between the eye and the object. Here is the distance in the story of Medusa.

3. The head of Medusa is, *finally,* a severed head, a decapitation.
 Freud identifies this as a castration, the lack or suppression of the
 expected object.

I have just told a story. Medusa stands erect and vigilant in the space
guarded by her two sisters who share a single eye. Perseus is on his way
toward her and encounters the aporia. He meets and sees Medusa, and,
with a glancing blow, kills and decapitates her. Three moments are con-
densed into a single instance involving both a positing and a suppression.

How can negation be "figured"? A negative judgment, we know, is
expressed by means of the word "not." But how can the function of "not"
be represented by an image? The way to do this is to represent the object
first, then its destruction. The head of Medusa and its gaze are the antici-
pated object, and the gaze doing the anticipating and performing the act
of decapitation is the gaze that discovers the absence of the anticipated
object.

What is a representation? Freud raises this question in his article
"Negation."

> We must recollect that all presentations originate from percep-
> tions and are repetitions of them. Thus originally the mere exis-
> tence of a presentation was a guarantee of the reality of what
> was presented. The antithesis between subjective and objective
> does not exist from the first. It only comes into being from the
> fact that thinking possesses the capacity to bring before the mind
> once more something that has once been perceived, by repro-
> ducing it as a presentation without the external object having
> still to be there. The first and immediate aim, therefore, of real-
> ity-testing is, not to *find* an object in real perception which cor-
> responds to the one presented, but to *refind* such an object, to
> convince oneself that it is still there.

From this point of view, then, representation is generally accompa-
nied by the conviction that the represented object is absent but not lack-
ing. Representation targets and brings to mind what is not there, but this
object was once there and can be rediscovered. An object is absent if it
cannot be directly perceived yet is present in representation.

Given these assumptions, the severed head of Medusa would be a representation in a single figure, of a contradiction: (1) the perception of the penis by the gaze, and (2) the gaze's observation that the penis is lacking. We realize that this must be the case when Freud interprets the viewer's petrifaction as an assertion: "I am not afraid of you, I defy you, I have a penis, an erection."

Yet the central episode of the myth goes unanalyzed by Freud, and it is precisely this very moment that is represented (or perhaps figured) in the *Head of Medusa*. This is the moment in which Medusa petrifies herself and Perseus decapitates her. This central moment is *the moment of the ruse* by means of which the hero turns Medusa's own strength against herself, thereby overcoming his own weakness. This is, of course, the ruse of turning the shield's reflective power into a weapon.

Freud's story—perhaps one should add, Freud's myth—which subtends his remarks on the head of Medusa, elides the "central" moment of the ruse, focusing instead on the beginning and end of the event: (1) Medusa petrifies those who see her, and (2) the virgin Athena carries the head of Medusa, petrifying those who attack her. But to get from the one to the other we have to encounter the moment of the ruse. There is a sense in which the decapitation is secondary, for it would be impossible without the machination in which Perseus uses his shield, in a sort of *bricolage,* as an optical device, a mirror to capture Medusa in the trap of her own deadly gaze.

One can, of course, forget the essential element and fall into the trap of emphasizing the moment of decapitation and castration, thereby interpreting it as the moment in which the object is at once present and absent. I can let myself be trapped by the representation, the trap within the trap created by Caravaggio, the very mainspring of representation in which the real itself is what is lacking. In the moment of representation, we are allowed not to see "the real," not to want to see it, for the "gap" where castration is made manifest is covered over by the erection of a substitute for the lacking penis; this substitute stands in the hole where sexual difference is revealed. But at the same time, representation marks this reality as a lack, underscoring it while trying to hide it. This is, in fact, a description of the simplest kind of trap, a hole in the earth covered over with branches, leaves, and some dirt. What looks like an unbroken surface is in fact just some leaves and grass hiding a discontinuity. The trick involved in a trap like this is that it is the animal's own weight

that causes it to fall into the hidden hole. The victim, that is, contributes to the working of the trap. Indeed, the bigger and stronger the animal, the more quickly it falls, as its strength cleverly is *turned against* it.

In other words, the psychoanalytic interpretation of representation as a fetish overlooks the fact that the fetish (representation) is a trap and thereby makes it function as one. Better yet, representation is the trap of interpretation. Freud reveals the trap of his account of the myth by forgetting that Medusa's self-petrifaction is the result of Perseus's ruse. Freud thereby falls into a trap while trapping us.

Caravaggio's *Head of Medusa,* then, is a counterruse mobilized against the ruse of pictorial representation. In this context, it would be appropriate to cite Ellis Waterhouse's remarks on Caravaggio's *Conversion of Saint Paul* and *Crucifixion of Saint Peter* (both of which hang in the Cerasi Chapel, Santa Maria del Popolo, Rome):

> The arrangement of these two pictures, conceived as receiving their light from a painted glory in the ceiling of the chapel, is *deliberately* illusionistic. Caravaggio has done everything possible to bring home to the spectator the vivid immediacy of the scene, as if he were witnessing the incident himself, rather than as if he were looking at a picture of it. The intention is not different from that recommended by the Jesuit *Exercises*, and *the picture, viewed in this light, has the hallucinatory quality of a vision beheld by the spectator himself.*

To conclude our interlude, we may define the trap and hole of the present. What Medusa's gaze provides us with is the representation of an embryonic time, an infinitesimal moment during which she has just looked at herself and is no longer doing so. This is the moment when her gaze has its effect on her. In a single enunciative and representational present, there are, in fact, two present moments, one that is an "up until now" in which the present moment brings an end to a story, and another present moment that is an "all of a sudden," a sudden moment that is only infinitesimally removed from the first present moment. In this *same* moment, "neither this nor that" and "both this and that" are conjoined. What is represented *here* is the gap upon which representation "is founded." This is a gap of the present, a point that is a hole, the hole of the eye through which the gaze of theory falls.

Notes

"Theoretical"

1. Friedlaender, catalogue raisonné, in *Caravaggio Studies*, 157.

2. I am drawing here on Friedlaender's *Caravaggio Studies.*

3. Friedlaender, *Caravaggio Studies*, 88.

4. See Cesare Ripa, *Iconologia* (New York: Garland, 1976), 452.

5. Friedlaender, *Caravaggio Studies,* 88.

6. Ibid., 88–89.

7. Hesiod, *"Theogony" and "Works and Days,"* trans. M. L. West (Oxford: Oxford University Press, 1988), 11.

8. Ovid, *Metamorphoses,* trans. A. D. Melville (Oxford: Oxford University Press, 1986), 98 (4.793–803).

"Analytic Strategy"

1. Nicolas Poussin, quoted in André Félibien, "Entretien VIII," in *Entretiens sur les vies et sur les ouvrages des plus excellens peintres anciens et modernes; avec la vie des architectes*, 6 vols. (Trevoux: de 1' imprimeric de S.A.S.), 4:44.

2. Ovid, *Metamorphoses,* trans. A. D. Melville (Oxford: Oxford University Press, 1986), 97–98 (4.772–78).

3. Ibid., 98 (4.778–80).

4. Ibid., (4.782–83).

5. Ibid., (4. 784–86).

6. Ibid., (4.786–88).

7. Marcel Détiene and Jean-Pierre Vernant, *Cunning Intelligence in Greek Culture and Society,* trans. Janet Lloyd (Sussex: Harvester, 1978).

53 ANN STANFORD
"Medusa" (1977)

In "The Women of Perseus" section of her 1977 collection *In Mediterranean Air*, American poet Ann Stanford uses dramatic monologues to explore the stories of Perseus from the points of view of the women he encounters on his adventures. In "Medusa," the Gorgon describes the anger of a raped woman, an anger that transforms her physically as well as emotionally. By focusing on the rape rather than the slaying of Medusa, Stanford de-emphasizes Perseus's heroism in favor of an exploration of Medusa's experience. Even in "Perseus," which follows "Medusa" in the collection, Perseus himself questions his heroism, acknowledging the physical brutality of slaying Medusa and the symbolic power he gains from violence.

1

Had I but known when I saw the god approaching!
His horses pulled him briskly over the water
as on dry land, wreathed in seaweed, dripping,
his chariot shone gold in the warm summer.
I stood as he walked—the old man—up from the shore.
He climbed the temple stairs. He praised my grace.
I had never seen a god before.
He seized and raped me before Athena's altar.

It is no great thing to a god. For me it was anger—
no consent on my part, no wooing, all harsh
rough as a field hand. I didn't like it.
My hair coiled in fury; my mind held hate alone.
I thought of revenge, began to live on it.
My hair turned to serpents, my eyes saw the world in stone.

2

Whatever I looked at became wasteland.
The olive trees on the hill as I walked down
rattled in wind, then stood—as if a hand
had fashioned them of bronze. I saw the town
where I was raised become a stone. The boys
ran by as on a frieze, the charioteer
whipping his horses, held his arm, mid-air.
His horses stopped in stride. My hair
started to hiss. I hurried to my door.
The servant with his water jar upraised
stands there forever. I strode across the floor.
My furious glance destroyed all live things there.
I was alone. I am alone. My ways
divide me from the world, imprison me in a stare.

3

The prisoner of myself, I long to lose
the serpent hair, the baleful eyes, the face
twisted by fury that I did not choose.
I'd like to wake up in another place,
look for my self again, but there recur
thoughts of the god and his misdeed always—
the iron arm, the fall, the marble floor
the stinking breath, the sweaty weight, the pain,
the quickening thrust.

And now the start,
the rude circling blood-tide not my own
that squirms and writhes, steals from me bone by bone—
his monster seed growing beneath my heart,
prisoned within my prison, left alone,
despised, uncalled for, turning my blood to stone.

54 STEPHEN HEATH
from "Difference" (1978)

On "The Look for the Woman"

Film theorist and professor Stephen Heath was an editor of *Screen* during the 1970s, when the journal published a number of essays still considered to be cornerstones of film criticism. In his 1978 essay "Difference," Heath explores Lacan's writing on sexual difference to formulate a theory of women's relationships to language and representation. Grappling with issues of essentialism, objectification, and representation raised by Laura Mulvey's groundbreaking essay "Visual Pleasure and Narrative Cinema," Heath argues that the advent of photography altered the economy of representation, allowing the representative to appear as the real. In this excerpt, Heath explains the function of Medusa as a metaphor for women's relationship to specularity.

What then of the look for the woman, of woman subjects in seeing? The reply given by psychoanalysis is from the phallus. If the woman looks, the spectacle provokes, castration is in the air, the Medusa's head is not far off; thus, she must not look, is absorbed herself on the side of the seen, seeing herself seeing herself. Lacan's femininity. By virtue of the doubling unity of her specular relation to the mother, parent of the same sex, the woman is specified as being in a particular, different relation to the scopic function, to pleasure in seeing: "For the girl, the setting at a distance is a difficult experience. She prefers to tip over into the image guaranteed for her (as she believes) by the quite as captive look of the mother and, later, by the all-powerful look of the father. So she prefers to believe in that image. She believes she is herself. She thus equates herself with the full and flawless figure, no crack, which preserves and is preserved by the parental authority. In so doing, she substitutes for the person of the mother crucial in the *fort/da* game her own person figured by her body in the specular image; an image that the mother's look brings out, "causes." It is an inverted *fort/da*, and it is the whole body which becomes the stake of symbolisation, with the consequent risks of

fragmentation and hysterical paralyses. But in thus offering herself to the look, in giving herself for sight, according to the sequence: see, see oneself, give oneself to be seen, be seen, the girl—unless she falls into the complete alienation of the hysteric—provokes the Other to an encounter and a reply which give her pleasure.[1]

Note

1. [Eugénie] Lemoine-Luccioni, *Partage des femmes,* p. 85.

55 SARAH KOFMAN

from *The Enigma of Woman: Woman in Freud's Writings* (1980)
translated by Catherine Porter

A Feminist Rereading of Freud's Medusa

Sarah Kofman, a French theorist and critic who published books and articles about art, literature, and psychoanalysis, was a professor of philosophy at the Sorbonne. Known particularly for her work on Freud, whom she read in conjunction with the work of later theorists such as Jacques Derrida and Luce Irigaray, Kofman published *The Enigma of Woman* in French in 1980. In it, she analyzed Freud's accounts of women, in particular his fascination and panic in the face of women's power.

Freud, who has Ferenczi to thank for the connection between woman's genitals and Medusa's head,[1] adds as his own personal contribution the idea that it is the mother's sex that turns out to be on display in this symbol. In "The Infantile Genital Organization," at the point where he is quoting Ferenczi, he adds in a note: "I should like to add that what is indicated in the myth is the *mother's* genitals. Athene, who carries Medusa's head on her armour, becomes in consequence the unapproachable woman, the sight of whom extinguishes all thought of a sexual approach." [Here Kofman quotes extensively from Freud's "Medusa's Head."[2] For both Freud texts see pp. 84–86 in this volume.]

The depreciation of woman, her sexual "debasement," far from facilitating intercourse, stifles all thought of closeness; woman in general becomes unapproachable, a forbidden Mother who repels all desire: the terror provoked by the genital organs is always linked to the desire for and the fear of incestuous relations, for if the father has already castrated the mother, his accomplice, he may equally well castrate the son—that is the danger against which "there [rises] in rebellion the portion of his narcissism which Nature has, as a precaution, attached to that particular organ" ("Fetishism," p. 153). The terror is never simply provoked by the castration of the other, the mother, it is always also castration anxiety for oneself (if only through identification with the mother). The conviction

that the woman/mother has no penis thus draws man away from woman and predisposes him to homosexuality. It is no accident, according to Freud, that we owe the symbol of Medusa's head to the Greeks: "Since the Greeks were in the main strongly homosexual, it was inevitable that we should find among them a representation [*Dar-stellung*] of woman as a being who frightens and repels because she is castrated" [p. 85].[3]

It seems indeed that in the face of this horror man has only two solutions, homosexuality or fetishism; far from being "pathological," either one, under these conditions, would be the *normal* destiny of the masculine libido. Under these conditions, what becomes *abnormal* is heterosexuality. We then have the problem of understanding how many men, if not all, manage to overcome their horror and even experience pleasure in sexual relations with a woman. Because to deal with this issue would perhaps lead him to doubt the views he has just presented, Freud without further ado refuses to address it.

> Probably no male human being is spared the fright of castration at the sight of a female genital. Why some people become homosexual as a consequence of that impression, while others fend it off by creating a fetish, and the great majority surmount it, we are frankly not able to explain. It is possible that, among all the factors at work, we do not yet know those which are decisive for the rare pathological results. We must be content if we can explain what has happened, and may for the present leave on one side the task of explaining why something has *not* happened. ("Fetishism," pp. 154–155)

He does not explain, at least "for the present," he says. One may wonder, indeed, whether Freud is not providing an "explanation" without admitting it, and whether belief in "penis envy" is not the solution he is proposing for this riddle. For if penis envy implies the absence of a penis and the castration of woman, it is also a way of affirming that man's penis remains intact. Woman's penis envy thus also provides man with reassurance against his castration anxiety; the horror inspired by Medusa's head is always accompanied by a sudden stiffening (*Starrwerden*), which signifies erection. "He is still in possession of a penis, and the stiffening reassures him of the fact" [p. 85]. Things that arouse horror in themselves "serve actually as a *mitigation* of the horror" (ibid.; emphasis added):

penis envy, one might say, plays the same role as the hair on Medusa's head, so often represented by serpents substituted for the penis, the absence of which is the essential cause of horror. Penis envy is seen as equivalent in a way to the symbolic multiplication of man's penis. And if horror in the face of woman's genital organs always has as its apotropaic counterpart the erection of the male organ, man's display of his penis as if to say, "I am not afraid of you. I defy you. I have a penis" [p. 85], we can then *understand how what was supposed to draw man away from woman is always at the same time what brings him closer to her.* Woman's genital organs arouse an *inseparable blend of horror and pleasure;* they at once awaken and appease castration anxiety.

Notes

1. In "Revision of the Theory of Dreams," in *New Introductory Lectures on Psycho-Analysis, 22*:7–30 (1933a [1932]), this motif of terror is related to that of the spider, symbol of the phallic mother, this time according not to Ferenczi but to Abraham.

2. This text was never published by Freud, perhaps because he did not dare uphold this interpretation of an *isolated* symbol when he had neither provided it with a "serious" genesis (the text attributes it only to the "strongly homosexual" tendencies of the Greeks) nor managed to establish a parallel with other myths, this time according to a method no longer genetic but comparative, structural. The text ends, in fact, as follows: "In order seriously to substantiate this interpretation it would be necessary to investigate the origin of this isolated symbol of horror in Greek mythology as well as parallels to it in other mythologies" (p. 274). I, Freud, am more serious than Ferenczi.

3. The French translation uses the phrase *de par leur forte tendance homosexuelle,* "owing to their strong homosexual tendency." One wonders, however, what *"a homosexual tendency"* might mean, since everywhere else Freud shows that homosexuality is not a specific tendency but one of the possible destinies of a bisexual libido.

56 GANANATH OBEYESEKERE
from *Medusa's Hair: An Essay on Personal Symbols and Religious Experience* (1981)

An Anthropological View

Gananath Obeyesekere is a professor of anthropology whose work focuses on the interrelation of anthropology and psychoanalysis and on the ways in which personal symbolism is related to religious experience. In the influential essay excerpted below, Medusa's hair becomes a thematic focus for an anthropological discussion of ecstatic religious figures in Sri Lanka.

> Everyone bears the responsibility of *situating* psychoanalysis in his own vision of things.
> —Paul Ricoeur

The title of this essay is deliberately misleading. Medusa's hair is the trigger that released my analysis of the experiences of the ecstatic priests who appear in these pages. I have selected a few cases from a larger sample of religious virtuosos I have known for the past ten years and have presented them at some length. True to the anthropological tradition, I view the rich ethnographic and psychological data presented here as intrinsically interesting and as "something to think with." I deplore the recent tendency among anthropologists to study symbol systems without reference to context. In this essay I go beyond a conventional description of the ethnographic background and articulate the symbol to the cultural, social, and psychological dimensions of the existence of my informants.

On the analytical level my study of personal symbols hinges on the view of culture that stems from Max Weber and on the theory of unconscious motivation that stems from Freud. For Weber culture is the result of the human tendency to impose meaning on every dimension of existence. Nevertheless, Weber neglected one area of human existence: those critical experiences that lie outside conscious awareness. This is where psychoanalysis comes in, with its theory of unconscious or deep

motivation. It depicts the way motives are linked with "symbols" or images, generally of a private nature, either in dreams or in fantasy. Yet in spite of Freud's own interest in culture it is rare to come across psychoanalysts or social scientists, with the notable exception of culture and personality theorists, who deal with the interdigitation of deep motivation and public culture. The bias is strong in the social sciences that culture must deal exclusively with group processes rather than with individual motivation.

In this essay I demonstrate that this view is wrong and show how certain cultural symbols are articulated with individual experience. I label these "personal symbols": cultural symbols operating on the levels of personality and of culture at the same time. Personal symbols form an identifiable set within the larger class of psychological symbols, not all of which have motivational significance. Through the study of personal symbols I attempt tentatively to integrate Max Weber's view of culture with Freud's theory of personality. . . .

Since 1970 I have visited Kataragama regularly during the hot, dry pilgrim season and gathered extensive information on the history and sociology of the place. I too come here to renew old ties with informants and make new friends. On one such occasion in July 1973 as I stood under the protective shade of the bo tree behind the main shrine, I was struck by the sight of a female fire walker dancing near the shrine of the god, her eyes shining, hands thrust outward in an imploring manner as if yearning for his love, and, what was most conspicuous, her matted hair flowing in the wind. A sudden thought crossed my mind: Medusa! and almost simultaneously I remembered Freud's paper "Medusa's Head," in which he links the fear of Medusa to the terror of castration. A further stream of associations: there are no snake hairs in nature, so it's possible that Medusa's snakes are only matted locks. I then wrote in my field notes that I had seen an ugly woman, her teeth stained with betel nut juice and bearing repulsive matted locks, dancing in ecstasy and adoration before the god.

This research itself got under way two years later when my friend Richard Gombrich, professor of Sanskrit at Oxford, came to Kataragama and I told him of my Medusa hypothesis. He mentioned a priestess with matted locks he had just met. She had casually claimed that her matted hair was in fact shaped like a cobra. This fresh piece of information

spurred me to interview people with matted hair, and this essay is the product of that research.

My first set of interviews were with Karunavati, the woman I saw dancing before the god. I soon got to know her well and found her an attractive person with an outgoing nature rare among Sinhala females. I liked her very much, and we soon became good friends. And yet the question kept haunting me: Why was I initially repelled by her—rendered anxious by her disturbing presence? I was no novice in the field. I had worked in Sri Lanka for many years, with peasants and urban people alike, with religious specialists ranging from Buddhist monks in their cool cloisters to sorcerers performing rituals in the heat of night in lonely graveyards. Moreover, I have interviewed many other female ecstatics without reacting with the same anxiety and revulsion. So surely there was something in Karunavati that other informants lacked, and I was reacting to it: Her matted locks!

Was it the anthropologist's own castration anxiety that provoked this reaction? Or was it the ordinary disgust of a fastidious scholar for something dirty and anomalous sticking out of her head? My own train of associations linking Karunavati's matted hair to Medusa and to Freud's paper seemed to support the castration idea, but, then, could it not have been a *fantasy* of castration anxiety by an anthropologist sensitive to psychoanalysis rather than the real thing? Be that as it may, it was my anxiety, and the associations that accompanied it, that led to the formulation of the initial Medusa hypothesis and a whole line of, I hope, fruitful research.

Though I was troubled initially, I later derived some comfort from the fact that another anthropologist had made a similar connection between snakes and matted hair. Hershman, in a discussion of Punjabi hair styles, also comments on the matted hair of Hindu ascetics, noting that "a Sadhu's hair develops the characteristic snake like matted locks." Siva's "matted locks are snake like and piled on his head in conical shape."[1] It is clear that here also the characterization of ascetic hair as snakes is Hershman's own projection. I was not the only person to project my anxiety onto the hair of ascetics. . . .

[And] it is not only Hershman and I who have reacted to this cultural symbol with our fantasies, constituted of our anxieties. Other members of the culture also do this and are indeed often anxious when they see the

matted hair of ascetics. Furthermore, note that at least one ascetic saw her own hair as cobra-like. So, I thought: let me utilize my own projections and intuitions and see where they land me, in what abstract realm. . . .

In August 1979, six years after I saw Medusa's hair flowing in the wind, I was seated once again on the steps of the Dadimunda shrine near the bo tree behind the main shrine at Kataragama, waiting. I had written the first draft of this essay, but I was in despair because I had not had the opportunity to record even one instance of that scarce species, a Sinhala Buddhist male ascetic with matted hair. Then on the afternoon before the final day of the festival he appeared before me, dressed in white robes, seated on a mat under the bo tree, his eyes closed yet directed to the tree, lost in deep meditation. He seemed indifferent to the *kavadi* dancers swinging around him, to the sound of horns and drums, to the hustle of moving people and the distant wail of a loudspeaker soliciting contributions from the devout for developing the sacred shrine premises of Kataragama. It was as if the god in his indifferent magnanimity had granted a boon to the skeptical anthropologist. . . .

Sada Sami (Matted Hair Sami) was born in Galle in 1909 as Simon Araccilage Karniyel Appu. . . .

How did this come about? "My hair was now really long. Suddenly I found myself in the Jetavanaramaya [a famous monastery of the Buddha's time], standing before the front door. Someone poured water on my head, perhaps a god. This was in a dream. Next morning I got up and my hair was sticky like wax. I got some limes and washed my hair four or five times, but the stickiness did not go away. Then I washed it with soap, but it still remained. Next day I had a high fever, and in this state I obtained four locks of matted hair.". . .

In his period of meditation at Kataragama he was assailed by the desires of the flesh as the Buddha himself was assailed by Mara. Then a divinity dressed like a gentleman appeared before him. "I will give you a discourse on the *vinaya* [discipline] of a true *yogi* and on *bhakti* [devotion]. A true *sami* must not trim his beard." "But I have to keep my face clean." "No, that cannot be done. A *sami* cannot cut his face hair. Remember

there are five senses—ear, nose, mouth, eyes, heart [mind]. You cannot emancipate yourself from these unless you let your beard grow. When these five senses unite you have feelings of love. That is sinful. You allow your beard to grow and I will visit you again in ten days." At 3:30 in the morning of the tenth day the god appeared when Sada Sami was asleep, turned him around several times, and said, "Now it is fine; your beard is growing, so I'll leave."

Soon he had a full beard, and his matted locks were piled on top of his head in a neat cone, known in Indian iconography as *jata mukuta*. He showed us an impressive photograph of himself taken at about this time. He was conscious that he was like Siva himself: indeed, the matted hair of this period was Siva's gift to him and thus the god's own ornament. He said he even felt like a divinity, though he was in fact only a human being.

Note

1. Paul Hershman, "Hair, Sex and Dirt," in *Man* 9 (1974), p. 287.

57 NEIL HERTZ

from "Medusa's Head: Male Hysteria under
Political Pressure" (1983)

Medusa in the French Revolution

This essay on "Medusa's Head" by Professor of Humanities Neil Hertz offers a bril-
liant analysis of the deployment of Medusa as a figure for the threat of revolt in the
context of the French Revolution. In the same issue of *Representations* in which
Hertz's article originally appeared (Fall 1983), Joel Fineman and Catherine Gallagher
present thoughtful responses.

Alios age incitatos, alios age rabidos

In the pages that follow, I shall be considering some examples of a recur-
rent turn of mind: the representation of what would seem to be a politi-
cal threat as if it were a sexual threat. Freud alludes to this at one point in
his article on fetishism, where he is momentarily led into a bit of dra-
matic miming, simulating the terror he imagines the little boy feels when
he first discovers his mother has no penis: "No," he writes, "that cannot
be true, for if a woman can be castrated then his own penis is in danger;
and against that there rebels part of his narcissism which Nature has
providentially attached to this particular organ." Freud then adds drily,
"In later life grown men may experience a similar panic, perhaps when
the cry goes up that throne and altar are in danger."[1] Questions of sexual
difference, of perception and of politics are rapidly brought into relation
here, and it is that set of relations that I should like to explore. My chief
examples are Parisian, taken from accounts of the 1848 Revolution and
of the Commune, but in order to suggest that what I'm considering is
not something merely febrile and all-too-French, I shall glance first at an
eighteenth-century British instance.

Burke's *Reflections on the Revolution in France* was published in 1790;
two years later an antirevolutionary cartoon appeared which, like Classic
Comics generally, can be read as an inadvertent parody of the work it

condenses and illustrates. The "contrast" is Burke's, and so is the franco-phobia that gives it its edge. Its images are drawn from the pages of the *Reflections:* the composed scene within "the shadow of the British oak," on the one hand, on the other the noble victim "hanged on the lamppost" and serving as a backdrop, if that's the right term, for one of those fig-ures Burke refers to as "the furies of hell, in the abused shape of the vilest of women."[2] She is, however, not Fury but a Gorgon—Medusa, in fact—here depicted not as a petrifier but as a beheader, her own head recogniz-ably snaky yet still firmly attached to her shoulders: Medusa usurping the pose of Cellini's Perseus, a decapitated male at her feet. Still another way—the print seems to suggest—in which the world has been turned upside-down. The question is, why should revolutionary violence be em-blematized in this way, as a hideous and fierce but not exactly sexless woman?

A related question is prompted by the first of the French texts, a brief one by Victor Hugo which appeared in a posthumously published collec-tion of fragments assembled by his literary executors and entitled, by them, "Things Seen," *Choses vues.*[3] It describes the fighting on the first of the June Days in 1848, and it appears to have been written shortly there-after. Hugo's relation to the events of 1848 shifted as the year went on, and could be described as an incomplete (and never-to-be-completed) process of radicalization. . . .

> The June uprising, right from the start, presented strange lineaments. It displayed suddenly, to a horrified society, mon-strous and unknown forms.
>
> The first barricade was set up by Friday morning the 23rd, at the Porte St. Denis; it was attacked the same day. The National Guard conducted itself resolutely. They were battalions of the 1st and 2nd Legions. When the attackers, who arrived by the Boulevard, came within range, a formidable volley was loosed from the barricade and it strewed the roadway with guardsmen. The National Guard, more irritated than intimidated, charged the barricade at a run.
>
> At that moment a woman appeared on the crest of the bar-ricade, a young woman, beautiful, dishevelled, terrifying. This woman, who was a public whore, pulled her dress up to the waist and cried to the guardsmen, in that dreadful brothel lan-

guage that one is always obliged to translate: "Cowards! Fire, if you dare, at the belly of a woman!"

Here things took an awful turn. The National Guard did not hesitate. A fusillade toppled the miserable creature. She fell with a great cry. There was a horrified silence at the barricade and among the attackers.

Suddenly a second woman appeared. This one was younger and still more beautiful; she was practically a child, barely seventeen. What profound misery! She, too, was a public whore. She raised her dress, showed her belly, and cried: "Fire, you bandits!" They fired. She fell, pierced with bullets, on top of the other's body.

That was how this war began.

Nothing is more chilling or more somber. It's a hideous thing, this heroism of abjection, when all that weakness contains of strength bursts out; this civilization attacked by cynicism and defending itself by barbarism. On one side, the people's desperation, on the other, the desperation of society.

It's impossible to determine how accurate this is; though it purports to be an eyewitness account, it differs in its details—and, particularly, in its most striking detail: the women's gesture—from other descriptions of what must be the same encounter.[4] But regardless of whether the provocative actions it reports took place or were a supplementary invention of Hugo's, there can be no doubt about how intensely stylized is this telling of the story. The managing of local rhythmic sequences (e.g., in the original, *une femme jeune, belle, échevelée, terrible*), the dreamlike abruptness with which the women are made to appear, the fairy-tale progression (first one young woman, then another younger still: one almost expects a third—the Cinderella of the barricades), the strong centripetal pull toward that meaningfully terse one-sentence paragraph ("That was how this war began")—all this heavy codification marks the anecdote as "representative," the story of a beginning that is intended as a revelation of essence. But the point is made in a still more telling way, one that has disappeared in translation. The feminine gender of the word for an uprising—*une émeute*—allows for a startling double entendre to develop, retroactively, in the second sentence: *Elle montra subitement à la société épouvantée des formes monstrueuses et inconnues.* What the revolution is

said to be doing figuratively is precisely what—in a moment—each of the women will be represented as doing literally, suddenly displaying monstrous and unknown forms to a horrified society. Or rather, to say that the women are doing "precisely" that is to submit to the spell of this lurid equivocation: between the first paragraph and the sentences describing the women's gesture a teasing relation is established that holds out the possibility of conflating the two actions. Once that possibility is glimpsed, then a number of sentences further along are rendered similarly *louche*. What was translated as "Here things took an awful turn" is, in French, "*Ici la chose devint effroyable*" (Here the thing became terrifying), a note that is repeated in the last paragraph's "It's a hideous thing" (*C'est une chose hideuse*), a glance back at the *formes monstrueuses et inconnues*. A context has been created in which the most abstract characterization of the revolution's essential meaning—"all that weakness contains of strength bursts out"—can be read as a final, oblique allusion to the source of the power of the women's gesture: this becomes a *chose vue* with a vengeance.

One's warrant for reading the Hugo passage in this way is provided, of course, by Freud's notes on Medusa's head. [Here Hertz quotes from "Medusa's Head"—see pp. 84–86 of this volume.] Freud describes a gesture similar to that of Hugo's women and offers a compelling account of why that gesture would come across as, in Hugo's language, *glaçant*, "chilling." In this interpretation, the strength contained in the woman's weakness is the power to frighten the man by revealing to him the possibility of his castration. At the barricades, the women's—or the revolutionaries'—lack of "property" betokens the soldiers'—or society's—risk.[5]

But Freud is as concerned with counterphobic or apotropaic effects as he is with castration anxiety proper. Indeed the interest of these notes, as Jean Laplanche has pointed out, is in the deftness with which they do justice both to the affect of fear and to the mechanisms of its mitigation. Here are the third and fourth paragraphs in Freud's text, . . .

> The hair upon Medusa's head is frequently represented in works of art in the form of snakes, and these once again are derived from the castration complex. It is a remarkable fact that, however frightening they may be in themselves, they nevertheless serve as a mitigation of the horror, for they replace the penis,

the absence of which is the cause of the horror. This is a confirmation of the technical rule according to which a multiplication of penis symbols signifies castration.

The sight of Medusa's head makes the spectator stiff with terror, turns him to stone. Observe that we have here once again the same origin from the castration complex and the same transformation of affect! For becoming stiff means an erection. Thus in the original situation it offers consolation to the spectator: he is still in possession of a penis, and the stiffening reassures him of the fact.

Laplanche's commentary draws attention to the multiple—in some cases, contradictory—associations that are brought into concentrated focus in the symbol as Freud unpacks it: following one strand of associations, for example, the snakes curling around Medusa's face are penises, following another they are the pubic hair surrounding the castrated (and—to the terrified child—castrating) sex of the mother. The symbol wouldn't function *as* a symbol, he reminds us, if such condensation and concentration weren't operative; further, in addition to the effects of "consolation" Freud attributes to specific elements in the mix (as when Medusa's grim powers of petrification are translated, reassuringly, into the stiffening of an erection, or her snakes into replaceable parts), Laplanche insists on the primary apotropaic power of symbolic concentration itself. The symbol of the Medusa's head is reassuring not only because its elements can be read in those ways, but because it is a symbol. Here Laplanche's analysis of Freud's notes rejoins one of the main currents of his own thought about the castration complex, his insistence on the reassurance implicit in any scenario (however scarifying) that structures anxiety and, more particularly, in a scenario which links a theory (of how women got that way) with a perception (of what their bodies look like). "It goes without saying," he remarks, "that castration is precisely not a reality, but a thematization of reality. A certain theorization of reality which, for Freud, is so anchored in perception that to deny castration is finally the same thing as denying the perceptual experience itself. . . ."[6] Those final dots appear in Laplanche's text: the paragraph ends with that nuance of inconclusiveness, partly, I suspect, because Laplanche wants to leave the referent of "the perceptual experience itself" (*ce serait finalement la même chose de dénier la castration que de dénier l'expérience perceptive elle-*

même . . .) ambiguous. He is certainly referring to the specific perceptual experience Freud's little boy is said to have of his mother's body; but beyond that Laplanche would claim more broadly that perception and castration are ineluctably linked, and linked by way of the child's narcissism, by the intensity of his investment in representations of himself and by the predominance of his penis among such representations.

Laplanche's discussion of anxiety can help us to formulate a litany of nervous questions that may be imagined as the murmured subtext of writing like Hugo's, questions that give expression to epistemological anxiety (can I trust my eyes?), to narcissism (can I hold myself together?), to sexual anxiety (can I hold on to my penis?), to—beyond that—social and economic fears about property and status (can I hold onto anything, including representations of myself?) or—put more grandly by one of this century's grand hysterics—can the center hold? or is mere anarchy to be loosed upon the world?

To return to Victor Hugo, we can say that his choice to concentrate his account of the beginnings of the June Days as he does, by focusing on the gesture of those two women, is equivalent to the acts of condensation and focusing that went into the production of the Medusa's head as a powerful symbol. It is appropriate that Hugo writes of the uprising that it "presented strange lineaments": the lineaments may be strange, they may indeed, in the next sentence, be transformed into "monstrous and unknown forms," but that they are namable as "lineaments" gives them a physiognomic legibility that is reassuring. Hugo's anecdote is about horror, but it is shaped into an apotropaic emblem.[7]

I have said nothing about that odd phrase in which Hugo apologizes, after a fashion, for not being able to report the first woman's speech quite accurately when she "pulled her dress up to the waist and cried . . . in that dreadful brothel language that one is always obliged to translate (*dans cette affreuse langue de lupanar qu'on est toujours forcé de traduire*) 'Cowards! Fire, if you dare, at the belly of a woman!'"The gesture might seem merely prim on Hugo's part, or else unpleasantly, leeringly allusive. More likely this is as close as Hugo will come in this text to betraying an uneasy self-consciousness about the activity of representation he is engaged in. Here it is productive of a momentary qualm. . . .

Maxime du Camp—*littérateur,* photographer, member of the Academie Française, friend of Flaubert, man-about-town—was sufficiently

disturbed by the events of 1870–71 to publish, ten years later, a four-volume denunciation of the Commune and defense of the actions of the forces of order. He entitled it *Les Convulsions de Paris* and in it he included an attack on the painter Courbet for his role in the destruction of the Vendôme column, the Napoleonic monument to the victories of the Grande Armée. Whether Courbet was in fact responsible for this was a matter of some debate: Courbet denied it, but he was nevertheless found guilty by the investigating panel, heavily fined, and driven into exile.[8] Du Camp is writing after the fact to justify the verdict on circumstantial grounds, claiming that both in his theory of painting and in his practice Courbet revealed himself as just the sort of person who would get mixed up in just this sort of thing: "The man who . . . could degrade his craft to the point of abjection is capable of anything."[9]

> Every weak case may be contested, and this poor man did what he could, before the military tribunals, to fend off, or at least to attenuate the accusation that weighed on him. He was a conceited man whose self-love had drawn him into a path that was not his own. His works, too much praised and too much denigrated, made him well known and provided him with a comfortable living. His absence of imagination, the difficulty he experienced in *composing* a painting, had forced him to limit himself to what has been called realism, that is, to the exact representation of natural objects, without discernment, without selection, just as they offered themselves to view: Thersites and Venus are thus equally beautiful simply because they exist; the humpback of the one is equal to the bosom of the other. This is the theory of impotent men, who erect their defects into a system; everyone knows the fable of the fox whose tail was cut off.

The rhetoric of political confrontation, like that of any specular facing-off, is inclined to draw its force from figures of reversal: so, for Hugo, the effect of the women's gesture—or of the *émeute* "herself"—could be caught in that phrase "all that weakness contains of strength." To speak of realism as "the theory of impotent men, who erect their defects into a system" is to draw on the same resources: du Camp is locating Courbet and his school where Hugo had placed women or the unpropertied classes—impotent, with nothing to show for themselves, no natural

talent, they would instead display a theory in its place. Du Camp's language finds *its* place somewhere between Freud's description of an apotropaic gesture ("To display the penis [or any of its surrogates]. . . .") and the metaphors with which Burke castigated the revolutionaries of 1789: "Is it then true . . . that it was of absolute necessity the whole fabric should be at once pulled down, and the area cleared for the erection of a theoretic experimental edifice in its place?"[10] In this view a system— a "theoretic experimental edifice"—whether it's a system of government or a system of aesthetics, is phallic or—more properly—fetishistic: it is an ersatz thing-in-itself which can be erected, narcissistically invested and then brandished in self-defense. Hence the castration jokes Maxime du Camp feels he can make at the Realists' expense.

Nor are the Realists the only fetishists in this text: the accusation is made explicit in du Camp's account of the toppling of the column. "This rage to take it out on material things, this reversed fetishism [*ce fétichisme à l'envers*] which is the height of fetishism, which was the sickness of the Commune, appeared in all its intensity at the moment of the column's fall [*lors du renversement de la colonne*]." Figures of reversal, including this image of a literal *renversement*, coexist here with a polemical stance that is both given to and braced against *tu quoque* retorts:

> The materialism which darkened the mind of these people led them to attach importance only to the exterior, to the materiality of things. . . . In this respect, as in many others as well, the men of the Commune were medieval men. To set up an idol, to pull down an idol, to be an idolator, to be an iconoclast—it's all the same; it is to believe in the idol.

It is part of the logic of such encounters that du Camp should himself sound somewhat overwrought here, just as, in a more interesting moment in his text, he seems peculiarly overexcited by what he finds obscene in a work of Courbet's:

> All that one may ask of a man—outside of the grand principles of morality which no one should neglect—is to respect the art he professes. He can be lacking in intelligence, in learning, in wit, in politeness, in urbanity, and still remain honorable, if he maintains the practice of his art aloft and intact. Now this ele-

mentary duty, which constitutes professional probity, Courbet ignored. To please a Moslem who paid for his whims in gold, and who, for a time, enjoyed a certain notoriety in Paris because of his prodigalities, Courbet, this same man whose avowed intention was to renew French painting, painted a portrait of a woman which is difficult to describe. In the dressing-room of this foreign personage, one sees a small picture hidden under a green veil. When one draws aside the veil one remains stupefied to perceive a woman, life-size, seen from the front, moved and convulsed, remarkably executed, reproduced *con amore*, as the Italians say, providing the last word in realism. But, by some inconceivable forgetfulness, the artist who copied his model from nature, had neglected to represent the feet, the legs, the thighs, the stomach, the hips, the chest, the hands, the arms, the shoulders, the neck and the head.

The man who, for a few coins, could degrade his craft to the point of abjection, is capable of anything.

There is a certain degree of overkill in Maxime du Camp's account of [Courbet's picture—see Figure 22]: the artist hadn't, it would appear, entirely neglected "the thighs, the stomach, the hips" or "the chest." The intensity of focus, that zeroing in on the woman's genitals, is the work of the beholder in this case, and it is coordinate with other features of his text: its disingenuous air of moral indignation, the coyness of its negative anatomy ("not this, not that . . . but you know what!"), its dragging-in of those innocent Italians, presumably so as to motivate the appearance of the word *con,* so that du Camp can surreptitiously name what is "difficult to describe" without openly using "that dreadful brothel language that one is always obliged to translate." It would be wrong to suggest, however, that behind all this periphrasis and moral outrage lies no more than the prurience of a closet voyeur: du Camp's dismay is as genuine and as powerful as his fascination. Together they produce an ambivalence that informs his discussion of the Commune and the aesthetic theories of the Realists as much as it does his response to Courbet's nude. To describe her body as "convulsed," for example, is to assimilate her horrid appeal to that of the political "convulsions" du Camp is charting in Paris. But the links among erotic, political, and aesthetic attitudes go deeper than that, and they become easier to discern when one collates the

apparently contradictory statements these pages on Courbet contain. It is because Courbet had difficulty *"composing* a painting," du Camp insists, that he was forced into realism, "the exact representation of natural objects . . . just as they offered themselves to view." And yet "the last word in realism" turns out to be this representation of a woman's genitals "just as they offered themselves to view," yet still *composed,* selected, and focused—in du Camp's account—with an intensity that would be hard to match. Here the traditional paradoxes about what it means for a painter to copy "Nature" are energized by the ambivalence—sexual and epistemological—that inheres in fetishism: What is there to be seen in the object? How passive—or how willfully systematic—is that seeing? How is what one sees shaped by what one thinks one has or fears to lose? These are the urgencies that are played out in Maxime du Camp's pages: it is not unreasonable that his hatred of the Commune should have led him, by something like free association, to Courbet's nude.

Confronted with such extravagant responses, we may decide to grant Victor Hugo the license of a poet and novelist and to write off Maxime du Camp as not much more than a panicky *arriviste,* the Norman Podhoretz of the Second Empire.[11] But what of a serious historian? Let us look now at Tocqueville's recollections of the events of 1848, as he set them down in his posthumously published *Souvenirs.* Although not a republican, Tocqueville was nevertheless not displeased when Louis-Philippe was overthrown in February. Like Hugo, he momentarily hoped that a regency could be established; when that did not materialize, he adopted an attitude he describes as one of somewhat remote curiosity, but by June he had become disturbed by the turn events were taking and when the fighting broke out he was very much on the side of the party of order. I quote his account of an incident on June 24, the second day of street-fighting, as he made his way to the Chamber of Deputies:

> When I was getting near and was already in the midst of the troops guarding it, an old woman with a vegetable cart stubbornly barred my way. I ended by telling her rather sharply to make room. Instead of doing so, she left her cart and rushed at me with such sudden frenzy that I had trouble defending myself. I shuddered at the frightful and hideous expression on her face, which reflected demagogic passions and the fury of civil war. I

mention this minor fact because I saw in it then, and rightly, a major symptom. At moments of violent crisis even actions that have nothing to do with politics take on a strange character of chaotic anger; these actions are not lost on the attentive eye and they provide a very reliable index of the general state of mind. It is as though these great public emotions create a burning atmosphere in which private feelings seethe and boil.[12]

This is a story with two points. One is about the nature of the June Days: like Hugo's, this is a representative anecdote, in which a woman's gesture encapsulates the meaning of the revolution. But Tocqueville also intends to tell us something about how one comes upon representative anecdotes, about the power of that "attentive eye" to grasp the meaning of a minor, possibly negligible, incident, a power that the author of *Democracy in America* can rightly claim for himself. He knows that an observer thoughtful and canny and experienced enough will "see" the meaning of historical moments in such small details. But perhaps "seeing" is not quite the right verb for what Tocqueville is demonstrating here: rather his power is that of someone who can "read" the meaning of a face in a rapid and unperplexed fashion. For, like Victor Hugo, Tocqueville is interested in the "lineaments"—what he calls *traits*, "features"—of physiognomy, and indeed physiognomy is his chief metaphor for historical interpretation. . . .

But if the language of Hugo's text immediately associated the "monstrous and unknown forms" with the sight of a woman's body, the path of association in Tocqueville is less rapid and direct: it goes by way of a denunciation of socialist theorizers as furiously energetic, crazed producers of signs:

It was those socialist theories, which I have previously called the philosophy of the February Revolution, that later kindled real passions, embittered jealousies, and finally stirred up war between the classes. . . .

After the 25th February a thousand strange systems poured from the impetuous imaginations of innovators and spread through the troubled minds of the crowd. Everything except Throne and Parliament was still standing; and yet it seemed that the shock of revolution had reduced society itself to dust, and

that there was an open competition for the plan of the new edifice to be put in its place; each man had his own scheme; one might publish his in the papers; another might use the posters that soon covered the walls; a third might proclaim his to the listening winds. One was going to abolish inequality of fortunes; another that of education; while a third attacked the oldest inequality of all, that between men and women. (S95/R74)

Like Pope's madman who "locked from ink and paper scrawls/With desperate charcoal round his darkened walls," the innovators are here conjured up in a vision of semiotic behavior gone haywire: the paragraphs link socialism to the grotesque proliferation of theories, to irregular publication, to the abolition of inequalities and—in a cadence that should by now seem predictable—to the final, one-would-have-thought ineradicable difference between the sexes. But how, exactly, did Tocqueville get from writing to women? A final quotation should make that clear: it is a vignette of a conversation Tocqueville had, in the spring of 1848, with the writer—and socialist sympathizer—George Sand:

> Milnes put me beside Madame Sand; I had never spoken to her, and I don't think I had ever seen her before (for I have not lived much in the world of literary adventurers which she inhabited). When one of my friends asked her what she thought of my book about America, she replied: "Sir, I make it a habit only to read the books that are presented to me by the authors." I had a strong prejudice against Madame Sand, for I detest women who write, especially those who disguise the weaknesses of their sex *en système*. . . . (S150/R134)

I have left the last two words in French because it's hard to find English equivalents that are both easily colloquial and accurate. . . . Tocqueville is using *en système* in the only way it is generally used in French; that is, in the same way Maxime du Camp is using it when he complains that the Realists are "impotent men, who erect their defects into a system" (*qui érigent leurs défauts en système*): the phrase should read "I detest women who write, especially those who disguise the weaknesses of their sex by producing a system," however awkwardly that strikes the ear. It is in this respect that George Sand serves as a transitional figure between Toc-

queville's dismay with socialist theories and the horror he felt when he stared into the face of the old woman.

If his use of *en système* aligns Tocqueville's text with du Camp's, his remark about women who disguise the weaknesses of their sex brings his language close to Hugo's "all that weakness contains of strength." Tocqueville's writing is more considered and less overwrought, but his implication in this tangled set of attitudes towards sexual differences, politics, and knowledge is similar to theirs. All three writers have produced intensely charged passages that are about a confrontation with a woman, a confrontation in which each finds an emblem of what revolutionary violence is all about. To rehearse the chain of associations we have been following in Tocqueville may allow us to see what is at work in the other writers as well. An investment in property, to begin with: property seen as a sign of privilege and set over against those other signs marked out by those without property, the systems and theories of socialists. It is they who publish attacks on all inequalities—any old inequality—including the oldest of all, that between men and women. And in this they are like those women writers who convert their weaknesses into systems and would brandish these substitutes apotropaically, defying those possessed of the more natural signs of privilege, of which property is the most fundamental. This would seem to be in defense of Tocqueville as a man-of-property, Tocqueville-from-Tocqueville. But it is also a defense of Tocqueville as the author of this resolutely nontheoretical account of what is happening in the world, a physiognomic reading of the confused features of his time which, though he contemplates them with mingled curiosity and fear, he nevertheless imagines to be *lookable at,* composable into features of the same face, if not characters of the great Apocalypse. What I'm suggesting is that it is this belief—that one can see history as the features of a face, read it off a composed physiognomy— that Tocqueville must defend, chiefly by casting out something that resembles it a bit too closely for comfort: that production of "unnatural" systems which interpret the historical world with a willed and artificial coherence, and which are manifestly invested by their creators with the narcissistic charge of something like property. They are threatening to the extent that they raise doubts about one's own more natural ways of looking at things; and it is that threat that prompts these powerfully rendered Medusa-fantasies when they are offered as substitutes for a more patient, inclusive account of political conflict.

A Vermiform Appendix: The Phrygian Cap

When I first presented this material to an audience at Johns Hopkins, Beatrice Marie, of the Humanities Center, suggested that some connections might be drawn between the complex of sexual, proprietary, and epistemological investments I had associated with the appearance of Medusa-fantasies in political contexts, on the one hand, and, on the other, the adoption, during the French Revolution, of the Phrygian cap as an emblem of Liberty. She had in mind the droopy-phallic look the cap takes on when its crown falls forward or to one side, as it does in [a] mocking portrayal of Louis XVI, obliged to wear the cap (apotropaically, but—as it turned out—ineffectively so) in June 1792; and she wondered if the cap might not consistently, if surreptitiously, be associated with the threat of impotence or castration. I had no ideas on the subject at the time, but I've since had a chance to read around in histories of costume and of iconography, and this reading would seem to confirm Ms. Marie's hunch. It also provides a further illustration of the odd now-you-see-it/now-you-don't logic with which these motifs appear and disappear, come together and disperse, in historical enactment and in historical interpretation.

The usual understanding of the *bonnet rouge de la Liberté* is as an unequivocally political symbol. The cap was taken to stand for liberty because it had stood for liberty in Rome: under the Empire it had been awarded to slaves on the occasion of their manumission; earlier still, it had been mounted on a staff and paraded through the streets of the city by Caesar's assassins. I cite a recent summary of this account from an article by Jennifer Harris:

> Along with other symbols borrowed from the period of classical antiquity (such as the Roman *fasces* denoting Unity and Indivisibility), [the *bonnet rouge*] early enters revolutionary iconography as a symbol of liberty, having been worn in Rome by freedmen as a sign of their new position, although it was also worn by several different nations of antiquity and by various individuals. It is associated, for example, with the dress of Paris who is shown wearing it in David's 1788 painting *Paris and Helen*. In Rome it does appear to have stood for liberty in the same way that it was to in France after 1789, for it is represented on a coin of Brutus,

issued in Asia Minor in 44–42 B.C., positioned between two daggers and recalling the Ides of March.[13]

But here a slight complication develops: the cap on the coin Harris is referring to doesn't look like a Phrygian cap—it lacks the droop. Does that matter? Apparently it does, at least to some historians, ancient and modern: as one reads further in French accounts of the *bonnet rouge* and in descriptions of classical headgear, the question of what the Roman cap of liberty actually looked like (and what sorts of cap it was to be distinguished from) gets interestingly tangled and generates more vehemence than you would think a hat properly should. . . .

Because it had been settled, by the end of the Revolution, that figures representing Liberty, or the Republic, or France, would be female,[14] the political themes played out in this wavering fashion could draw, consciously or subliminally, on attitudes towards sexual difference for their affective force. A straightforward example of this can be found in an editorial [Maurice] Agulhon cites from *L'Artiste* of March 1848: "The Republic will wear no red cap," it decrees, "she will be no camp-follower but a serene, glorious and fertile mother who will hold festivals and shed smiles upon her children."[15] But more bizarre and, for our purposes, more telling evidence that the Phrygian cap carried a high sexual charge can be found in a pamphlet entitled *De l'Origine et de la forme du bonnet de la Liberté* (1796). Its author, Esprit-Antoine Gibelin, identifies himself as a *Peintre d'histoire,* but he must also have been a reader of considerable range, capable of rapidly surveying the uses the cap was put to from classical times through the Renaissance. But chiefly he writes as a distinguisher, someone anxious to disseminate the "true meaning" of the *bonnet rouge* by insisting that its "true form" is that of the simple, rounded *pilleus,* just as it appears on the coin of Brutus: semioval, chaste, and droop-free. I cite at length, to convey the urgency of his insistence and the sexual polemic which informs it:

> . . . our French artists, in the many paintings, sculptures, and engravings made since the beginning of the revolution, have used the form of the Phrygian cap to adorn the head even of the figure of Liberty. Seduced by the refined turn of this effeminate cap [*Séduits par le galbe recherché de ce bonnet efféminé*], that ancient monuments have conserved for us on the graceful heads of a

Paris and of a Ganymede, they have not considered that nothing is less appropriate to designate liberty than the Phrygian cap; that it is an Asian headgear; that liberty never dwelt in those lands; that even the Asiatic section of Greece was unable to conserve its own liberty and that the enslaved kings pictured on Roman arches of triumph wear an almost similar cap.

In truth, when the semi-oval form of the ordinary cap is a little elongated, the part that exceeds the crown of the head folds and falls, sometimes forward, sometimes back. Then it more or less imitates the form of the Phrygian cap, and the caps of those enslaved kings, placed in Rome on the arch of triumph of Constantine, and on the stairway of the Farnese palace, seem to be of that sort; but, once again, this is not the true cap of Liberty as it is represented on ancient medals and monuments.

It must be semi-oval, and if artists may permit themselves, in their imitation, to give it a little bit more fullness, in order to obtain picturesque folds, they must never, running to excess, expose to our view a Phrygian cap as a cap of Liberty [*il ne faut point que, donnant dans l'excès, ils exposent à nos regards un bonnet Phrygien pour un bonnet de la liberté*].

It is especially essential, in a symbolic representation of this sort, to avoid anything that can mislead the imagination by associations that are seductive [*d'éviter tout ce qui peut égarer l'imagination par des rapports séduisans*] and contrary to the goal proposed by the majority. It is necessary to determine [*fixer*] a just idea of the emblematic meaning of each form.[16]

The dangers to be avoided here are indeterminately political, sexual, and epistemological. Enslavement, seduction, the loss of manhood, and the unfixing of determinate ideas of what things mean are held up as equivalent threats, and these baleful consequences inhere in the overly refined turn of the top of a cap, or—more theatrically—in the possibility that, looking for Liberty (or for the Republic, that "serene, glorious and fertile mother"), we may find, exposed to our glance, the droop of the Phrygian cap. This is the rhetoric of male hysteria, playing out, with an only slightly different set of images, the Medusa-fantasies we have been considering in the earlier pages of this paper. And I suspect that it is in these terms that we can best understand an otherwise puzzling moment

in Agulhon's history. Here again he is citing *L'Artiste,* this time a set of instructions, published in April 1848, on how properly to represent the figure of the Republic. She should be seated, thus expressing, as Agulhon notes, calm and order; she should manifest all three of her aspects—Liberty as well as Equality and Fraternity—hence she should wear the cap, but with a difference:

> I nearly forgot to mention the cap. I indicated above that the Republic should sum up the three forces of which her symbol is combined. You are therefore not in a position to remove this sign of liberty. Only do find some way of transfiguring it.

Agulhon quotes these lines then wonders, in a footnote, what they can mean, exactly: "Although the intentions are clear, the concrete instructions are less so. How can one 'transfigure' a cap but 'not make it disappear' in its accustomed form?"[17] I think the answer is simple: remove the droop and you transfigure the cap. The author of those instructions shared, no doubt unconsciously, Gibelin's feelings about the proper look, the "true form" of the cap of Liberty.

Untransfigured, the Phrygian cap aroused strong feelings; indeed, after the Commune it became, in Agulhon's words, "an object of official loathing," and the last chapters of his book chart the intensities of opposition during the 1870s and 1880s. I have been implying that, whatever its political sources, some of that intensity was psycho-sexual in origin, the result of the cap's signifying, equivocally, both the possession and the lack of phallic power.[18] Just as Gibelin urgently repeats his identification of the effeminate cap with that of "the enslaved kings pictured on Roman arches of triumph," so nineteenth-century men of property could read in the cap the provocative lineaments of power and abjection, both "all that weakness contains of strength" and, proleptically, all that their own strength might conceal of weakness. For if caps can be removed, so can heads; and, not so long before, a certain number of heads *had* been removed by people wearing those very caps. Shortly after Louis XVI's execution, a print appeared showing his head held aloft like Medusa's (Figure 12). Beneath it are two revolutionary emblems, the cap of Liberty and the Masonic level, the sign of Equality. Supported by the level, the cap has been carefully aligned with the King's head, so that its tip, soft-falling to the right, echoes the fall of the King's hair. Detached in

this way, the cap functions as a mini-Medusa, and it seems to have been capable of producing something of the same *frisson*.

Agulhon, who is wary of psychoanalytic interpretations, and who would no doubt find this association of the *bonnet rouge* with Medusa both far-fetched and tendentious,[19] nevertheless provides further evidence of its plausibility in his chapter on the early 1870s. He describes, in fascinating detail, the conservative polemic against republicanism, the attempts to keep representations of the Motherland free of any taint of revolutionary imagery, attempts which included the destruction of a statue wearing the Phrygian cap, as well as official proclamations condemning the cap as a violent and "seditious" emblem. In this context he takes up a painting produced in 1872, "a representation of Evil entitled 'The Fatal Fall'" which depicts Mankind toppling into the abyss, apparently propelled there by the powerfully malign influence of three allegorical personages, a sophistic Blakean "Human Reason" and two bad women, whom Agulhon describes in these terms:

> One of them lies there naked, in a state of abandon, with a wineglass in her hand—she clearly represents Evil in private life; the other, whose upper body only is naked, must be Evil in social life, namely Revolt. In her left hand she holds a torch and in her right a dagger. We cannot fail here to recognize the accessories that have become so familiar to us in their classic reactionary interpretation. The torch of Enlightenment has become the brand that set Paris alight and the sword of political conflict has shrunk to an assassin's dagger.
>
> We are bound, in all honesty, to admit that this fury is not wearing a Phrygian cap. Her heavy locks could be interpreted rather as the serpents of discord—a motif which is, after all, close to it.[20]

Close enough, I would agree.

One final example: in 1797 Antonio Canova began work on a statue of *Perseus Triumphant,* holding at arm's length the head of Medusa; customarily such depictions of Perseus—Cellini's, for example—show him wearing the helmet given him by Hades, the helmet of invisibility (Figures 9 and 10). In Canova's statue he is wearing an odd conglomerate

headpiece, combining the traditional winged helmet with the lappets and the droop of the Phrygian cap. Perhaps there was precedence for this, but I doubt it: it seems unlikely that Perseus could have been represented in this way before 1793—that is, before the guillotining of the king. Canova has also departed from Cellini's example by having Perseus rotate the head so that it is almost—almost, but, for safety's sake, not quite—facing him. The result is to fix in marble an emblem of the political and sexual specularity we have been considering, the interchangeability of the Phrygian cap and the head of Medusa.

Notes

1. Sigmund Freud, "Fetishism," in *Sexuality and the Psychology of Love,* ed. Philip Rieff (New York, 1963), p. 215.

2. Edmund Burke, *Reflections on the Revolution in France,* ed. Conor Cruise O'Brien (Baltimore, 1968), pp. 181, 166, and 165.

3. *Oeuvres complètes,* tome XXXI (Paris, 1955), pp. 365–66.

4. Cf. the following account from *The Examiner,* a London weekly:

> One of the females, a young woman neatly dressed, picked up the flag, and leaping over the barricade, rushed towards the national guards, uttering language of provocation. Although the fire continued from the barricade, the national guards, fearing to injure this female, humanely abstained for some time from returning it, and exhorted her to withdraw. Their exhortations, however, were vain, and at length self-preservation compelled them to fire, and as the woman was in front of the barricade a shot reached her and she was killed. The other female then advanced, took the flag, and began to throw stones at the national guards. The fire from the barricade had become feeble, but several shots were fired from the sides and from the windows of houses, and the national guards, in returning the fire, killed the second female.

This appeared in the issue of July 1, 1848, and is described as a translation of an eyewitness account which had appeared earlier in Paris.

5. This combination of offenses—against property and decency—reappears in an American National Guardsman's recollections of his participation, ten years earlier, in the encounter with protesters in Kent State:

> "James W. Farriss admits he was excited when he heard his National Guard unit was going to Kent State. He had never been on a college campus.
>
> "He recalls now that when he got to campus he was repelled by the students' obscene gestures and filthy language. As a soldier sent to protect property, he was outraged to see it destroyed.
>
> "'It seemed like all the young women were shouting obscenities or giving obscene gestures. I had never seen that before,' said Farriss. 'I've heard a few men talk like that, but not women.'
>
> "There were 75 guardsmen besides Farriss on the hill alongside Taylor Hall, according to Guard reports. A 13-second fusillade stilled the din of an anti-war protest." (From an Associated Press story published in the *Ithaca Journal*, May 4, 1979)

6. Jean Laplanche, *Problématiques II / Castration-Symbolisations* (Paris, 1980), p. 66.

7. The *politically* apotropaic effects of the Medusa's head derive from its reappearance on Minerva's shield and from the use of representations of that shield as symbols of the State's power to defend itself against its enemies. See, for example, the ceremonial use of the shield in Rubens's *Philip IV Appoints Prince Ferdinand Governor of the Netherlands* (Figure 66 in John Rupert Martin, *The Decorations for the Pompa Introitus Ferdinandi* [London and New York, 1972]). In *Détruire la peinture* (Paris, 1977), Louis Marin discusses a notorious instance, Caravaggio's *Medusa's Head* painted on a circular shield, a work commissioned by a cardinal as a present to the Grand Duke of Tuscany. Marin's analysis is detailed and fascinating and should be read—especially the section entitled "Intermède psychanalytique"—as a counterirritant to the argument of this paper. Marin notes the ways in which thinking about matters of representation can lead one into the thematics of castration, but he is leery of what he takes to be the pathos—or bathos—of Freud's reading of the Medusa's head.

8. The details of Courbet's involvement in the Commune, his trial, and ex-

ile are summarized in Marie-Thérèse de Forges's *Biographie* in the catalogue of the centenary exhibit of his work in Paris, 1977–78, *Gustave Courbet (1819–1877)* (Paris: Éditions des musées nationaux, 1977), pp. 46ff. A longer account may be found in Gerstle Mack, *Gustave Courbet* (New York, 1951).

9. *Les Convulsions de Paris,* 4 vols., 5th ed. (Paris, 1881), vol. 2, chap. V ("La Colonne de la Grande Armée"). I have translated passages from pp. 183, 184, 189–90, and 209.

10. *Reflections,* p. 230.

11. This may seem like a gratuitous slur, but Podhoretz is, in fact, the interesting contemporary analogue and his book, *Breaking Ranks* (New York, 1979), takes a position in relation to "The Movement" remarkably like that of du Camp in relation to the Commune. Compare du Camp's sexual-political fulminations with this, from Podhoretz's "Postscript" (addressed, instructively, to his young son): "But if the plague seems for the moment to have run its course among these groups [i.e., "the young, the blacks and the intellectuals"], it rages as fiercely as ever among others: among the kind of women who do not wish to be women and among those men who do not wish to be men. . . . [T]here can be no more radical refusal of self-acceptance than the repudiation of one's own biological nature; and there can be no abdication of responsibility more fundamental than the refusal of a man to become, and to be, a father, or the refusal of a woman to become, and be, a mother" (p. 363). Peter Steinfels, in *The Neoconservatives* (New York, 1979), offers a measured but deftly witty discussion of the sociology as well as the intellectual background of writers in Podhoretz's group and indeed sees their dependence on a tradition that extends back through Tocqueville to Burke. For a less scholarly but even funnier discussion, see Gore Vidal's "Pink Triangle and Yellow Star" in *The Second American Revolution and Other Essays* (New York, 1982).

12. *Oeuvres Complètes,* 12, ed. Luc Monnier (Paris, 1964), pp. 159–60. *Souvenirs* has been translated by George Lawrence, under the title *Recollections,* ed. J. P. Mayer and A. P. Kerr (Garden City, N.Y., 1970), where this passage appears on p. 145. I have generally quoted Lawrence's translation, occasionally modifying it to produce a more literal rendering. Page references will henceforth be given in the text, in both French (S) and English (R) editions.

13. "The Red Cap of Liberty: A Study of Dress Worn by French Revolutionary Partisans 1789–94," *Eighteenth-Century Studies* 14 (1981), 283–312. Similar remarks can be found in Jules Renouvier's *Histoire de l'Art pendant la Révolution,* 2 vols. (Paris, 1863), vol. 2, pp. 394–96, and in the introductory pages of the most recent, sophisticated discussion of the iconography of Liberty

in France, Maurice Agulhon's *Marianne into Battle: Republican Imagery and Symbolism in France, 1789–1880* (Cambridge, England, 1981).

14. Lynn Hunt, in "Hercules and the Radical Image in the French Revolution," *Representations* 2 (1983), 95–117, offers a more nuanced account of this development than Agulhon's. See also her *Politics, Culture, and Class in the French Revolution* [Berkeley and Los Angeles: University of California Press, 1984].

15. *Marianne into Battle,* p. 84.

16. *De l'Origine et de la forme du bonnet de la Liberté* (Paris: Buisson, 1796), pp. 24–26. Renouvier (see n. 13, above) draws on this pamphlet for his discussion of the *bonnet rouge;* he gives a brief sketch of Gibelin's career in the first volume of his *Histoire,* pp. 132–34.

17. *Marianne into Battle,* p. 82 and n. 73.

18. That these sexual associations would be repressed and would surface only in oddities of phrasing or of iconographical development is one of the (conventional enough) assumptions of this paper. But there are likely to be exceptions that serve as proof of this rule, occasional acts of explicitness, marginal voices more apt to be ignored than suppressed. One of these voices is that of Joel Barlow, the Connecticut poet (and friend of Tom Paine) who was living in Paris during the 1790s. Barlow left behind a brief, undated manuscript entitled "Genealogy of the Tree of Liberty" which is now in the possession of the Houghton Library of Harvard University (bMS Am 1448). Barlow traces the festive use of the Liberty Tree back to Bacchic and, beyond that, Egyptian worship of the phallus. "The *liberty cap,*" he adds, "is precisely from these [?] origins. It is taking a part for the whole, as the *Ear of Wheat* is used, in some planispheres, to represent the *harvest Virgin* or *Ceres* in the Constellations. The Liberty Cap is the head of the Penis, an emblem of Liberty. The first civil or political use that was made of it was by the Romans when they gave liberty to a Slave. They put a Red Cap upon his head, which he wore ever after, to denote that he was a Freed Man.—Neither master nor man knew the origin of this curious emblem" (p. 13, recto). I'm grateful to the Houghton Library for permission to reprint the text, and to Robert Dawidoff and Eve Kosofsky Sedgwick for help tracking it down.

19. See his "On Political Allegory: A Reply to Eric Hobsbawm," *History Workshop* 8 (1979), 169: "Certainly such areas need exploring, and the (only recently abandoned) reluctance to explore them was undoubtedly misguided. However, now that the taboo on the history of sexuality has been lifted, there is as much danger in attaching undue importance to it, as in the past there was error in ignoring it altogether." This is sensible enough and, in the context of

Agulhon's quarrel with Hobsbawm, very much to the point. But consider this more elaborate expression of his scepticism, from the conclusion of *Marianne into Battle*. He is speculating on why "the Republic" was given a woman's name and he notes that "a number of subtle writers have meditated upon similar themes." From one such meditation, by Jean Giraudoux, Agulhon cites the following sentence—"He felt that to change a country from a kingdom (*un royaume*) into a Republic (*une* Republique) was to change its very sex . . ."—then continues: "The sex of a Nation! . . . One can imagine how far up the garden path of socio-psychoanalytical meditation one could be led if one pursued that track. We must admit that we would put no great faith in such a venture, believing that to apply categories of individual psychology to collective concepts could lead one to make the mistake of taking metaphors for realities" (p. 185). Neither of the distinctions relied on here—between "categories of individual psychology" and "collective concepts," or between "metaphors" and "realities"—seems refined enough to justify a serious methodological *parti pris*.

20. *Marianne into Battle,* p. 159. The painting is reproduced on p. 160.

from *The Mirror of Medusa* (1983)

Medusa as Double

Tobin Siebers, a professor of English, specializes in postmodern and critical theory. In his 1983 book, *The Mirror of Medusa*, he considers how Medusa becomes crucial to an anthropological understanding of curses and amulets across cultures. Siebers relates these phenomena to the cultural prominence of narcissism. His analysis allows him to offer a reading of the material culture incorporating Medusa—jewelry, coins, and vases—along with a reading of the myth itself.

Circulating on the aegis of Athena and in the hands of Perseus, the head of Medusa fascinates; its horrifying countenance spontaneously transforms its beholder to stone. Yet the mask of Medusa also serves an apotropaic function, as do all masks, by protecting its wearer against fascination. The mask of Medusa once more presents a familiar paradox: the Gorgoneion both causes and cures the evil eye.

Yet Perseus also carries and cures the disease of fascination. Seeking out his enemies, he focuses a terrible glance upon them. His anger and hatred are concealed as he seems *to mask* himself with Medusa's fatal countenance. This gesture stimulates the imagination, and its appropriate image is provided by Benvenuto Cellini (Figure 9). Cellini's marvelous statue provides a stunning vision of Perseus and Medusa, attesting to the enormous intuitive power of great art and its capacity to rearrange and reveal mythological material. When the statue is seen from behind, Perseus and Medusa resemble each other; the hero's tangled locks mimic the coils of the serpents that entwine his victim's head. Hades's cap of invisibility depicts the god's gloomy countenance, indicating Cellini's belief that the cap was a mask. The features of the god of the underworld thus join with those of Perseus to compose a rather odd Janus figure. As this monstrous Perseus gazes ahead at his enemies, the god of death stares to the rear, counting the victims left in the wake of the hero's swift and relentless advance. Viewed from Perseus's right side, the statue re-

veals another Janus figure; the hero and monster displaying identical profiles. The aquiline noses, delicate cheek bones, and lowered eyes twin each other, presenting a baffling spectacle for those in need of clear distinctions between the heroic and monstrous. Standing in front of the statue, the beholder is mortified to discover that the faces of the slayer and victim are doubled. Both the Gorgon and Perseus poise themselves in serenity and peace, the only trace of violence being the twisted limbs and spurting neck wound of Medusa's headless corpse. . . .

The mask of Medusa, however, conceals another monstrous double whose story exhibits the secret violence at the heart of the myth. According to Apollodorus, it is Athena who orders Medusa's death, guides Perseus's deadly sword stroke, and eventually receives the head from the hero's hands. In Euripides's *Ion,* a simpler and presumably Attic form of the myth, Athena slays the Gorgon and places the head on her aegis. The *Theogony* records a scene in which Poseidon and Medusa consort in a beautiful meadow. An Alexandrian poet retells the story, resituating the violation in the temple of Athena. Apparently, Athena witnesses the impious act and punishes the youngest and most beautiful of the three Gorgons by turning her into a monster. Pindar's version, later corroborated by Apollodorus, also describes the rivalry between Athena and Medusa. Accordingly, Medusa dares to compare her beauty to Athena's, which angers the goddess of reason to such an extent that she crowns the Gorgon's head with a wreath of hissing serpents. Pindar also evidences the beauty of Medusa by describing her as "fair-cheeked." Moreover, in Greek the name "Medusa" attests to the Gorgon's singular stature for it means "queen."

The queen of the city and the queen of hell share a history of rivalry, which is dramatically stressed by the fact that the birth of Athena presents the *mirror image* of Medusa's death. After either Hephaestus or Prometheus opens Zeus's head with an axe, Athena, fully armed, springs from the wound. Medusa dies from the sword blow of Perseus, and from her head spring Pegasus and Chrysaör. These two scenes, by virtue of their similarity, again present the violent competition between goddess and monster. Both in the beauty contest and in the above scene, Athena must overcome Medusa to establish her own identity. In the final analysis, however, she is only marked by her conflict with the monster, as the Gorgoneion on her aegis so clearly witnesses.

59 TERESA DE LAURETIS
from "Desire in Narrative" (1984)

Medusa in Cinema

In *Alice Doesn't: Feminism, Semiotics, Cinema*, Teresa de Lauretis synthesizes semi-
otics and psychoanalysis to provide a feminist narrative theory that scholars have
subsequently found extremely valuable for reading both filmic and literary texts.
Chapter 5 of that volume explores the interrelation of desire and narrative—a rela-
tion materially inscribed through the woman's body. In this excerpt, de Lauretis turns
to the myth of Medusa, suggesting that classical mythology as we know it restricts
the narrative role of women in ways that the original myth did not, because we have
inherited only "hero narratives." Medusa's fate, she argues, is one that might befall
any woman consumed by questions of "cinematic identification and spectatorship."

My question . . . , what did Medusa feel seeing herself reflected in
Perseus's shield just before being slain, was intended very much in the
context of a politics of the unconscious. It is a rhetorical question, but
one that nonetheless needs to be posed within the feminist discourse and
urgently demands of it further theoretical attention. It is a rhetorical
question in the sense that, I believe, some of us do know how Medusa
felt, because we have seen it at the movies, from *Psycho* to *Blow Out*, be
the film a *Love Story* or *Not a Love Story*. Yet our knowledge, and the expe-
rience of that feeling are discounted by film critics as subjective and idio-
syncratic, and by film theorists as naive or untheoretical. Some, for
example, would remind us that when we see Medusa being slain (daily)
on the screen, as film and television spectators, we have a "purely aes-
thetic" identification.[1]

Others—and probably you, too, reader—would object that my
question about Medusa is tendentious, for I pretend to ignore that in the
story Medusa was asleep when Perseus entered her "cave"; she did not
see, *she did not look*. Precisely. Doesn't an "aesthetic" identification mean
that, though we "look at her looking" throughout the movie, we too,
women spectators, are asleep when she is being slain? And only wake up,

like Snow White and Sleeping Beauty, if the film ends with the kiss? Or you may remark that I am indeed naive in equating Perseus's shield with a movie screen. Yet, not only does that shield protect Perseus from Medusa's evil look, but later on, after her death (in his further adventures), it serves as frame and surface on which her head is pinned to petrify his enemies. It is thus, pinned up on the shield of Athena, that the slain Medusa continues to perform her deadly task within the institutions of law and war . . . and cinema (I would add), for which Cocteau (not I) devised the well-known definition, "death at work."

In an equally well-known paper of 1922, entitled "Medusa's Head," Freud reiterated his theory that "the terror of castration . . . is linked to the sight of something," the female genitals; and similarly "the sight of Medusa's head makes the spectator stiff with terror, turns him to stone," but at the same time offers him "consolation . . . the stiffening reassures him."[2] This is what Cixous parodies in "The Laugh of the Medusa," when she says: "[Men] need femininity to be associated with death; it's the jitters that give them a hard-on! for themselves!" (p. 255). "What then of the look of the woman?" asks Heath. "The reply given by psychoanalysis is from the phallus. If the woman looks, the spectacle provokes, castration is in the air, the Medusa's head is not far off; thus, she must not look, is absorbed herself on the side of the seen, seeing herself seeing herself, Lacan's femininity." And he quotes the Lacanian analyst Eugénie Lemoine-Luccioni: "In thus offering herself to the look, in giving herself for sight, according to the sequence: see, see oneself, give oneself to be seen, be seen, the girl—unless she falls into the complete alienation of the hysteric—provokes the Other to an encounter and a reply which give her pleasure."[3] Cixous's anti-Lacanian response is certainly more encouraging, but only slightly more useful practically or theoretically: "You only have to look at the Medusa straight on to see her. And she's not deadly. She's beautiful and she's laughing" (p. 255). The problem is that to look at the Medusa "straight on" is not a simple matter, for women or for men; the whole question of representation is precisely there. A politics of the unconscious cannot ignore the real, historical, and material complicities, even as it must dare theoretical utopias.

Freud may not have known it, but in that two-page paper he put forth the definitive theory of pornographic cinema and, some have argued, of cinema *tout court*. Death at work. But whose death is it, whose work, and what manner of death? My question then, how did Medusa

feel looking at herself being slain and pinned up on screens, walls, bill-
boards, and other shields of masculine identity, is really a political ques-
tion that bears directly upon the issues of cinematic identification and
spectatorship: the relation of female subjectivity to ideology in the rep-
resentation of sexual difference and desire, the positions available to
women in film, the conditions of vision and meaning production, for
women.

Notes

1. Seymour Chatman, "What Novels Can Do That Films Can't (and Vice
Versa)," *Critical Inquiry* 7, no. 1 (Autumn 1980): 139.

2. Sigmund Freud, "Medusa's Head," *SE*, vol. 18, pp. 273–74.

3. Eugénie Lemoine-Luccioni, *Partage des femmes* (Paris, 1976), quoted by
Stephen Heath, "Difference" [*Screen* 19, no. 3 (1978)], p. 85.

from "The Voice of the Shuttle Is Ours" (1984)

Rape and Silence in the Medusa Story

Patricia Klindienst Joplin's influential essay is a response to Geoffrey Hartman's "The Voice of the Shuttle: Language from the Point of View of Literature" which, for Joplin, elided the "gender-specific violence of rape and the politics of literary representation" in its discussion of the myth of Philomela. In the following excerpt from "The Voice of the Shuttle Is Ours," Joplin argues for another instance of real violence to women that has been elided in myth—this time, the myth of Medusa—and claims that Medusa, herself silenced, has been used to silence other women.

Among the women represented with "their own features and a proper background" in Arachne's tapestry is Medusa herself. To tell the tale of Poseidon's rape of Medusa is to suggest what the myth of the woman who turns men to stone conceals. The locus of that crime was an altar in the temple of Athene. The background of the crime was the city's need to choose what god to name itself for or what is usually represented as a rivalry between Poseidon and Athene for the honor. Was Medusa raped, or was she sacrificed on the altar to Athene? Was the woman "punished" by Athene, or was she killed during a crisis as an offering to the "angry" goddess by the city of Athens, much as Iphigenia was said to be sacrificed to a bloodthirsty Artemis?

Medusa does not become a beautiful human virgin in Greek myth until very late. Behind the decapitated woman's head Perseus uses to turn men to stone lies the ancient gorgon. The gorgon or Medusa head was also used as an apotropaic ritual mask and is sometimes found marking the chimney corners in Athenian homes.[1] The mythical Medusa may recall a real sacrificial victim. The violence is transformed into rape, but the locus of the act—the altar—is preserved, and responsibility for the crime is projected onto the gods. But even there, it must finally come to rest upon another "woman," Athene. Behind the victim's head that turns men to stone may lie the victim stoned to death by men. Perhaps it is the

staring recognition of human responsibility for ritual murder that is sym-
bolized in the gaze that turns us to stone. The story is eroticized to locate
the violence between men and women, and Freud in his equation "de-
capitation = castration" continues the development of mythological and
sacrificial thinking inherent in misogyny. If Medusa has become a central
figure for the woman artist to struggle with, it is because, herself a si-
lenced woman, she has been used to silence other women.[2]

Notes

1. See Hazel E. Barnes, "The Myth of Medusa," *The Meddling Gods: Four Es-
says on Classical Themes* (Lincoln: University of Nebraska Press, 1974), p. 6; and
Jane Ellen Harrison, *Prolegomena to the Study of Greek Religion* (Cambridge: Cam-
bridge University Press, 1903), pp. 187–196. [Mary] Douglas notes that in
some cultures strict taboo regulates when a woman can work with fire. [René]
Girard notes that Hestia may be the locus of the early sacrificial rites, but he
does not ask why the common hearth should be given a female identity and be
identified with virginity. See ch. 9 of *Purity and Danger* and pp. 166–167 (on
masks) and pp. 305, 314–315 (on Hestia) of *Violence and the Sacred*. If the com-
mon hearth was in fact the locus of ritual sacrifice, it is all the more important
that in myth Procne *turns back* to the hearth to cook her own *child* as she undoes
all of her female roles in culture.

2. Freud's formula can be found in "Medusa's Head," where it becomes
clear that his greatest dread is the woman as mother: Medusa's snaky head is the
sign of the mother's monstrous genitals. For a list of modern women's poems
about Medusa and their intense struggle to free themselves from the mythic
uses of her, see [Alicia] Ostriker, "The Thieves of Language."

61 CRAIG OWENS
from "The Medusa Effect or, The Specular Ruse" (1984)

Barbara Kruger and the Medusa Effect

In his essay on the photographer/textual artist Barbara Kruger, art critic and theorist Craig Owens calls Medusa's ability to petrify with her gaze a "proto-photographic" process with relevance throughout Western art. Reading both the myth of Perseus slaying Medusa and Kruger's art through Lacan's theory of the imaginary, Owens muses on what it means to "capture" an "image." Kruger's *Untitled* (*Your Gaze Hits the Side of My Face*) is Figure 27 in this volume.

> *To speak is to make words common, to create commonplaces.*
> —Emmanuel Lévinas, *Totality and Infinity*

Barbara Kruger propositions us with commonplaces, stereotypes. Juxtaposing figures and figures of speech—laconic texts superimposed on found images (Kruger does not compose these photographs herself)—she works to expose what Roland Barthes called "the rhetoric of the image": those tactics whereby photographs impose their messages upon us, hammer them home. It was Barthes who first proposed to replace the ideology of literary invention with an "ideolectology" whose operative concepts would be citation, reference, stereotype; and many artists today work within the regime of the stereotype, manipulating mass-cultural imagery so that hidden ideological agendas are supposedly exposed. But most of these artists treat the stereotype as something arbitrarily imposed upon the social field from without, and thus as something relatively easy to depose. Kruger, however, regards it as an integral part of social processes of incorporation, exclusion, domination and rule—that is, as a weapon, an instrument of power.

Thus, in a recent work she interposes, between the viewer and a photograph of a woman in repose, a text which alludes to the stereotypical way society disposes of woman, positioning her outside "culture," in

a state of nature/nurture. "We won't play nature to your culture," Kruger declares, thereby opposing what is itself already an opposition—nature/culture—and all that it presupposes: a binary logic that divides the social body into two unequal halves in order to subject one to the other ("Your assignment," Kruger writes in an earlier work, "is to divide and conquer") or, more precisely, the Other to the One (as she writes in a third work, "You destroy what you think is difference"). In refusing this assignment, Kruger poses a threat; nevertheless, her work remains cool, composed. As she proposes elsewhere, "I am your reservoir of poses."

An inventory of Kruger's montage techniques—she juxtaposes, superimposes, interposes texts and images—and of the ends to which these techniques are put—she exposes, opposes, deposes stereotypes and clichés—indicates the importance of a "Rhetoric of Pose" to all her work. Most of the photographs Kruger reuses were originally staged—posed—and she crops, enlarges and repositions them so that their theatricality is emphasized. She does not work with snapshots, in which the camera itself suspends animation, but with studio shots, in which it records an animation performed only to be suspended—a gesture, a pose. "What is a gesture?" Jacques Lacan asks in the ninth chapter (titled "What is a Picture?") of *The Four Fundamental Concepts of Psycho-Analysis.* "A threatening gesture, for example? It is not a blow that is interrupted. It is certainly something done in order to be arrested and suspended."[1] . . .

Immobility is a pervasive theme in Kruger's work: a female silhouette, literally pinned down, may appear with the injunction "We have received orders not to move"; or a patient may be held in place by a battery of dental appliances while the viewer is admonished, "You are a captive audience"; or the words "Your gaze hits the side of my face" may appear beside a female portrait head. In this last work, Kruger alludes specifically, to the power attributed to vision to suspend movement and arrest life. . . . [For what we see] before us is a woman immobilized—turned to stone, in fact—by the power of the gaze . . . Medusa?

Remember that it was *Medusa's* gaze that was endowed with the power of turning to stone all who came within its purview—with the power, that is, of creating figures, statues. Remember as well that Perseus contrived to steal this power for himself (and the appropriation of the gaze is the principal theme of the myth, beginning as it does with the theft of an eye),[2] to himself become a producer of figures. This he ac-

complished by means of a ruse: using his shield as a mirror, he reflected the deadly gaze back upon itself, whereupon Medusa was *immediately*— or so the narrative proposes—petrified. Turned against itself, Medusa's power turns out to be her vulnerability, and Perseus's vulnerability, his strength.

The myth's central episode is almost proto-photographic; it seems to describe that split-second in which vision bends back upon itself to produce its own imprint. Perseus inserts Medusa into a closed system, a relation of identity between seer and seen; the immediacy of this link makes the relationship of Medusa with her image indexical (and not simply iconic). Thus, Medusa is transformed into an image, inserted into the order of designation; henceforth, she will serve primarily as the support for a long chain of discursive and figural events, beginning with Perseus's own account of his triumph over Medusa (recounted by Ovid), including the famous Roman mosaic depicting Perseus with Medusa's severed head (the prototype for countless depictions of the myth in the history of Western art), and extending into our own century with Ferenczi's, Freud's and Hélène Cixous's psychoanalytic accounts of the myth. But what each of these authors—including myself—will systematically repeat and simultaneously deny is the ruse whereby Medusa is inserted into discourse in the first place—the violence whereby she becomes an object of depiction, narration, analysis. For Medusa herself will not depict, narrate, analyze; as Cixous says, Medusa never gets a chance to tell her side of the story.

Since Freud's well-known text "Das Medusenhaupt," the meaning of the myth has itself been petrified, immobilized. Focusing on Medusa's head as an apotrope—Athena, Freud reminds us, bore this emblem on her breastplate in order to repulse (in both senses) her enemies—he interprets it as a fetish, an emblem of castration, a displaced representation of female genitalia. Given the instantaneity invoked by the myth's central episode—Medusa sees herself and is immediately turned to stone— Freud might have related it not to the boy's, but instead to the girl's realization of her own "castration," at least as he imagines this scenario: "A little girl behaves differently [from a little boy]. She makes her judgment and her decision in a flash. She has seen it and knows that she is without it and wants to have it."[3] Instead, Freud makes *his* judgment and *his* decision in a flash; he has seen it and he knows "to decapitate = to castrate."[4] Thus, Hélène Cixous, in her manifesto "The Laugh of the Medusa,"

attacks Freud's interpretation as a masculine projection: "You have only to look at the Medusa straight on to see her. And she's not deadly. She's beautiful and she's laughing." But Cixous also treats Medusa primarily as an apotrope: "Let the priests tremble, we're going to show them our sexts!"[5] What both Freud and Cixous overlook is the importance of the myth's central episode—the specular ruse whereby Perseus was able to decapitate/"castrate" Medusa in the first place.

Psychoanalysis can, however, tell us a great deal about the significance of this episode, for there is more to the story of Perseus and Medusa than meets the eye. Medusa's is clearly an imaginary capture, a capture in the Imaginary. (Can it be that Perseus, like Kruger, had read Lacan?) For in this act of seeing that is its own sight, this instantaneous identification, what we recognize is the duality, the specularity, the symmetry and immediacy that characterize Lacan's Imaginary order. "Lacan defines the essence of the imaginary as a dual relationship, a reduplication in the mirror, an immediate opposition between consciousness and its other in which each term becomes its opposite and is lost in the play of the reflection."[6] Moreover, he repeatedly refers to the subject's identification with an image as its *capture;* it is with this capture that the ego is constituted. (In Lacan, the ego is always an imaginary construct.) And in the *Discours de Rome* he refers to the patient's imaginary constructions of identity as *statues.*

Lacanian psychoanalysis also enables us to detect, in the myth's central episode, a crucial elision; for this episode collapses what are, in fact, two distinct moments: one in which Medusa sees herself, and another in which she is petrified. These two moments must logically be distinct: how can Perseus decapitate Medusa, if she is already turned to stone? What Perseus's sword separates, then, is not only a head (or phallus) from a body, but also, in narrative terms, an initial moment of seeing from a terminal moment of arrest. In an important passage in *Four Fundamental Concepts . . .* devoted to the power of the evil eye to "arrest movement and, literally, kill life," Lacan discusses precisely these two moments, referring to their "pseudo-identification" as (a) suture (a Lacanian concept which specifies the subject's relation to the chain of its own discourse):

> What I noticed there [Lacan has been discussing the Peking Opera fight scenes] was the suture, the pseudo-identification that exists between what I called the time of terminal arrest of

the gesture and what, in another dialectic that I called the dialec-
tic of identificatory haste, I put as the first time, namely, the mo-
ment of seeing. The two overlap, but they are certainly not
identical, since one is initial and the other is terminal. (p. 117)

The psychoanalytic concept of suture (derived from surgical termi-
nology: to join the two lips of a wound) itself seems to have an
apotropaic effect; I propose, therefore, to rename suture—at least inso-
far as Lacan uses the term to designate the "pseudo-identification" of an
initial moment of seeing and a terminal moment of arrest—"the Medusa
Effect": specular ruse, imaginary identification of seer and seen, immedi-
acy, capture, *stereotype*. Lacan's discussion of the evil eye includes not only
a description of the Medusa Effect, but also a prescription against it. Sig-
nificantly, this prescription inverts the temporal order of the two mo-
ments which it elides (vision, Lacan argues, reverses the logical order of
speech): *first,* a terminal moment of arrest; *then and only then,* an initial
act of seeing:

> There, that by which the original temporality in which the rela-
> tion to the other is situated as distinct is here, in the scopic di-
> mension, that of the terminal moment. That which in the
> identificatory dialectic of the signifier and the spoken word will
> be projected forward as haste is here, on the contrary, the end,
> that which, at the outset of any new intelligence, will be called
> the moment of seeing. (p. 114)

In placing the moment of arrest prior to the moment of seeing, La-
can is, of course, simply describing what happens when we look at a pic-
ture, any picture—first an arrested gesture (painting, photograph); then
the act of viewing which completes the gesture. But he is simultaneously
describing the mechanism of *pose*: to strike a pose is to present oneself to
the gaze of the other as if one were already frozen, immobilized—that is,
already a picture. For Lacan, then, pose has a strategic value: mimicking
the immobility induced by the gaze, reflecting its power back on itself,
pose forces it to surrender. Confronted with a pose, the gaze itself is im-
mobilized, brought to a standstill (for the object does not move with the
eye); a pose, then, is an apotrope. And to strike a pose is to pose a threat.
 In Kruger's work, the strategic value Lacan attributes to pose is

doubled and then redoubled. Doubled: To reiterate, a stereotype is an apotrope; posing as a mirror-image of social reality, its adequate, identical reflection, it is engineered to immediately immobilize the social body. Redoubled: Kruger reflects the stereotype back on itself, mimicking its techniques—its double address, its transformation of action into gesture, its instant legibility. How else to defeat an apotrope than with another apotrope?

Kruger's work, then, engages in neither social commentary nor ideological critique (the traditional activities of politically motivated artists: consciousness-raising). Her art has no moralistic or didactic ambition. Rather, she stages for the viewer the techniques whereby the stereotype produces subjection, interpellates him/her as subject. With one crucial difference: in Kruger's double inversion, the viewer is led ultimately to *reject* the work's address, this double postulation, this contradictory construction. There is a risk, of course, that this rejection will take the form of yet another gesture—a gesture of refusal. It can, however, be an active renunciation. Against the immobility of the pose, Kruger proposes the *mobilization* of the spectator.

Notes

1. Jacques Lacan, *The Four Fundamental Concepts of Psycho-Analysis,* ed. Jacques-Alain Miller, trans. Alan Sheridan (New York: Norton, 1978), p. 116. [All further references to Lacan are to this work and will be indicated in text by page numbers.]

2. In Ovid, the story of Perseus's capture of Medusa begins: "He told them how there lay, beneath cold Atlas, / A place protected by the bulk of the mountain / Where dwelt twin sisters, daughters, both, of Phorcys. / They had one eye between them, and they shared it, / Passing it from one sister to the other, / And he contrived to steal it, being so handed, / And slipped away." *Metamorphoses*, trans. R. Humphries, IV. 771–78. Few of the myth's commentators even mention this remarkable episode; an exception is Louis Marin, who interprets it as an allegory of monocular perspective. *Détuire la peinture* (Paris: Galilée, 1977), pp. 137–48.

3. Sigmund Freud, "Some Psychological Consequences of the Anatomical Distinction Between the Sexes," in *Sexuality and the Psychology of Love*, ed. Philip Rieff (New York: Collier, 1963), p. 187.

4. Freud, "Medusa's Head," in Rieff, p. 212.

5. Hélène Cixous, "The Laugh of the Medusa," trans. K. and P. Cohen, in *New French Feminisms,* ed. E. Marks and I. de Courtivron (New York: Schocken, 1981), p.255.

6. Anika Lemaire, *Jacques Lacan* (London: Routledge & Kegan Paul, 1977), p.60.

JEAN-PIERRE VERNANT
from "Death in the Eyes" and "In the Mirror of Medusa" (1985)
translated by Thomas Curley and Froma I. Zeitlin

Frontality and Monstrosity

Jean-Pierre Vernant is professor emeritus at the Collège de France where he held a
chair of comparative studies in ancient religions. Vernant has been a radical re-
thinker of classical studies. His work on myth, religion, ritual, literary aesthetics, and
the sociopolitical structure of the city-state have all contributed significantly to the
field. In this essay, excerpted from *Mortals and Immortals*, Vernant conducts an ex-
tensive exploration of the Gorgon as a representative of the "Other" and of the
masked being in ancient Greek society.

Death in the Eyes: Gorgo, Figure of the Other

Why study Gorgo? The reason is that for a historian, and a historian of
religion in particular, the problem of alterity or "otherness" in ancient
Greece cannot be limited to the representation the Greeks made of oth-
ers, of all those whom, for the purposes of reflection, they ranked under
different headings in the category of difference, and whose representa-
tions always appear deformed because these figures—barbarian, slave,
stranger, youth, and woman—are always constructed with reference to
the same model: the adult male citizen. We must also investigate what
could be called extreme alterity and ask about the ways in which the an-
cients attempted to give a form in their religious universe to this experi-
ence of an absolute other. The issue is no longer one of a human being
who is different from a Greek, but what, by comparison to a human be-
ing, is revealed as radical difference: instead of an other person, the
other of the person.

Such, we think, were the sense and function of this strange sacred
Power that operates through the mask, that has no other form than the
mask, and that is presented entirely as a mask: Gorgo.

In certain qualities she is close to Artemis.[1] In the sanctuary of

Artemis Orthia in Sparta, among the votive masks dedicated to the goddess (the young had to wear likenesses of these in the course of the *agōgē* in order to execute their mimetic dances), there are many that reproduce the monstrous and terrifying face of Gorgo.

But the otherness that the young of both sexes explore under the patronage of Artemis seems to be situated entirely on a kind of horizontal plane where the question is one of time or space. This is the kind of alterity that marks the first moments of human life, which is punctuated by various stages and passages until the time when a man and a woman become fully themselves. This same alterity rules over the frontiers of civic territory, uncultivated lands, far from the city and civilized life, on the margins of the wild. The wildness Artemis seems to share with Gorgo, however, is manifested by her in a different way in that Artemis emphasizes the wild and gives it a place only in order better to relegate it to the periphery.

In determining that the young, in their differences from the group, may experience different forms of alterity on the boundaries, Artemis sees to it that they embark correctly on their learning of the model to which, one day, they will have to conform. From the margins where she rules, she prepares the return to the center. The nurture of the young she practices in a zone of the wild aims at their satisfactory integration into the heart of civic space.

The alterity Gorgo incarnates is of a very different type. Like that of Dionysos, it operates according to a vertical axis. This alterity no longer concerns the early part of life nor those regions far removed from the civilized horizon. Rather, it is one that, at any moment and in any place, wrenches humans away from their lives and themselves, whether with Gorgo, to cast them down into the confusion and horror of chaos, or with Dionysos and his worshippers, to raise them up high, in a fusion with the divine and the beatitude of a golden age refound.[2]

Plastic representations of Gorgo—both the *gorgoneion* (the mask alone) and the full feminine figure with a gorgon face—appear not only on a series of vases, but from the archaic period on, they can be seen on the façades of temples or as *acroteria* and antefixes. We find them as emblems on shields or decorating household utensils, hanging in artisans' workshops, attached to kilns, set up in private residences, and also, finally, stamped on coins. This representation first appears early in the seventh century B.C.E., and by the end of the second quarter of the same

century, the canonical types of the model are already codified in their essential features. Leaving aside the variants in Corinthian, Attic, and Laconian imagery, we can, on a first analysis, identify two fundamental characteristics in the portrayal of Gorgo.

First, frontality. In contrast to the figurative conventions determining Greek pictorial space in the archaic period, the Gorgon is always, without exception, represented in full face. Whether mask or full figure, the Gorgon's face is at all times turned frontally toward the spectator who gazes back at her.

Second, monstrousness: whatever kinds of distortion are involved, the figure systematically plays on the confusion of human and bestial elements, juxtaposed and mingled in a variety of ways. The enlarged rounded head recalls the face of a lion. The eyes are staring; the gaze is fixed and piercing. The hair resembles an animal's mane or bristles with snakes. The ears are overly large, deformed, at times like those of a cow. Horns sometimes grow from the skull. The gaping, grinning mouth extends so far that it cuts across the breadth of the face, revealing rows of teeth, fangs, or wild-boar tusks. The tongue thrusts forward and protrudes outside the mouth. The chin is hairy or bearded, and the skin is sometimes furrowed with deep wrinkles. The visage looks more like a grimace than a face. In disrupting the features that make up a human face, it produces an effect of disconcerting strangeness that expresses a form of the monstrous that oscillates between two extremes: the horror of the terrifying and the hilarity of the grotesque. Despite the evident contrasts between the horror of Gorgo and those Satyrs and Silenoi, who, on a scale of monstrosity, tend more toward the grotesque, there are still significant collusions between them. These two types also have noticeable affinities with the stark and crude representation of the sexual organs—both masculine and feminine—a representation that, just like the monstrous face whose equivalent it is in certain respects, also has the power to provoke both sacred fear and liberating laughter.

To clarify the play between the face of Gorgo and the image of the female sexual organ—as between the *phallos* and the figures of Satyrs and Silenoi, whose humorous monstrosity is also disturbing—a word should be said about the strange figure of Baubo, a personage with two aspects: a nocturnal specter, a kind of ogress, related, like Gorgo, Mormo, or Empusa, to infernal Hekate,[3] but also like an old woman whose cheerful jokes and vulgar gestures provoke Demeter's laughter

and thus induce the goddess mourning for her daughter to break her stubborn fast. The correlation between the relevant texts[4] and the statuettes of Priene, which represent a female reduced to a face that is also a lower belly,[5] gives an unequivocal meaning to Baubo's gesture of lifting her dress to exhibit her intimate parts. What Baubo actually displays to Demeter is her genitals made up as a face, a face in the form of genitals; one might even say, the genitals made into a mask. By its grimace, this genital face becomes a burst of laughter, corresponding to the goddess's laugh, just as the terror of the one who looks at Gorgo's face corresponds to the grimace of horror that cuts across it. The *phallos,* one of whose names is *baubōn,*[6] emphasizes the relationship with Baubo and acquires a symmetrical function at the opposite pole of the monstrous. Normally, the *phallos* adds to the humor and accentuates the grotesque quality of those amusing monsters who are the Satyrs, but in initiations it produces an effect of sacred dread, of terrified fascination, which is expressed by the gestures of certain feminine individuals, who shrink away from its unveiling.

Moreover, there are two mythic versions of Demeter's laughter during the time she is searching for her daughter, and in each, the protagonist, in order to produce a liberating shock as an antidote to grief, resorts to indecency in different ways. According to the first version, Iambe, *graia Iambē,* the old Iambe, as Apollodorus says (1.5.1),[7] mocks Demeter and interrupts her mourning with the obscene jokes, the *aischrologia,* used at the Thesmophoria or at the *gephurismos* of the Eleusinian procession.[8] Iambe can be considered as the feminine of Iambos, the iamb, with its musical element of satyric song and its poetry of invective and derision. The liberating effect of an unbridled sexuality, close to the monstrous by virtue of its anomic character, operates in and through language: insulting witticisms, obscene insults, and scatological jokes—everything the Greeks understood in the expression *skoptein* or *paraskoptein polla.* In the second version, Baubo replaces Iambe and puts the same procedures on the visual level; she substitutes spectacle for words, she displays the object rather than naming it. When she crudely exhibits her genitals with a kind of obscene wiggle, Baubo makes the merry face of a young boy peep out, that of the child Iacchos, whose name evokes the mystic cry of the initiates (*iachō, iachē*) but who also is related to the *choiros,* the piglet (Athen. 3.98d), and likewise, of course, to the feminine genitals.[9]

Frontality and monstrosity: these are the two features of Gorgo's iconography that suggest questions about her origins. Antecedents have been sought in the Near Eastern, the Creto-Mycenean, and the Sumero-Accadian worlds.[10] Some scholars have suggested parallels with the figure of the Egyptian Bes and especially with that of the demon Humbaba as he is represented in Assyrian art.[11] Despite their value, these studies miss what I consider the essential fact: the specific form of a figure that, whatever borrowings or transpositions may have taken place, still stands out as a new creation that is very different from the antecedents invoked to explain it. The originality of this image cannot be grasped without considering how it is related in Greek archaic life to ritual practices and mythic themes, and above all, to a supernatural Power, which emerges and asserts itself just when the symbolic model that represents it is constructed and fixed in the particular form of the Gorgon's mask.

For this reason, Jane Harrison's efforts at interpretation seem finally unsuccessful. Relying on several figurative analogies among Harpies, Erinyes, and Gorgons, she tried to connect them all to the same "primitive" religious base and make them different types of "Keres"—evil spirits, phantoms, pollutions.[12] But it is not methodologically recommended to combine five different figures in the same vague category without concern for the clear and distinct differences that give each its appropriate significance and particular place in the system of divine Powers. The Erinyes have neither wings nor masks; the Harpies have wings but no masks. The Gorgons may be winged, but they are the only ones represented with the face of a mask (cf. Aesch., *Eum.* 48–51). The affinities between Gorgo and the Mistress of the Animals, the Potnia, as Theodora Karagiorga strongly emphasizes,[13] are more promising. There are shared contacts between the two types, and their iconographical representations reveal resemblances or, at least, parallels with each other. These should be taken into account. In certain of her aspects, Gorgo appears as the dark face, the sinister reverse of the Great Goddess whose legacy Artemis, in particular, will later inherit. But even here, the fact that there are also differences and discrepancies between the two models ought to warn us against a pure and simple assimilation. It still remains crucial to understand why and how the Greeks developed a symbolic figure that, in its combination of frontality and monstrosity in a single form, can be clearly distinguished from all the others so as to be instantly perceived for what it is: the face of Gorgo. . . .

Certain musical instruments, when used orgiastically to provoke delirium, play on this scale of infernal sounds. The effect of Terror these produce in their hearers is all the more intense when the musicians and their instruments are not seen and the source of the sounds is concealed. These sounds seem to rise up directly out of the invisible, to come up from the beyond like the disguised voice of a ghostly Power, an echo come from afar and mysteriously resounding here on earth. A fragment from Aeschylus's *Edonians,* quoted by Strabo (10.3.16), is significant in this regard: "One, holding in his hands the pipe, the labor of the lathe, blows forth his fingered tune, even the sound that wakes to frenzy. Another, with brass-bound cymbals, raises a clang . . . the twang shrills; and unseen, unknown, bull-voiced mimes in answer bellow fearfully, while the timbrel's echo, like that of subterranean thunder, rolls along inspiring a mighty terror."

But among all the musical instruments, the flute, because of its sounds, melody, and the manner in which it is played, is the one to which the Gorgon's mask is most closely related. The art of the flute—the instrument itself, the way it is used, and the melody one extracts from it—was "invented" by Athena to "simulate" the shrill sounds she had heard escaping from the mouths of the Gorgons and their snakes. In order to imitate them, she made the song of the flute "which combines all sounds [pamphōnon melos]" (Pind., *Pyth.* 12.18ff.). But the risk in playing the role of the shrieking Gorgon is actually to become one—all the more so as this *mimēsis* is not mere imitation but an authentic "mime," a way of getting inside the skin of the character one imitates, of donning his or her mask. The story is told that Athena, wholly absorbed in blowing into the flute, did not heed the warning of the satyr, Marsyas, who, when he saw her with distended mouth, puffed-out cheeks, and a face wholly distorted by the effort of getting a sound from the flute, said to her: "These ways do not become you. Take up your weapons, put down the flute, and compose your features." But it was only when she looked at herself in the waters of a river and saw that what the mirror reflected was not the beautiful face of a goddess but the hideous rictus of a Gorgon that she threw away the flute once and for all, crying "be damned, shameful object, outrage to my body; I will not surrender myself to this ignominy." Frightened "by the deformity that offends the sight," she gave up the instrument that her intelligence was able to invent. Nevertheless, the flute was not altogether lost for everyone. Marsyas seized it; the flute became

the pride and joy of the satyr, "the brute who claps his hands," a monster whose ugly face harmonizes with the melody and playing of the instrument.[14] Marsyas's glory is also his misfortune. Athena discovered that by playing the flute she had descended to the level of monstrosity. Her face was demeaned to become a semblance of a Gorgon's mask. Marsyas, however, thinks that by playing the flute he can raise himself to the level of the god, Apollo. He claims victory over the god in a musical contest. But in the hands of Apollo, the lyre produces a melody in harmony with human song and its accompanying words. On the other hand, in the huge mouth of the satyr, even when it is covered with a piece of leather, the *phorbeia,* and a halter to soften the violence of his breathing and mask the distortion of his lips, the *aulos* or *syrinx,* the double flute or the flute of Pan, leaves no room for human song or voice. At the end of the contest, Apollo is declared the winner; he flays Marsyas alive, hanging his skin in a cave at the springs of the Meander[15]—just as Athena, according to certain versions, wears over her shoulders as an aegis, not the head but the flayed skin of Gorgo.[16]

What do these stories about the affinities between the flute and the mask of terror teach us?[17] First, of course, that the sounds of the flute are alien to articulate discourse, poetic song, and human speech. Second, that the flutist's distorted face, deformed to look like a Gorgon's, is that of a person possessed by madness and disfigured by anger and who, as Plutarch observes, ought, like Athena, to look at himself in the mirror in order to calm himself and recover his normal human state (*De tranq. an.,* 456a–b). Aristotle's remarks go even further. If Athena rejected the flute, he observes, it was not only because this instrument deforms the face, but also because the flute contributes nothing to the improvement of intelligence (*Pol.* 1341bff.). The goddess is opposed to the kind of instruction that prevents the use of speech. And, above all, flute music has the least ethical and the most orgiastic character. It produces its effects not through a mode of instruction (*mathēsis*) but by purification (*katharsis*), "for everything that belongs to the Bacchic trance and to all impulses of this sort depends, from the instrumental point of view, on the flute" (*Pol.* 1342a3; 1342b5). Thus the flute is the instrument par excellence of trance, orgiastic celebrations, delirium, and of rituals and dances of possession. Citing mothers, whose children have difficulty sleeping, and who, in order to calm them, rock them and sing them lullabies instead of leaving them alone in silence, Plato declares: "It is as if, in the full sense

of the words, they play the flute in front of their children [*kataulousi tōn paidiōn*] as before frenzied bacchants [*ekphronōn bakcheiōn*], who are cured by the use of the movements of both dance and music" (*Laws* 7.790d). To play the bacchant or corybant is to hear or to think one hears flutes. Corresponding to Plato's remark, "those who play the corybant think they hear flutes" (*Crito* 54d), is Iamblichus's assertion: "Certain ecstatics hear flutes, cymbals, drums or some melody and are thus in a state of enthusiasm [*enthousiōsin*]. . . . Flutes both excite or heal passions of frenzy; some melodies cause a trance [*anabakcheuesthai*], others put an end to it [*apopauesthai tēs bakcheias*]" (*De myster.* 3.9).

There are several ways, however, of being a bacchant, and in states of possession, it is not always the same divinities who take hold of their worshippers, put the bit and bridle on them, and ride them into the cavalcade of madness. In contrast to the bacchant of Dionysos, whom the imagery associates with figures of Maenads along with their exuberant escort of Satyrs and Silenoi, we must distinguish what Euripides calls a "bacchant of Hades" (*Haïdou bakchos, Her. fur.* 1119) who is compelled by the rabies of a frenzied madness, *Lussa*, to dance while playing a tune of terror (*Phobos*) on the flute. What is this sinister power of enragement that finds its rhythm in the flute, "the music of madness"? The tragic poet supplies the answer: "It is the Gorgon, daughter of Night, and her vipers with their hundred clamorous [*iachēmasin*] heads; it is Lyssa of the petrifying gaze" (884). In this dance, which transforms Herakles into Terror itself—both the internal terror that possesses and torments him and the external terror he stirs up around him—"neither the tambourines nor the friendly thyrsus of Bromios appears. She [Terror] wants blood, not the bacchic libation of the juice of the vine" (891–95; cf. Eur., *Or.* 316–20). During the attack of frenzy in the course of which Fright, like a supernatural power, takes possession of Herakles, the music of the flute and the hero's face both take on the hideous appearance of Gorgo's mask: "Horrible, horrible is the music of this flute [*daion tode daion melos epauleitai*]," sings the chorus. As for Herakles, at the onslaught of the trance, "already he tosses his head and silently, with terrifying looks, rolls his twisted eyeballs [*gorgōpas koras*]" (*Her. fur.* 868). A little later, "the face distorted, he rolled his eyes where there appeared a network of blood-red veins and foam trickled on his thick beard. . . . He rolled the wild eyes of a Gorgon [*agriōpon omma Gorgonos*]" (931, 990). . . .

If we were to analyze the myth of Perseus—which tells how, with the

aid of the gods, a hero dares to confront the lethal regard of Medusa, how, by cutting off her head, he comes to conquer the face of terror and escape the pursuit of the two remaining Gorgons—we would be obliged, for purposes of comparison, to take up the different versions of the story: from Hesiod and Pherecydes to Nonnos and Ovid. To keep to the essentials, we will only indicate some important points, starting with the presence in myth of the traditional heroic pattern—the exposure of the newborn hero and the trial imposed on him in his adolescence that takes place during a festival banquet in a context of boasts and challenges.

Let us briefly summarize the outline of the story: Akrisios, king of Argos, has a daughter, Danaë. If she gives birth to a boy, the oracle announces, the grandson will kill his grandfather. Akrisios immediately immures Danaë in a subterranean chamber with walls of bronze. But Zeus comes to visit the girl in the form of a shower of gold. After the birth of their offspring, named Perseus, the cries of the infant attract Akrisios's attention. To escape his predicted fate, the king places Danaë and the child in a wooden chest, which he throws into the sea. The waves propel the chest safely to the island of Seriphos where Diktys, a fisherman, brings it back in his nets, shelters Danaë, and raises Perseus until his adolescence. Seriphos is ruled by the tyrant Polydektes who covets Danaë, but Perseus keeps watch over his mother. Polydektes summons the youth of the country to a festive banquet (*eranos*) where all, to put up a good show, vie with each other in parading their generosity. When his turn comes, Perseus, to outdo everyone else, boasts he will offer his host, not the horse he demands, but the head of the Gorgon. Polydektes takes him at his word. Perseus has no choice but to fulfill his promise.

Supernatural birth, expulsion from the human world, abandonment of the infant in the space of that other world symbolized by the immensity of the sea, survival and return among men after going through the ordeal whose normal outcome ought to have been death: Perseus's biography from the very outset, even before the career of his exploits begins, contains all the ingredients needed to give the young man his properly "heroic" dimension.

But the story continues. With Athena and Hermes as guides, Perseus sets out on the journey. To kill Medusa, he must obtain from the Nymphs the instruments of victory over the monster with the fatal gaze; in particular, the helmet of Hades, the *kuneē*, and the winged sandals. And to find the Nymphs, he must first constrain the Graiai to reveal the route that

leads to them. Sisters of the Gorgons, the Graiai are also dreadful figures, although they have only one single tooth and one single eye among the three of them. Always on the alert, there is always one who, when the other two sleep, keeps the eye open and the tooth ready at hand. Perseus confronts them and defeats them as in a parlor game of "pass the slipper." He snatches the eye and the tooth at the precise moment when, passing from hand to hand, they are out of service for any of the sisters.

One theme is central to this chain of episodes: the eye, the gaze, the reciprocity of seeing and being seen. This theme appears already in the sequence of the three Graiai with their single tooth and eye, which they pass back and forth so the trio will never be caught by surprise without any defense—without a tooth for eating and an eye for looking (the single tooth is that of devouring monsters and of toothless hags; the single eye that of beings with an ever-vigilant gaze, but whom a bold maneuver can blind).[18] The theme is found again in the *kuneē,* the magical instrument of invisibility concealing from all eyes the presence of the one whose head it covers, and also in the detail that Perseus turned his eyes away at the moment of Medusa's death. He does this when he cuts the monster's throat, and later too, when he brandishes her head to turn his enemies into stone and prudently looks in the opposite direction. The theme finds its full development in those versions, attested from the fifth century on, that insist on the indispensable recourse to the mirror and its reflection that enables the young man to see Gorgo without having to cross glances with her petrifying gaze. We should also note the role and meaning of the magical objects, which, more than mere instruments, are talismans that seem to be the true agents of the exploit. There is the cap of invisibility, which gives the living hero the mask of a dead man and thus puts him under the protection of the Powers of Death; the *harpē* and *kibisis,* the sickle and pouch, implements for headhunting;[19] and the winged sandals, which give Perseus a privilege like that of the Gorgons by allowing him to telescope all spatial directions, to reach both the heavens and the underworld, to pass from the shores of Okeanos to the land of the Hyperboreans. Finally, it is worth recalling several significant details: the hostility of Perseus to Dionysos, his satyrs and maenads, whom the hero, at the end of his journey, combats and pursues when they arrive in Argos, as if their frenzied band contained a gorgonlike element in its madness; the play of beauty and ugliness in the person of Medusa;[20] the emphasis on the theme of the mirror and its reflection in a

late author like Ovid,[21] and its treatment in iconographic representations. In the images that illustrate the episode of the hero decapitating the Gorgon, Perseus, sometimes viewed full face, looks straight ahead, fixing his eyes on those of the spectator, with Medusa standing at his side. At times he turns his head to look the opposite way; at other times he looks at the face of the monster reflected in a mirror, on the polished surface of a shield, or on the surface of a pool of water.

Some provisional conclusions to close this inquiry. In contrast to human figures and human faces, the mask of Gorgo, as an isolated head, contains elements in its composition that are marked with strange and unusual features. The usual conventions and typical classifications are syncopated and intermixed. Masculine and feminine, young and old, beautiful and ugly, human and animal, celestial and infernal, upper and lower (Gorgo gives birth through the neck like weasels are supposed to do, who, in producing their young from their mouths, invert buccal and vaginal orifices), inside and outside (the tongue, instead of remaining hidden within the mouth, protrudes outside like a masculine organ—displaced, exhibited, and threatening): in short, all the categories in this face overlap in confusion and interfere with one another. Thus this figure establishes itself right away in a realm of the supernatural that somehow calls into question the rigorous distinctions among gods, men, and beasts, as well as those between different cosmic elements and levels. A disquieting mixture takes place, analogous to the one Dionysos achieves through joy and liberation toward a communion with a golden age. But with Gorgo, the disorder is produced through horror and fear in the confusion of primordial Night.

The telescoping of what is normally kept separate, the stylized deformation of features, and the face breaking into a grimace convey what we have been calling the category of the monstrous, which, in its ambivalence, hovers between the terrifying and the grotesque, oscillating from one pole to the other.

This is the context in which to examine the frontality of Gorgo. The monstrousness of which we speak is characterized by the fact that it can only be approached frontally, in a direct confrontation with the Power that demands that, in order to see it, one enter into the field of its fascination and risk losing oneself in it. To see the Gorgon is to look her in the eyes and, in the exchange of gazes, to cease to be oneself, a living being, and to become, like her, a Power of death. To stare at Gorgo is to lose

one's sight in her eyes and to be transformed into stone, an unseeing, opaque object.

In this face-to-face encounter with frontality, man puts himself in a position of symmetry with respect to the god, always remaining centered on his own axis. This reciprocity implies both duality (man and god face each other) and inseparability, even identification. Fascination means that man can no longer detach his gaze and turn his face away from this Power; it means that his eye is lost in the eye of this Power, which looks at him as he looks at it, and that he himself is thrust into the world over which this Power presides.

In Gorgo's face a kind of doubling process is at work. Through the effect of fascination, the onlooker is wrenched away from himself, robbed of his own gaze, invested as if invaded by that of the figure facing him, who seizes and possesses him through the terror its eye and its features inspire. Possession: to wear a mask means to cease being oneself and for the duration of the masquerade to embody the Power from the beyond who has seized on you and whose face, gestures, and voice you mimic. The act of doubling the face with a mask, superimposing the latter on the former so as to make it unrecognizable, presupposes a self-alienation, a takeover by the god who puts bridle and reins on you, sits astride you, and drags you along in his gallop. As a result, man and god share a contiguity, an exchange of status that can even turn into confusion and identification. But in this very closeness, a violent separation from the self is also initiated, a projection into radical alterity, a distancing of the furthest degree, and an utter disorientation in the midst of intimacy and contact.

The face of Gorgo is a mask, but instead of wearing it to mime the god, this figure reproduces the effect of a mask by merely looking you in the eye. It is as if the mask had parted from your face, had become separated from you, only to be fixed facing you, like your shadow or reflection, without the possibility of your detaching yourself from it. It is your gaze that is captured in the mask. The face of Gorgo is the Other, your double. It is the Strange, responding to your face like an image in the mirror (where the Greeks could only see themselves frontally and in the form of a disembodied head), but at the same time, it is an image that is both less and more than yourself. It is a simple reflection and yet also a reality from the world beyond, an image that captures you because instead of merely returning to you the appearance of your own face and re-

fracting your gaze, it represents in its grimace the terrifying horror of a radical otherness with which you yourself will be identified as you are turned to stone.[22]

To look Gorgo in the eye is to find yourself face-to-face with the beyond in its dimension of terror, to exchange looks with the eye that continually fastens on you in what might be described as the negation of looking, and to receive a light whose blinding brilliance is that of the night. When you stare at Gorgo, she turns you into a mirror where, by transforming you into stone, she gazes at her own terrible face and recognizes herself in the double, the phantom you become the moment you meet her eye. To express this reciprocity, this strangely unequal symmetry of man and god, in other terms, what the mask of Gorgo lets you see, when you are bewitched by it, is yourself, yourself in the world beyond, the head clothed in night, the masked face of the invisible that, in the eye of Gorgo, is revealed as the truth about your own face. This grimace is also that which shows on the surface of your own visage as a mask that is put there, when to the tune of the flute you deliriously dance the bacchanal of Hades. . . .

In the Mirror of Medusa

How will Perseus succeed in decapitating Medusa and appropriating her head? The story, as it proceeds, will put other, complementary questions into place. How is one to see something when the sight of it cannot be endured, see it without glancing at it and without falling under its glance? To exorcise, if not her death-dealing gaze, then at least the terror she inspires, how is one to master that by representing her, by figuring the traits of a monster whose horror thwarts every attempt at figuration? In other words, how is it possible to make seen—to visualize—the face it is impossible to see and the eye that is forbidden to the gaze in order to appropriate them and turn them against one's enemies?

Three episodes, three tests, three stages in the journey that leads Perseus to a successful confrontation with the horrible face of death. First, the Graiai: these aged maidens, these ancestral dames, born wrinkled and with white hair, sisters of the Gorgons, are possessors of a secret. They know the route that leads to the hidden Nymphs, invisible in a place where no one can find them. Only the Nymphs can furnish those

talismans that can turn this impossible exploit into a reality—kill the Medusa, the one Gorgon of the three who is not entirely immortal, then detach from her dead body the head whose eyes and face still retain their lethal power, and finally, carry it off to bring it back into the world of men, escaping the pursuit and terrifying glances of the two furious survivors. Medusa has death in her eyes; the one who will be able to put the head of Medusa in his pouch and hide it there will be declared a master of Terror, *mēstōr phoboio*, lord over death.[23]

The Graiai form a disturbing trio: youthful old witches, they have only one tooth among them and only one eye, which they pass from hand to hand to be used by each in turn. Somewhat reassuring, then, at first glance. But one must not be too confident. Is the single tooth that of an old toothless woman or of a young ogress eating human flesh? One eye for three—this looks a little better. In reality, however, this eye, continually passed from one face to another, is always kept in service, always on the lookout; forever open and alert, it never sleeps. Just as one tooth, if it is a good one, is sufficient for devouring, only one eye is needed to see, providing it can never close. The single eye of the Graiai corresponds in symmetrical and inverse form to the hundred eyes of Argus whom only Hermes, the good voyeur (*Euskopos*), can take by surprise and kill. A hundred eyes for a single body means that Argus looks at all sides at the same time and never ceases to see. When fifty eyes slumber, the other fifty are awake. The result is similar with a single eye for three bodies. One of the three Graiai will always have the eye. To conquer these ladies of the eye and harsh tooth, Perseus, led by Athena and Hermes—the subtle and wily gods who protect him—will have to guess the weak point, leap to the occasion, and aim just right. As in a game of "pass the slipper," the hero finds the precise instant, the brief and mysterious interval where, in transit from one Graia's hand to another's, the eye has no place, not yet or no longer in anyone's use. It is at this moment that Perseus jumps up and puts his hand on the eye, and the Graiai are rendered blind and harmless. They ask for mercy. In return for the eye, they pass on the secret of where the Nymphs reside.

Perseus then goes to hunt down the Nymphs. Huddled together defenseless in their hiding place, they do not need much pleading to offer the young man the three means of magic defense against the visual ray of death. They give him first the *kuneē*, the helmet of Hades, the head-covering that, "containing the shadows of Night" (Hes., *Shield* 227), makes

anyone who covers his head with it as invisible as the god of the Under-
world and the hordes of the dead who populate his empire. To foil the
gaze that dispatches the onlooker to the king of shades, Perseus is
masked in night, indiscernible, and though alive, he assumes a dead
man's countenance.

The Nymphs then give him winged sandals like those of Hermes.
Thus in addition to the trait of invisibility, he acquires the faculty of ubiq-
uity, the power to pass instantly by means of flight from one place to an-
other, to travel the whole extent of the world from the subterranean
dwellings on those frontiers of Night where the Gorgons live to the
boundaries of Earth and Heaven. The helmet, the sandals, no face that
can be spotted by the eye that tries to see you, no fixed place either
where the gaze can reach you with its aim.

The third gift is the *kibisis*, the hollow pouch, the deep hunter's bag
where one can bury the head of Medusa, once it is cut off. Enclosed in
the darkness of its hiding place, the head cannot exercise its sinister
power until it has been withdrawn and brandished about. As long as it is
kept concealed, the head with the eye of death can neither see nor be
seen. Like a veil cast over a mirror, the face-to-face meeting with the
Gorgon can be interrupted at will. To these three gifts the gods add a
fourth: the instrument of beheading, the curved sickle, the blade of close
combat, of ambush, the weapon of those who cut off heads—the *harpē*.[24]
Thus equipped, Perseus is now properly outfitted to embark on the ulti-
mate phase of his drama. He is come into the presence of the three Gor-
gons. The moment has come for action.

In the most complete and consistent version, that of Apollodorus
(2.4.2), the tale of the final action—decapitation—lists a whole series of
seemingly indispensable precautions, even though any one of these
would have probably sufficed to assure the success of the enterprise. In
any case, since he is invisible and can fly through the air, does not Perseus
already hold all the trumps for taking Medusa by surprise and cutting off
her head? Still, he must be sure that the monster's gaze is not going to
meet his eye and pierce the mask of invisibility the hero is wearing at the
moment when he spies the head that has to be severed from its neck. The
Gorgons must be approached under very specific conditions—when
they are sleeping and the fire of their gaze is extinguished under their
drowsy eyelids. But timing itself is not enough. Medusa is always just on
the verge of awakening. Like Zeus, whose gaze strikes like a thunderbolt,

she only sleeps with one eye. Care must be taken then not to repeat the misadventure that befell the monster Typhoeus (Epimenides 11 frag. B8 DK). Seeing the king of the gods asleep, he thought he could take advantage of the moment to snatch his scepter and with it, the sovereignty of the heavens. But Typhoeus had hardly taken a first step when the eye of Zeus struck him and reduced him to ashes.[25] Other strategies must therefore be invented to counter the perils of the eye—the face-to-face ordeal with its exchange of looks and the inevitable reciprocity of seeing and being seen.

First solution: it is Athena who guides the hand of the hero, leads his right arm, and directs his act; Perseus with his eyes averted can see nothing. Second solution, which is added in the text to the first: Perseus acts from one side and looks from the other; to cut Medusa's throat without seeing her, he turns his head and eyes in the opposite direction. Third solution, which synthesizes the first two: Perseus performs by gazing not at the face or eyes of Medusa, but at the reflection presented on the polished surface of the bronze shield, which Athena uses like a mirror to capture the image of the monster. Because the ray is deviated when reflected, the mirror allows him to see Medusa without looking at her. He thus turns away from her as in the second solution, and in keeping his eyes elsewhere, as in the first, Athena's mirror lets him see Medusa from behind, without viewing the monster face-to-face—not in the mortal reality of her person but in an image. Medusa is an exact copy. It is as if the image were she, but also as though she were absent in the presence of her reflection.

Let us pause for a moment at this point when the eye of Gorgo—this mirror transforming the living into the dead—is deprived of its deadly power in and through the mirror where it is reflected. Before the fourth century B.C.E., the motif of reflection (first on the shield of Athena, later also in the waters of a spring, or on a mirror properly speaking) was absent from Perseus's exploit.[26] Now it is introduced on vases and in texts to explain the victory of the hero over Medusa. This then is a new element, something "modern" to the extent that it clearly contrasts the image and the real, the reflection and the thing reflected. The motif thus seems connected to the efforts of contemporary painters to give the illusion of perspective, to philosophers' reflections about *mimēsis* (imitation), and also to the beginning of experiments that, from Euclid to Ptolemy, will lead to a science of optics. Still, we must bear it

well in mind that this "modernity" is not our own. In the context of a culture that cannot separate the seen and the visible, that merges them into the idea of a visual luminous ray—the sight that "knows color" in being colored, knows "white because it becomes white, black because it becomes black," as the great Ptolemy writes in the second century before our era[27]—in such a context, neither the image nor its reflection nor the mirror can have the status we recognize in these today.

In his treatise *De insomniis*, Aristotle indicates that mirrors tarnish when women use them to look at themselves during their menstrual periods (459b26). This tarnish forms like a bloody cloud on the surface; the stain is difficult to remove when the mirror is new. By just regarding themselves in newly polished metal, the women project their reflections there. Although it is a simple, look-alike image of themselves, it nevertheless impregnates the surface with a crimson haze. Something in the complexion of women, when their menses are flowing, reaches the mirror through reflected rays, is impressed there, and remains even after they have turned away from it. The mirror's image, declares Proclus in his commentary on Plato's *Republic* (290, 1-–25 Festugière) acts "sympathetically" to retain the qualities of the bodies from which they came.

Would the reverse case, however, be true? Would the monster's image on the shield, which Athena turns toward Medusa's face to be reflected there, have entirely lost the noxious properties of the model? The answer given by the myth suggests that matters are not so simple as they seemed at first. True, the face-to-face, the shock of gazes, and the reciprocity of seeing and being seen have been avoided, to Perseus's greatest advantage, through the tactic of the mirror. In this sense, it is true that the image of Medusa is something other than Medusa. Yet is this to say that the image is nothing but an illusion, a subjective impression in the consciousness of the spectator? The myth claims exactly the opposite. The image of Gorgo, as presented in reflection on the shield, has a real efficaciousness, an active power that emanates from it in the rays it sends back with an impact like that of its model. It is just that through the intervention of the mirror or the use of some other mode or represented image, this power of radiation is controlled, used for certain ends, and directed according to the disparate religious, military, and aesthetic strategies required. In the "sympathy" they share, there is no absolute break between the image and the real, but rather affinities and means of passing from one to the other.

Athena knows what she is doing when she offers her shield so that the image of Gorgo can be inscribed at its center. She is adorning her defensive weapon with a traditional blazon, an *episēmē,* which the goddess's shield must have in order to fulfill its function: the Gorgoneion that, as its double, corresponds to the true head of Medusa that Athena has worn as the aegis on her breast ever since Perseus gave it to her as a gift. In this sense the detail added in the fourth century to the mythic episode of Medusa's decapitation acquires the value of an aetiological story, which justifies a posteriori the custom that is attested from the earliest period of representing Gorgo on warriors' shields in order to heighten their prestige, provoke terror in the foe, and consign them in advance to flight and death. Exhibited as an image, Medusa's face makes the warrior a "master of Terror."[28] The Gorgoneion, however, is not only represented on shields. Its figure, multiplied over and over—on pediments of temples, on their roofs as *akroteria* and antefixes, in private homes, on fabrics, gems, seals, coins, the feet of mirrors, the belly of vases, and the base of cups—succeeds in visualizing the blinding black sun of death, and in this way succeeds in neutralizing its horror through the most conventional, even banal, images by mobilizing and exploiting the terrifying effects that emanate from this powerful sign. The image of this face that may not be seen[29] is a *teras,* a prodigy that can equally be described as "terrible to look upon" and "marvelous to behold."[30] As a prodigy, the *eikōn,* the image-reflection of Medusa, is also close to the *eidōlon* or the double (the image of a dream sent by the gods, a specter of the dead or the appearance of a phantom).[31] By establishing a bridge between our world and the one beyond and by making visible the invisible, the image of Gorgo combines the features of a disturbing and maleficent supernatural presence and a deceptive counterfeit, an illusionist artifice whose aim is to captivate the eyes. Depending on the case, Gorgo's image can lean toward either the horrible or the grotesque. It may appear terrifying or ridiculous, repulsive or attractive. Sometimes the charming traits of a feminine countenance are substituted for the traditional mask of the monster who grimaces in a hideous smile. From the late fifth century, at the moment itself when the motif of the mirror arises, the turning point begins that will lead to representing Medusa as a young woman of marvelous beauty. In certain versions of the myth recounted by Apollodorus, Pausanias, and Ovid,[32] it is the excess of this beauty and its radiance that constitutes the dynamic element of the drama, whether because it un-

leashes the jealousy of Athena and impels the goddess to slaughter her rival, or because it leads Perseus, dazzled by the perfection of Medusa's face, to cut off her head after having killed her so he will never have to separate himself from this resplendent visage.

Notes

1. Both have affinities with the *Potnia therōn,* the great feminine divinity, mistress of the wild beasts and of wild nature, who preceded them in the Creto-Mycenaean world and whose legacy each inherits in her own way by profoundly transforming it in the context of civic religion.

2. Cf. Françoise Frontisi-Ducroux and J.-P. Vernant, "Figures du masque en Grèce ancienne," *Journal de Psychologie* 1–2 (1983): 68.

3. Cf. Orph., *Fr.* 53 (Kern); Orph., p. 289.3.2 (Abel). A first version of this part of the text appeared in a shorter and somewhat different form in *Pour Léon Poliakov: Le racisme, mythes et sciences,* ed. M. Olender (Brussels, 1981), 141–55.

4. Clem. Alex., *Protrep.* 2.21 = Orph., *Fr.* no. 52 (Kern); Arnob., *Adv. nat.* 5.25. p. 196, 3 Reiff = Orph., *Fr.* 52 (Kern).

5. For these statuettes, see J. Raeder, *Priene: Funde aus einer griechischen Stadt* (Berlin, 1983), especially figures 23a, b, c. On the entire collection of evidence pertaining to Baubo, see Maurice Olender, "Aspects de Baubo: Textes et contextes antiques," *RHR 1* (1985): 3–55, and see the English translation in abridged form in *Before Sexuality: The Construction of Erotic Experience in the Ancient Greek World,* ed. David Halperin, John J. Winkler, and Froma I. Zeitlin (Princeton, 1990), 83–113. See also the remarks of Froma I. Zeitlin in "Cultic Models of the Female: Rites of Dionysus and Demeter," *Arethusa* 15 (1982): 26–34.

6. Cf. Herod., *Mim.* 6.19.

7. Cf. the three Graiai who are the sisters of the Gorgon.

8. *Aischrologia:* to speak of vulgar and shameful things. On the *gephurismos,* cf. Hesych., s.v. *gephuris, gephuristai;* on the ritual exchange of insult and abuse among women at the Thesmophoria, cf. H. W. Parke, *Festivals of the Athenians* (London, 1977), 86–87.

9. Cf. in particular, Aristoph., *Ach.* 764–817.

10. Bernard Goldman, "The Asiatic Ancestry of the Greek Gorgon." *Berytus* 14 (1961): 1–23; Spyro Marinatos, "Gorgones kai gorgoneia," *Arch. Eph.* (1927–28): 7–41; and Ernest Will, "La décollation de Méduse," *Rev. Arch.* 27 (1947): 60–76.

11. Clark Hopkins, "Assyrian Elements in the Perseus-Gorgon Story," *AJA* (1934): 341–53, and "The Sunny Side of the Greek Gorgon," *Berytus* 14 (1961): 25–35.

12. *Prolegomena to the Study of Greek Religion* (1903; reprint, New York, 1957), chap. 5, "The Demonology of Ghosts and Sprites and Bogeys," 163–256.

13. *Gorgeie Kephale* (Athens, 1970).

14. Arist., *Pol.* 1341bff.; ps. Apollod. 1.4.2; Athen. 14.616e–f; Plut., *Mor.* 456bff.

15. Herod. 7.26: Xen., *Anab.* 1.2.

16. Eur., *Ion* 995–96; ps. Apollod. 1.6.1; Diod. Sic. 3.69.

17. In addition to the two versions of the laughter of the Mother, distracted from her mourning by Iambe and Baubo, Euripides adds a new one that is different and instructive. This time, it is the Mother's act of taking up the flute that, along with the noise of cymbals and tambourine, takes the place of the obscene joking and exhibition of genitals. "Then Kypris, the most beautiful of goddesses, for the first time made echo the bronze with the infernal voice and seized the tambourine of taut leather. And the goddess mother began to laugh; charmed by the sounds, she took into her hands the low-sounding flute." *Hel.* 1338ff.

18. To recover their eye and tooth, the old Graiai have to give over the secret of the Nymphs. These young rustic divinities give to Perseus the helmet that makes him invisible, the magic sandals that let him pass from one place to another, and the *kibisis*, the pouch in which he can bury the head of Medusa to hide it from view. To this equipment, Hermes adds the *harpē,* the machete in the form of a sickle used by Kronos to castrate Ouranos.

19. [As the instrument used for both the beheading of Medusa and the castration of Ouranos, the *harpē* is another important indication of the correspondences between the upper and lower parts of the body, especially between the head (neck and mouth) and the sexual organs, that we have already seen in the dual aspects of Baubo. (For the female, see further Giulia Sissa, *Le corps virginal* [Paris, 1987], 76–93.) Both Ouranos and Medusa give birth from the place (or effects) of severing—Ouranos from his blood and semen, Medusa from her neck. If Medusa's decapitation can be construed as the "castration" of her genitalized head, the neck, in particular, is associated with female sexuality, in that, after defloration, the bride's neck is thought to thicken and her voice grow deeper (see the evidence in Ann Hanson and David Armstrong, "The Virgin's Voice and Neck: Aeschylus' *Agamemnon* 245 and Other Texts" (*BICS* 33 1986: 97–100). The *harpē* is primarily an agricultural implement, used to cut off the

"heads" of grain, but here too, the same correspondence is valid. A field of standing corn is also imaged as an expanse of bristling swords and warriors (cf. the birth of the Sown Men), and the *stachus,* or head of wheat, also represents the "virginal" young of both sexes (*Anth. Pal.* 9.362.24–27 . . .) who may be "harvested" in war, death, or defloration. Ed.]

20. On the tradition that makes Medusa a ravishing young girl, desirous of rivaling the most beautiful goddesses, cf. ps. Apollod. 2.4.3; Ov., *Met.* 4.795ff.

21. Perseus could only look at the hideous face of Medusa and her petrifying eye in its weakened reflection. The theme is taken up and redoubled by Ovid in the episode of the deliverance of Andromeda, saved by the hero en route while returning home. In his stupidity the marine monster who attacks Perseus throws himself, not on the young man, but on the young man's shadow; with his claws he vainly tears at the reflection that the hero projects on the smooth surface of the sea.

22. [Although women are, even more than men, subject to possession, madness, and bewitchment, the petrifying effect of the Gorgon seems reserved only for men, in a tête-à-tête between a male and the deadly gaze of the female. I know of no case in which Medusa engages with a female figure, although, for other reasons, she can, like Niobe, be turned into stone through excessive grief. Ed.]

23. This is the name given to Perseus by Hesiod in the *Catalogue of Women*, frag. 129.15 Merkelbach-West; cf. on this point, along with others on which we agree, Ezio Pellizer, "Voir le visage de Méduse," *MÉTIS* 2 (1987): 45–60.

24. [Or genitals, as in the case of Ouranos and Kronos. Ed.]

25. Cf. Marcel Detienne and Jean-Pierre Vernant, *Les ruses de l'intelligence: La mētis des Grecs,* 2d ed. (Paris, 1978), 116.

26. The motif appears in texts at the end of the fifth century B.C.E. (Eur., *Andr.*) and on vase paintings (southern Italian) at the beginning of the fourth.

27. *Optics* 2.24. Cited by Gérard Simon, "Derriére le miroir," *Le temps de la réflexion* 2 (1981): 309

28. See Pellizer, "Voir le visage," 53, on the links that join the exploit of Perseus to the theme of the shield as a defensive weapon casting terror into the enemy camp. Abas, great-grandfather of Perseus, is reputed to have invented the shield. Other traditions attribute this invention to the following generation during a war that pits the twins, Akrisios and Proitos, against each other, grandfather and great-uncle, respectively, of Perseus (unless one accepts that Danaë was united with Proitos and not with Zeus).

29. "How could [Perseus] have seen [the Gorgons]? They cannot be looked at [*atheatoi*]," Lucian has a Nereid say in his *Dial. mar.* 14 (= 323), and see the commentary of Frontisi-Ducroux, *Prosōpon*, vol. 1, p. 163.

30. Aesch., *Eum.* 34: *deina d'ophthalmois drakein;* Hes., *Shield* 224: *theama idesthai.*

31. On the *eidōlon*, cf. Jean-Pierre Vernant, *Mythe et pensée chez les Grecs: Etudes de psychologie historique,* 10th ed. (Paris, 1985), 326–38, 339–51.

32. Ps. Apollod. 2.4.3; Paus. 2.21.5; Ov., *Met.* 4.754ff.; cf. Lucian, *Imag.* 1–3.

63 NANCY J. VICKERS
from "'The blazon of sweet beauty's best':
Shakespeare's *Lucrece*" (1985)

The Face of Medusa

Professor of French, Italian, and Comparative Literature, and President of Bryn Mawr
College, Nancy J. Vickers has offered multiple readings of gender in the early mod-
ern period, focusing especially on anatomical blazons. She invokes Medusa as the
countertale to Shakespeare's Lucrece, noting that both stories of women's sexual
behavior—Medusa's "adulterie" and Lucrece's chastity—served as lessons to
Renaissance audiences. At the same time, she reveals a cautionary tale about
rhetoric itself embedded in the descriptions that circulated around both Medusa and
Lucrece.

When, in his *Accedence of Armorie*, Gerard Leigh enumerates the nine
"sundry fashions" of shields, he begins with the "firste, and ancients of all
others."[1] The source for this postulation of origin, we are told, is to be
found in "the Poets" who tell of the transformation of an exquisitely beau-
tiful woman, Medusa, into an "ouglie, monstrous shape."[2] Medusa figures
in two contexts as a face on a shield: first, Perseus uses a shield to reflect
her image and thus to enable him to decapitate her either by avoiding the
need to look at her directly or by stupefying her with the sight of her own
reflection; and second, when the battles of Perseus are done and Medusa's
head is no longer needed to petrify male rivals, he gives it to Athena, who
bears it on her shield, a shield in turn copied by later warriors. It is the
latter shield, the Gorgon-bearing shield of Athena, "godesse of Here-
haughts [heralds],"[3] that Leigh goes on to describe as follows:

> this targe of the celestial goddes sheweth thincestious life and
> filthy act committed by Medusa daughter to King Phorcius, who
> spared not a publique place for holy rites. Ye the sacred Temple
> of Minerva to practise her filthy lust, with that same godde Nep-
> tune, wherof as she openly fled the discipline of womanly sham-

fastnes, she was by the godes decree for hir so foule a fault, bereft of all dame Bewties shape, with every comely ornament of Natures decking. The glyding eye framed to fancies amorous lust, turned was to wan and deadlie beholding. And for those golden and crisped lockes, rose fowle and hideous serpents . . . Thus everie seemelie gifte transformed into loathsome annoiance, of a beautiful Queene, is made a beastlie monster, horrible to mankinde, a mirror for Venus minions.[4]

Leigh, writing during the reign of a "most gorgious and bewtifull" virgin queen,[5] reports the story of Medusa as a moral tale, as a lesson about the dangers of straying from "womanly shamfastnes" and, by implication, of frequenting women who do. Gifted with every "comely ornament" of conventional Petrarchan beauty—bright eyes, curly golden hair— Medusa's fair face's field is metamorphosed in the name of punishment for a sin Leigh elsewhere refers to as an "adulterie."[6] The Gorgon's face, then, stands as the reverse of Lucrece's face, and the act defining that difference, in Leigh's rendition, would seem to be any unlawful expression of female sexuality.

The report Leigh makes of Medusa is, of course, precisely the report Lucrece most fears for herself: her suicide is specifically motivated by a desire not to be matter for epideictic orators who might speak in blame or for "feast-finding minstrels" who might win profit by "tuning [her] defame" (815–19). Her dramatic refusal to live is, in part, a refusal to encourage wantonness in women. And yet what is strikingly coincident in the narratives of both Medusa and Lucrece is the determining presence of a rape. For, at least in Ovid's most familiar account, Medusa too is not only a paragon of beauty but also a victim of violation:

> she both in comly port
> And beautie, every other wight surmounted in such sort,
> That many suters unto hir did earnestly resort.
> And though that whole from top to toe most bewtifull she were,
> In all hir bodie was no part more goodly than hir heare.
> I know some parties yet alive, that say they did her see.
> It is reported how she should abusde by Neptune bee
> In Pallas Church.[7]

Rape, according to Ovid, is the price Medusa pays for being "beauty's best"; monstrousness, the price for having been raped. But the line separating idealization from denigration, beauty from the beast, is marked here by a male, not a female, gesture of violation.

"Medusa," wrote the Italian humanist Coluccio Salutati, "is artful eloquence."[8] Salutati explained his suggestive identification of a beautiful/monstrous woman's face with artful speech by elaborating a false etymology, one that depends upon reading the name of Medusa's father, Forcus, as derived from the Latin *for* ("to speak"). And yet the pairing of Medusa with eloquence appears not only in the work of Salutati, but also in a privileged classical source. During still another lighthearted male contest of both drinking and oratory, the *Symposium*, a flattering Socrates tells Agathon, the speaker who immediately precedes him, that he was held spellbound by the dazzling display of Agathon's speech. He compares Agathon to the master rhetorician Gorgias, and then permits himself a witty play on words: "I was afraid that when Agathon got near the end he would arm his speech against mine with the Gorgon's head of Gorgias' eloquence, and strike me as dumb as a stone" (198c).[9] As the woman's face that one carries into battle, that reduces eloquent rivals to silent stone, the apotropaic power of the "Gorgon's head of Gorgias' eloquence" resides in its ability to stupefy a male opponent: "Whatever the horror the Medusa represents to the male imagination," writes John Freccero, "it is in some sense a female horror. In mythology, the Medusa is said to be powerless against women, for it was her feminine beauty that constituted the mortal threat to her admirers."[10] And that threat is a threat of forgetting: "By Medusa he [Fulgentius] wants to signify oblivion (which is without doubt to signify rhetorically); by changing the states of mind of men, she makes them forget previous thoughts."[11]

Shakespeare returns repeatedly to the dangers of falling victim to the manipulation of descriptive rhetoric about women: one need only think of Othello's vulnerability to Iago, or Posthumus's to Iachimo. More specifically, at the end of *I Henry VI*, the Earl of Suffolk outmaneuvers his king by displaying a Gorgon's head of gorgeous eloquence that makes his young monarch forget all former engagements: "Your wondrous rare description, noble Earl, / Of beauteous Margaret hath *astonish'd* me" (V.v. 1–2; my italics). Suffolk protests that his praise has been but superficial:

> The chief perfections of that lovely dame,
> Had I sufficient skill to utter them,
> Would make a volume of enticing lines,
> Able to ravish any dull conceit;
>
> <div align="right">(I Henry VI, V.v. 12–15)</div>

The play's concluding lines point to the disastrous consequences of both Suffolk's ample rhetorical skill and Henry's defenselessness before the "force of [his] report" (V.v. 79). Suffolk momentarily prevails, and thus advances his plot to rule not only Margaret but, more importantly, "the King, and realm" (V.v. 108). Similarly, in the single stanza between the narrator's report of Collatine's descriptive blazon and the vision of Lucrece's face as shield, an astonished Tarquin speeds to Collatium, "His honour, his affairs, his friends, his state, / Neglected all" (45–6). Suffolk's consciously motivated description, like Collatine's carelessly miscalculated boast, clearly stupefied the opposition; it functioned as did perfect shields "in such glorious and glittering manner, that they dazzled the eyes of the beholders."[12] Here rhetorical display and heraldic display seem of a like purpose; and here both turn upon a male figuration of a woman's face.

When in the final poem of the *Rime Sparse*, Petrarch's speaker turns toward the Virgin, that "solid shield of afflicted people" (366, 17), he simultaneously turns away from a Laura now recognized to be a Medusa: "Medusa and my error have made me a stone" (366, 111).[13] That same Laura had, of course, constituted the obsessive fixation of an entire "volume of enticing lines" informed by a specifically descriptive project: "Love, who first set free my tongue, wishes me to depict and show her to whoever did not see her, and therefore a thousand times he was vainly put to work wit, time, pens, papers, inks" (309, 5–8). The poet's labor is vain only in the sense that verse will never successfully represent her; and yet each failure provokes another attempt; each fragmentary portrait, because fragmentary, generates another. It is his mastery of what George Puttenham would later label "The Gorgious" that makes of Petrarch a poet's poet, that wins him the laurel crown. "The Gorgious" designates for Puttenham "the last and principall figure of our poeticall Ornament": it is the figure by which we "polish our speech and as it were attire it with copious and pleasant amplifications and much varietie of sentences, all running upon one point and one intent."[14] Petrarch's daz-

zling descriptive display, all running upon the figuration of Laura's beauty, functions—to continue Puttenham's analogy—as does the placing of "gorgious apparell" on a naked body, or the polishing of "marble or porphorite . . . so smoth and cleere, as ye may see your face in it."[15] It is indeed that fixity of vision, Petrarch would suggest, that turns him to *petra* ("stone"); but it is also that self-glorifying fixity that makes of him Petrarca: "Medusa is, like the lady of stone, no historic character at all, but the poet's own creation. Its threat is the threat of idolatry. In terms of mythological *exempla*, petrification by the Medusa is the real consequence of Pygmalion's folly."[16]

One might then wonder, following Mary Jacobus, if there is a woman in this text explicitly dedicated to the celebration of a woman.[17] Or, rather, does the shield of Laura/lauro but stand as a glossy surface positioned both to reflect Petrarch's own image of himself and to dazzle a world of rival poets stupefied by its display? For it is, in some senses, the fascination with that "feminized" median surface of one's own creation that must be conquered: if it threatens petrification, one must first petrify it. Thus Petrarch's characteristic descriptive moves—fragmentation and reification—are, like the moves of Perseus, designed not only to neutralize but also to appropriate the threat. By first decapitating Medusa and then converting her severed head into an object of use in his own defense, Perseus conquers the fear of that which both repels and fascinates, the fear cast from a Freudian, male perspective as fear of the female (the mother's) body. And yet, as recent critics have shown, the sexual threat figured as the face of the Medusa serves in turn to figure other threats—"male hysteria under political pressure," for example, or male anxiety before the limits of representation.[18] The male rhetorician, both politician and artist, thus places the shield of eloquence between himself and the "world of harms" that surrounds him. That shield, of course, is artfully painted on both faces; it speaks both in praise and in blame. The turn of the shield, like the flip of a Lucrece/Medusa coin, is a gesture subject only to his potentially capricious will. And, as Shakespeare demonstrates, even when that gesture problematizes its own status, it nonetheless remains embedded in the descriptive rhetoric it undercuts. The merging of the heraldic and the rhetorical, central to the very notion of a "blazon of sweet beauty's best," then, emblematizes the trap which description has traditionally constructed for "woman"; it remains, it would seem, to women to write their way out of it.[19]

Notes

1. Gerard Leigh, *Accedence of Armorie* (London, 1591), 16.

2. Ibid., 16ᵛ.

3. Ibid., 16ᵛ.

4. Ibid., 118ᵛ–19ᵛ.

5. George Puttenham, *The Arte of English Poesie*, ed. Edward Arber (London, 1869), 255.

6. Leigh, op. cit., 16.

7. W. H. D. Rouse (ed.), *Shakespeare's Ovid Being Arthur Golding's Translation of the Metamorphoses* (London, 1904), 101.

8. Coluccio Salutati, *De Laboribus Herculis*, ed. B. L. Ullman (Zurich, 1951), 418. My translation.

9. Plato, *Symposium*, tr. Michael Joyce, in Edith Hamilton and Huntington Cairns (eds.), *The Collected Dialogues of Plato* (Princeton, 1961), 550.

10. John Freccero, "Medusa: The letter and the spirit" (*Yearbook of Italian Studies*, 1972), 7.

11. Salutati, op. cit., 417. My translation.

12. John Guillim, *A Display of Heraldrie*, 4th ed. (London, 1660), 6.

13. Petrarch, *Rime Sparse*, tr. Robert Durling, in *Petrarch's Lyric Poems* (Cambridge, Mass., 1976). All further references to Petrarch are to this edition and translation of the *Rime Sparse*, and will appear in parentheses in the text.

14. Puttenham, op. cit., 254.

15. Ibid., 254.

16. Freccero, op. cit., 13.

17. "Is there a woman in this text?" (*New Literary History*, 14 (1982)).

18. See Neil Hertz, "Medusa's head: Male hysteria under political pressure," *Representations* 4 (1983): 27–54; and Louis Marin, *Détruire la peinture* (Paris, 1977).

19. "If Medusa has become a central figure for the woman artist to struggle with," writes Patricia Klindienst Joplin, "it is because, herself a silenced woman, she has been used to silence other women." See page 202 in this volume.

64 EMILY ERWIN CULPEPPER
from "Ancient Gorgons: A Face For Contemporary Women's Rage" (1986)

Experiencing My Gorgon Self

Emily Erwin Culpepper, a professor of religion, writes about issues of gender and spirituality. This piece, which appeared originally in the journal *Woman of Power*, asserts the importance of Medusa's force and fury for women today. Noting the invocation of the Gorgon by other writers and artists as well as her own experience fending off a physical attack, Culpepper not so much recuperates Medusa as she relies upon her as a means of transformation, self-empowerment, and thus survival.

> Amazons of Dahomey
> Amazons of Dahomey
> I am haunted and sexed with your image
> What need What memory
> Do you awaken?[1]

Diverse legends give differing versions of the origins of the Gorgons. Perhaps the most familiar legends are the Greek stories describing them as female monsters. Their description as monstrous suits the Gorgons' status as enemies of the Greeks.[2] The most famous such Gorgon is Perseus's enemy—the fierce Medusa, from whose head swirled hundreds of snakes, and whose furious gaze turned men to stone. The Gorgon was a popular figure in Greek art in the archaic period (late seventh century to early fifth century B.C.E.). Tamsey Andrews has vividly described the Gorgon on the Temple of Artemis on Corfu:

> Medusa is intact and unmolested. Perseus does not figure here because the scene does not exist to glorify any hero. Medusa, and her children, and her lion companions, function here entirely in an apotropaic aspect—to turn away evil from the tem-

ple and the goddess within. The fierce strength of the Gorgon is clear, accentuated by the open-mouthed striking position of the twin serpents at her waist, and the snarling lions. The entire scene on the pediment is one of teeth, fury and dark power. . . . [3]

Some feminists have theorized that the Gorgons were a Black Amazon tribe, "whose kinky hair caused the Greeks to mock them as having snakes for hair."[4] Others see the Gorgons' distinctive snake-hair as originating in the frequent association of Goddesses with snakes as a symbol of wisdom, power, and cyclic regeneration. In this view, the fierce appearance expresses and signifies the Destroyer/Warrior aspect of the Triple Lunar Goddess and the Gorgoneion (Gorgon head) may have originally been a mask worn by the priestess to represent this.[5] Both these views may well be true, for the Gorgon stories seem to go back from Greece, through the Near East and into Africa, to stories of African Amazons.[6] Many contemporary feminists link the Gorgons to African Amazons. Most often mentioned are the Amazons of Dahomey (who existed in recent times). They especially figure in the writing of Audre Lorde, for example.[7]

One thing is very clear. The Amazon Gorgon face is female fury personified.[8] This Gorgon/Medusa image has been rapidly adopted by large numbers of feminists who recognize her as one face of our own rage. Besides the daily outrages women face in patriarchy, physical violence against women is widespread and multiform. Such dangers make it desirable and vitally important for women to learn how to manifest a visage that will repel men when necessary. We are not repelled by the Gorgon's face.

> Medusa of the Snakes
> They used your name
> to frighten us,
> But you
> don't frighten me. . . .
> No more this lie
> No more this fear.
> You belong to us again.

> We call your name
> to aid us.
> and you
> Greet us anew.
> Medusa! Medusa! Medusa![9]

Judy Chicago cited Medusa as background for the "Amazon Plate" in her controversial and acclaimed art project *The Dinner Party*.[10] A contemporary drawing of Medusa stares out from the cover of *WOMEN Magazine*'s special issue on "Women and Power." The editors explain:

> No longer afraid of our power we will not turn to stone if we look into Medusa's face. It can be a map to guide us through our terrors, through the depths of our anger into the sources of our power as women. "I turn your face around! It is my face. That frozen rage is what I must explore!"[11]

But surely the most familiar Gorgon image to radical feminists is the one glaring magnificently from *They Will Know Me By My Teeth* by Elana Dykewoman, a book intended "to be sold and shared with women only."[12] The cover is its public face, staring forth from bookstore shelves, fulfilling the ancient Gorgon's function as guardian and promise of the female power within. This face attracts those women who identify with its fiercely independent assertion of woman power. A popular feminist button reproduces a Gorgon face, very similar to the one on Dykewoman's book.[13] The button contains no words, for it needs no explanation of what it is. This face is self-explanatory. The father of an acquaintance saw this button on the book bag I carry. He had never heard of Gorgons nor seen a picture of one and asked me what it meant. I asked him to tell me first what he thought it meant. Immediately he replied, "It means: Keep Out!"

Medusa appears in the influential work of French feminist Monique Wittig. In *Lesbian Peoples: Material for a Dictionary* by Wittig and Sande Zeig, the definition/description of Medusa contains the following dramatic passage:

> Medusa had an abundant and curly head of hair, into which she intermingled black snakes. . . . When she joined in battle on

her mare, all the snakes would rise at once, hissing, furious, agitated with movement, sowing panic among her enemies.[14]

In *Les Guérillères,* one of the women warriors recites a legendary tale about an ancient heroine:

> her beautiful body is black and shining. Her hair consists of slender mobile snakes which produce music at her every movement. This is the hortative head of hair. It is so called because it communicates by the mouths of its hundred thousand snakes with the woman. . . .[15]

The Gorgon has much vital, literally life-saving information to teach women about anger, rage, power, and the release of the determined aggressiveness sometimes needed for survival.

Experiencing My Gorgon Self

I have learned and am continuing to learn about the release of rage through consciousness-raising conversations and through studying self-defense and karate in feminist classes. Feminism has shown me ways to break through years of conditioning (mine was the white southern trying to become middle-class variety) to be always pleasant and "nice." Learning to fight involves exploring your capacity for fierce determination, and its focused expression. Especially vivid is practicing the karate yell. While doing so, I felt an immediate, emphatic connection—spiritually, emotionally, physically—with stories I had heard and pictures I had seen of Gorgons. I began to ponder these images. In August of 1980, while meditating on the Gorgon cover of *They Will Know Me By My Teeth,* I suddenly composed the following poem:

> Through karate I
> find my Gorgon's eye
> Gaze
> for turning men to stone
> Stop
> them in their tracks and

> Save my Self.
> Gorgon myth lives for me in
> Self-defense
> from patriarchy.[16]

Little did I know when I wrote those words, that three months later I would graphically experience this reality in the extreme situation of defending myself from an actual physical attack at my home. Identifying with Gorgons is not an unreal, escapist romanticizing of female ferocity. Engaged in self-consciously in a realistic way, it is an important survival tool. There are, of course, no guarantees of success against attack, "only" means of improving the odds, increasing the likelihood that you will succeed.[17] I know better than anyone that the Gorgon Self which sprang forth in my hour of need did not make me invulnerable. But I also know that it was by my total violent focus into this Gorgon identity that I saved myself.

I do not tell this story to be shocking, though it was a shocking experience, nor to ask for sympathy. It is a graphic witness to the phenomenon that feminists are *living* the knowledge gained from tapping deep and ancient symbolic/mythic power to change our lives. This mode of power is accessible to every woman. It can be very effective as one means for learning to leave victimized self-images and to find our fighting spirit. Here is my story.

On November 16th, 1980, I was attacked at my home. About 9:30 at night, while I was working on writing my dissertation,[18] the doorbell rang. Impatient with this interruption, my mind on my work, I looked through the door's blinds at the young man standing there and asked what he wanted. His words were unclear, something about my neighbor. Thinking he was a friend I had recently seen with my neighbor, still not clearly understanding the mumbled words, I opened the door slightly. Abruptly he pushed forward into the room and started grabbing me. I forcefully knocked him off and shoved him back and out—shouting, feeling my face painfully contort with the force of a fierce and desperate rage.

Now that is a bare bones, matter of fact description of what happened. But the lived experience as I recorded it in my journal immediately afterward gives a truer picture of how I felt this emergence of my will to fight, my Gorgon spirit. I know that is the Self that saved me in this terrible emergency. I wrote in my journal:

Having just been attacked as I try to write my dissertation, the most calming thing I can do—now that the police have come and gone—is to write about it. I feel many things at once . . . enraged at the attacker, enraged at myself for opening the door that stupid little bit. I know better. I've told so many other women never to do what I just did. Now I'm feeling, through the shaking that's still there, more angry at myself than at him for trying to break in and . . . to . . . do what?! I hear a noise and try to stay calm. I'm afraid he will come back—even though I shoved him back out the door and even though three cops came and walked around the house with their flashlights. I sit with the phone right beside me and try to think about what it means that he very likely *knew* I was home alone.

This was made completely clear the following morning when I discovered a box under a high window, evidence that he had looked in.

This writing calms me. I need to, I *must* make my reality larger than this incident. Most of all, I am furious that the reason I opened the door was that my mind was at my desk, my consciousness was peering into the typewriter, wrestling the dissertation onto the pages. Damn! How all too typical—dangerously typical—this is, as an example of male intrusion into our creative space. . . . So hard to get lost in thought, especially woman-identified taboo thoughts. Thoughts I hope will be part of breaking patriarchy's hold, and zap! The very absorption necessary for my own creative struggle does not mesh right with the realities of a stranger at my door, at night, alone. Bitter irony I feel to have opened up my guard to reach the writing places in me, and this very act makes me vulnerable to committing the most basic of errors. I am simultaneously embarrassed at my mistake *and* stubbornly defensive about it too. There *is* a reason why it happened—I was *thinking*, I was *writing*.

At least, once I realized my mistake—in a flash!—no doubt about it!—his gloved hand grabbing my mouth—his body pushing in the door, I immediately "came to." No more mind at the desk. No more musing thoughts stretching back into my work

space. NO! DANGER! Right here! NOW! PUSH his body BACK! KNOCK his hand AWAY! Shove and—loud—yell, "GET OUT! GET OUT! GET OUT!" I am staring him out, pushing with my eyes too. My face is bursting, contorting with terrible teeth, flaming breath, erupting into ridges and contours of rage, hair hissing. It is over in a flash. I *still* see his eyes, stunned, wide and staring almost quizzically, at me, looking oddly puzzled, as if *I* am acting strange, as if *I* were acting wrong! As soon as I realize I've succeeded in shoving him outside onto the porch, I slam the door. Wondering as I slam it, if he'll try to push in—but feeling no resistance as I hear the lock CLICK. Then I start to shake. Or is it only then that I realize I am shaking?

While I was writing this, less than an hour after the attack, I realized that the journal writing was calming because it helped me to focus, to know what had happened—what he did and what I did. It was so enormous an event that I had to exert great effort and energy to know it fully. I was still in a great struggle—to focus my Rage more on the outrage of the attack than on myself for being immersed in thought and therefore opening the door. I next focused on defending to myself the absorption necessary for my work, my writing.

I realized then that I felt it was my solitude, my mind, my mental concentration, my freedom of thought that had been attacked as much as my body. *This* is the greatest Rage! This is the further dimension I must continue to repel. To know my rage fully is the key to not turning it on myself in the form of self-blame, doubts, depression.

As I further struggled that night to know fully my Rage, to know the Self that had succeeded in throwing off the danger, I realized I needed to look at the terrible face that had erupted and sprung forth from within. I wanted and *needed* to see this truth. With swirling emotions, I went to the mirror. I felt self-conscious, "silly," curious, and urgently called by my Self to SEE.

I let the fearful, alarmed, desperate Rage so recent, still fresh, well up in me again in full force. As I felt my face twist again into the fighting frenzy, I turned to the mirror and looked. What I saw in the mirror is a Gorgon, a Medusa, if *ever* there was one. This face was my own and yet I knew I had seen it before and I knew the name to utter. "Gorgon! Gor-

gon!" reverberated in my mind. I knew then why the attacker had become so suddenly petrified. And knew with a great shuddering relief that I would win the fight against self-blame and claim my ability and right to write.

Notes

1. Brenda Walcott, "Amazons of Dahomey," *Slave of a Slave*, n.p.

2. The birth of three sisters, two immortal and one mortal, who are Gorgons is described in Hesiod's *Theogony*. The Argive Cycle of heroic sagas describes Perseus's conflict with the mortal sister, Medusa, in which he decapitates her, and Athena eventually places the Gorgon's head on her shield. Some see this story as an invention to explain a Gorgon/Goddess face on Athena's shield and sever Athena's connection with triple Goddess meanings. (See Barbara G. Walker, *The Woman's Encyclopedia of Myths and Secrets*, p. 629.)

3. Tamsey Andrews, "Notes on Gorgons," unpublished paper, p. 5. Andrews cites photographs of this pediment in *Archaic Greek Art* by Jean Charbonneaus, Roland Martin, and François Villard, pp. 17 and 26.

4. Z. Budapest described conversations with various women, quoted in Marcia Womongold, "Politics of Spirituality and Goddess Worship," *WomanSpirit Magazine* 8: 25.

5. Walker, pp. 349 and 629. See also Patricia Monaghan, *The Book of Goddesses and Heroines*, pp. 120–21. Both Walker and Monaghan cite Robert Graves for this hypothesis (as well as his reference that an Orphic epithet for the moon was "Gorgon's Head"). This is also the view of Jane Ellen Harrison who states, "she [Medusa] is in a word a mask with a body later appended . . . The ritual object comes first; then the monster begotten to account for it . . . The function of such masks is permanently to make an ugly face *at you* if you are doing wrong . . . *for you* if you are doing right." (*Prolegomena to the Study of Greek Religion*, pp. 187–88.)

6. The Gorgons are identified as Lybian Amazons in Helen Diner, *Mothers and Amazons*, pp. 105–11. "Lybia" was sometimes used in ancient writing (e.g., Herodotus) to describe all of Africa that was known. (Merlin Stone, *Ancient Mirrors of Womanhood*, vol. 1. pp. 134–35.) It is worth noting that this convention of referring to Africans as Lybians was used in modern times to describe Afro-Americans. Harriet Beecher Stowe published an article in *Atlantic Monthly*

in 1863, praising that Amazonian abolitionist and woman's right activist, Sojourner Truth. She titled her article, "Sojourner Truth, the Lybian Sibyl." Apparently this was a classical reference intended to urge respect for this "full blooded African." (See Sterling Stuckey, ed., *Sojourner Truth: Narrative and Book of Life*, pp. 116–33.)

7. Audre Lorde, *The Black Unicorn* and *The Cancer Journals*. The Amazons of Dahomey were an all-female warrior group that guarded the Panther Kings of Dahomey. (See also Peggy Reeves Sanday, *Female Power and Male Dominance*, pp. 86–90.)

8. Though I am focusing here on Gorgons, it is important to know that there are Gorgon-like faces of horrific female deities from many religions of the world. The Hindu *Kali*, the Balinese *Rangda*, the Aztec *Coatlicue*, the Mayan *Ixchel*, and the Egyptian *Ta-urt* are just a few examples to show the cross-cultural scope.

9. Ann Forfreedom, "Medusa," *The Book of the Goddess*, p. 72.

10. Judy Chicago, *The Dinner Party*, p. 115.

11. The WOMEN Collective, *WOMEN: A Journal of Liberation*, VI, no. 1, inside cover page. They are quoting a poem by May Sarton, "The Muse as Medusa."

12. Elana Dykewoman, *They Will Know Me By My Teeth*, Megaera Press, 1976: cover drawing by Laura Kaye. Lesbians especially (though not exclusively) seem able to identify with Gorgons. Might this be because we are less ambivalent about appearing horrible and terrifying to men?

13. Button by Whitemare Productions, New York, N.Y.

14. Monique Wittig and Sande Zeig, *Lesbian Peoples: Material for a Dictionary*, p. 106.

15. Monique Wittig, *Les Guerillas* [sic], p. 52. This passage is part of a revision of the myth of Eve and the snake, in which the woman's search for knowledge is celebrated rather than punished as sinful.

16. Emily Erwin Culpepper, unpublished poem.

17. I have discussed this and other aspects of women and self-defense study in two other articles. See "Martial Arts Meditation," *WomanSpirit Magazine* 8: 60, and "Feminism and Martial Art Meditation," *The Politics of Women's Spirituality*, ed. Charlene Spretnak, pp. 26–30.

18. This article is a revised section from the chapter "Amazons Among Us" in the dissertation. (See *Philosophia in a Feminist Key: Revolt of the Symbols*, unpublished doctoral dissertation, Harvard Divinity School, 1983.)

Amy Clampitt published her first volume of poems, *The Kingfisher*, to wide praise at the age of 63. She was quickly hailed as an important new figure in contemporary poetry. She continued to publish over the next eleven years, receiving a MacArthur Foundation Grant in 1992, ten years after a Guggenheim Fellowship. "Medusa" refutes the highly gendered idea of Medusa, instead depicting the Gorgon as representative of a visceral, elemental terror.

The tentacles, the brazen phiz whose glare
stands every fibril of the mind on end—
lust looked at backward as it were,
an antique scare tactic, either self-protection
or a libel on the sex whose periodic
blossom hangs its ungathered garland
from the horned clockwork of the moon:
as cause or consequence, or both, hysteric
symptoms no doubt figure here. She'd been
a beauty till Poseidon, in a flagrant
trespass, closed with her on Athena's temple floor.

The tide-rip torrents in the blood, the dark
gods not to be denied—or a mere indiscretion?
Athena had no time at all for talk like this.
The sea-god might be her old rival, but the woman
he'd gone to bed with was the one who paid.
A virginal revenge at one remove—there's none more
sordid or more apt to ramify, as this one did:
the fulgent tresses roiled to water-snake-
like writhe, and for long lashes'
come-hither flutterings, the stare
that hardens the psyche's soft parts to rock.

The female ogre, for the Puritan
revisionists who took her over, had a new
and siren sliminess. John Milton
put her at the gate of hell, *a woman to
the waist, and fair; but ended foul,
in many a scaly fold, voluminous and vast*—
whose name indeed was Sin. And in the den
of doctrine run amok, the armored glister
of a plodding Holiness revealed her
as likewise divided but, all told, *most
loathsome, filthy, foul, and full of vile disdain.*

The Gorgon, though, is no such Manichean tease,
no mantrap caterer of forbidden dishes,
whose lewd stews keep transgression warm.
The stinging jellyfish, the tubeworm,
the tunicate, the sea anemone's
whorled comb are privier to her mysteries:
her salts are cold, her home-
land Hyperborean (the realm that gave us
the Snow Queen and the English gentleman),
her mask the ravening aspect of the moon,
her theater a threshing floor that terror froze.

Terror of origins: the sea's heave, the cold mother
of us all; disdain of the allure that draws us in,
that stifles as it nurtures, that feeds on
what it feeds, on what it comforts, whether male
or female: ay, in the very tissue of desire
lodge viscid barbs that turn the blood to coral,
the heartbeat to a bed of silicates. What surgeon
can unthread those multiplicities of cause
of hurt from its effect; dislodge, spicule by spicule,
the fearful armories within; unclench the airless
petrifaction toward the core, the geode's rigor?

Shakespeare's "New Gorgon"

Marjorie Garber is a Shakespeare scholar who writes broadly on topics in Renaissance and contemporary culture. Her reading of *Macbeth* is part of a wider discussion of Shakespeare and uncanny causality.

With its gaping mouth, its snaky locks and its association with femininity, castration, and erection, Medusa's head ends up being the displacement upward neither of the female nor of the male genitals but of gender undecidability as such. *That* is what is truly uncanny about it, and it is that uncanniness that is registered in the gender uncertainties in *Macbeth*. Yet Freud (along with virtually all other commentators on Medusa as well as on *Macbeth*, including recent feminist critics) enacts the *repression* of gender undecidability. Freud's text is positively acrobatic in its desire to reassign decidable difference, to read the Medusa figure in terms of castration anxiety and penis display, and to locate fetishism as an identifiable variant of this same anxious and repressive process. Shakespeare's play, however, resists such assignment, resists even the present-day tendency to see the play in terms of male homosocial bonding or anxiety about female power.[1] Power in *Macbeth* is a function of neither the male nor the female but of the suspicion of the undecidable. The phallus as floating signifier is more powerful than when definitely assigned to either gender.

The presence of gender anxiety and its contiguity to border crossings and boundary transgressions has been evident from the opening moments of the play, when the three witches, the weird sisters, gloatingly plot their revenge upon the sailor's wife through their designs upon her husband, the "master o' the Tiger." The witches, who physically exhibit signs of their gender undecidability, as Banquo notes ("you should be women, / And yet your beards forbid me to interpret / That you are so" [1.3.45–47]), are in a sense pluralized, replicative dream-figures for Lady Macbeth. Both they and she whisper plots and hint at the glorious

future for Macbeth, goading him on to "dare." We may remember also that Medusa, whose name means "the Queen," was originally one of three. Wherever Macbeth goes, to the castle or to the heath, he encounters the same powerful female presence that lures him to destruction.

As for the witches, their language early in the play is what we might now recognize as Medusa language, the language of gender undecidability and castration fear. "Like a rat without a tail" the First Witch will "do"; in glossing this zoological peculiarity the eighteenth-century editor George Steevens noted a belief of Shakespeare's time "that though a witch could assume the form of any animal she pleased, the tail would still be wanting, and that the reason given by some old writers for such a deficiency was, that though the hands and feet by an easy change might be converted into the four paws of a beast, there was still no part about a woman which corresponded with the length of tail common to almost all our four-footed creatures."[2] Again the woman comes up short—a Renaissance witch, it seems, could not even aspire to mimetic rathood, but instead had to content herself with a curtailed or foreshortened version of that condition. The gleeful assertion, "I'll drain him dry as hay" (1.3.18) may refer to unslakable thirst, a common affliction of sailors, but it is also plausibly a description of a man exhausted ("drained dry") by excessive sexual demands made upon him. "Sleep shall neither night nor day / Hang upon his penthouse lid . . . Weary sev'nights, nine times nine, / Shall he dwindle, peak and pine" (1.3.19–23).[3] The transgressive and usurping androgynous power of the witches seems to justify, indeed to invite, a reading of these lines as sexually invasive and demeaning; the drained husband will not, unlike the weird sisters, be capable of "doing." "Look what I have," the First Witch cries delightedly.

> *2 Witch.* Show me, show me.
> *1 Witch.* Here I have a pilot's thumb,
> Wrack'd as homeward he did come. *Drum within*
> *3 Witch.* A drum, a drum!
> Macbeth doth come. (26–31)

This dismembered "pilot's thumb" culminates the implicit narrative of sexual disabling and castration. The repetition of the word "come" to describe the progress of both Macbeth and the hapless "pilot" reinforces

the metonymic association of the two figures, especially since Macbeth is also on his way home to be "wrack'd." (He uses the word in a similar context of storm and disaster just before his own decapitation at the play's close: "Blow wind, come wrack, / At least we'll die with harness on our back!" [5.5.50–51]) Nor can we entirely ignore the possibility that "look what I have" can function as a gleeful, childlike announcement of sexual display. Just as the Medusa head incorporates the elements of sexual gazing (scopophilia) and its concomitant punishment, castration, so the First Witch's exhibition of a prize, coming as it does in the narrative just after the account of the "drained" sailor, invites a similar transgressive sight. The morphological similarity between thumb and phallus needs no elaboration, and the possession by the witches of a thumb/phallus as a fetishistic object would emphasize their ambiguous, androgynous character, shortly to be remarked by Banquo. The witches' chortling exchange, aptly described by Coleridge as exhibiting "a certain fierce familiarity, grotesqueness mingled with terror,"[4] introduces the entrance of Macbeth and Banquo, and marks Banquo's questions of them as appropriate descriptions of the uncanny:

> What are these
> So wither'd and so wild in their attire,
> That look not like th'inhabitants o' th' earth,
> And yet are on't? Live you? or are you aught
> That man may question? . . .
> You should be women,
> And yet your beards forbid me to interpret
> That you are so. (1.3.39–47)

The "Medusa complex," if we may continue to call it that, persists throughout the play, from Macduff's horrified cry to the final scene. Macbeth's first act is to display a severed head. Even before the murder there is a muted anticipation of the myth, in an image that seems localized but will recur: Macbeth's curious insistence on the phenomenon of his hair standing on end as if it were alive. Learning that he is Thane of Cawdor, and therefore that the witches' other prophecies may come true, he contemplates the murder of Duncan and is terrified at the thought. "Why," he wonders aloud,

> do I yield to that suggestion
> Whose horrid image doth unfix my hair
> And make my seated heart knock at my ribs
> Against the use of nature? (1.3.134–37)

The word "horrid" comes from a Latin word meaning "to bristle with fear," and is used to mean "bristling, shaggy," throughout the Renaissance. Metaphorically, at least, Macbeth's hair stands on end, "unfixed" by the "horrible imaginings" that flood his mind. Significantly, his imagined physiological response occurs in a key passage about undecidability and the sensation of the uncanny. The "supernatural solicitings" are the text of transgressive doubt, when "nothing is but what is not."

Much later in the play he makes use of the same image, this time to emphasize not his emotional distraction but the numbness that has succeeded it. Hearing the distressful cry of women, he speculates on its source, but does not otherwise respond.

> I have almost forgot the taste of fears.
> The time has been, my senses would have cool'd
> To hear a night-shriek, and my fell of hair
> Would at a dismal treatise rouse and stir
> As life were in't. I have supp'd full with horrors. (5.5.9–13)

Notice "as life were in't." Hair that stands on end is occasionally mentioned elsewhere in Shakespeare, notably when Brutus beholds the ghost of Caesar and addresses it as a "monstrous apparition." "Art thou any thing?" he asks. "Art thou some god, some angel, or some devil, / That mak'st my blood cold, and my hair to stare?" (*Julius Caesar* 4.3.278–80). Never, however, does this figure appear with the imaginative intensity that it does in *Macbeth*. Occurring once near the beginning of the play and once near the end, the picture of the man with horrid, bristling hair frames the dramatic action in an oddly haunting way.

Like Brutus, Macbeth is also visited by the ghost of a man he has murdered, and that encounter provides the opportunity for another, more substantial evocation of the Medusa story. On this occasion Macbeth is the horrified onlooker, and the ghost of Banquo the instrument of his petrification.

The scene is the banqueting hall, where the Scottish lords are gather-

ing to feast with their new king. Macbeth has just learned of the successful murder of Banquo—"his throat is cut" (3.4.15). It is therefore with some complacency that he addresses the assembled lords, expressing the disingenuous hope that "the grac'd person of our Banquo" (3.4.40) is merely tardy rather than fallen upon "mischance" (42). But no sooner has he said these words than he turns to find the ghost of his old companion seated in the king's place. His shock is profound, and his language significant. In effect he is petrified, turned to stone.

Desperately he resolves to visit the weird sisters and compel them to show him the future. But when they do, it is only to present him with another Gorgon, one he will neither recognize nor interpret correctly. For the first apparition summoned by the witches is "an armed Head," prefiguring Macbeth's own ignoble decapitation. Had he read the apotropaic warning in the disembodied head, or in its words, his story might have ended differently. But his failure to "beware the Thane of Fife" (4.1.72), like his inability to comprehend the limits of his own power and knowledge, spell his doom. It remains for the Thane of Fife to transform him into yet another "new Gorgon," a warning sign to Scotland and to the audience of tragedy.

When Macduff confronts Macbeth on the field of battle, he offers, unwittingly, an explanation of the second apparition displayed by the witches, the bloody child. The apparition had proclaimed that "None of woman born / Shall harm Macbeth" (4.1.80–81) so that Macbeth departed confident of his safety. But now Macduff reveals that he "was from his mother's womb/Untimely ripp'd" (5.8.15–16). Macduff's Caesarean birth recalls the moment before the play began when, according to the sergeants' report, Macbeth "carv'd out his passage" (1.2.19) through the rebels and "unseam'd" Macdonwald "from the nave to th'chops" (22).[5] To be "not of woman born" is at least rhetorically to be exempt from the gender anxiety that so torments Macbeth—to be a man born only from a man. And the image of parthenogenesis suggested by this deliberately "paltering" phrase may also bring to mind the figure of Athena, the virgin war goddess, bearer of the Gorgon shield, who sprung full grown, armed and shouting from the head of her father, Zeus. Both of these births avoid the normal "passage" through the female body. Both avoid a disabling identification with the mother and with female weakness, empowering the figures thus begotten as appropriate emblems of retribution. Hearing this phrase—"from his mother's womb / Untimely

ripp'd"—Macbeth's courage begins to fail. "I'll not fight with thee," he declares (22). "Then yield thee, coward," retorts Macduff,

> And live to be the show and gaze o' th' time!
> We'll have thee, as our rarer monsters are,
> Painted upon a pole, and underwrit,
> "Here may you see the tyrant." (5.8.23–27)

"Monster," a word which for the Renaissance carried the modern meaning of an unnatural being, also retained the force of its Latin root, *monēre* (to warn), and hence meant a divine portent or sign. In Macduff's scenario the picture of Macbeth is to become an object lesson, a spectacle, a warning against tyranny, a figure for theater and for art. Like the head of Medusa, this painted figure would serve a monitory role, much in the manner of the dead suitors whose severed heads were to adorn the walls of Antioch in *Pericles*. Ultimately, however, taunted by so inglorious a fate, Macbeth decides to fight—and it is at this point that the next "new Gorgon" appears. Macbeth is slain, and in the next scene we find the stage direction, "Enter Macduff with Macbeth's head."

On the stage this is, or should be, an extremely disturbing moment. The head is presented to the spectators, both the onstage Scottish troops and the audience in the theater, and it is reasonable to suppose that before Macduff's speech of homage to Duncan's son, Malcolm ("Hail, King! for so thou art" [5.9.19]) there should be a brief silence. Even though this is a bloody play, and the soldiers are engaged in bloody battle, the sudden appearance of a severed head—and a recognizable one, at that—might give one pause. The audience, if not turned to stone, is at least likely to be taken aback. Macduff the avenging Perseus, Macbeth the horrified Medusa head, are presented as if in allegorical tableau. And since there is no stage direction that indicates departure, the bloody head of the decapitated king must remain onstage throughout all of Malcolm's healing and mollifying remarks. In his final speech he refers to "this dead butcher" (5.9.35), presumably with some sort of gesture in the direction of the head. However complete Malcolm's victory, however bright the future for Scotland under his rule, the audience is confronted at the last with a double spectacle; the new king and the old tyrant, the promising future and the tainted past.

Yet just as the head of Medusa became a powerful talisman for good

once affixed to the shield of Athena, so the head of Macbeth is in its final appearance transformed from an emblem of evil to a token of good, a sign at once minatory and monitory, threatening and warning. Not in the painted guise foreseen by Macduff, but in its full and appalling reality, the head of the monster that was Macbeth has now become an object lesson in tyranny, a demonstration of human venality and its overthrow—"the show and gaze o' th' time."

The severed head, the gory locks of Banquo, and the armed head that appears as the witches' first apparition—all these have an iconographic congruence to the "new Gorgon" Macduff announced. But there is yet one more episode in the play which, to me at least, suggests associations with the Gorgon story, and which is, in its way, the most remarkable version of that story in the play. I refer to the final apparition displayed for Macbeth on the heath, at his importunate insistence: . . . *"A show of eight Kings, (the eighth) with a glass in his hand, and Banquo last."* . . . The eighth king appears with "a glass," which shows us many more kings to come. A glass is a mirror—in the context of the scene a magic mirror, predicting the future, but as a stage prop quite possibly an ordinary one, borne to the front of the audience where at the first performance King James would have been seated in state. James, of course, traced his ancestry to Banquo, a fact which—together with his interest in witchcraft—may have been the reason for Shakespeare's choice of subject. The "glass" is another transgression of the inside/outside boundary, crossing the barrier that separates the play and its spectators.

Moreover, the word "glass" in Shakespeare's time meant not only "mirror" but also "model" or "example." Thus Hamlet is described as "the glass of fashion and the mould of form" (*Hamlet* 3.1.153); Hotspur as "the glass/Wherein the noble youth did dress themselves" (*2 Henry IV* 2.3.21), and King Henry V, in a variant of the figure, as "the mirror of all Christian kings" (*Henry V* 2. Prologue. 6). For the apparition of the eighth king to reflect such a "glass" (in the person of James I) with the glass he bears would therefore approximate in metaphorical terms the optical phenomenon of infinite regress when two mirrors face one another. Banquo's line would indeed "stretch out to th' crack of doom." Implicitly this trope is already present, since the king reflects all his ancestors. In this sense as well he is "a glass/Which shows [Macbeth] many more." James himself would later explicate this figure of the king as mirror in a speech to Parliament on 21 March, 1609:

Yee know that principally by three wayes yee may wrong a mirrour.

First, I pray you, look not vpon my Mirrour with a false light: which yee doe, if ye mistake, or mis-vunderstand my Speach, and so alter the sence thereof.

But secondly, I pray you beware to soile it with a foule breath, and vncleane hands: I meane, that yee peruert not my words by any corrupt affections, turning them to an ill meaning, like one, who when he hears the tolling of a Bell, fancies to himself, that it speakes those words which are most in his minde.

And lastly (which is worst of all) beware to let it fall or breake: (for glass is brittle) which ye doe, if ye lightly esteeme it, and by contemning it, conforme not your selues to my perswasions.[6]

What I would like to suggest here is that the reflecting glass or mirror in this scene is the counterpart of Perseus's reflecting shield, another transgression of the boundary between stage and reality. Perseus, we are told, was able to gaze on the reflection of Medusa without harm, although had he looked at her directly he would have been turned to stone. But the reflection or deflection of the dreadful image made it bearable. When the head was presented to Athena, and its image fixed on her aegis, it became a positive force, allied with the goddess and the virtues for which she stood. In the context of *Macbeth* the reflecting glass is the binary opposite of Macbeth's severed head: the glass is a happy spectacle demonstrating the long line of kings descended from Banquo, a line which James would doubtless hope to have "stretch out to th' crack of doom"; the head is a dismal spectacle signifying the end of a tyrant's solitary reign. Both are displaced versions of the Gorgon myth, "new 'Gorgons,'" since what horrifies Macbeth gratifies King James and the Jacobean audience. Indeed it may not be too extreme to suggest that James himself is the Athena figure here, to whom the head of the slain Macbeth is offered as a talisman and sign.

Notes

1. For a strong and appealing presentation of this case, see Janet Adelman, "'Born of Woman': Fantasies of Maternal Power in *Macbeth*," in *Cannibals,*

Witches, and Divorce: Estranging the Renaissance, ed. Marjorie Garber (Baltimore: Johns Hopkins University Press, 1986), pp. 90–121. Though I admire Adelman's essay, I differ with her conclusion, which maintains that "Macbeth is a recuperative consolidation of male power" (p. 111). Another thoughtful recent reading of the play is offered by Jonathan Goldberg in "Speculations: *Macbeth* and Source," in *Post-Structuralist Readings of English Poetry,* ed. Richard Machin and Christopher Norris (Cambridge: Cambridge University Press, 1987). "The hypermasculine world of *Macbeth* is haunted," writes Goldberg, "by the power represented by the witches; masculinity in the play is directed as an assaultive attempt to secure power, to maintain success and succession, at the expense of women" (p. 52). Yet Goldberg too reads the witches, and Mary Queen of Scots, "the figure that haunts the patriarchal claims of the *Basilikon Doron*" (p. 53), as woman, as female, rather than as the emblems of a disquieting gender undecidability (bearded women; woman as head of state).

2. Muir, ed., p. 12.

3. In his notes on Shakespeare's Sonnet 116, coincidentally another poetic narrative of marriage, a tempest, and a "wandering bark," Stephen Booth remarks that "many of the metaphors and ideas of this sonnet seem just on the point of veering off toward puerile joking about temporary abatement of female sexual desire." Booth situates the "puerile joking" and "preposterous teasing" (392) in the confident tone of the lover-poet; in *Macbeth* the tone is of course malevolent rather than erotic; dismissive, vengeful, and vituperative rather than indulgent and affectionate—but the trope is a similar one. See also Booth's note on the word *bark* in Sonnet 80, line 7, *Shakespeare's Sonnets* (New Haven: Yale University Press, 1977), pp. 391–92.

4. Quoted in Frank Kermode, ed., *Four Centuries of Shakespearean Criticism* (New York: Avon Books, 1965), p. 537. From a report of a lecture given in Bristol in 1813.

5. Robert Watson describes the actions of several Shakespearean protagonists, Macbeth among them, as "enforcing their own rebirths by a sort of Caesarean section, carving out the opening through which the ambitious new identity appears" (*Shakespeare and the Hazards of Ambition*, p. 19). If recognized as a Caesarean operation, however, Macbeth's offstage action before the play begins encodes his own dramatic teleology, and thus insures the uncanny appropriateness of Macduff as the man who beheads him, also offstage, at the play's close.

6. *Political Works*, p. 325.

67 RITA DOVE
"Medusa" (1989)

Rita Dove is a professor of English and former Poet Laureate of the United States as well as a writer of short stories. Dove's "Medusa" originally appeared in *Caprice* and was subsequently published in her 1989 book of poems, *Grace Notes*.

I've got to go
down where my eye
can't reach
hairy star
who forgets to shiver
forgets the cool suck
inside

Someday long
off someone will
see me
fling me up
until I hook
into sky

drop his memory

My hair
dry water

68 BARBARA FRISCHMUTH

"Grown Older . . ." (1989)

translated by Francis Michael Sharp

Medusa by Free Association

Barbara Frischmuth is a contemporary Austrian novelist. Autobiographical in im-
pulse and feminist in motivation, Frischmuth's work explores the uncanny, frag-
mented, and often troubling return of myth and magic in the lives of modern women
and men. The following excerpt is from a short story in which a couple takes refuge
from the rain in a museum.

Moving into another room, from which at an angle the view of the "Pic-
ture of a Woman" is still possible, though not compelling, the woman
frightens the man with one of those game words which they have gotten
into the habit of using. They associate the words with people and objects,
attaching to them a meaning that extracts them from the world and crys-
tallizes them into a story.

"Medusa" whispers the woman, holding the man by the arm and in-
stinctively pointing out the direction, while the man's eyes light upon the
creature—a word that fits exactly this apparition of a spirit's bodily pres-
ence. With half-opened violet lips and that snake hair he has seen in many
depictions as he has grown older, a face disguises the glance, and he has
to retreat to escape harm from those arched yet seemingly subdued eyes.
Leaning a little to the side, his gaze again falls upon the "Picture of a
Woman" and he almost cries out in recognizing the resemblance of that
beautiful woman to the hideous one. That's the answer. It seems to him as
if the woman in the picture is opening her narrow red lips in the same
way as that modern, vacantly gazing female standing in the line of sight
between him and the picture.

Then the woman too, still holding on to his arm, has grasped the
connection and, both grown older, they undertake their mutual deliver-
ance by turning towards one another at the last moment.

"Addicted," the man remarks, returning from his profound terror

and softening his remark with a timely word, while the woman closes her eyes for a few seconds in order to withdraw into herself even the slightest trace of Medusa. She must never, never permit them to turn into stone at the sight of each other.

As the man and the woman leave the museum it has stopped raining and, grown older, they slowly climb the broad park stairway. On its far side it drops off towards the gate to the stand of poplars where they originally were headed.

69 SANDER GILMAN
from *The Jew's Body* (1991)

The Syphilitic Woman

Sander Gilman is a cultural and literary historian. In the chapter of *The Jew's Body* excerpted here, Gilman explores ideas about prostitution, syphilis, and the image of Medusa as lethal woman. In a 1916 Belgian poster, reproduced in Gilman's book, the infected female seductress maintains the "spiderlike hair" and "vampiric power" of the Medusa (Figure 24).

What will be found in the body of these drowned women? Will it be the hidden truths of the nature of the woman, what women want, the answer to Freud's question to Marie Bonaparte? Will it be the biological basis of difference, the cell with its degenerate or potentially infectious nature which parallels the image of the female and its potential for destroying the male? Will it be the face of the Medusa, with all of its castrating power? Remember that in that age of "syphiliphobia" the "Medusa" masks the infection hidden within the female. In Louis Raemaker's 1916 Belgian poster representing the temptation of the female as the source of syphilis, much of the traditional imagery of the seductress can be found standing among rows of graves, wearing a black cloak, and holding a skull which represents her genitalia, she is the essential femme fatale But there is a striking fin-de-siècle addition to the image—for here "la syphilis" is the Medusa. Her tendril-like hair, her staring eyes, present the viewer with the reason for the male's seduction: not his sexuality, but her vampiric power to control the male's rationality. The Medusa is the genitalia of the female, threatening, as Sigmund Freud has so well demonstrated, the virility of the male, but also beckoning him to "penetrate" (to use Freud's word) into her mysteries.

70 FRANÇOISE FRONTISI-DUCROUX
"The Gorgon, Paradigm of Image Creation" (1993)
translated by Seth Graebner

Medusa as Maker of Images

Françoise Frontisi-Ducroux of the Collège de France is the author of a number of works on ancient Greece, particularly relating to the visual arts. She writes on the theme of metamorphosis in Greek texts and images.

[Iconopoesis]

The mythic figure of the Gorgon, called Medusa or Gorgo, will be examined here from a particular point of view, that of its function in narrative and figuration: a paradigm for the production of images. This paradigm has two facets:

—First, the Gorgon's iconopoetic effectiveness: the Medusa's gaze is a producer of images, in this case of petrified figures. This petrification operates in two different ways, according to the mythic traditions. Gorgo's victims may be reduced to a formless state, a rocky mass, or find themselves made into statues, keeping their form intact.

—Second, the "iconopoesis" of which Gorgo is herself the object, and which is the condition of her visibility, since her forbidden face is accessible only in the form of images. . . . The most important characteristic of these monsters, their mortal gaze, is evoked only through its effect, petrification. The organ itself, the Gorgon's eye, is neither mentioned nor described. This is a constant feature of evocations of Gorgo, of whom no Greek text gives a detailed description. Medusa and her beheaded sisters, and even the *gorgoneion* itself, are evoked much more than described. . . . This quasi-systematic verbal repression constitutes a first characteristic. The second is that this figure, defined as impossible to look at, is paradoxically ubiquitous in the Greeks' environment.

Texts aside, archaeology gives an idea of this figurative profusion in images and objects. The Gorgon and the *gorgoneion* (woven, engraved,

carved, painted, or sculpted) decorated clothing, jewelry, gems, orna-
ments of rings, bracelets or pendants, fibulas, belt buckles, mirror han-
dles . . . it figured on seals and coins, and it ornamented furniture,
placed on chests, beds, the metal feet of chairs, or the joints of folding
screens. . . . In short, this forbidden face, which the poets renounced
describing, was the object of a superabundant figuration in the plastic
arts....Most remarkably, this unspeakable vision, whose blurred features
announce its uncontemplatable character, is at the same time completely
unavoidable. Gorgo's major characteristic is her frontal nature....

[Frontality]

The frontal character is a figure cut off or turning away from its iconic
environment. By that very fact it can come into contact with the ad-
dressee of the image. I call this sortie of the image *apostrophé*, which
means turning aside, deviation, or about-face. Greek grammarians used
the term to designate a change of interlocutor in a discourse or story,
and, accordingly, to name the rhetorical figure of interpellation or "apos-
trophe." The frontalized figure, object of a pictorial *apostrophé*, takes on a
different status: it belongs at once to the space of the image and to that of
the spectator. . . . In representations of Perseus and the Gorgon, the
hero generally has his head turned, an attitude described in the narra-
tives as *apostrophein*. The images show him turning his head, to feel his
way to accomplish his exploit of decapitating the Medusa. . . . The
turned head became the permanent and characteristic epithet of
Perseus, permitting one to identify him without ambiguity, to differenti-
ate him in particular from Bellerophon, who, like him, rides Pegasus. On
the terra-cotta reliefs of Melos, Bellerophon forges resolutely ahead,
while Perseus looks back.

 The head-turning—*apostrophé*—which, in the iconic space, desig-
nates the visual taboo attached to the Gorgon, seems to me to comple-
ment the monster's frontal nature; the monster's face strikes the
spectator with another turning, a rotation of a quarter-turn away from
the canonical profile pose. This second *apostrophé* marks the Gorgon's be-
longing to two spaces, that of the image, where her sight is intolerable
for the actors of the story pictured (except for the gods), and that of the
spectator on whom she is imposed, and for whom she is view-

able. . . . This iconographic motif has no textual equivalent. The scene
showing Perseus looking at the severed head does, however, evoke a sec-
ondary narrative sequence, which relates how Athena, at the moment of
decapitation, placed her shield so as to reflect the Medusa's head, and to
permit the hero better to aim his blow. This addition, probably inserted
in the legend at the end of the fifth century, and which thus describes
Athena's invention of the rearview mirror, was not indispensable for the
verisimilitude of the plot. Perseus compensated very well for the handi-
cap imposed by the visual taboo; he guided himself by touch. Many im-
ages show him grasping the serpentine hair or immobilizing the neck of
his victim. The artifice of the mirror-shield is therefore not merely a ra-
tionalist complement to the story. It presents a new implication for the
theme of vision so fundamental to the myth. It adds a supplementary
term to the alternation of *visibility/nonvisibility* or *invisibility* which punc-
tuates the entire story of Perseus's adventures.[1]

This new sequence means that sight of the invisible is possible when
a simulacrum replaces it. What Perseus contemplates is only a duplicate
of the original purged of its poison, an *eikon*. Athena's ingenuity in cap-
turing the Gorgon's reflection on her buckler, in the place of the *gor-
goneion* on warriors' shields and on her own, justifies a posteriori the
effective visibility of Gorgo's face and the paradoxical profusion of its
representations. It becomes a bearable sight because it is an *eikon,* and it
is the iconicity of the Medusa which the reflection sequence reveals, both
in the narrative version which situates the scene at the moment of decap-
itation, as well as in the figurative version which places it afterwards. . . .

[Coral]

We find a new transformation of this motif in a sequence providing a se-
quel to the freeing of Andromeda: the birth of coral, one of the Greek
names for which is *gorgoneion*. Ovid reports the event:[2] after the execu-
tion of the sea-monster, Perseus washes his hands after placing the head
on some leaves to prevent it from being damaged. The soft stems of the
seaweed harden on contact with the monstrous head, absorbing its power,
and the nymphs playfully repeat the experiment with other branches,
whose seed they throw into the water. From then on, coral has kept the
property of hardening on contact with air. A flexible branch in the water,

it becomes stone—*saxum*—when it dries. . . . Petrification is a paradigm for theorizing the passage from living to dead, animated to fixed, supple to rigid—the same transformation suffered by the victims of Gorgo's mortal gaze. Coral, however, also presents the inversion peculiar to Medusa's face itself, which is only viewable when decapitated (or even petrified, according to a late and deviant version in which the Gorgon petrifies herself by seeing herself on the shield), or rather which becomes viewable in the form of a reflection and an image, an *eikon*. As a mythic model, an object which can be thought through, coral takes its place among the victims of the Medusa's gaze, since it turns to stone on contact with the head placed on the ground (this purely tactile variant changes little, because for the Greeks, sight was touching at a distance). However, coral is also a double for the head become viewable once severed from the body, as it is itself separated from the sea-bottom in which it was rooted. Its name, *gorgoneion*, clearly suggests this equivalence, parallel to the other *gorgoneion,* the fixed and visible figuration of a living original inaccessible to the gaze. We may also read this equivalence in the genetic name for coral, according to a scholiast who derived *coralium* from *coré*, "young girl," reminding us that Medusa was a young girl (seduced or raped by Poseidon, who fathered on her Pegasus and Chrysaor). We should also recall that the severed head belongs to Coré-Persephone, Queen of the Dead.

[Conclusion]

The figure of the Medusa furnishes an effective mythic paradigm on both the narrative and figurative levels; in figuration, it is set in place apart from any verbalization. Artists have used it to think through the problem of figuration, and particularly of mimesis of an invisible original. Rendering visible the nonvisible constitutes an essential aspect of figuration, which in ancient Greece appeared essentially in religious terms. One had to give a face to the gods, characterized by their *éclat*, or brilliance, unbearable for mortal eyes.[3] The Gorgon represents the extreme of monstrosity, of the unspeakable horror of death whose representation it allows (whereas Hades, god of the Dead, whose name *A-idés* also speaks of nonvisibility, is very rarely represented).

This catalyst is constantly at work, taking two divergent paths from the beginning:

—the one, which shows the petrification of Gorgo's victims, explored by a tradition of narrative painting, which makes this freezing of the image a figure *en abîme* of pictorial practice;

—the other, which short-circuits narration by projecting the Gorgon's face on the spectator, to petrify him ["*pour le méduser*"]. This solution is very ancient, since it goes back to the frontal *gorgoneion*, and has also been very fertile ground in the history of painting. We might mention, among many others, Caravaggio's *Medusa*, painted on a shield,[4] or the crawling head, the work of Rubens, both of which brought considerable renewal to the motif.[5]

Notes

1. Cf. J.-P. Vernant, *La Mort dans les yeux*, Paris, 1985.
2. Ovid, *Metamorphoses*, [IV. 740–752].
3. Cf. *Corps des dieux. Le Temps de la Réflexion* VII, 1986.
4. Cf. the analysis of Louis Marin, *Détruire la peinture*, Paris, 1977.
5. Cf. Jean Clair, *Méduse*, Paris, 1989.

from "Berggasse 19: Inside Freud's Office" (1996)

Medusa in the Mirror

In this 1996 essay, Diana Fuss, a professor of English, and Joel Sanders, a professor of architecture, undertake a study of the spatial configuration of Freud's Vienna office. They note that the analysand was positioned literally face-to-face with Freud and metaphorically in a Medusan position.

The patient's entry into Freud's office initiates a series of complicated and subtle transactions of power, orchestrated largely by the very precise spatial arrangement of objects and furniture. Freud held initial consultations, between three and four every afternoon, in the study section of his office. Preferring a face-to-face encounter with prospective patients, Freud seated them approximately four feet away from himself, across the divide of a table adjacent to the writing desk. Located in the center of a square room, at the intersection of two axial lines, the patient would appear to occupy the spatial locus of power. As if to confirm the illusion of his centrality, the patient is immediately presented, when seated, with a reflection of his own image, in a small portrait-sized mirror, framed in gold-filigree and hanging, at eye-level, in a facing window. As soon as Freud sits down at his desk, however, interposing himself between patient and mirror, the patient's reflection is blocked by Freud's head. Head substitutes for mirror in a metaphorical staging of the clinical role Freud seeks to assume. "The doctor," Freud pronounces in *Papers on Technique*, "should be opaque to his patients and, like a mirror, should show them nothing but what is shown to him" (12:118).

Freud's clinical assumption of the function of the mirror, and the substitution of other for self that it enacts, sets into motion the transferential dynamics that will structure all further doctor-patient encounters. In preparation for the laborious work of overcoming their unconscious resistances, patients are required to divest themselves of authority while seated in the very center of power. In a reverse panopticon, the most

central location in Freud's study (the point from which the gaze normally issues) turns out to be the most vulnerable, as the patient suddenly finds himself exposed on all sides to a multitude of gazes. Viewed from both left and right by a phalanx of ancient figurines (all displayed at eyelevel and arranged to face the patient), as well as from behind by a collection of detached antique heads and from in front by Freud's imposing visage, the patient is surveyed from every direction. Power in this transferential scene is exercised from the margins. From the protected vantage point of his desk chair, Freud studies his patient's face, fully illuminated by the afternoon light, while his own face remains barely visible, almost entirely eclipsed by backlighting from the window behind him.

"The process of psychoanalysis," Freud goes on to remark in *Papers on Technique,* "is retarded by the dread felt by the average observer of seeing himself in his own mirror" (12:210). The analogy of the mirror, used to describe the process of psychoanalytic self-reflection, makes its first appearance in Freud's work in his reading of the memoirs of Daniel Paul Schreber. Mirrors figure prominently in Schreber's transvestic identification: "Anyone who should happen to see me before the mirror with the upper portion of my torso bared—especially if the illusion is assisted by my wearing a little feminine finery—would receive an unmistakable impression of a *female bust*" (12:33). And what did Freud see when, alone in his office amongst his classical heads and ancient figurines, he turned to face his own image in the mirror? Freud, too, saw the unmistakable impression of a bust—head and shoulders severed from the body, torso-less and floating, like the Roman head overlooking his consulting room chair or the death mask displayed in his study. His head decapitated by the frame of the mirror, Freud is visually identified with one of his own classical sculptures, transformed into a statuary fragment.

Looking in the other direction Freud also saw only heads. A wooden statue of a Chinese sage sitting on the table between Freud and his patient severs the patient's head in the same way Freud's head is decapitated by the frame of the mirror. From the vantage point of the desk chair, the patient's disembodied head assumes the status of one of Freud's antiquities, homologous not only to the stone heads filling the table directly behind the patient (the only table in the office displaying almost exclusively heads) but also to the framed photographic portraits above them, hanging at the exact same level as the mirror.

For Freud, every self-reflection reveals a death mask, every mirror

image a spectral double. In his meditation on the theme of doubling, Freud remarks in "The 'Uncanny'" that while the double first emerges in our psychical lives as a "preservation against extinction," this double (in typically duplicitous fashion) soon reverses itself: "From having been an assurance of immortality, it becomes the uncanny harbinger of death" (17:235). By captivating our image, immobilizing and framing it, the mirror reveals a picture of our own unthinkable mortality.

Yet, as Freud notes elsewhere, it is finally impossible to visualize our own deaths, for "whenever we attempt to do so we can perceive that we are in fact still present as spectators" (24:289). The mirror that memorializes also reincarnates, reconstituting us as phantom spectators, witnesses to our own irreplaceability. The mirror thus functions simultaneously like a window, assisting us in passing through the unrepresentable space of our violent eradication, and helping us, in effect, to survive our own deaths. This was indeed the function of Etruscan mirrors (so prominent in Freud's own private collection) on whose polished bronze surfaces mythological scenes were engraved. By differentiating between pictorial space and real space, the frame of the Etruscan mirror offers the illusion of a view onto another world. These mirrors, originally buried in tombs, assisted their owners in passing through their deaths: the Etruscan mirror opened a window onto immortality.

Lacan saw as much in his early reflections on the mirror stage. Radically dislocating the traditional opposition of transparency and reflectivity (window and mirror), Lacan instructs us to "think of the mirror as a pane of glass. You'll see yourself in the glass and you'll see objects beyond it."[1] In Freud's office, the placement of a mirror on a window frame further complicates this conflation of transparency and reflectivity by frustrating the possibility of opening up the space of looking that both crystalline surfaces appear to offer. Normally, when mirrors are placed against opaque walls, they have the capacity to act as windows; they dematerialize and dissolve architectural edges, creating the illusion of extension and expanding the spatial boundaries of the interior. But in this highly peculiar instance of a mirror superimposed on a window, visual access is obstructed rather than facilitated. Unlike the glass panes on Berggasse 19's rear entry doors, which allow the viewer's gaze to pass easily along a central axis from inside to outside, the composition of Freud's study window, with the mirror occupying the central vanishing point, redirects the gaze inward. By forcing the subject of reflection to

confront an externalized gaze relayed back upon itself, the mirror on Freud's window interrupts the reassuring classical symmetries of self and other, inside and outside, and seeing and being seen that constitute the traditional humanist subject.[2]

The architectonics of the Freudian subject depends fundamentally upon a spatial dislocation, upon seeing the self exteriorized. It is not only that when we look in the mirror we see how others see us, but also that we see ourselves occupying a space where we are not. The statue that confronts us in the mirror permits us to look not only at but through ourselves to the "object who knows himself to be seen."[3] The domain delimited by Lacan's *imago*, "the statue in which man projects himself,"[4] is thus a strangely lifeless one. As Mikkel Borch-Jacobsen pictures it in "The Statue Man," this mirror world is "a sort of immense museum peopled with immobile 'statues,' 'images' of stone, and hieratic 'forms.'" It is "the most inhuman of possible worlds, the most *unheimlich*."[5]

What Freud sees in his mirror is a subject who is, first and foremost, an object, a statue, a bust. The "dread" of self-reflection that Freud describes in *Papers on Technique* appears to issue from a fear of castration, of dramatic bodily disfigurement. If, as Freud insists in "Medusa's Head," the terror of castration is always linked to the sight of something, then it is the sight of *seeing oneself seeing* that possesses lethal consequences for the figure in the mirror. Like Medusa, who is slain by the fatal powers of her own gaze reflected back to her by Perseus's shield, Freud's narcissistic gaze makes him "stiff with terror, turns him to stone" (18:273). Self-reflection petrifies. Perhaps this is the knowledge that so frightened, and so fascinated, Freud: the realization that the subject's "optical erection" could only be achieved at the price of its castration, its instantaneous, fatal transformation into a broken relic.

Notes

Reprinted from *Stud: Architectures of Masculinity*, edited by Joel Sanders (New York: Princeton Architectural Press, 1996).

1. Jacques Lacan, *Seminar I: Freud's Papers on Technique*, ed. Jacques-Alain Miller, trans. John Forrester (New York: Norton, 1988), p. 141.

2. For an excellent discussion of challenges to the traditional humanism of the architectural window, see Thomas Keenan, "Windows: of vulnerability," in

The Phantom Public Sphere, ed. Bruce Robbins (Minneapolis: University of Minnesota Press, 1994), pp. 121–41. See also Colomina, *Privacy and Publicity,* esp. pp. 80–82, 234–38, and 283ff. An earlier discussion of windows and mirrors can be found in Diane Agrest, "Architecture of Mirror / Mirror of Architecture," in *Architecture from Without* (Cambridge: MIT Press, 1991), pp. 139–55.

3. Lacan, *Seminar I*, p. 215; see also p. 78.

4. Lacan, "The Mirror Stage as Formative of the Function of the I as revealed in Psycnoanalytic Experience," in *Écrits*, trans. Alan Sheridan (New York: Norton, 1977), p. 2.

5. Mikkel Borch-Jacobsen, *Lacan: The Absolute Master,* trans. Douglas Brick (Stanford: Stanford University Press, 1991), p. 59.

from "Who's Looking at Who(m): Re-viewing Medusa" (1996)

Medusa in Theater and Performance Art

Lizbeth Goodman directs the Institute for New Media Performance Research and teaches theater and performance studies at the University of Surrey. She has written several works on theater, feminism, and gender studies.

Is it Medusa's image or her gaze which has caused all the trouble, and earned her such a bad rep? What or who, exactly, is turned to stone by Medusa? Is it those who dare to look at her, or those at whom she looks? What is it about Medusa which so frightens mortals with a need to look around, and which offers to those making theatre today such a strong metaphor for the transformative power of women? And what is it about the languages of performance which allows us to transcend some of the rules of grammar and syntax, while remaining ambiguously framed by our own words, voices, ways of communicating and creating? Where, if anywhere, can we draw any lines or boundaries between performance and communication, text and subtext, sexual desire and sexual expression, longing and imagining, movement and the thought of movement, looking, seeing, being seen, and being seen to be seen . . . so that we may choose to present ourselves in deliberately provocative ways?

What happens if for "Medusa" we read "lesbian theatre maker" or "performance artist or theatre practitioner interested in borderlines between sexuality and creative expression"? The broader the term, the more accurate and interesting, and also the harder to pin down, to freeze into one image or form which can be easily identified, defined, analysed. . . .

The figure of Medusa can be seen looking out of and at much feminist theory of the past few decades, although she remained largely invisible in and to much feminist and specifically lesbian theatre and performance artwork of the 1970s and 1980s. By contrast, the 1990s has seen an increase in the extent to which feminist theory has begun to inform

women's and lesbian theatre work, and the extent to which lesbian theoretical perspectives have been adopted by gay male artists and those who write about queer culture. Medusa now figures in a wide variety of plays and performance pieces, often in work which pushes past boundaries of single disciplines by combining scripted text with movement, direct address to the audience, dance, visual images, and multimedia formats. . . .

Medusa is the title of a one-woman performance piece devised and presented by Dorothea Smartt at the Institute of Contemporary Arts, London, in 1993. Dorothea Smartt is a self-taught poet and performance artist who began writing when she was inspired by the telling of personal stories within the black feminist movement in England in the 1970s. . . .

In *Medusa*, Smartt shows how expectations about black women's appearance are connected to a sense of self-definition in relation to the cultural values of (white) women's appearance. She draws on the figure of Medusa partly to connect with her status as a powerful mythic figure, and partly for a more physical, and comically understandable, reason: children in her Brixton neighbourhood would see her hair and call her "Medusa"; in turn, Smartt not only looked at the children but looked at herself through their eyes, and took that title back as a comic claim of the mythic status, and also a powerful way to connect with a powerful figure.

In performance, Smartt becomes Medusa, visually translating herself into the semiotic sign for Medusa by allowing the full-size image of Medusa's head to fill the space. Her hair is everywhere. It seems to move. The audience stares, transfixed, and also amused, for the hair which is so familiar on the streets, in the audience, is transformed into something with vague mythic associations, unnerving, at once strange and comically familiar. Smartt's Medusa locks become a metonym for the power of transformation, which is defined as a female power, achieved through self-reflection. By offering her own image, she encourages the audience to see aspects of themselves in her, to identify, to empathize, to share an inside joke. She makes Medusa less frightening. And within this performance, Smartt's sexuality, while endorsed by the presence of friends in the lesbian community who attend on the night, is not the issue, or the "sign" to be addressed by this performance. The event is about all kinds of border crossings. . . .

Smartt offers images of Medusa which are realistic and mystical, deadly serious and wryly ironic. Perceiving herself to be both a citizen

and an "outsider" in England, she considers herself to be perpetually "under siege," and observes that the safety of sameness is closed off to her on several levels; so the contrast between "sameness" and difference can be consciously subverted in performance with no threat of censure. In physicalities like the style of her hair and the way she uses language to her choice of movements and range of references in the work, Smartt makes deliberate choices about self-presentation. She holds a mirror up to herself and to her audience, and dares anyone not to look her in the eye. Interestingly, she compares her choice to do up her hair in "loks" [sic] with the discovery of her sexuality as major points in her life, both about recognition of "not being the same." So the focus on Medusa's hair in her performance symbolizes not only a deliberate choice of black-identified representation but also a range of associated symbols, for—to Smartt—Medusa's hair (and her own hair) has real power: mythical, symbolic, sensual, and sexual:

> To me, hair is an extension of your skin: yet what you put on your hair you wouldn't dream of putting on your face, your skin. I was sparked by a programme I heard on the radio in New York . . . about caring for African hair. It was raving about the importance of hair, on a spiritual level: hair as antennae to the cosmos, power coil, circular imagery of matriarchal religious communities of women. If you think about the curl, the kink, the happiness of black hair, then to straighten it is to unplug yourself from a power source. And then to perm it back is to uncoil the receiver and coil it back on itself the other way. I realized that when I changed my hair, people looked at me differently, got angry, mad, even scared. I would go home and look in the mirror and ask myself what had vexed them.
>
> I thought to myself: Medusa was probably some black woman with nappy hair, and some white man saw her and cried: a monster!, and feared her, and so told stories about her dangerous potential. To see her more clearly, I studied anthropology and thought about the first encounters of white men in Africa, and how they might have viewed and feared these strange and fantastic creatures: black women. What did early explorers see or think they saw? That's what I ask, in a sense, in performance.[1]

In her explanation of Medusa's power, Smartt comments on masks and hair as metonymic images for the sexual power of the black woman, the lesbian, the "outsider." She tries to see Medusa, and herself, through the eyes of others, just as in her performance work she projects images which offer points of identification and of alienation. Smartt's poem, "Medusa? Medusa Black!" — one part of the performance sequence — was, she admits, a doubly political statement. In the poem, she says she would never perm her hair, and within the extended metaphors of agency and identity set up in previous poetic sequences, this is a clear claim to black, lesbian, "alien" power: Medusa's power. People who don't like it, she says, don't have to look.

Note

1. Dorothea Smartt in interview with Lizbeth Goodman, ICA, London, August 1995. All further statements attributed to Smartt in this article are from the same interview. [For Smartt, see "Medusa? Medusa black!" in *Mythic Women / Real Women: Plays and Performance Pieces by Women*, ed. Lizbeth Goodman (London: Faber and Faber, 2000)].

73 GIANNI VERSACE
from "The Versace Moment" by Mark Seal (1996)

Seduction

Gianni Versace, the brilliant Italian couturier murdered in 1997, was well known for his upscale and cutting-edge designs. He adopted an image of Medusa as the cornerstone of his advertising campaigns, placing Medusa's face on many of his famous scarves and accessories (Figures 28 and 29). In an interview with Mark Seal, excerpted here, he provided a brief but nonetheless suggestive explanation of his choice of Medusa as the defining and abiding symbol of the House of Versace.

INTERVIEWER: Tell me why Medusa is your logo.

GIANNI VERSACE: Seduction. . . . Sense of history, classicism. You stay with me, or no. That's it. Medusa means seduction . . . a dangerous attraction.

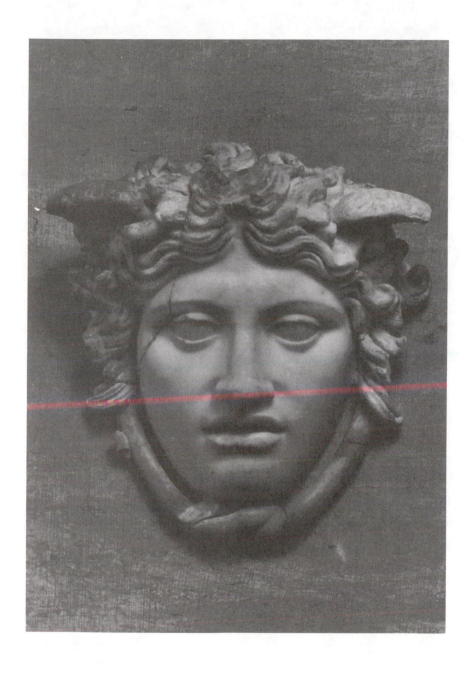

Bibliography

Any attempt at a complete bibliography an Medusa would, in fact, be incomplete by the time of its publication, since this ancient figure continues to generate interest, not only in the fields of art, literature, and history, but also in psychology and psychoanalysis, in women's and gender studies, and, increasingly, in popular culture (from song lyrics to amusement parks). The works listed in this bibliography range in scope from ancient texts that reflect the rich tradition surrounding the importance of the myth in antiquity to extended modern interpretations and applications of the Medusa story. Our selection, while including a number of modern works, offers an extensive list of ancient and medieval works about Medusa and will guide the reader to most of the pertinent older sources. Some texts below, while clearly based on the myths surrounding Medusa, may not mention her explicitly by name; this is especially true in the case of fiction. Page numbers, when indicated, will mark explicit references to the myth. No pages are cited when Medusa appears throughout the work as a character or as a structuring theme.

Most of the references included below are in English, although many are translations from works in other languages. Those interested in reading these works in the original languages (Greek, Latin, French, German, or Italian) should be able to identify and locate them by consulting the editions, texts, and notations cited here.

Art, Film, Music, and Theater Criticism

Ashmole, Bernard. "Cyriac of Ancona and the Temple of Hadrian at Cyzicus." *Journal of the Warburg and Courtauld Institutes* 19, no. 3–4 (1956): 179–91.

Berger, Maurice. "Edward Burne-Jones' 'Perseus-Cycle' and the Vulnerable Medusa." *Arts Magazine* 54, no. 8 (1980): 149–53.

Beylie, Claude. "The Curtain of the Medusa." *L'Avant-scène Cinéma* 315 (1983): 84–85.

Bryson, Norman, and Bernard Barryte. *In Medusa's Gaze: Still Life Paintings from Upstate New York Museums*. Rochester, N.Y.: Memorial Art Gallery of the University of Rochester, 1991.

Bundtzen, Lynda K. "Monstrous Mothers, Medusa, Grendal, and Now 'Alien.'"
 Film Quarterly 40, no. 3 (1987): 11–17.

Clair, Jean. *Méduse: contribution à une anthropologie des arts du visuel*. Paris: Galli-
 mard, 1989.

Cropper, Elizabeth. "The Petrifying Art: Marino's Poetry and Caravaggio." *Met-
 ropolitan Museum Journal* 26 (1991): 193–212.

Daly, P. M. "Alciato Emblem 'Concordiae Symbolum'—A Medusa Mirror for
 Rulers." *German Life and Letters* 41, no. 4 (1988): 349–62.

Dick, Bernard F. "Celluloid Woman." *Southern Quarterly* 16, no. 4 (July 1978):
 345–57.

Eitner, Lorenz. *Géricault, His Life and Work*. London: Orbis Publishing, 1983.
 181, 310.

Friedlaender, Walter. *Caravaggio Studies*. Princeton: Princeton University Press,
 1955.

Forbes, J. "Varda, Agnes: The Gaze of the Medusa." *Sight and Sound* 58, no. 2
 (1989): 122–24.

Goodman, Lizbeth. "Who's Looking at Who(m)?: Re-viewing Medusa." *Modern
 Drama* 39, no. 1 (1996): 190–210.

Higonnet, H. R. "The Voice of Medusa." *German Quarterly* 64, no. 4 (1991):
 604–6.

Holzapfel, Tamara. "A Mexican Medusa." *Modern Drama* 12, no. 3 (1969):
 231–37.

Jacobs, Andrew Seth. *Two pieces for chorus: 1. a persuasion; 2. Medusa*. 1994.

Ketting, Otto. *Medusa: for alto saxophone and orchestra, 1992*. Amsterdam: Done-
 mus, 1994.

Kleiman, Ed. "Campion New Admired Guest, Muse or Medusa." *ANQ* 1, no. 3
 (1988): 85–88.

Lund, Deborah S. "The Art of Killing Medusa." *German Quarterly* 61, no. 4
 (1988): 587–88.

Moir, Alfred. *Caravaggio*. New York: H. N. Abrams, 1982.

O'Connor, John J. "Medusa: Dare to Be Truthful." *New York Times,* Dec. 2, 1991,
 sec. C, p. 13, col. 1.

Pater, Walter. "Leonardo da Vinci." In *Walter Pater, Three Major Texts*. Edited by
 William E. Buckler. New York: New York University Press, 1986. 134–52.

Perseus Project. Edited by Gregory R. Crane. Tufts University.
 http://www.perseus.tufts.edu (October 1998).

Rossetti, Dante Gabriel. "To C. P. Matthews." In *Letters*. Vol. 2. Edited by

Oswald Doughty and John Robert Wahl. Oxford: Clarendon, 1965. 642–43.

Rossetti, William Michael. *Rossetti Papers, 1862 to 1870.* London: Sands and Co., 1903. 280–82, 290–94.

Schor, Mira. "Medusa Redux: Ida Applebroog and the Spaces of Post-modernity." *Artforum* 28, no. 7 (1990): 116–23.

Schneider, Laurie. "Donatello and Caravaggio, the Iconography of Decapitation." *American Imago* 33, no. 1 (1976): 76–91.

Fiction, Poetry, Drama, and Autobiography

Aeschylus. "The Libation Bearers." (From the *Oresteia*.) Translated by Richmond Lattimore. In *Aeschylus*. Edited by David Grene and Richmond Lattimore. Chicago: University of Chicago Press, 1942. 105–50.

———. "Prometheus Bound." Translated by David Grene. In *Aeschylus*. Edited by David Grene and Richmond Lattimore. Chicago: University of Chicago Press, 1942. 201–45.

Andersen, H. C. "Psyche." In *Stories and Tales*. Boston: Houghton Mifflin Company, 1870. 236–43.

Apollinaire, Guillaume. "La Méduse." In *Le Bestaire: ou, Cortège d'Orphée*. Translated by Lauren Shakely. Paris: Delplanche, 1911. Reprint, New York: Metropolitan Museum of Art, 1977.

Bacon, Josephine Dodge Daskam. *Medusa's Head*. New York: D. Appleton and Co., 1926.

Barth, John. "Perseid." In *Chimera*. New York: Random House, 1972. 57–134.

Barthelme, Donald. "A Shower of Gold." In *Come Back, Dr. Caligari*. Boston: Little, Brown, 1964. 171–83.

Bogan, Louise. "Medusa," "The Sleeping Fury." In *The Blue Estuaries: Poems, 1923–1968*. New York: Farrar, Straus and Giroux, 1968. 4, 78–79.

Byatt, A. S. "Medusa's Ankles." In *Matisse Stories*. New York: Random House, 1995. 1–28.

Carballido, Emilio. "Medusa." *An English Translation of Three Plays by Emilio Carballido*. Translated by Douglas-Scott Goheen. Diss. University of Denver, 1974. Ann Arbor: University of Michigan Press, 1972.

Cather, Willa. *Youth and the Bright Medusa*. New York: Alfred A. Knopf, 1945.

Chalker, Jack L. *Medusa: A Tiger by the Tail*. New York: Ballantine Books, 1983.

Clampitt, Amy. "The Mirror of the Gorgon." In *Archaic Figure: Poems*. New York: Alfred A. Knopf, 1987. 19–36.

D'Annunzio, Gabriele. "Gorgon." *Poésie complète*. Vol. 2. Bologna: N. Zanichelli, 1953. 1–24.

Disch, Tom. "Medusa at Her Vanity." *Poetry* 151, no. 1–2 (1987): 42.

Drabble, Margaret. *The Radiant Way: A Novel*. New York: Alfred A. Knopf, 1987. 343, 349.

Drummond, William. "Poems, Part 1: Sonnet XXXVll," "Madrigals and Epigrammes: 'The Statue of Medusa.'" In *William Drummond of Hawthornden: Poems and Prose*. Edited by Robert H. MacDonald. Edinburgh: Scottish Academic Press, 1976. 38, 73.

DuPlessis, Rachel Blau. "Medusa." In *Wells*. New York: Montemora Foundation, 1980.

Eliot, George. *The Mill on the Floss*. 1860. Edited by Sally Shuttleworth. New York: Routledge, 1991. 89.

Fawcett, Edgar. "Medusa." In *Fantasy and Passion*. Boston: Roberts Brothers, 1878. 181.

Fleming, George [pseud.]. *The Head of Medusa*. Boston: Roberts Brothers, 1880.

Frischmuth, Barbara. "Grown Older . . . " Translated by Francis Michael Sharp. In *Relationships: An Anthology of Austrian Prose*. Edited by Donald G. Daviau. Riverside, Calif.: Ariadne, 1991. 154–58.

Germain, Sylvie. *The Medusa Child*. Translated by Liz Nash. Sawtry, Cambs: Dedalus, 1994.

Gould, Lois. *Medusa's Gift*. New York: Alfred A. Knopf, 1991.

Greene, Robert. *The History of Orlando Furioso*. 1594. Reprint, London: Oxford University Press, 1907.

Gregory, Horace. *Medusa in Gramercy Park*. New York: Macmillan, 1961.

Grilikhes, Alexandra. "Medusa, Smiling." In *On Women Artists: Poems 1975–1980*. Minneapolis: Cleis Press, 1981. 72–73.

Hake, Thomas Gordon. "The Infant Medusa." In *The Poems of Thomas Gordon Hake*. Chicago: Stone and Kimball, 1894.

Harrison, Tony. "The Gaze of the Gorgon." In *The Gaze of the Gorgon*. Newcastle upon Tyne, Eng.: Bloodaxe, 1992. 57–75.

Harvey, Gabriel. "A new letter of notable contents, With a straunge Sonet, intituled Gorgon, or, The wonderfull yeare." 1593. In *The works of Gabriel Harvey*. Vol. 1. Edited by Alexander B. Grosart. New York: AMS Press, 1966. 295–97.

Hawthorne, Nathaniel. "The Gorgon's Head." In *The Centenary Edition of the Works of Nathaniel Hawthorne*. Vol. 7. Edited by William Charvat et al. Columbus: Ohio State University Press, 1963. 10–34.

Hayden, Robert Earl. "Perseus." In *Collected Poems*. Edited by Frederick Glaysher. New York: Liveright, 1985. 44.

Henderson, Nancy Wallace. *Medusa of Forty-Seventh Street: A Play in One Act*. New York: Samuel French, 1969.

Hoban, Russell. *The Medusa Frequency*. New York: Atlantic Monthly, 1987. 121–22.

Hoffmann, E. T. A. "The Mines of Falun." In *Selected Writings of E. T. A. Hoffmann*. Edited and translated by Leonard J. Kent and Elizabeth C. Knight. Chicago: University of Chicago Press, 1969. 208–9.

Innes, Hammond. *Medusa*. New York: Atheneum, 1988.

Jarrell, Randall. "The Bronze David of Donatello." In *The Complete Poems*. New York: Farrar, Straus and Giroux, 1969. 273–75.

Jones, Howard Mumford. *The Bright Medusa*. Urbana: University of Illinois Press, 1952.

Jonson, Ben. "Epicoene, or, The Silent Woman." 1616. Reprint in *Ben Jonson*. Vol. 5. Edited by C. H. Herford and Percy Simpson. Oxford: Clarendon Press, 1954–65. 188 (II.4.9–19), 217 (III.7.21).

———. "Ode: Yff Men, and tymes were nowe. . . ." Reprint in *Ben Jonson*. Vol. 8. Edited by C. H. Herford and Percy Simpson. Oxford: Clarendon Press, 1954–65. 419 (line 41).

Kantchev, Nicolai. "Medusa." In *Medusa, Selected Poems. Quarterly Review of Literature* (Poetry Series VII) Vol. 26 (1986).

Keats, John. "Lamia." In *The Poems of John Keats*. Edited by Jack Stillinger. Cambridge, Mass.: Belknap Press of Harvard University Press, 1978.

Lawrence, D. H. *St. Mawr and Other Stories*. Edited by Brian Finney. Cambridge: Cambridge University Press, 1983. 37.

Lee-Hamilton, Eugene. *The New Medusa*. London: E. Stock, 1882. Reprint, New York: Garland, 1984.

Lindsey, Karen. "medusa," "visions." In *Falling Off the Roof*. Cambridge, Mass.: Alice James, 1975. 22, 25.

Lloyd-Smith, A. G. *Uncanny American Fiction: Medusa's Face*. Basingstoke: Macmillan, 1989.

Lovecraft, H. P. *Medusa: A Portrait*. 1921. Reprint, New York: Oliphant, 1975.

Lowell, Robert. "Near the Ocean." In *Near the Ocean*. New York: Farrar, Straus and Giroux, 1967. 42–49.

Marlowe, Christopher. "Tamburlaine." In *The Complete Works of Christopher Marlowe*. Edited by Fredson Bowers. Cambridge: Cambridge University Press, 1973. 121 (pt. 1, IV.1.17–19).

MacLeish, Archibald. "The Happy Marriage." In *The Happy Marriage, and Other Poems*. Boston: Houghton Mifflin Co., 1924. 1–39.

MacNeice, Louis. "Perseus." In *Collected Poems*. Edited by E. R. Dodds. New York: Oxford University Press, 1967. 24–25.

McClure, Michael. *Fragments of Perseus*. New York: J. Davies, 1978.

Meigs, Mary. *The Medusa Head*. Vancouver: Talonbooks, 1983.

Merwin, W. S. "Ode: The Medusa Face." In A *Mask for Janus*. New Haven, Conn.: Yale University Press, 1952. 40.

Meyer, C. F. "Die sterbende Meduse." In *Sämtliche Werke in zwei Bänden*. Vol. 2. Munich: Winkler Verlag, 1988. 121–22.

Milton, John. "A Mask . . . Presented at Ludlow Castle." In *Complete Poems and Major Prose*. Edited by Merritt Y. Hughes. New York: Odyssey, 1957. 100.

Montague, John. "Meduse." In *Selected Poems*. Winston-Salem, N.C.: Wake Forest University Press, 1982. 81.

Morris, Lewis. *The Epic of Hades. In Three Books*. Vol. 1. London: Kegan Paul, 1879. 186–96.

Morris, William. "The Doom of King Acrisius." In *The Earthly Paradise: A Poem*. Boston: Roberts, 1871. 142–96.

Murdoch, Iris. *A Severed Head*. New York: Viking Press, 1961. 49–50, 146–53, 221.

Percy, William Alexander. *Lanterns on the Levee: Recollections of a Planter's Son*. New York: Alfred Knopf, 1941. Reprint, Baton Rouge: Louisiana State University Press, 1984. 331

————. "Medusa." In *Collected Poems of William Alexander Percy*. New York: Alfred A. Knopf, 1943. 376.

Pettie, George. *A Petite Pallace of Pettie His Pleasure, Containing Many Pretie Histories, by Him Set Forth in Comely Colours and Most Delightfully Discoursed*. 1576. Vol. 2. Edited by I. Gollancz. London: Chatto and Windus, 1908. 138.

Petrarca, Francesco. "Poem 179," "Poem 197," "Poem 366." In *Petrarch's Lyric Poems: The Rime Sparse and Other Lyrics*. Edited and translated by Robert M. Durling. Cambridge, Mass.: Harvard University Press, 1976. 324, 342, 574–83.

Plath, Sylvia. "A Birthday Present," "Perseus," "Medusa." In *The Collected Poems*. Edited by Ted Hughes. New York: Harper & Row, 1981. 82–83, 206–8, 224–26.

Poliziano, Angelo. *The* Stanze *of Angelo Poliziano.* Translated by David Quint. Amherst: University of Massachusetts Press, 1979. 81, 83.

Pound, Ezra. "Canto XV." In *The Cantos, 1–95.* New York: New Directions, 1956. 64–67.

Preuss, Paul. *The Medusa Encounter.* New York: Avon, 1990.

Queneau, Raymond. *Chêne et chien.* Translated by Madeleine Velguth. New York: Peter Lang, 1995. 56, 82 n.68.

Ransford, Tessa. "Medusa Dozen." In *Medusa Dozen and Other Poems.* Edinburgh: Ramsay Head Press, 1994.

San Juan, Epifanio. *Smile of the Medusa.* Manila: Anvil, 1994. 107–20.

Sartoris, Adelaide Kemble. *Medusa, and Other Tales.* Boston [18–].

Shaffer, Peter. *The Gift of the Gorgon.* New York: Viking Press, 1993.

Shakespeare, William. "The Tragedy of Antony and Cleopatra." In *The Riverside Shakespeare.* Edited by G. Blakemore Evans et al. Boston: Houghton Mifflin, 1974. 1360 (II.5.116–17).

Smartt, Dorothea. "Medusa? Medusa Black!" In *Mythic Women / Real Women: Plays and Performance Pieces by Women.* Edited by Lizbeth Goodman. London: Faber and Faber, 2000. 259–63.

Spenser, Edmund. *Edmund Spenser's* Amoretti *and* Epithalamion: *A Critical Edition.* Edited by Kenneth J. Larsen. Tempe, Ariz.: Medieval and Renaissance Texts and Studies, 1997. 113.

———. *The Faerie Queen.* Edited by Thomas P. Roche. New Haven, Conn.: Yale University Press, 1981. 51 (III.9.22).

Speyer, Leonora. "The Maid Medusa," "Again, Medusa." In *Naked Heel.* New York: Alfred A. Knopf, 1931. 40–41, 42.

Squires, Radcliffe. "The Garden of Medusa." In *Gardens of the World: Poems.* Baton Rouge: Louisiana State University Press, 1981. 47–48.

Stanford, Ann. "The Women of Perseus." In *In Mediterranean Air.* New York: Viking Press, 1977. 33–48.

Stoker, Bram. *The Essential Dracula.* Edited by Leonard Wolf. New York: Plume, 1993. 258.

Tchicaya U Tam'si. *The Madman and the Medusa.* Translated by Sonja Haussmann Smith and William Jay Smith. Charlottesville: University Press of Virginia, 1989.

Thomas, Lewis. *The Medusa and the Snail: More Notes of a Biology Watcher.* New York: Viking Press, 1979. 1–6.

Thrap, Newton J. "'The Quest of the Gorgon:' The Fourth Grove Play." In *The Grove Plays of the Bohemian Club.* Vol. 1. Edited by Porter Garnett. San Fran-

cisco: Printed for the Bohemian Club at the Press of the H. S. Crocker
 Company, 1918. 77–121.
Tournier, Michel. *The Golden Droplet*. Translated by Barbara Wright. New York:
 Doubleday, 1987. 192.
Vercors. *The Raft of the Medusa*. Translated by Audrey C. Foote. New York: Mc-
 Call Publishing Company, 1971.
Wagoner, David. "Medusa's Lover." In *First Light: Poems*. Boston: Little, Brown,
 1983. 41–42.
Wakoski, Diane. "City of Lights (Las Vegas)." In *Medea the Sorceress*. Santa Rosa,
 Calif.: Black Sparrow Press, 1991. 132, 176.
_____. *The Rings of Saturn*. Santa Rosa, Calif.: Black Sparrow Press, 1986.
Walker, Alice. *The Temple of My Familiar*. San Diego: Harcourt Brace Jovanovich,
 1989. 267, 268–69.
Weaving, Willoughby. "Medusa Awake." In *The Star Field, and Other Poems*. Ox-
 ford: B. H. Blackwell, 1916. 53.
Welty, Eudora. A *Curtain of Green*. Garden City, N.Y.: Doubleday, Doran and
 Company, 1941.
_____. *The Golden Apples*. New York: Harcourt, Brace, 1949.
Wilson, Edward Osborne. *Naturalist*. Washington, D.C.: Island Press / Shearwa-
 ter Books, 1994. 5–8.

History, Archaeology, and Anthropology

Boardman, John. *Archaic Greek Gems: Schools and Artists in the Sixth and Early Fifth
 Centuries B.C.* Evanston, Ill.: Northwestern University Press, 1968. 27–44,
 45–47, 60, 90, 164.
Bonnell, Thornton. "The Battle of the Wigs. An additional canto to Dr. Garth's
 Poem of Dispensary. Occasioned by the disputes between the Fellows and
 Licentiates of the College of Physicians, in London." Edited by Sylvanus
 Urban. *The Gentleman's Magazine and Historical Chronicle* 38 (1768): 132.
Croon, J. H. "The Mask of the Underworld Daemon—Some Remarks on the
 Perseus-Gorgon Story." *Journal of Hellenic Studies* 75 (1955): 9–16.
Elworthy, Frederick Thomas. *The Evil Eye: An Account of This Ancient and Wide-
 spread Superstition*. London: J. Murray, 1895. Reprint, New York: Bell Pub.
 Co., 1989.
Farnell, Lewis Richard. *The Cults of the Greek States*. Vol. 1. 1896–1909.
 Reprint, New Rochelle, N.Y.: Caratzas Brothers, 1977. 286–88.

Fear, A. T. "Bladud: The Flying King of Bath." *Folklore* 103, no. 2 (1992): 222–24.

Feldman, Thalia. "Gorgo and the Origins of Fear." *Arion* 4, no. 3 (1965): 484–94. (See also Thalia Howe)

Gershonson, D. E. "The Beautiful Gorgon and Indo-European Parallels." *Mankind Quarterly* 29, no. 4 (Summer 1989): 373–90.

Glenn, Justin. "Psychoanalytic Writings on Classical Mythology and Religion: 1909–1960." *Classical World* 70, no. 4 (Dec. 1976–Jan. 1977): 225–48.

Goldman, Bernard. "The Asiatic Ancestry of the Greek Gorgon." *Berytus* 14, no. 1 (1961): 1–23.

Hopkins, Clark. "Assyrian Elements in the Perseus-Gorgon Story." *American Journal of Archaeology* 38 (1934): 341–58.

_____. "The Sunny Side of the Greek Gorgon." *Berytus* 14, no. 1 (1961): 25–35.

Howe, Thalia Phillies. *An Interpretation of the Perseus-Gorgon Myth in Greek Literature and Monuments through the Classical Period.* Diss. Columbia University. 1952. Ann Arbor: University of Michigan Press, 1952. (See also Thalia Feldman)

_____. "The Origin and Function of the Gorgon-Head." *American Journal of Archaeology* 58 (1954): 209–21.

Karo, Georg. *Greek Personality in Archaic Sculpture.* Cambridge, Mass.: Harvard University Press, 1948. 34-35, 114–16, 148, 247, 293 n. 19.

Lettvin, Jerome. "The Gorgon's Eye." In *Astronomy of the Ancients.* Edited by Kenneth Brecher and Michael Feirtag. Cambridge, Mass.: MIT Press, 1979. 133–51.

Mylonas, George E. *Ancient Mycenae: The Capital City of Agamemnon.* Princeton: Princeton University Press, 1957. 3–4, 15–17.

Napier, A. David. *Foreign Bodies: Performance, Art, and Symbolic Anthropology.* Berkeley and Los Angeles: University of California Press, 1992. 77–111.

_____. *Masks, Transformation, and Paradox.* Berkeley and Los Angeles: University of California Press, 1986. 60–62, 83–134, 148–49, 164–87, 199–206.

Nilsson, Martin P. *The Mycenaean Origin of Greek Mythology.* 1932. Berkeley and Los Angeles: University of California Press, 1972. 40–42.

Obeyesekere, Gananath. *Medusa's Hair: An Essay on Personal Symbols and Religious Experience.* Chicago: University of Chicago Press, 1981.

Padilla, Mark. "The Gorgonic Archer." *Classical World* 86, no. 1 (1992): 1–12.

Phinney, Edward, Jr. "Perseus' Battle with the Gorgons." *Transactions and Proceedings of the American Philological Association* 102 (1971): 445–63.

Shweder, Richard A. "How to Look at Medusa without Turning to Stone." *Contributions to Indian Sociology* 21, no. 1 (1987): 37–55.

Siebers, Tobin. *The Mirror of Medusa.* Berkeley and Los Angeles: University of California Press. 1983.

Stafford, Barbara. "'Medusa' or the Physiognomy of the Earth, Humert de Superville's Cosmological Aesthetics." *Journal of the Warburg and Courtauld Institutes* 25 (1972): 308–38.

Wohlgelernter, Maurice. "Facing Medusa without Mirrors: Three Women Reflect on the Holocaust: A Review Essay." *Modern Judaism* 12, no. 1 (1992): 85–103.

Zimmer, Heinrich Robert. *Myths and Symbols in Indian Art and Civilization.* Edited by Joseph Campbell. New York: Pantheon Books, 1946. 175, 182.

Literary Criticism

Arens, Katherine. "From Caillois to 'The Laugh of the Medusa': Vectors of a Diagonal Science." *Textual Practice* 12, no. 2 (1998): 225–50.

Arthur, Marilyn. "From Medusa to Cleopatra: Women in the Ancient World." In *Becoming Visible*, 2nd edition. Edited by Renate Bridenthal et al. Boston: Houghton Mifflin, 1987. 77–105.

Ascoli, Albert Russell. *Ariosto's Bitter Harmony: Crisis and Evasion in the Italian Renaissance.* Princeton: Princeton University Press, 1987. 67, 166–67, 250–51.

Baker, Moira P. "The Uncanny Stranger on Display: The Female Body in Sixteenth- and Seventeenth-Century Love Poetry," *South Atlantic Review* 56, no. 2 (May 1991): 7–25.

Bennett, Paula. *My Life, A Loaded Gun: Female Creativity and Feminist Poetics.* Boston: Beacon Press, 1986. 245–60.

Berthold, Dennis. "Melville, Garibaldi, and the Medusa of Revolution." *American Literary History* 9, no. 3 (1997): 425–61.

Berlant, Lauren. "Re-writing the Medusa: Welty's 'Petrified Man.'" *Studies in Short Fiction* 26, no. 1 (1989): 59–70.

Blin, R. "Pegasus and Medusa in Literature and the Arts." *La nouvelle revue française* 445 (1990): 69–72.

Boccaccio, Giovanni. *Boccaccio on Poetry.* Translated by Charles G. Osgood. Indianapolis and New York: Bobbs-Merrill Co., 1956. xviii.

Brown, Ellen. "Between the Medusa and the Abyss: Reading Jane Eyre, Read-

ing Myself." In *The Intimate Critique: Autobiographical Literary Criticism.* Edited by Diane P. Freedman, Olivia Frey, and Frances Murphy Zauhar. Durham, N.C.: Duke University Press, 1993. 225–35.

Clark, Suzanne. *Sentimental Modernism: Women Writers and the Revolution of the Word.* Bloomington: Indiana University Press, 1991. 99–126.

Clayton, Jay. "Concealed circuits: Frankenstein's monster, the Medusa, and the Cyborg." *Raritan* 15, no. 4 (1996): 53–69.

Closs, August. *Medusa's Mirror: Studies in German Literature.* London: Cresset Press, 1957. 38–40.

Conley, Katharine. *Automatic Woman: The Representation of Woman in Surrealism.* Lincoln: University of Nebraska Press, 1996. 16–17, 115–16.

Davey, Frank. "Atwood's Gorgon Touch." *Studies in Canadian Literature* 2 (1977): 146–63.

Dumoulie, C. "The Poet and the Head of the Medusa." *La nouvelle revue française* 462 (1991): 199–220.

Eagleton, T. Review of "The 'Gaze of the Gorgon,' by T. Harrison." *Poetry Review* 82, no. 4 (1993): 53–54.

Edinger, Edward. *Melville's Moby Dick: A Jungian Commentary.* New York: New Directions Pub. Corp., 1978. 89–96.

Elias-Button, Karen. "The Muse as Medusa." In *The Lost Tradition: Mothers and Daughters in Literature.* Edited by Cathy N. Davidson and E. M. Broner. New York: Frederick Ungar Publishing, 1980. 193–206.

Enciclopedia Dantesca. Vol. 3. Rome: Istituto della Enciclopedia Italiana, 1970–78. 883–84.

Finney, Gail. *Women in Modern Drama.* Ithaca, N.Y.: Cornell University Press, 1989. 70, 77.

Flavell, M. K. "The Art of Killing Medusa." *Modern Language Review* 85 (1990): 519–22.

Frank, Lawrence. "Dreaming the Medusa: Imperialism, Primitivism, and Sexuality in Arthur Conan Doyle's *The Sign of Four*." *Signs* 22, no. 1 (1996): 52–86.

Freccero, John. "Dante's Medusa." In *By Things Seen: Reference and Recognition in Medieval Thought.* Edited by David L. Jeffrey. Ottawa: University of Ottawa Press, 1979. 33–46.

———. "Medusa: The Letter and the Spirit." *Yearbook of Italian Studies* (1972): 1–18.

Gallagher, Catherine, Joel Fineman, and Neil Hertz. "More about 'Medusa's Head.'" *Representations* 4 (1983): 55–72.

Gallagher, Lowell. *Medusa's Gaze: Cauistry and Conscience in the Renaissance*. Stanford, Calif.: Stanford University Press, 1991.

Goldberg, Jonathan. *Voice Terminal Echo: Postmodernism and English Renaissance Texts*. New York: Methuen, 1986. 139–40, 146, 149–56.

Haddad, Miranda Johnson. "Ovid's Medusa in Dante and Ariosto: The Poetics of Self-Confrontation." *Journal of Medieval and Renaissance Studies* 19, no. 2 (1989): 211–25.

Hedley, Jane. "Sylvia Plath's Ekphrastic Poetry." *Raritan* 20 (Spring 2001): 37–73.

Helterman, Jeffrey. "Gorgons in Mississippi: Eudora Welty's 'Petrified Man.'" *Notes on Mississippi Writers* 7 (1974): 12–20.

Herzfeld, Claude. *La figure de Méduse dans l'oeuvre d'Octave Mirbeau*. Paris: Libraire A.G. Nizet, 1992.

Hildebrand, William. "Self, Beauty and Horror: Shelley's Medusa Moment." In *The New Shelley: Later Twentieth-Century Views*. Edited by G. Kim Blank. London: Macmillan, 1991. 150–65.

Hughes, Daniel. "Shelley, Leonardo, and the Monsters of Thought." *Criticism* 12 (1970): 195–212.

Huot, Sylvia. "The Medusa Interpolation in the Romance of the Rose: Mythographic Program and Ovidian Intertext." *Speculum: A Journal of Medieval Studies* 62, no. 4 (1987): 865–77.

Hyles, Vernon. "Medusa and the Romantic Concept of Beauty." In *The Shape of the Fantastic: Selected Essays from the 7th International Conference on the Fantastic in the Arts*. Edited by Olena H. Saciuk. New York: Greenwood Press, 1990. 143–47.

Laporte, Paul M. "The Passing of the Gorgon." *Bucknell Review* 17, no. 1 (March 1969): 55–71.

Lauter, Estella. *Women as Mythmakers: Poetry and Visual Art by Twentieth-Century Women*. Bloomington: Indiana University Press, 1984. See 236 n.

Leupin, Alexandre. "The Powerlessness of Writing: Guillaume de Machaut, the Gorgon, and *Ordenance*." Translated by Peggy McCracken. *Yale French Studies* 70 (1986): 127–49.

Lima, Maria Isabel Piresde. "Nadja: Entre Melusina e Medusa." *Coloquio-Letras* 72 (1983): 41–50.

Lloyd-Smith, A. G. *Uncanny American Fiction: Medusa's Face*. New York: St. Martin's Press, 1989.

Materer, Timothy. *James Merrill's Apocalypse*. Ithaca, N.Y.: Cornell University Press, 2002. 19–20.

Mazzola, E. "Marrying Medusa, Spenser." *Genre* 25, no. 2–3 (1992): 193–210.

Mazzotta, Giuseppe. *Dante, Poet of the Desert: History and Allegory in the Divine Comedy.* Princeton: Princeton University Press, 1979. 163–64, 277–78, 284–86.

McConnell, Frank D. *Four Postwar American Novelists: Bellow, Mailer, Barth, and Pynchon.* Chicago: University of Chicago Press, 1977. 151–58.

McGann, Jerome. "The Beauty of the Medusa: A Study in Romantic Literary Iconology." *Studies in Romanticism* 11 (1972): 3–25.

McMahon, Lynne. "Female Erotics: Paralysis and Passion." *American Poetry Review* 20, no. 3 (1991): 9–19.

Munich, Adrienne. *Andromeda's Chains: Gender and Interpretation in Victorian Literature and Art.* New York: Columbia University Press, 1989.

Nohrnberg, James. *The Analogy of The Faerie Queene.* Princeton: Princeton University Press, 1976. 104, 194–95, 456 n–457 n, 472–73.

Orgel, Stephen. "Jonson and the Amazons." In *Soliciting Interpretation: Literary Theory and Seventeenth-Century English Poetry.* Edited by Elizabeth D. Harvey and Katharine Eisaman Maus. Chicago: University of Chicago Press, 1990. 119–39.

Ostriker, Alicia. *Stealing the Language: The Emergence of Women's Poetry in America.* Boston: Beacon Press, 1986. 45–46, 73, 187, 221–22.

Patterson, Kent. "A Terrible Beauty: Medusa in Three Victorian Poets." *Tennessee Studies in Literature* 17 (1972): 111–20.

Pratt, Annis. *Dancing with Goddesses: Archetypes, Poetry, and Empowerment.* Bloomington: Indiana University Press, 1994. 42–54.

Quinn, Bernetta. "Medusan Imagery in Sylvia Plath." In *Sylvia Plath: New Views on the Poetry.* Edited by Gary Lane. Baltimore: Johns Hopkins University Press, 1979. 97–115.

Rapaport, Herman. *Milton and the Postmodern.* Lincoln: University of Nebraska Press, 1983. 132–33, 150–52, 214.

Robertson, R. M. "Disinterring the 'Scandal' of Willa Cather: *Youth and the Bright Medusa.*" *Criticism* 32, no. 4 (1990): 485–509.

Robinson, Mary F. "Anne Tyler: Medusa Points and Contact Points." In *Contemporary American Women Writers: Narrative Strategies.* Edited by Catherine Rainwater and William J. Scheick. Lexington: University Press of Kentucky, 1985. 119–47.

Rogers, Neville. "Shelley and the Visual Arts." *Keats-Shelley Memorial Association* 12 (1961): 9–17.

Running-Johnson, Cynthia. "The Medusa's Tale: Feminine Writing and 'La Genet.'" *Romantic Review* 80, no. 3 (1989): 483–95.

Sanders, Karin. "Nemesis of Mimesis: The Problem of Representation in H. C. Andersen's 'Psychen.'" *Scandinavian Studies* 64, no. 1 (1992): 1–25.

Schmidt, Peter. *The Heart of the Story: Eudora Welty's Short Fiction*. Jackson: University Press of Mississippi, 1991.

Schwartz, Kathryn. *Tough Love: Amazon Encounters in the English Renaissance*. Durham, N.C.: Duke University Press, 2000. 29–33, 122–23.

Segal, Charles. "The Gorgon and the Nightingale: The Voice of Female Lament and Pindar's Twelfth 'Pythian Ode.'" In *Embodied Voices: Representing Female Vocality in Western Culture*. Edited by Leslie C. Dunn and Nancy A. Jones. Cambridge: Cambridge University Press, 1994. 17–34.

Shoaf, R. A., "The Franklin's Tale: Chaucer and the Medusa." In *Chaucer: Contemporary Critical Essays*. Edited by Valerie Allen and Ares Axiotis. New York: St. Martin's Press, 1997. 242–52.

Showalter, Elaine. *Sexual Anarchy: Gender and Culture at the Fin de Siècle*. New York: Viking Press, 1990. 145–48.

Silvestris, Bernardus. *Commentary on the First Six Books of Virgil's "Aeneid."* Translated by Earl G. Schreiber and Thomas E. Maresca. Lincoln: University of Nebraska Press, 1979. 57, 69–70.

Stevens, Dorothy. *The Limits of Eroticism in Post-Petrarchan Narrative: Conditional Pleasures from Spenser to Milton*. Cambridge University Press, 1998. 73–101.

Suther, Judith D., and R. V. Giffin. "Dante's Use of the Gorgon Medusa in *Inferno* IX." *Kentucky Romance Quarterly* 27, no. 1 (1980): 69–84.

Truax, Elizabeth. *Metamorphosis in Shakespeare's Plays: A Pageant of Heroes, Gods, Maids, and Monsters*. Lewiston, N.Y.: Edwin Mellen Press, 1992. 84, 161, 171 (16 n, 17 n), 199 (28 n), 263.

Vickers, Nancy. "Diana Described: Scattered Woman and Scattered Rhyme." *Critical Inquiry* 8 (1981): 265–79.

Viti, Elizabeth Richardson. "Marcel and the Medusa: The Narrator's Obfuscated Homosexuality." In *A la recherche du temps perdu*. *Dalhousie French Studies* 26 (Spring 1994): 61–68.

Weltman, Sharon Aronofsky. "Mythic Language and Gender Subversion: The Case of Ruskin's Athena." *Nineteenth-Century Literature* 52, no. 3 (1997): 350–71.

Wigginton, Waller B. "'One Way Lie a Gorgon': An Explication of *Antony and Cleopatra*, 2:5.116–17." *Papers on Language and Literature* 16, no. 4 (1980): 366–75.

Wilner, Eleanor. "The Medusa Connection." *Tri-Quarterly* 88 (1993): 104–32.

Mythology and Religion: Ancient, Medieval, and Renaissance

Aelian. *On the Characteristics of Animals.* In *Aelian.* Vol. 1. Translated by A. F. Scholfeld. London: Heinemann; Cambridge, Mass.: Harvard University Press, 1958. 197, 199 (111.37).

Aeschylus. *Libation Bearers.* In *Aeschylus.* Vol. 2. Translated by Herbert Weir Smith. Cambridge, Mass.: Harvard University Press, 1996. 263 (lines 1048–50).

————. *Eumenides.* In *Aeschylus.* Vol. 2. Translated by Herbert Weir Smith. Cambridge, Mass.: Harvard University Press, 1996. 277 (lines 46–49).

————. *Prometheus Bound.* In *Aeschylus.* Vol. 1. Translated by Herbert Weir Smith. Cambridge, Mass.: Harvard University Press, 1996. 287, 289 (lines 790–800).

Apollodorus. *The Library.* In *Apollodorus.* Vol. 1. Translated by James George Frazier. Cambridge, Mass.: Harvard University Press, 1990. 153–63 (2.4.1–4), 235 (2.5.12).

Apollonius Rhodius. *The Argonautica.* Translated by R. C. Seaton. Cambridge, Mass.: Harvard University Press, 1988. 397 (IV.1512–17).

Ariosto, Lodovico. "Satire IV." In *The Satires of Ludovico Ariosto: A Renaissance Autobiography.* Translated by Peter DeSa Wiggins. Athens: Ohio University Press, 1976. 105 (lines 127–29).

Aristophanes. *Acharnians.* In *Aristophanes.* Vol. 1. Translated by Jeffrey Henderson. Cambridge, Mass.: Harvard University Press, 1998. 125, 127 (lines 574–82), 181 (lines 964–65), 199 (line 1095), 203 (line 1124), 209, 211.

————. *The Frogs.* In *Aristophanes.* Vol. 2. Translated by Benjamin Bickley Rogers. Cambridge, Mass.: Harvard University Press, 1996. 339 (lines 477–78).

————. *The Peace.* In *Aristophanes.* Vol. 2. Translated by Benjamin Bickley Rogers. Cambridge, Mass.: Harvard University Press, 1996. 51 (lines 560–61), 75 (lines 804–11).

————. *The Thesmophoriazusae.* In *Aristophanes.* Vol. 2. Translated by Benjamin Bickley Rogers. Cambridge, Mass.: Harvard University Press, 1996. 229, 231 (lines 1099–1104).

Athenaeus. *The Deipnosophists.* In *Athenaeus.* Vol. 2. Translated by Charles Burton Gulick. Cambridge, Mass.: Harvard University Press, 1993. 499–505 (5.221).

Aurelianensis, Arnulfus. *Glosule super Lucanum.* Edited by Berthe M. Marti. Rome: American Academy in Rome, 1958.

Batman, Stephen. *The Golden Booke of the Leaden Gods*. London, 1577. Reprint, New York: Garland, 1976. 5, 20–21.

Boer, C. de. *Ovide Moralisé en Prose (texte du quinzième siècle)*. Amsterdam: North-Holland Publishing Company, 1954. 161–67 (4.XXV–XXX).

Cicero. *Against Verres*. In *Cicero*. Vol. 8. Translated by L. H. G. Greenwood. Cambridge, Mass.: Harvard University Press, 1988. 435 (4.124).

Colonna, Francesco. *Hypnerotomachia: The Strife of Love in a Dream*. 1592. Edited by Andrew Lang. London: David Nutt, 1890.

Dio Chrysostom. "The Sixty-Sixth Discourse: On Reputation," "The Seventy-Seventh/Eighth Discourse: On Envy." In *Dio Chrysostom*. Vol. 5. Translated by H. Lamar Crosby. Cambridge, Mass.: Harvard University Press, 1985. 109 (lines 17–21), 285 (lines 23–26).

Elyot, Thomas. *The Gouernour (The Boke Named The Gouernour)*. 1531. Reprint, New York: E. P. Dutton, 1937. 39.

Euripides. *Alcestis*. In *Euripides*. Vol. 4. Translated by Arthur S. Way. Cambridge, Mass.: Harvard University Press, 1958. 501 (line 1118).

————. *The Bacchanals*. In *Euripides*. Vol. 3. Translated by Arthur S. Way. Cambridge, Mass.: Harvard University Press, 1979. 85 (lines 989–90).

————. *Electra*. In *Euripides*. Vol. 2. Translated by Arthur S. Way. Cambridge, Mass.: Harvard University Press, 1988. 43 (lines 458–61), 79 (line 856), 111 (lines 1254–57).

————. *Ion*. In *Euripides*. Vol. 4. Translated by Arthur S. Way. Cambridge, Mass.: Harvard University Press, 1958. 21 (line 210), 23 (line 226), 97, 99, 101 (lines 989–1017), 105 (lines 152–56), 121 (lines 1264–65), 137 (line 1420), 143 (line 1478).

————. *The Madness of Heracles*. In *Euripides*. Vol. 3. Translated by Arthur S. Way. Cambridge, Mass.: Harvard University Press, 1979. 199 (lines 880–84), 207 (line 990).

————. *Orestes*. In *Euripides*. Vol. 2. Translated by Arthur S. Way. Cambridge, Mass.: Harvard University Press, 1988. 257, 259 (lines 1520–21).

————. *The Phoenician Maidens*. In *Euripides*. Vol. 3. Translated by Arthur S. Way. Cambridge, Mass.: Harvard University Press, 1979. 381 (lines 452–56).

————. *Rhesus*. In *Euripides*. Vol. 1. Translated by Arthur S. Way. Cambridge, Mass.: Harvard University Press, 1988. 183 (lines 306–8).

Fraunce, Abraham. *The Third Part of the Countesse of Pembrokes Yvychurch entituled, Amintas Dale*. London, 1592. Reprint, New York: Garland, 1976. 25, 29, 40, 47.

Giraldi, Lilio Gregorio. *De deis gentium.* Basel, 1548. Reprint, New York: Garland, 1976.

Googe, Barnabe. *Eglogs, Epytaphes, and Sonettes.* London 1563. Facsim. ed., Gainsville, Fla.: Scholars' Facsimiles and Reprints, 1968. 110.

Grange, John. *The Golden Aphroditis and Grange's Garden.* London, 1577. Facsim. ed., New York: Scholars' Facsimiles and Reprints, 1939. G2, Kl, Nl, Q4.

Greville, Fulke. "Cælica, Sonnet 42." In *Poems and Dramas of Fulke Greville, First Lord Brooke.* Vol. 2. Edited by Geoffrey Bullough. Edinburgh: Oliver and Boyd, 1939. 97–98.

Henkel, Arthur, and Albrecht Schone, eds. *Emblemata.* Stuttgart: J. B. Metzler, 1967. Cols. 1248, 1665–68, 1733–35.

Herodotus. *Histories.* In *Herodotus.* Vol. 1. Translated by A. D. Godley. Cambridge, Mass.: Harvard University Press, 1990. 375, 377 (291).

Homer. *The Iliad.* Vol. 1. Translated by A. T. Murray. Cambridge, Mass.: Harvard University Press, 1988. 363, 365 (8.348–49).

————. *The Odyssey.* Vol. 1. Translated by A. T. Murray, rev. George E. Dimock. Cambridge, Mass.: Harvard University Press, 1995. 447 (11.633–35).

de Lorris, Guillaume, and Jean de Meun. *The Romance of the Rose.* Translated by Charles Dalhberg. Princeton: Princeton University Press, 1971. 421 (note to line 20811).

Lycurgus. "Against Leocrates." In *Minor Attic Orators.* Vol. 2. Translated by K. J. Maidment and J. O. Burtt. Cambridge, Mass.: Harvard University Press, 1980. 91 (line 100).

Manilius, Marcus. *Astronomica.* Translated by G. P. Goold. Cambridge, Mass.: Harvard University Press, 1992. 33 (1.358–60), 303 (5.2223), 347–51 (5.567–618).

Nonnus. *Dionysiaca.* In *Nonnus.* Vol. 2. Translated by W. H. D. Rouse. Cambridge, Mass.: Harvard University Press, 1985. 253–61 (25.31–142), 417 (30.264–77), 423, 425 (31.8–25).

————. *Dionysiaca.* In *Nonnus.* Vol. 3. Translated by W. H. D. Rouse. Cambridge, Mass.: Harvard University Press, 1984. 407–23 (47.498–741).

Ovid. *The Art of Love.* In *Ovid.* Vol. 2. Translated by J. H. Mozley. Cambridge, Mass.: Harvard University Press, 1985. 87 (2.309–310).

————. *Ibis.* In *Ovid.* Vol. 2. Translated by J. H. Mozley. Cambridge, Mass.: Harvard University Press, 1985. 287–89 (lines 447–48), 299 (lines 553–54).

Pauly, August Friedrich von. *Real-Encyclopädie der Classischen.* Stuttgart: J. B. Metzler, 1914.

Pausanias. *Description of Greece.* In *Pausanias.* Vol. 1. Translated by W. H. S. Jones. Cambridge, Mass.: Harvard University Press, 1992. 103–5 (1.21.3), 113 (1.22.7), 119 (1.23.7), 125 (1.24.7), 329 (2.16), 353 (2.20.7), 358, 361 (2.21.5–8), 373 (2.23.7), 391–93 (2.27.2).

———. *Description of Greece.* In *Pausanias.* Vol. 2. Translated by W. H. S. Jones and H. A. Ormerod. Cambridge, Mass.: Harvard University Press, 1993. 105 (3.17.3), 371 (4.35.9), 431–33 (5.10.4), 447 (5.12.4), 487 (5.18.5).

———. *Description of Greece.* In *Pausanias.* Vol. 4. Translated by W. H. S. Jones. Cambridge, Mass.: Harvard University Press, 1995. 135 (8.47.5–6), 323 (9.34.2).

Pindar. *Pythian Odes.* In *Pindar.* Vol. 1. Translated by William H. Race. Cambridge, Mass.: Harvard University Press, 1992. 363–65 (10.31–50).

———. *The Odes of Pindar.* Translated by Geoffrey S. Conway. London: J. M. Dent, 1972. 166–67.

Plato. *Phaedrus.* In *Plato.* Vol. I. Translated by Harold North Fowler. Cambridge, Mass.: Harvard University Press, 1995. 421 (229d).

Plutarch. *Themistocles.* In *Plutarch's Lives.* Vol. 2. Translated by Bernadotte Perrin. Cambridge, Mass.: Harvard University Press, 1985. 31 (10.4).

Polyidus. "Fragment 837." In *Greek Lyric.* Vol. 5. Edited and translated by David A. Campbell. Cambridge, Mass.: Harvard University Press, 1991. 203.

Ripa, Cesare. *Baroque and Rococo Pictorial Imagery: The 1758–60 Hertel Edition of Ripa's "Iconologia."* Translated by Edward A. Maser. New York: Dover, 1971. 36, 57, 74, 102.

Ross, Alexander. *Mystagogus Poeticus, or The Muses Interpreter.* 1647. Reprint, edited by John R. Glenn. New York: Garland, 1987. 344–48, 489–92.

Strabo. *The Geography of Strabo.* Vol. 4. Translated by Horace Leonard Jones. Cambridge, Mass.: Harvard University Press, 1998. 195 (8.6.21).

———. *The Geography of Strabo.* Vol. 5. Translated by Horace Leonard Jones. Cambridge, Mass.: Harvard University Press, 1996. 171–73 (10.5.10).

Tooke, Andrew and François Pomey. *The Pantheon.* London, 1713. Facsim. ed., New York: Garland, 1976. 110–11, 116, 305, 355–57.

Topsell, Edward. *The History of Four-Footed Beasts and Serpents and Insects.* 1658. Vol. 1. Reprint, New York: Da Capo Press, 1967. 206–7.

Virgil. *The Aeneid.* In *Virgil.* Vol. 1. Translated by H. Rushton Fairclough. Cambridge, Mass.: Harvard University Press, 1994. 335 (2.615–16), 527 (6.289).

———. *The Aeneid.* In *Virgil.* Vol. 2. Translated by H. Rushton Fairclough.

Cambridge, Mass.: Harvard University Press, 1996. 27 (7.341), 91 (8.435–38).

Watson, Thomas. *The Hekatompathia; or, Passionate Centurie of Love*. London, 1582. Facsim. ed., Gainesville, Fla.: Scholars' Facsimiles and Reprints, 1964. 49 (XXXV).

Xenophon. *Symposium*. In *Xenophon*. Vol. 4. Translated by O. J. Todd. Cambridge, Mass.: Harvard University Press, 1992. 577 (4:24–25).

Mythology and Religion: Modern

Barb, A. A. "Diva Matrix." *Journal of the Warburg and Courtauld Institutes* 16 (1953): 193–238.

————. "Antaura: The Mermaid and the Devil's Grandmother." *Journal of the Warburg and Courtauld Institutes* 29 (1966): 1–23.

Cahill, Jane. "Medusa's Story." In *Her Kind: Stories of Women from Greek Mythology*. Orchard Park, N.Y.: Broadview, 1995.

Campbell, Joseph. *The Masks of God: Creative Mythology*. New York: Penguin Books, 1984. 229, 505.

Caputi, Jane. "On Psychic Activism: Feminist Mythmaking." In *The Feminist Companion to Mythology*. Edited by Carolyne Larrington. London: Pandora, 1992. 425–40.

Connor, Randy P., David Hatfield Sparks, and Mariya Sparks. *Cassell's Encyclopedia of Queer Myth, Symbol, and Spirit: Gay, Lesbian, Bisexual, and Transgender Love*. Herman, Va.: Cassell, 1997. 162, 229.

Dall, Caroline Wells Healey. *Margaret and Her Friends; Or, Ten Conversations with Margaret Fuller upon the Mythology of the Greeks and Its Expression in Art*. Boston: Roberts Brothers, 1895. 130–33.

Daly, Mary, with Jane Caputi. *Websters' First New Intergalactic Wickedary of the English Language*. Boston: Beacon Press, 1987. 132, 270, 281–82.

Dijkstra, Bram. *Idols of Perversity: Fantasies of Feminine Evil in Fin-de-Siècle Culture*. New York: Oxford University Press, 1986. 137–39, 309–11, 325.

Downing, Christine. *The Goddess: Mythological Images of the Feminine*. New York: Crossroad, 1981. 124–25.

————. *Gods in Our Midst: Mythological Images of the Masculine: A Woman's View*. New York: Crossroad, 1993. 124–25.

DuBois, Page. *Sowing the Body: Psychoanalysis and Ancient Representations of Women*. Chicago: University of Chicago Press, 1988. 87–93.

Eckstein-Diener, Berta [Helen Diner]. *Mothers and Amazons.* Edited and translated by John Philip Lundin. Garden City, N.Y.: Doubleday, 1973. 106–7.

Fontenrose, Joseph Eddy. *Python. A Study of Delphic Myth and Its Origins.* Berkeley and Los Angeles: University of California Press, 1959. 275–306.

Gantz, Timothy. *Early Greek Myth: A Guide to Literary and Artistic Sources.* Baltimore: Johns Hopkins University Press, 1993. 303–10.

George, Malcolm J. "Into the Eyes of Medusa: Beyond Testosterone, Men, and Violence." *Journal of Men's Studies* 5, no. 4 (May 1997): 295 (19).

Gimbutas, Marija Alseikaitė. *The Godesses and Gods of Old Europe 6500–3500 BC: Myths and Cult Images.* London: Thames and Hudson, 1982. 93–101, 148–49.

Girard, René. *Violence and the Sacred.* Translated by Patrick Gregory. Baltimore: Johns Hopkins University Press, 1977. 37–38.

Glueck, Nelson. *Deities and Dolphins: The Story of the Nabatnaeans.* New York: Farrar, Straus and Giroux, 1965. 79–84, 335–36, 353–56.

Graves, Robert. *The Greek Myths.* Vol. 1. Baltimore: Penguin, 1955. 237–45.

Harris, Maxine. *Sisters of the Shadow.* Norman: University of Oklahoma Press, 1991. 145–46.

Harrison, Jane Ellen. *Prolegomena to the Study of Greek Religion.* Cambridge: Cambridge University Press, 1903. 187–97.

Hartland, Edwin Sidney. *The Legend of Perseus: A Study of Tradition in Story, Custom and Belief.* London: D. Nutt, 1894–96.

Hume, Beverly A. "Of Krakens and Other Monsters: Melville's *Pierre.*" *American Transcendental Quarterly* 6, no. 2 (June 1992): 85–108.

Joplin, Patricia Klindienst. "The Voice of the Shuttle Is Ours." *Stanford Literature Review* 1, no. 1 (Spring 1984): 25–33.

Keightley, Thomas. *The Mythology of Ancient Greece and Italy.* New York: D. Appleton and Company, 1866. 223–24, 321, 368–73.

Kingsley, Charles. "Perseus." In *The Heroes, or, Greek Fairy Tales for My Children.* Philadelphia: Altemus, 1895. 21–67.

Knight, Richard Payne. *The Symbolical Language of Ancient Art and Mythology.* Edited by Alexander Wilder. New York: Bouton, 1877. 130.

Kolbenschlag, Madonna. *Kiss Sleeping Beauty Good-bye: Breaking the Spell of Feminine Myths and Models.* New York: Bantam Books, 1981. 30–31.

Larrington, Carolyne, ed. *The Feminist Companion to Mythology.* London: Pandora, 1992.

Law, Helen Hull. *Bibliography of Greek Myth in English Poetry.* Philadelphia: R. West, 1979.

Lefkowitz, Mary R. *Women in Greek Myth*. London: Duckworth, 1986. 75, 190.

Meyerson, Philip. *Classical Mythology in Literature, Art, and Music*. New York: John Wiley, 1971. 29–30, 291–95.

Miller, Arthur A. "An Interpretation of the Symbolism of Medusa." *American Imago* 15 (1958): 389–99.

Monaghan, Patricia. *The Book of Goddesses and Heroines*. St. Paul, Minn.: Llewellyn, 1990. 137, 212–13.

Müller, Karl Otfried. *Introduction to a Scientific System of Mythology*. Translated by John Leitch. London: Longman, Brown, Green, and Longmans, 1844. 246–54.

Peradotto, John. *Classical Mythology: An Annotated Bibliographical Survey*. American Philological Association Bibliographical Guides. Urbana, Ill.: American Philological Association, 1973.

Praz, Mario. *The Romantic Agony*. Translated by Angus Davidson. London: Oxford University Press, 1933. 22–50.

Reik, Theodor. "Modern Medusa." *American Imago* 8 (1951): 323–28.

Robbins, Kittye Delle. "Tiamat and Her Children: An Inquiry into the Persistence of Mythic Archetypes of Woman as Monster/Villainess/Victim." In *Face to Face: Fathers, Mothers, Masters, Monsters: Essays for a Nonsexist Future*. Edited by Meg McGavran Murray. Westport, Conn.: Greenwood, 1983. 47–69.

Rose, H. J. *A Handbook of Greek Mythology, Including Its Extension to Rome*. New York: Dutton, 1928. 29–30, 111, 272–73.

Ruskin, John. *The Queen of the Air: Being a Study of the Greek Myths of Cloud and Storm*. New York: John Wiley, 1869. 14, 34.

Scott-Stokes, Henry Folliott. *Perseus; or, Of Dragons*. London: Kegan Paul, Trench, Trubner, 1924.

Sjöö, Monica, and Barbara Mor. *The Great Cosmic Mother: Rediscovering the Religion of the Earth*. San Francisco: Harper and Row, 1987. 209–10.

Slater, Philip. *The Glory of Hera: Greek Mythology and the Greek Family*. Boston: Beacon Press, 1968. 31–32, 308–36.

Snodgrass, Mary Ellen. *Voyages in Classical Mythology*. Santa Barbara, Calif.: ABC-CLIO, 1994. 239–49.

Valentis, Mary, and Anne Devane. *Female Rage: Unlocking Its Secrets, Claiming Its Power*. New York: Carol Southern Books, 1994.

Walker, Barbara G. *The Woman's Encyclopedia of Myths and Secrets*. San Francisco: Harper and Row, 1983. 349, 629.

Warner, Marina. *Monuments and Maidens: The Allegory of the Female Form.* New York: Atheneum, 1985. 104–26.

Weigle, Marta. *Spiders and Spinsters: Women and Mythology.* Albuquerque: University of New Mexico Press, 1982. 75–76, 77.

Wilk, Stephen. *Medusa: Solving the Myth of the Gorgon.* New York: Oxford University Press, 2000.

Wittig, Monique, and Sande Zeig. *Lesbian Peoples: Material for a Dictionary.* New York: Avon, 1979. 106.

Woodward, Jocelyn. *Perseus: A Study in Greek Art and Legend.* Cambridge: Cambridge University Press, 1937.

Philosophy, Psychology, and Psychoanalysis

Bolen, Jean Shinoda. *Goddesses in Everywoman: A New Psychology of Women.* San Francisco: Harper and Row, 1984. 101–3.

Buci-Glucksmann, Christine. *Baroque Reason: The Aesthetics of Modernity.* Translated by Patrick Camiller. Thousand Oaks, Calif.: Sage, 1994. 163–73.

Cherver, B. "Myth Petrification and Primordial Differentiation." *Revue française de psychanalyse* 57, no. 2 (1993): 535–49.

Derrida, Jacques. *Dissemination.* Translated by Barbara Johnson. Chicago: University of Chicago Press, 1981. 40–41 n. 39.

———. *Glas.* Translated by John P. Leavey, Jr., and Richard Rand. Lincoln: University of Nebraska Press, 1980. 45–46.

Deveraux, Mary. "Oppressive Texts, Resisting Readers, and the Gendered Spectator: The 'New' Aesthetics." *Journal of Aesthetics and Art Criticism* 48 (Fall 1990): 337–47.

Ebreo, Leone. *The Philosophy of Love.* 1535. Translated by F. Friedberg-Seeley and Jean H. Barnes. London: Soncino Press, 1937. 111–12.

Fleugel, J. "Polyphallic Symbolism and the Castration Complex." *The International Journal of Psychoanalysis* 5, no. 1 (Jan. 1924): 155–96.

Jones, Ernest. *On the Nightmare.* London: Hogarth Press, 1949. 80, 298, 299, 303.

Krell, David Farrell. *Postponements: Woman, Sensuality, and Death in Nietzsche.* Bloomington: Indiana University Press, 1986. 20, 35, 38, 68–69, 71, 81, 85, 87, 113 n. l2.

Lederer, Wolfgang. *The Fear of Women.* New York: Harcourt Brace Jovanovich, 1968. 3, 43, 253–56.

Mulvey, Laura. "Visual Pleasure and Narrative Cinema." *Screen* 16, no. 3 (1975): 6–18.

Oliver, Kelly. *Womanizing Nietzsche: Philosophy's Relation to the Feminine.* New York: Routledge, 1995. 115–17, 155.

Pautrat, Bernard. "Nietzsche Medused." In *Looking After Nietzsche.* Edited by Laurence A. Rickels and translated by Peter Connor. Albany: State University of New York Press, 1990. 159–73.

Rupprecht, Carol Schreier. "The Common Language of Women's Dreams: Colloquy of Mind and Body." In *Feminist Archetypal Theory: Interdisciplinary Re-visions of Jungian Thought.* Edited by Estella Lauter and Carol Schreier Rupprecht. Knoxville: University of Tennessee Press, 1985. 212–13.

Smith, J. C. *The Castration of Oedipus: Feminism, Psychoanalysis, and the Will to Power.* New York: New York University Press, 1996.

Travis, Molly Abel, and Jamie Barlowe. "Dialogue of the Imaginary." *Women and Language* 18, no. 2 (1995): 47–51.

Other

Elworthy, Frederick Thomas. *The Evil Eye: An Account of this Ancient and Widespread Superstition.* New York: Bell Pub. Co., 1989.

Fear, A. T. "Bladud: The Flying King of Bath." *Folklore* 103, no. 2 (1992): 222–24.

Lettvin, Jerome. "The Gorgon's Eye." In *Astronomy of the Ancients.* Edited by Kenneth Brecher and Michael Feirtag. Cambridge, Mass.: MIT Press, 1979. 133–51.

Mayer, M. "Hofmannsthal, 'Electra,' the Poet and the Medusa." *Zeitschrift für deutsche Philologie* 110, no. 2 (1991): 230–47.

McMahon, L. "Terror of Origin—On Hysteria and the Medusa." *American Poetry Review* 20, no. 3 (1991): 15–19.

The Medusa; or, Penny Politician. London: T. Davidson, 1819–1820.

Thomas, Lewis. *The Medusa and the Snail: More Notes of a Biology Watcher.* New York: Viking Press, 1979. 1–6.

Wilner, Eleanor. "The Medusa Connection." *TriQuarterly* 88 (Fall 1993): 104–32.

Sources and Permissions

Selections from Homer, *The Iliad*, in *"The Iliad" and "The Odyssey" of Homer*, translated by Richmond Lattimore, reprinted from *Great Books of the Western World* (Chicago: Encyclopedia Brittanica, 1990). Copyright © 1952, 1990 Encyclopedia Britannica, Inc.

Selections from Hesiod, *The Shield of Herakles* and *Theogony*, in *The Works and Days; Theogony; The Shield of Herakles*, translated by Richmond Lattimore (Ann Arbor: University of Michigan Press, 1991). Copyright © The University of Michigan Press. Reprinted by permission of the publisher.

Pindar, "Twelfth Pythian Ode," from *The Odes of Pindar*, translated by Geoffrey S. Conway (London: Dent, 1972). Copyright © 1972 Everyman's Library, David Campbell Publishers Ltd.

Selection from Euripides, *Ion*, translated by Ronald Frederick Willetts, in *The Complete Greek Tragedies*, edited by David Grene and Richmond Lattimore, vol. 4 (Chicago: The University of Chicago Press, 1959). Copyright © 1958 The University of Chicago. Reprinted by permission of The University of Chicago Press.

Selection from Palaephatus, *On Unbelievable Tales*, translated by Jacob Stern. (Wauconda, Ill.: Bolchazy-Carducci Publishers, Inc., 1996), 62–64.

Selection from Apollodorus, *The Library*, translated by James Frazier (Cambridge, Mass.: Harvard University Press, 1990). Reprinted by permission of the publisher and the Loeb Classical Library.

Selection from Diodorus Siculus, *The Historical Library of Diodorus the Sicilian, in Fifteen Books*, translated by G. Booth, vol. 1 (London: W. McDowall for J. Davis, 1814).

Selections from Ovid, *Metamorphoses*, translated by Rolfe Humphries (Bloomington: Indiana University Press, 1955).

Selection from Lucan, *Pharsalia*, translated by Robert Graves (Baltimore: Penguin Books, 1957). Reprinted by permission of Carcanet Press Ltd.

Selections from Lucian, *The Hall*, translated by A. M. Harmon, vol. 1

(Cambridge, Mass.: Harvard University Press, 1961). Reprinted by permission of the publisher and the Loeb Classical Library.

Selection from Pausanias, "Corinth," in *Description of Greece*, translated by W. H. S. Jones, vol.1 (London: William Heinemann; New York: G. P. Putman's Sons, 1918).

Selection from Achilles Tatius, *Leucippe and Clitophon*, translated by John J. Winkler, in *Collected Ancient Greek Novels*, edited by B .P. Reardon (Berkeley and Los Angeles: University of California Press, 1989). Reprinted by permission of the publisher.

Selections from Fulgentius, in *Fulgentius the Mythographer,* translated by Leslie G. Whitbread (Columbus: Ohio State University Press, 1971). Reprinted courtesy of Marjorie Whitbread.

Selections from John Malalas, *The Chronicle of John Malalas*, translated by Elizabeth Jeffreys, Michael Jeffreys, and Roger Scott (Melbourne: Australian Association for Byzantine Studies, 1986). Reprinted by permission of the publisher.

Selection from Dante Alighieri, "Canto 9," in *The Divine Comedy of Dante Alighieri: Inferno*, translated by Allen Mandelbaum. (Berkeley and Los Angeles: University of California Press, 1980). Copyright © 1980 Allen Mandelbaum. Reprinted by permission of Bantam Books, a division of Bantam Doubleday Dell Publishing Group, Inc.

Petrarch, *"Rime Sparse 197,"* from *Petrarch's Lyric Poems: The "Rime Sparse" and Other Lyrics*, translated by Robert Durling (Cambridge, Mass.: Harvard University Press, 1976). Reprinted by the permission of the publisher.

Selection from Coluccio Salutati, *De Laboribus Hercules* [*On the Labors of Hercules*], edited by B. L. Ullman, vol. 1 (Zürich: Artemis-Verlag, 1951). Translated by Lesley E. Lundeen (1998). Translation printed by permission of Leslie E. Lundeen.

Selection from Christine de Pizan, *The Book of the City of Ladies*, translated by Earl Jeffrey Richards (New York: Persea Books, 1982). Copyright © 1982 Persea Books, Inc. Reprinted by permission of Persea Books, Inc.

Selection from Leone Ebreo, *The Philosophy of Love,* translated by F. Friedeberg-Seeley and Jean H. Barnes (London: The Soncino Press, 1937).

Selections from Giorgio Vasari, *Lives of the Artists,* translated by George Bull, vol. 1 (New York: Penguin Books, 1965), 258–60. Copyright © 1965 George Bull. Reprinted by permission of Penguin Books Ltd.

Selections from Natale Conti, in *Natale Conti's Mythologies: A Select Translation*, translated by Anthony DiMatteo (New York: Garland, 1994).

Selection from Vincenzo Cartari, *Imagini delli dei de gl'antichi* [*Images of the*

Gods] (Genova: Nuova Stile Regina Editrice, 1987). Translated by Walter Hryshko (1998). Translation printed by permission of Walter Hryshko.

Selection from John Harington's preface to his translation of the *Orlando Furioso* by Ludovico Ariosto (Oxford: Clarendon Press, 1972). Reprinted by permission of Oxford University Press.

Selection from Francis Bacon, "Perseus, or War," in *The Works*, edited by James Spedding, Robert Leslie Ellis, and Douglas Denton Heath, vol. 6 (London: Longman & Co., 1870; reprint, New York: Garrett Press, 1968).

William Drummond, "The Statue of Medusa," from *William Drummond of Hawthornden: Poems and Prose*, edited by Robert H. MacDonald (Edinburgh: Scottish Academic Press, 1976). Copyright © 1976. Reprinted by permission of the Scottish Academic Press.

Selection from Johann Wolfgang von Goethe, *Faust,* translated and edited by Stuart Atkins (Cambridge, Mass.: Suhrkamp / Insel, 1984). Reprinted by permission of Princeton University Press.

Percy Bysshe Shelley, "On the Medusa of Leonardo da Vinci in the Florentine Gallery," in *The Complete Poetical Works of Percy Bysshe Shelley*, edited by Thomas Hutchinson (London: Oxford University Press and Humphrey Milford, 1934).

Selection from Karl Marx, *Capital,* in *The Marx-Engels Reader*, 2d ed., edited by Robert C. Tucker (New York: W. W. Norton and Company, 1978). Reprinted by permission of W. W. Norton and Company, Inc.

Dante Gabriel Rossetti, "Aspecta Medusa," in *The Collected Works of Dante Gabriel Rossetti*, edited by William M. Rossetti, vol. 1 (London: Ellis and Elvey, 1897).

Selection from Friedrich Nietzsche, *The Birth of Tragedy,* from *The Basic Writings of Nietzsche* (New York: Modern Library, 1968*)*. Copyright © 1967 Walter Kaufmann. Reprinted by permission of Random House, Inc.

David Starr Jordan, "The Head and the Snakes," in *The Book of Knight and Barbara* (New York: D. Appleton and Company, 1899).

Louise Bogan, "Medusa," from *The Blue Estuaries* (New York: Farrar, Straus and Giroux, 1968). Copyright © 1968 Louise Bogan. Reprinted by permission of Farrar, Straus and Giroux, Inc.

Sigmund Freud, "Medusa's Head" and a selection from "The Infantile Genital Organization," in *The Standard Edition of the Complete Psychological Works of Sigmund Freud*, translated and edited by James Strachey. "Medusa's Head," *SE*, vol. 18 (1955; reprint, London: The Hogarth Press and The Institute of Psycho-Analysis, 1981); "The Infantile Genital Organization," *SE*, vol. 19 (London: The Hogarth Press and The Institute of Psycho-Analysis, 1961).

tuality, and Politics 3 (Winter/Spring 1986). Copyright © 1986 Emily Erwin Culpepper.

Amy Clampitt, "Medusa," from *Archaic Figure* (New York: Alfred A. Knopf, 1987). Copyright © 1987 Amy Clampitt. Reprinted by permission of Alfred A. Knopf, Inc.

Selections from Marjorie Garber, *Shakespeare's Ghost Writers: Literature as Uncanny Causality* (New York: Methuen, 1987). Copyright © 1987 Marjorie Garber. Reprinted by permission of Routledge.

Rita Dove, "Medusa," from *Grace Notes* (New York: W. W. Norton and Company, 1989). Copyright © 1989 Rita Dove. Reprinted by permission of the author and W. W. Norton and Company, Inc.

Selection from Barbara Frischmuth, "Grown Older . . . ," translated by Francis Michael Sharp, in *Relationships: An Anthology of Contemporary Austrian Prose*, selected and introduced by Adolf Opel, edited by Donald G. Daviau (Riverside, Calif.: Ariadne Press, 1991). Reprinted by permission of Ariadne Press.

Selection from Sander Gilman , *The Jew's Body* (New York: Routledge, 1991). Copyright © 1991 Sander Gilman. Reprinted by permission of Routledge, Inc.

Selections from Françoise Frontisi-Ducroux, "La Gorgone, Paradigme de création d'images" [The Gorgon, Paradigm of Image Creation], *Les Cahiers du College Iconique: Communications et Débats I* (1993). Translated by Seth Graebner (1999). Translation printed by permission of the author and the translator.

Selection from Diana Fuss and Joel Sanders, "Berggasse 19: Inside Freud's Office," in *Stud: Architectures of Masculinity*, edited by Joel Sanders (New York: Princeton Architectural Press, 1996).

Selections from Lizbeth Goodman, "Who's Looking at Who(m)?: Reviewing Medusa," *Modern Drama* 39:1 (Spring 1996). Reprinted by permission of the University of Toronto Press.

Selection from Mark Seal, "The Versace Moment," *American Way* 29:15 (August 1996). Reprinted by permission of the author.

Illustration Permissions and Credits

Figure 1, *The Head of Medusa*: Alinari / Art Resource, New York; Figure 2, Boeotian amphora vase: R. M. N., by permission of Musée du Louvre, Paris; Figure 3, Panathenaic amphora vase: Staatliche Antikensammlungen und Glypothek, Munich; Figure 4, Vase interior: Museum of Fine Arts, Boston and the

Henry Lillie Pierce Fund; Figure 5, Ten scruples coin: Museum of Fine Arts, Boston and the Theodora Wilbour Fund; Figure 6, *Medusa Rondanini* (Roman copy): H. Koppermann, by permission of Staatliche Antikensammlungen und Glyptothek, Munich; Figure 7, Perseus with the head of Medusa: Biblioteek der Rijksuniversiteit, Leiden, Netherlands; Figure 8, Venetian illumination: Biblioteca Riccardiana, Florence; Figure 9, Cellini, *Perseus*: Alinari / Art Resource, New York; Figure 10, Canova, *Perseus Holding the Head of Medusa*: Metropolitan Museum of Art, Fletcher Fund, 1967, New York; Figure 11, Cort, *Head of Medusa*: Bibliotheque Royale Albert, Brussels; Figure 12, *Matière à réflection pour les jongleurs couronnées*: Cliché Bibliotèque Nationale de France, Paris; Fig; 13, Rubens, *The Head of Medusa*: Erich Lessing / Art Resource, New York; Figure 14, Flemish School, *Medusa*: Alinari / Art Resource, New York; Figure 15, Barney, *Medusa (Laura Dreyfus Barney)*: National Museum of American Art, Smithsonian Institution, Washington, D.C. / Art Resource, New York; Figure 16, Lévy-Dhurmer, *Medusa*: R. M. N., by permission of Réunion des Musées Nationaux, Paris; Figure 17, Hosmer, *Medusa*: Detroit Institute of Arts, Detroit, Michigan, Founders Society Purchase, Robert H. Tannahill Foundation Fund, copyright © 1985 The Detroit Institute of Arts; Figure 18, de Morgan, Bust of Medusa: de Morgan Foundation, London; Figure 19, Burne-Jones, *The Birth of Chrysaor from the Blood of Medusa*: Southampton City Art Gallery, Southampton, England; Figure 20, Bourdelle, *Head of Medusa*: Rhodia Dufet Bourdelle copyright © 1999 Artists Rights Society (ARS), New York / ADAGP, Paris; Figure 21, Flack, *Colossal Head of Medusa*: Steve Lopez, by permisson of Louis K. Meisel Gallery, New York; Figure 22, Courbet, *The Origin of the World*: R. M. N., by permission of Réunion des Musées Nationaux, Paris; Figure 23, Magritte, *Le viol [The Rape]*: Hickey-Roberston, Houston, Texas, by permission of the Menil Collection, Houston, Texas; Figure 24, *La Syphilis*: by permission of the Health Sciences Library, Rare Books and Special Collections, University of Wisconsin at Madison; Figure 25, Miller, *David E. Scherman*: Lee Miller Archives, East Sussex, England; Figure 26, *The Pleasures of Crewel*, "Medusa Head Picture": General Mills, Inc.; Figure 27, Kruger, *Untitled (Your Gaze Hits the Side of My Face)*: Zindman/Fremont, New York, by permission of Mary Boone Gallery, New York; Figure 28, Versace women's couture: Richard Avedon for Gianni Versace, 1994; Figure 29, Versace men's underwear: Bruce Weber for Gianni Versace, 1995; Figure 30, Harrison Ford as Medusa: Jay L. Abramovitz, by permission of Jay Abramovitz; Figure 31, Lennox, *Medusa*: Bettina Rheims, 1995 copyright © Bettina Rheims / BMG Records; Figure 32; Medusa, Six Flags Great Adventure, Jackson, New Jersey